SOL LEWITT

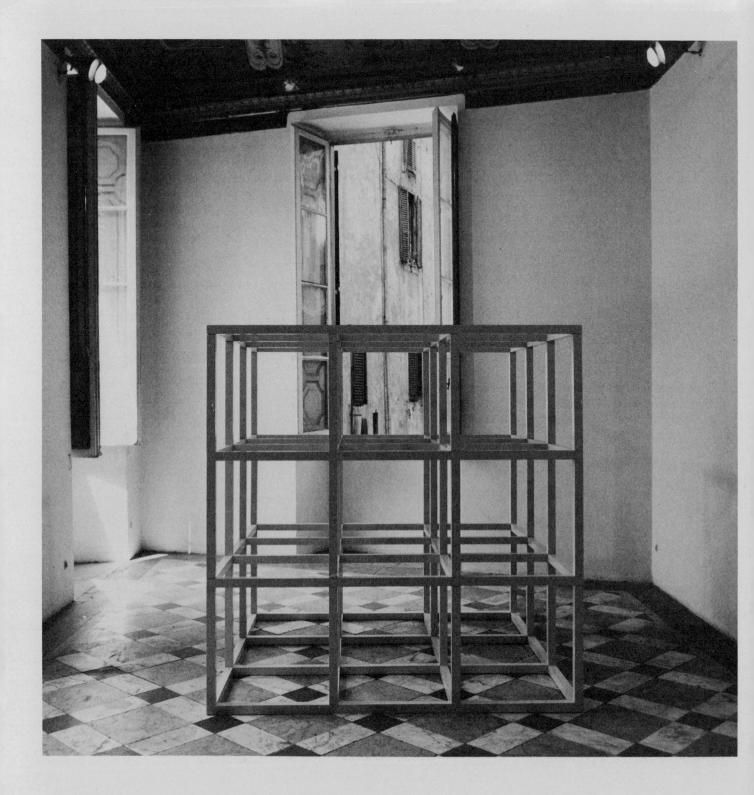

SOL LEWITT
THE MUSEUM OF MODERN ART
NEW YORK
EDITED AND INTRODUCED BY
ALICIA LEGG
DESIGNED BY SOL LEWITT
ESSAYS BY
LUCY R. LIPPARD
BERNICE ROSE
ROBERT ROSENBLUM

Frontispiece: *Modular Cube.* 1966, remade 1969. Painted steel,
6 x 6 x 6 ft. (182.9 x 182.9 x 182.9 cm).
Sperone Westwater Fischer, Inc., New York

*This was the first modular cube. It was made in the winter of 1965–66. The
height, six feet, was approximately human scale. It was intended to be large,
but not too large. That spring it was shown at the "Primary Structures"
show at the Jewish Museum, New York.*

Copyright © 1978 The Museum of Modern Art
All rights reserved
Library of Congress Catalog Card Number 77–15309
Clothbound ISBN 0–87070–427–3
Paperbound ISBN 0–87070–428–1

Type set by David Seham Associates, Metuchen, N.J.
Color separations by Offset Separations Corp., New York, N.Y.
Color Printed by Eastern Press, New Haven, Conn.
Black and White Printed by Halliday Lithograph Corp., West Hanover, Mass.
Bound by Sendor Bindery, New York, N.Y.

The Museum of Modern Art
11 West 53 Street
New York, New York 10019

*This book and the exhibition it accompanies have been made possible
through the generous support of the National Endowment for the Arts
in Washington, D.C., a federal agency.*
Printed in the United States of America

ACKNOWLEDGMENTS

Working with Sol LeWitt on this book, which he has designed and which accompanies his exhibition at The Museum of Modern Art, has been a rewarding experience for me and for many members of the staff. We are grateful to him for his openness in exchanging ideas and for providing essential information on the development of his art.

The exhibition is devoted to LeWitt's modular and serial structures, framed drawings, and wall drawings. Because a number of gallery areas were given over to wall drawings, it was not possible to include prints. It is fortunate, therefore, that the Brooklyn Museum arranged a Sol LeWitt print exhibition to run concurrently with our exhibition, giving all New Yorkers an opportunity to see LeWitt's complete oeuvre.

This publication, while not a catalog of the exhibition, includes a large selection of early works as well as reproductions of whole series, of which only one or a few can actually be shown. We are fortunate in our authors on LeWitt. Lucy Lippard, critic and writer on recent developments in American art, has known the artist since 1960 and has closely followed his careers as both a creator of ideas and an artist. Bernice Rose, Curator of Drawings at the Museum, also writes from long familiarity with the artist's work; her essay is largely devoted to his drawings. Robert Rosenblum, critic, and Professor at the Institute of Fine Arts, New York University, discusses LeWitt's career in relation to contemporary movements, particularly his involvement with Conceptual art.

We are pleased that the exhibition will be seen in Canada, at the Museum of Contemporary Art, Montreal; the Krannert Art Museum, University of Illinois, Champaign; and the La Jolla Museum of Contemporary Art in California, and we wish to acknowledge the participation of these museums.

Our deepest thanks are due the following lenders of works by LeWitt who willingly cooperated in the exhibition: Dr. Angelo Baldassarre; Dr. and Mrs. Lorenzo Bonomo; Mr. and Mrs. M. Boulois; Daniel Buren; J. Frederic Byers III; Beatrice Conrad-Eybesfeld; Dr. Luca A. Dosi-Delfini; Virginia Dwan; Dr. and Mrs. Aaron H. Esman; Mrs. Marilyn Fischbach; Philippe and Maya Garboua; Gilman Paper Company; Susan Ginsburg; Mr. and Mrs. Sy Greenbaum; Laura Grisi; Donald Judd; Robert King Associates; Mr. and Mrs. Ronald S. Lauder; Sol LeWitt; Ira and Jennifer Licht; Lucy R. Lippard; Robert and Sylvia Mangold; Mr. and Mrs. Morton Neumann; Mr. and Mrs. S. I. Newhouse, Jr.; Giuseppe Panza di Biumo; Parasol Press; Henry Pearson; Michael M. Rea; Friedrich E. Rentschler; Dorothea Rockburne; Estate of Robert Smithson; Dr. Paul M. Vanek; Martin Visser; Dorothy and Herbert Vogel; Ruth Vollmer; Annina Nosei

Weber; John and Kay Weber; Mimi Wheeler; Kunstmuseum Basel; Wadsworth Atheneum, Hartford, Connecticut; The Tate Gallery, London; Los Angeles County Museum of Art; New Britain Museum of American Art, New Britain, Connecticut; The Museum of Modern Art, New York; The St. Louis Art Museum; San Francisco Museum of Modern Art; Paula Cooper Gallery, New York; Gloria Cortella, Inc., New York; Dwan Gallery, New York; Rosa Esman Gallery, New York; Sperone Westwater Fischer, Inc., New York; John Weber Gallery, New York; and Konrad Fischer Gallery, Düsseldorf.

Jennifer Licht, formerly of the Department of Painting and Sculpture, who knew LeWitt well and had followed his work closely, was the first to propose the exhibition. Her continued encouragement is greatly appreciated by her colleagues. I would like to thank William Rubin, Director of the Department of Painting and Sculpture, for his support and assistance on this project. Laura Rosenstock, Curatorial Assistant, has been an invaluable colleague, collaborating in all aspects of the exhibition and of this book; she compiled the bibliography, assisted in verifying all the documentation, and also helped on the layout. Vera Elizabeth Kalmykow ably handled the exhibition correspondence and the typing of all manuscript and documentary material.

Richard Palmer and Mary Lea Bandy of the Department of Exhibitions made arrangements for the tour of the exhibition and handled the complicated scheduling of the installation, ably assisted by William Williams and Fred Coxen and by the preparators who installed the works. This exhibition, which contained more wall drawings under one roof than have ever before been presented, necessitated close planning of the work schedules of the Museum's excellent technical staff, all of whom performed with their usual professionalism. Eloise Ricciardelli, Acting Registrar, and Diane Jablon, Senior Cataloger, have with their usual care and efficiency arranged for the transport of the works of art and their excellent handling within the Museum. Other members of the staff whose services were essential in mounting the exhibition are Patricia Houlihan, Senior Sculpture Conservator, and Henry Cohen, Sculpture Conservator; Antoinette King, Paper Conservator; William Burback, Director's Special Assistant for Education, who organized a lecture program and other events; Barbara London for her work in video; Richard Tooke, Supervisor, Department of Rights and Reproductions; Esther Carpenter, Archival Assistant; and Kate Keller, who made a number of new photographs in color and black-and-white for this book.

John Weber and the staff of his gallery provided valuable

documentation on LeWitt's career and information on specific works. We are especially grateful to Susanna Singer for her good-humored efficiency. Paul Toner, representative of the Dwan Gallery, has been very helpful, as has Annemarie Verna of Zurich.

Finally, I wish to thank the Department of Publications for their enthusiastic cooperation on the book. Special mention must be made of Susan Weiley's perceptive editorial guidance and Patrick Cunningham's willing collaboration with LeWitt on the preparation of the graphic material and the layout of the text section. Stevan A. Baron and Yone Akiyama have seen the book through the various stages of production, and Nancy Kranz has arranged for its distribution. Frances Keech, Permissions Editor, has also made an important contribution. The knowledge and expertise of all have been essential and very much appreciated.

Alicia Legg

I want to thank Alicia Legg, Laura Rosenstock, Susan Weiley, and Patrick Cunningham, and the Museum staff for their help with the show and catalog; Jo Watanabe, Akira Hagihara, and Kazuko Miyamoto, and all my other assistants for their help in preparing the work; and the lenders to the exhibition, especially Virginia Dwan.

Sol LeWitt

CONTENTS

INTRODUCTION by Alicia Legg

PAINTER, SCULPTOR, DRAFTSMAN, PRINTMAKER, and originator of wall drawings, Sol LeWitt uses the grid as his basic ingredient. His open cubes, with their ordered grid construction and their multiple corridors with receding perspective, are now known throughout the United States as well as in Europe, South America, Japan, and Australia.

In 1962 and 1963 LeWitt's paintings became reliefs; the square surface was repeated in successively smaller squares telescoped to a central, projecting rod. These simple but powerful square shapes were among the first to deal with a fundamental element of form, the right angle. From this, boxes (or cubes) were juxtaposed and rearranged. Cages, lattices, clustered or stacked cubes, first in black and then in white, preempted the space they occupied, whether they were free-standing or attached to the wall. Forms evolved that comprised the skeleton or the skin of a shape, such as the framework of a cube, or a box with all solid sides, or one with one or two open sides. Numerous possibilities opened up, and the cube assumed primary importance; in the mid-1960s it became LeWitts's modular unit.

LeWitt's grids are ubiquitous. As structures they hang on the wall, fit into the corner, or "hold the floor." The wall pieces can be flat, with only the shallow depth of the members defined by shadows, or they can project to the depth of a cubic unit and, depending on the number of units, set kinetic passage in motion as the viewer approaches. Shadows also play a role, creating diagonal lines in this three-dimensional crosshatching. Free-standing grids are either pure cubes or rectangular shapes, vertical like shafts or flat like platforms. There are even cubes stacked like building blocks, some in steel or aluminum are as high as ten feet; others in wood or metal can be held in the hand.

Because of the possibilities for multiplication inherent in the grid form, a basic and seemingly unlimited vocabulary was at LeWitt's disposal. In 1966 he began to work in serial form and produced multipart pieces of finite order but infinite complexity. The first serial piece, *Serial Project No. 1 (ABCD)* (fig.130), composed of four sets of nine sections, was based on placing one form within another, with variations, in two and three dimensions. Progression moved from the delicate tracery of squares and rectangles on a grid base to the gradual integration of solid shapes, until the final set of block forms stood in solemn grandeur. The following year he exploited the numerous variations in three-dimensional open and closed cubes in as many as sixty-three different examples. In another important serial piece of 1974, *Variations of Incomplete Open Cubes* (fig.144), he assembled 122 variations on the linear structure of a cube; here the piece progressed from the fundamental three-bar form to the penultimate one of eleven bars (twelve completing the cube). The viewer becomes fascinated and intrigued with the task of mentally filling in the missing bars along the course of the planned progression.

LeWitt's interest in repetition led him to subtly refine the placing of a cube inside a larger cube. In his *Cubes with Hidden Cubes* (fig.139) one sees five identical solid cubes on five flat bases. Only from the markings on the bases of the area of the successively smaller cubes can one guess that there may actually be fifteen cubes in this five-part piece! In effect, only the first cube is empty. Inside the other four are one, two, three, and four cubes, respectively.

LeWitt's descriptive titles — for example, *Geometric Figures, Open, Geometric Figures, Solid* or *Lines Not Long, Not Straight, Not Touching* —are the essence of succinctness, and it is just this compactness that is stimulating—both in the written form as well as in the completed work. Despite the innumerable permutations, one gathers that no extra step has been taken and that the logical conclusion has been reached. An analogy to sailing comes to mind. The artist is the skipper and his materials are the boat, its fittings, and the crew. There is a place for every man and every instrument and certain conditions when each is used. It is the artist's skill that plots the course and his ingenuity that brings him through the heavy weather. Sol LeWitt has maintained an amazing control over his many simultaneous projects: designing and overseeing the fabrication of his structures and the execution of his wall drawings, producing books that he conceives and designs, and making innumerable drawings, both singly and in series, as well as many editions of colored prints.

LeWitt refers to his work as Conceptual art. He believes that the initial idea is paramount and that it must be fully understood by the artist before a work is carried out. If the thinking has been done in advance, he wrote, "the execution is a perfunctory affair."[1] The notion of encouraging the mind to discover, or fill out what is unseen, is expressed in a problem posed by a "cube" of 1966: the piece occupies a corner, its three empty square frames, one on the floor and the others on each wall, leaving it to the mind's eye to join the corresponding edges at bottom and sides (fig.49). LeWitt continued, "the idea becomes the machine that makes the art,"[2] and it is the idea that engages the viewer, who responds first with amused expectation and then often with delight to see how the proposition is realized.

Like LeWitt's structures, his first important drawings were also derived from the grid. Their basic configuration is paral-

lel lines and their direction the cardinal points and the intermediate points, or vertical, horizontal, and the two diagonals. In his characteristic way, LeWitt has refined this pattern, first by developing extraordinary skill and control in maintaining an even, narrow space between the lines, and then by the multiple variations of these "points of the compass." When color is used and its basic rule is laid out (yellow–vertical; black–horizontal; red–diagonal left to right; blue–diagonal right to left), the combinations range from subtle tints to vibrant hues.

Considering the primary characteristics of a line—straight, not straight, and broken—LeWitt produced a large group of drawings with his ingenious variations based on these rubrics. He then added new rules calling for lines of a certain length, not touching, or lines drawn on the wall between architectural points—points of ceiling beams to the corner of a floor board, or a door hinge to a light outlet, and so on. In 1975 a series of drawings combined the printed description of what is going on with the actual line; thus the page is covered with verticals, horizontals, and diagonals that are actually lines, with printed words saying that the line is vertical, horizontal, or whatever, printed above or below them. The artist's wit is apparent, but his deliberate seriousness is never totally compromised.

Since 1968 LeWitt's wall drawings have gained international attention. Their premise is two-dimensionality, and LeWitt sought the most direct way to achieve this, which was to use the wall as his sheet of paper. The owner of a wall drawing acquires, in addition, a certificate, which is a photograph of the wall drawing, and written instructions; this gives him the right to execute this drawing on a wall of his choice. Wall drawings are comparable to the sheet drawings but have surpassed them. Owing to the nature of architectural spaces, the shapes of walls dictate designs or patterns that would never suit a sheet of paper, and LeWitt's responses to this challenge have been daring, inventive, and often extraordinarily beautiful. The drawing *All Combinations of Arcs from Corners; Straight, Not-Straight, and Broken Lines* (fig.216), when rendered in black chalk on the wall of a cloister of a deconsecrated Italian church, accommodated to the rough finish of the wall, the curved and straight lines crisp at times but fading at others according to the mellow, uneven surface. In comparison, a variation of this series decorated the walls of a contemporary gallery in Rome; there the sharp, sweeping arcs and decisive lines on smooth plaster contrasted strongly with the geometric tiled floor.

Since 1966 Sol LeWitt's own publications have added another dimension to his prolific repertory. LeWitt's writings in exhibition catalogs and art periodicals are listed in the bibliography, as are the books and catalogs designed by him. These already number more than thirty-one. In her essay on page 23, Lucy Lippard discusses LeWitt's theories on the communication of ideas and his regard for inexpensive editions that can reach a large audience. Wide dissemination of information and visual material seem to relate to his attitude toward wall drawings; it is the direct approach to the public that appeals to him.

LeWitt's books correspond chronologically with his work in structures and then in drawing. His first group of publications was devoted to his Serial Projects, both three-dimensional and linear. LeWitt's first publication was called *Serial Project No. 1, 1966.* It was a sixteen-page pamphlet devoted to the four-part set of nine sections, which has come to be called the "ABCD Piece." Each group comprises variations on open and closed forms. LeWitt's characteristic format of a line defining the margins is introduced here. He uses line drawings and diagrams opposite text and in four double-page spreads he illustrates the thirty-six variations in grids of nine sections.

In 1967–68 he presented another serial piece in a twenty-eight page booklet on the 47 *Three-Part Variations on Three Different Kinds of Cubes,* known as the "1,2,3 Piece" (fig.132). In a format of 6¾ x 14 inches, with the margins outlined in black, the artist rendered in pen and ink the various combinations of stacked cubes with open and closed sides, each having a numbered diagram and a caption on the opposite page.

LeWitt produced another serial work in 1974: the book *Incomplete Open Cubes,* which accompanied the exhibition at the John Weber Gallery. Beginning with a schematic drawing illustrating the 122 variations of the linear members of an open cube, the book illustrates on the left-hand pages photographs of three-dimensional modules and on the right-hand pages line drawings of the identical unit. These facing pages present a vivid contrast: a photograph of a white unit on a strong black square with a wide white border; opposite, a line drawing that violates the margin's edge. Periodically, headings in bold type oppose a schematic drawing, as in "Six-Part Variations," a caption for a grid with twenty-four line drawings. All told, this exhibition, which was almost breathtaking in its three-dimensional form of 122 eight-inch units laid out on a grid platform, is equally fascinating in book form.

LeWitt's work in line had crystallized by 1968 and in December he showed his classic *Set II A, 1-24* drawings at the Ace Gallery in Los Angeles. The whole work, entitled *I, II, III, IIII,* was published by Sperone/Fischer in 1974. It presents the four basic kinds of line—vertical, horizontal, and the two diagonals—in 192 drawings of finely drawn lines on four 4½-inch squares, each one containing four smaller squares. The four sets of twenty-four drawings each are divided into two parts: (A) on the left-hand pages the squares are filled with single lines; (B) on the right-hand pages the grid invades the austerity of the sixteen close-lined squares, creating varied plaid patterns of light, dark, and middle-toned squares. For each set there are "composites" of as many as 384 squares to a single page, or on a smaller scale two double-page spreads of 768 squares, one each for the A and B series; they are a *tour de force* of draftsmanship and printing. The pages of single-line squares are so fine and so uniform, the overall effect is like gray velvet. In contrast, the checkered squares of the B series pulsate with lights and darks.

Four Basic Kinds of Lines, a book on a similar theme, was published in 1969 by *Studio International.* Here again, on toned paper, the 1,2,3,4 formula was rendered on the full eight-by-eight-inch page in lines so close the final grid is a charcoal black against the facing off-white page.

In 1972 the Kunsthalle Bern and Paul Bianchini published

Arcs, Circles & Grids. This commences with a page entitled *Arcs from One Corner* in which curves radiate from the lower left corner like a rising sun and when they reach the opposite corner the lines have become straight. When circles and grids enter the picture, successively and then simultaneously, the overlapping becomes complex but never too dense; the network of the final page is still brilliantly woven.

In *Geometric Figures within Geometric Figures,* published by the University of Colorado at Boulder in 1976, LeWitt's diagram in thirty-six squares contains all combinations of circles, squares, triangles, rectangles, trapezoids, and parellelograms within circles, squares, and so forth. The title page of this book is so repetitive it can almost seem ludicrous—until one peruses the pages, with their separate exposition of each form, drawn with exquisite delicacy in diagrams and single page designs. On the back cover the six geometric shapes are superimposed.

The *Location of Straight, Not-Straight & Broken Lines and All Their Combinations,* published in 1976, resembles geographical markings in line and dotted line; it is punctuated by blocks of printed text anchored on the relevant line and describing its function.

In *Modular Drawings,* published by Adelina von Furstenberg in 1976, there are fifty pages of drawings commencing with a stack of five squares and continuing within the limits of their furthest extension, creating forms that are part of a grid. This is the only book that is not a finite and complete series.

LeWitt has also produced a number of books in color that are of excellent quality and very inventive. The first, *Four Basic Colours and Their Combinations,* was issued by Lisson Publications in 1971. The front cover states the premise: the 1,2,3,4 are now colored lines and the rule is: vertical—yellow; horizontal—black; diagonal (left-right)—red; diagonal (right-left)—blue. The fifteen pages of colored lines and grids cover the full page; a final page with the diagram shows all the color combinations in a grid. The back cover displays four squares of superimposed colors.

Lines & Color of 1975 begins with two pages listing the color combinations, followed by a page each with bold type to introduce the contents: "Straight, Not-Straight and Broken Lines Using All Combinations of Black, White, Yellow, Red and Blue, for Lines and Intervals." Each double-page spread is a reverse image—black on white/white on black, etc., and the visual impact of the contrasts, both of primary colors and complementary colors, as well as of the three basic kinds of line, is at first matter-of-fact, but gradually becomes

very dynamic.

A small booklet published in 1975 by the Israel Museum, Jerusalem, is entitled *Red, Blue and Yellow Lines from Sides, Corners and the Center of the Page to Points on a Grid.* There are seven pages with radiating lines in one and all of the three primary colors. Each kind of line expresses a function and color; for example, red from the sides, blue from the corners, and yellow from the center.

"*Grids, Using Straight, Not-Straight and Broken Lines in Yellow, Red & Blue and All Their Combinations.* Forty-five etchings in an edition of ten with seven artist's proofs, printed by Crown Point Press, Oakland. Published by Parasol Press Ltd, New York City 1975." The above text fills the title page, which is followed by two pages listing the forty-five combinations of three different kinds of line in three colors. The 10½ x 10½-inch sheets present ⅛-inch grids containing between eighty and ninety squares. The visual effect of this unusually generous format for an etching series is stunning; the fundamental properties of line rendered free-hand evoke fascination and delight, which is enhanced by the quality of the color printing.

Other books on which Sol LeWitt has collaborated include the important publication issued by the Gemeentemuseum at The Hague, The Netherlands, for his exhibition held there in 1970. The design of this catalog introduces a number of his later graphic mannerisms, including the grid "spreads" of small illustrations that unfold the chronological development of his work. Special critical articles and excerpts from other artists' statements are included, as are as some of LeWitt's early writings.

Graphik: Siebdrucke, Lithographien, Radirrungen, Bücher, a ninety-six-page book on LeWitt's graphic work from 1970 to 1975, was published by the Kunsthalle Basel & Verlag Kornfeld & Cie., Bern, in collaboration with LeWitt, and printed by Stämpfli & Cie, Bern, for his exhibition of silkscreens, lithographs, and etchings. The color printing, in line instead of halftone, produces extraordinary clarity of line and accuracy of color. There are also diagrams of his various linear inventions both in black-and-white and color.

LeWitt's concern in a book is information. He believes numerous illustrations are essential to demonstrate the development of his themes. He wishes to show how ideas are brought to realization and, although not adhering to a rigid set of ground rules, he has devised a system of layout that reveals how ingeniously modular combinations and variations can be exploited.

—Alicia Legg, Associate Curator,
Department of Painting and Sculpture

NOTES

1. "Paragraphs on Conceptual Art," *Artforum* (New York), June 1967, p. 80. (See page 166 of this book.)
2. Ibid.

1928	Sol LeWitt born to Abraham and Sophie LeWitt on September 9 in Hartford, Connecticut. His parents, who were Russian Jews, had emigrated separately to the United States. His father graduated from Cornell Medical School in 1901 and practiced in Hartford. His parents were married in 1921. After his father's death in 1934, LeWitt and his mother moved to New Britain, Connecticut, where he attended elementary and high schools.
1945–49	Attended Syracuse University, Syracuse, New York, graduating with a BFA. He selected Syracuse because it was one of the few universities that had an art department.
1951–52	Served in the U.S. Army in Japan and Korea; this gave him an opportunity to study Oriental shrines, temples, and gardens.
1953	Moved to New York. Attended Cartoonists and Illustrators School (later known as The School of Visual Arts).
1954–55	Worked at *Seventeen* magazine as a photostat operator. The following year he was hired to do production work for the magazine.
1955–56	Worked as a graphic artist for the architect I. M. Pei on a project for the Roosevelt Field Shopping Center in Long Island, New York.
1957–60	Painted, and also did graphic design for a commercial firm.
1960–65	Worked at Information and Book Sales Desk, The Museum of Modern Art. Also worked as night receptionist at the Museum's staff entrance. In 1960 he met Lucy Lippard, who worked in the Museum Library, and the artists Robert Mangold, Robert Ryman, and Dan Flavin, who were working as guards.
1963–64	LeWitt's first three-dimensional works, included in a group show at St. Mark's Church, New York, in 1963, showed the influence of the Bauhaus, De Stijl, and Constructivism. In 1964 he was included in a group show at the Kaymar Gallery, New York. His own style—geometric reliefs, box forms, and wall structures—was already evident.
1964–71	In 1966 he was included in a three-man show (with Robert Smithson and Leo Valledor) at the Park Place Gallery, New York. Served as part-time instructor for The Museum of Modern Art's school, The People's Art Center (1964–67). LeWitt later taught at the following New York City art schools: Cooper Union (1967–68), School of Visual Arts (1969–70), and Education Department, New York University, Washington Square (1970–71).
1965	LeWitt's first modular pieces of open cubic forms were

made. In May he had his first one-man exhibition, at the Daniels Gallery, New York (showing painted wood constructions).

1966	Began combining modules in serial form.
1966–70	Participated in important group exhibitions of Minimal art, including "Multiplicity" at the Institute of Contemporary Art, Boston (1966), "Primary Structures" at the Jewish Museum, New York (1966), "Minimal Art" at the Gemeentemuseum, The Hague, The Netherlands (1968), and "The Art of the Real" at The Museum of Modern Art, New York (1968).
1967, 1969	Published two influential statements on Conceptualism: "Paragraphs on Conceptual Art" (*Artforum,* June 1967) and "Sentences on Conceptual Art" (*Art-Language,* May 1969).
1968	Developed a fundamental premise for drawings: "lines in four directions—vertical, horizontal, and the two diagonals." This was presented in his first wall drawing, done in October at the Paula Cooper Gallery, New York. He has since continued to investigate this in a varied series of black-and-white and color works.
1969–70	Included in group exhibitions of Conceptual art such as "When Attitudes Become Form" at the Kunsthalle Bern, Switzerland (1969); "Konzeption/Conception" at the Städtisch Museum, Leverkusen, West Germany (1969); and "Information" at The Museum of Modern Art, New York (1970).
1976	LeWitt's deep interest in bookmaking is shared by Lucy Lippard. In 1976 Lippard wrote a monograph on the artist Eva Hesse, published by the New York University Press. LeWitt designed the book. That year LeWitt and Lucy Lippard founded Printed Matter, a group whose aim is to publish as well as distribute artists' books. More than a dozen books have already appeared. Other members of the group are Edit de Ak, Amy Baker, Pat Steir, Mimi Wheeler, Robin White, and Irena von Zahn.

Artists whose friendship and professional association have been important to LeWitt include Eva Hesse, whom he knew well from 1960 until her death in 1970. Among other artist friends are Carl Andre, Jo Baer, Mel Bochner, Dan Graham, Michael Kirby, the late Robert Smithson, Marjorie Strider, and Ruth Vollmer.

Since 1967 LeWitt has traveled extensively in connection with his work. His individual and group exhibitions are listed chronologically in the Bibliography (p. 175). Exhibitions or projects in which the artist had personally participated, either by setting up serial works or by creating or supervising the execution of wall drawings, are indicated with an asterisk.

THREE ESSAYS

NOTES ON SOL LEWITT by Robert Rosenblum

CONCEPTUAL ART? The very sound of those words has chilled away and confused spectators who wonder just what, in fact, this art could be about or whether it is even visible. For like all labels that awkwardly blanket a host of new forms and attitudes, this one could become an out-and-out deception for those who never bothered to look and to discriminate. But this is hardly unfamiliar. Could one ever tell from the word "Cubism" what a typical Cubist work looked like? (A Sol LeWitt modular cube looks more literally "Cubist" than anything by Picasso.) Could one ever guess that one catchall phrase, "Abstract Expressionism," ended up by bracketing pictures that look and feel as different as, say, those by de Kooning and Newman? Indeed, wouldn't "Conceptual art" apply far better to the work of Leonardo da Vinci than to that of, say, Vito Acconci, a Conceptual artist who uses his very body and voice in his art? So yet again, one must be careful not to let vague and simple-minded words obliterate the enormous range of intentions and visible results placed under the same umbrella.

Perhaps one should be even more careful this time, since many so-called Conceptual artists have willfully tried to divorce themselves from inherited traditions of "object" art by implying or stating that art can remain gray matter in the mind and still be art. LeWitt himself has written, "Ideas can be works of art; they are in a chain of development that may eventually find some form. All ideas need not be made physical."[1] (But come to think of it, wasn't the physical *fact* of the Parthenon, experienced by relatively few people, infinitely less important than the *idea* of the Parthenon, which was to become a touchstone of Western civilization and architectural theory and practice? And wasn't this belief in perfect thought as opposed to imperfect and transitory matter shared by many Renaissance painters, sculptors, and architects who held that the tangible work of art was only a flawed reflection of an ideal concept, just as later, many Neoclassic artists prized the idea of a work of art more than its palpable materialization?) Some younger art historians, too, have supported the claims of total newness by sensing so drastic a change in the premises of Conceptual art in general and of LeWitt in particular that, as in the case of a recent critical combat (Kuspit vs. Masheck)[2] of unusual erudition and intellectual fervor, the very question was raised of whether words and ideas like "beauty" or "style" have not become irrelevant or anachronistic in dealing with LeWitt's work.

Yet, as happens with most innovative art, the passage of time softens the blow of what at first seemed unrecognizably new, slowly uncovering traditional roots and continuities that were initially invisible. How many times in this century, not to mention the last one, were audiences confronted with an art that was supposed to be intrinsically different from all earlier art, but that ended up being very much a part of it? Cubism, for one, was said to have achieved the most irrevocable rupture with all earlier traditions, but now it often looks more at home with the still lifes, figure paintings, and landscapes of the nineteenth century than it does with most later twentieth-century art. Abstract Expressionism, too, in the first shock of its originality, appeared to be a total break with a Western pictorial past, but it also looks comfortable now in a world of venerable easel painting traditions, so that a Rothko and a de Kooning can hang harmoniously with a Matisse and a Kandinsky, not to mention a Turner and a Hals. Pop art was no less startling an assault; however its heresies, like those of Abstract Expressionism, became familiar pieties and soon evoked respectable ancestors, so that Lichtenstein, for example, now looks quite as solemnly museum-worthy as Léger or Stuart Davis, who, in turn, must first have looked as brashly unprecedented as the Pop artists. And Earth Works, which seemed to undermine even the material conventions of Western art, have taken on, now that the dust has settled, a historical resonance that permits us to think of the best of them as, among other things, noble efforts to synthesize the grandest powers of man and nature in a geographic union that recreates, in late twentieth-century terms, our deepest Western memories of monuments as remote and awesome as Stonehenge or the Pyramids of Giza.

The same sort of thing is now happening with so-called Conceptual art, for not only is it fitting more and more readily into familiar patterns of historical continuity but also, in its wide range of manifestations (which were originally all lumped together in a pro-or-con situation, as with most new isms or movements that are initially praised or scorned blindly), we are gradually seeing both more trees and more forests, as well as distinguishing more easily between good and indifferent, major and minor work. Over the years now, Sol LeWitt has been looming ever larger as one of the most coherent, innovative, and liberating of those artists who presume to balance the constant eye-mind equation of art in favor of the mind; but even more to the point, his art has turned out to be stunningly beautiful. The use of this old-fashioned adjective may be inflammatory in the context of the rhetoric of both Conceptual artists and their critic-polemicists, but the experienced truth is that the finest of LeWitt's work elicits, especially among younger-generation spectators more quickly at home than their elders with the

visual idioms of the last decade, an instant response to its sheer visual excitement and daring, an immediate awe that, for better or for worse, has to be translated by the same feeble words—beautiful, elegant, exhilarating—that we use to register similar experiences with earlier art. The theories, the geometries, the ideas may all be called into play for a fuller elucidation of what is going on, but both initially and finally, it is the visible works of art that dominate our attention. The perceptual whole is far more than the sum of its conceptual parts, although the visual memory of LeWitt's executed images, like our imaginary recall of Greek sculpture or of a lost or damaged masterpiece by Leonardo, may outlive the actual objects. Were this not the case, LeWitt's work, as Lucy Lippard wrote in 1967, would be theory rather than art.[3]

There is really nothing new about this. One thinks of Uccello, whose perspectival calculations obsessed his mind and his pen, but whose art—finally more fantastic and beautiful than simply rational—is in no way to be equated with a Renaissance treatise on perspective or, for that matter, with the art of a lesser master who employed the same conceptual systems of projecting three-dimensional forms on a two-dimensional surface.[4] Or one thinks of Seurat, whose quasi-scientific theories—were we to deal only with them—might obscure the fact that his paintings, unlike those conceived or executed by other artists and theorists concerned with similar problems of rationalizing color, composition, and emotion, impose themselves first and foremost as breathtaking visual experiences that later, if we wish, can be dissected and analyzed in the light of Seurat's own writings (which may even be contradicted by his art). Thus, LeWitt's art may be steeped in his cerebral, verbal, and geometric systems, as was that of so many great, as well as inconsequential, artists before him, but its impact is not reducible to words. The immediate experience, like that of any important art that stops us in our tracks and demands lingering attention, is visual and visceral, rather than exclusively intellectual, and as such bears an intensely personal flavor that distinguishes it at once from the work of other contemporary artists concerned with, say, modular systems or the realization of verbal-visual equations. It is comforting here to have LeWitt's own sanction concerning the discrepancies between his own conceptual intentions and the ongoing perceptual life of the work itself: "It doesn't really matter if the viewer understands the concepts of the artist by seeing the art. Once it is out of his hand the artist has no control over the way the viewer will perceive the work. Different people will understand the same thing in a different way."[5]

Gradually, that is, we shall have to find ways of articulating our particular visual and emotional responses to LeWitt's work, as we have for other difficult new work of the past. Thus, Donald Kuspit's comment that LeWitt's objects seem "like a cold bath, at once repressive and exhilarating, instinct-denying and at the same time creating a sense of dammed-up energy,"[6] is one such vivid pinpointing in a simile of something of the peculiarly complex and irrational flavor we are beginning to discern in LeWitt's art. It is true, that is, that LeWitt insists on using words and forms with a logical rigor that implies the tonic, intellectual clarity of a

Euclidean theorem. But at the same time, his systems of elementary shapes can proliferate with a crazy extravagance that, to our surprise, puts the rational gray matter of logic, mathematics, and science at the service of a wildly florid artistic imagination. It is as if the computer systems that silently and invisibly permeate our late twentieth-century world had been freed from their utilitarian duties and had gone berserk in new two- and three-dimensional, cellular or labyrinthine structures at once numbingly simple and bewilderingly complex. The venerable duality in Western art between universal reason and private aesthetic fantasy seems freshly reinvented within a contemporary context.

LeWitt's search for the building blocks of form, for the basic alphabet, vocabulary, and grammar of all structures, is one that has a deeply ingrained tradition in the history of modern art, from its late eighteenth-century beginnings, with the purist reforms of Neoclassic geometry, to the wealth of twentieth-century investigations of the rudiments of art. A major impulse of all these pursuits, especially the rebellious isms of the early twentieth-century—Cubism, Suprematism, De Stijl, Purism, Constructivism—was to bury forever the moribund past and to start on a clean slate with a visual language that approached or attained what were presumed to be unpolluted formal essences—disembodied lines and arcs, squares and circles, verticals and horizontals, whites and blacks, primary colors. Ironically, these lucid, primitive statements would quickly be elaborated into refinements and intricacies that demanded the most sophisticated perceptions, which in turn would provoke yet another purist reform. The need for this ritual house-cleaning in twentieth-century art is apparently unquenchable.[7]

In American art since 1945, this impulse to strip art of everything but elemental truths has been unusually passionate and productive. Beginning with the Abstract Expressionists, most of whom pruned their inherited pictorial worlds to the most potent visual and emotional simplicity, this search for the roots of form and feeling has continued into the 1960s and the 1970s. The drive toward what appear to be unadulterated foundations of art has often produced extreme displays of the most overtly rational order (for example, Reinhardt, Kelly, Stella) as well as its obverse, an overtly irrational disorder predicated on impulse and chance (for example, Pollock, Kline, Twombly). At this level of reduction, the ruled line and the scrawl would alternately be proclaimed king. In a similar way, the direct disclosure of seemingly urgent, self-revealing emotion in much Abstract Expressionist art has its counterpart in the willful insistence upon an ostensibly total concealment of the artist's private feelings, as in Warhol's recording of both flowers and suicides with an equally deadpan stance, or in the nominally detached, emotionless look of much Minimal art of the 1960s. But these polarities are more illusory than real. It should be quickly emphasized that these recurrent extremes in art since 1945 are not to be transposed into simple-minded equations in which, say, geometric forms would equal chilly reason and impersonal order, or contrariwise, irregular, spontaneous forms would equal humanist passion and personal communication. We should all know by now that Pollock's or Kline's discipline in har-

nessing a vocabulary of apparent impulse was far stronger than that of many lesser artists dealing routinely with the already disciplined forms of geometry. In the same way, the private passions involved in the conceiving and making of Reinhardt's squares, Stella's stripes, or Andre's metal grids may be far more urgent or even irrational than those of a lesser Abstract Expressionist dealing secondhand with a vocabulary that superficially signifies a display of feeling. In short, to associate the look of geometry with a heart of stone or, vice versa, to assume that the presence of spontaneous brushmarks or eruptive calligraphy must reveal the outpourings of a passionate soul is as naive as thinking that, say, mathematicians are less "human" or "feeling" than tragedians. Such basic points perhaps need to be made yet again to counter prevailing misinterpretations of so much American art of the 1960s whose cool, minimal, or geometric look prevented many critics and spectators from sensing the often irrational fervor behind the best of this work.[8]

In October 1965 Barbara Rose published "ABC Art,"[9] a lucid and sympathetic analysis of the new Minimalist aesthetic viewed against a broad historical background. At the very same time, LeWitt had his first one-man show in New York. Just missing inclusion in Ms. Rose's article, whose generalizations would have encompassed it, LeWitt's work arrived on the New York scene in the nick of time for Kynaston McShine's manifesto exhibition at New York's Jewish Museum in 1966, "Primary Structures," which featured one of LeWitt's new modular cubes (frontispiece). It was soon clear that LeWitt had joined forces with those artists of the early 1960s—Tony Smith, Frank Stella, Donald Judd, Carl Andre, Robert Morris, and Dan Flavin, among others—who had sought out a new version of modern art's unending quest for the force and purity of a primal statement. In LeWitt's case, the pursuit of these rock-bottom foundations quickly took on a distinctive character, especially in his disarming rejection of our preconceptions about such conventional artistic categories as architecture, sculpture, painting, and drawing (a rejection that was to become so thorough, by the way, that one might well puzzle over which of The Museum of Modern Art's traditionally categorized departments—Painting and Sculpture, Prints and Illustrated Books, Drawings, or Architecture and Design—should be first in command of a LeWitt retrospective). Already in October 1965, on the occasion of LeWitt's first one-man show at the short-lived John Daniels Gallery in New York, a sharp-eyed reviewer, Anne Hoene, noted incisively that perhaps new phrases such as "sculpture" or "post-painterly relief" would have to be coined to describe these unfamiliar objects.[10] With this she put her finger on the radical way in which LeWitt seemed to uncover the roots of a structural world so elementary that the conventions that would come to characterize the different visual arts were irrelevant. As LeWitt later demonstrated even more amply, he was determined to free himself from the inherited restrictions of painting versus sculpture versus architecture.

Nevertheless, LeWitt's early works, in their two- and three-dimensional realizations of what seemed to be the

foundations of all potential structures, often evoked the themes and variations of purist geometries explored by International Style architects. Although their occasional similarities to actual architectural models of the 1920s may be fortuitous (such as the resemblance between a few of LeWitt's early striped table structures of 1963 [fig. 16] and Adolf Loos's 1928 project for a house for Josephine Baker), their forms, like those of many other artists of the 1960s, are related in a deeper sense to traditions of twentieth-century purist architectural design, especially as realized in drawing-board geometries and simplified scale models.[11] It should be recalled here that LeWitt actually worked in the graphics department of I. M. Pei's office in 1955–56; and that his art, like his writing, has always been in close touch with the abstract components of architecture, witness his first using a projecting ziggurat shape in a relief of 1963 (fig. 17) and then recommending, in an article of 1966[12] (see p.172), not so much the utilitarian, zoning-code aspects of post-1945 ziggurat-shaped office buildings in New York, but rather the sheerly abstract beauty and logic of their set-back forms.

But LeWitt's structures (characteristically, he dislikes their being called "sculptures") can take us even further back in an imaginary history of forms, beyond even the Platonic ideas of cubic, trabeated buildings or of modular Utopian city plans. At times these works look like an even more archaic manifestation of the concept of a rectangular aesthetic shape that, lo and behold, would one day become, milleniums later, the frame of a painting or, expanded to three dimensions, the volume of a sculpture or of a house. In one such work of 1966 (fig. 49), three square frames—two on perpendicular wall planes, one on the ground—evoke not only two-dimensional, planar areas that might eventually enclose images yet to be painted or drawn, but also, given the frame on the floor, an incomplete cubic volume that might someday contain a sculptural form or, wedded as it is to the floor and walls of a particular interior, go on to articulate architecturally the very room in which the work is seen.

LeWitt's presentation of the cerebral nuggets that would underlie all two- and three-dimensional forms, all plane and solid geometries, was quickly elaborated in expanding series that, with a relentless inevitability, seem to grow in and take over the very spaces in which we perceive them. Although LeWitt prefers finite series (such as the various demonstrations in both two and three dimensions of all possible combinations of incomplete cubes), the overall visual effect counters this intellectual tidiness by offering a world of endlessly expanding mazes. What Lawrence Alloway has defined as "a spectrum of continuous multiple possibilities"[13] becomes the work of a new Sorcerer's Apprentice, so that the deadpan, inert simplicity of a fundamental component—an open or closed cubic volume, a square plane crossed by parallel lines, or simply a line drawn between two designated points on a surface—is swiftly but logically multiplied by and combined with related components until suddenly the eye and the mind are boggled by the irrational, cat's-cradle complexities that can spring from such obvious foundations. In this LeWitt's work often seems an abstract recreation of the metamorphic miracles of worlds both organic and intellectual, whether in

terms of mirroring biological evolution from single cells to elaborate organisms, mathematical series that start with cardinal numbers and simple geometries and proceed to dizzying theoretical constructions, or linguistic developments from phoneme and alphabet to the intricacies of advanced syntax.

Faced with the absence of any absolute reigning system of order, twentieth-century artists have again and again been obliged to construct their private system of rules, often inventing their own vocabulary and grammar as the basis of a personal and frequently cryptic language. LeWitt's response to this recurrent modern dilemma is one that has a close precedent in many of Jasper Johns's own permutations and combinations of colors, alphabets, words, and numbers. Especially in his variations on numerical series (as in the *0-9* lithographs of 1960–63), Johns's internal systems of sequence and ordering create, for solely aesthetic purposes, an intensely personal yet logical reconstruction of these numerical means that are usually oriented to public and utilitarian ends. Similarly, LeWitt will take geometric commonplaces (his mathematics is simple, and unrelated to that of the later twentieth century) and construct from them his own coherent, but useless, aesthetic systems. Like Johns, too (and before him, Picasso and Braque in their Cubist phases), LeWitt often joins words and abstract shapes in the same work (as in his connection by straight lines of all *ifs, ands,* and *buts* that appear on a printed page), thus establishing a dialogue between two different kinds of symbols that equate and therefore aestheticize both verbal and geometric languages. Words become points on a plane, geometries become abstract patterns, so that these two modes of impersonal communication are rendered void, no longer working in the expected way, but transformed into pawns in a complex visual and intellectual chess game. Such personal fantasies have a special alchemy in which the most ordinary symbols are made magical by their subjection to a newly invented system. At times the most elaborate of these constructions resemble translations of complete philosophical systems into a purely formal language. If anyone could perceive the structural beauty of, say, Descartes's or Kant's treatises and then go on to recreate them as exclusively visual metaphors, it is surely LeWitt.[14]

It is typical of LeWitt that he chose artistic means as immaterial and abstract as the systems that regulate his art. Even the materials of most Minimal art—Andre's bricks and pure metals, Stella's striped, metallic paint surfaces, Flavin's fluorescent tubes, Judd's Plexiglass and plywood—are somehow, for all their plainness and clarity, too literal, too palpable for LeWitt, who seeks out rather the most abstract looking materials, or ideally, nonmaterials, to render, in Donald Kuspit's felicitous phrase, "the look of thought."[15] Like Robert Morris, who already in 1961 tried to disembody further a "minimal" eight-foot-high rectangular column by covering its simple plywood volume with Merkin Pilgrim gray paint, LeWitt also selected a substance for his structures—in his case, a white baked enamel—that would seem as free of worldly association and specific identity as possible. As he himself has said, it had to be either white or black, and he chose white. With such clinical material—like the stuff of demonstrations in a solid geometry lesson—the

idea appears to take precedence over the palpable material of which the structure is made, so that the physical means to the formal ends remain as intangible and unobtrusive as possible. Indeed, the laws of gravity seem to be repealed in these structures, whose overt weightlessness (they project as easily outward from the wall as upward from the floor) confirms that they belong more to a mental than to a physical realm.

In making flat images—prints or drawings—LeWitt again prefers the most impersonal and impalpable means. Oil paint, usually so viscous and physical in substance and so susceptible to traces of individual facture, is replaced by printer's ink and hard pencil lines, mark-makers that seem to imply as little space and weight as possible and that evoke anonymous architectural renderings. It was predictable, too, that when LeWitt began to consider color and its combinations in two-dimensional works, he would choose the four basic colors—red, yellow, blue, black (black being considered a color in this context)—used in the world of color printing, thus paralleling in his art the infinite permutations and combinations of hue and tone achieved by machines using this four-letter alphabet of colors. LeWitt's pure reds, yellows, and blues provide once again, in the history of twentieth-century art, the shock of recognizing the unadulterated beauty of these primary hues, a eureka experience we were taught most insistently by Mondrian, but which every generation feels the need to rediscover (witness Newman, Kelly, Johns, Stella) and to which every important artist lends his personal stamp. (Thus, LeWitt's red or blue, for all its allusions to and use of impersonal color-printing processes, is as distinctive as, say, the printer's-ink reds and blues in Matisse's *papiers découpés*.) And just as LeWitt can multiply his simple geometries into constructions of dazzling subtlety, so too can he metamorphose his printer's-ink reds, yellows, blues, and blacks into dense yet intangible weaves that emanate hues and tones of unprecedented fragility and evanescence. There are no words in either the geometry textbooks or the color-theory treatises to define the unfamiliar effects he can attain from these elementary units.

LeWitt's search for the most universal and impersonal means of creating art may at first appear to be the exclusive domain of the Minimal art of the 1960s, in which presumably only rock-bottom visual experiences, whether of color, shape, or material, are permitted and in which the idea is so dominant that the actual execution of the work has little or nothing to do with the artist's own hand. But in a broader context, it is worth noting how these attitudes are shared by other artists of the 1960s and 1970s who, at first glance, might seem remote from LeWitt's world. Lichtenstein, for one, has similarly reduced his aesthetic means to an elementary vocabulary of image-making that mimics the regularized printer's formulas of machine reproduction—screens of dots, clean black lines, primary colors—while also molding these commercial techniques into tools of the most personal inflection. The evolution of his colors in particular parallels LeWitt's. Beginning with the rawest, flattest primary hues, Lichtenstein refined these foundations to a point of such astounding sensibility that even the iridescent shimmer of Monet's haystack and Rouen Cathedral series was not

beyond translation into a private language derived from ben-day dots. The chromatic and tonal results in what might be called a Neo-Neo-Impressionist aesthetic are rivaled by LeWitt's own paradoxical mixture of the thoroughly public means of mass-produced images and the most distinctively personal flavor. (There are provocative analogies, too, between Lichtenstein's and LeWitt's absorption of modern color printing techniques and Seurat's late use, for equally aesthetic goals, of pure color dots, increasingly inspired by new methods of chromolithographic reproduction developed in the 1880s.[16] Fascinated by this flat, mechanistic regularity and assimilating it into his own pictorial vocabulary, Seurat nevertheless transformed these public, anti-artistic means into thoroughly personal ends that enriched rather than impoverished the language of modern painting.) It is a phenomenon often observable in the 1960s and 1970s, witness the Photo-Realism of Chuck Close. Insisting, too, on the artist's almost mechanical replication of a predetermined body of data, Close shares many of LeWitt's own concerns with the meticulous, impersonal realization of a given, abstract idea, creating equally individual results that are brilliantly polarized between something startingly simple and direct and something visually astounding in its infinite detail. As in LeWitt's work, we shift rapidly from micro- to macro-structure in a world where familiar human scale has become irrelevant.

To consider the family resemblances between LeWitt's art and that of both his abstract and figurative contemporaries is to be reminded that, despite claims that LeWitt's work is somehow beyond art, beauty, or style, in retrospect it appears most intelligible within the broad context of the art of the 1960s and 1970s, revealing an increasingly discernible period-look and redefining, in the freshest terms, many inherited traditions. With this in mind, LeWitt's wall drawings demand particular attention, for they extend the premises not only of his own earlier work but also those of earlier abstract painting. More phantom than substance, these boundless, gossamer traceries appear like mirages on walls and ceilings, and seem to be simultaneously nowhere and everywhere. But the magical shimmer and mysterious mathematical symbols of these environmental fantasies are also subject to the kind of simple rationalization that permeates all of LeWitt's work, as if the roles of primitive sorcerer and geometer were combined. The formulas given are easy enough (for example *Straight Lines in Four Directions, Superimposed* or *Lines Not Long, Not Straight, Not Touching, Drawn at Random Using Four Colors*) and the execution can be entrusted to any number of competent draftsmen (although LeWitt himself made his first wall drawing in 1968), yet the experience of the completed works is not one of dry cerebration but, as Jean-Louis Bourgeois phrased it in 1969, "like yard after yard of exquisite gauze."[17]

In many ways these wall drawings provide a stunning series of contradictions that LeWitt has fused indissolubly. For one, they reconcile two opposing modes of structure that have fascinated many artists of the 1960s: the rigorous order of a simple repetitive system (grids, parallels, concentric circles, etc.) and the abdication of this elemental order in favor of the random (or, in the fashionable word of the period, the aleatory). Artists as unlike as Warhol and Andre have alternated between the A-A-A-A rhythms of repeated patterns and the contrary look of scatter, freedom, chance. In LeWitt's wall drawings, these antithetical systems of order and anti-order are merged. The predetermined rules for execution are no harder than a first lesson in geometry, but the actual results are in equal part unpredictable, offering such infinite variables as the determination of where, according to the draftsman's choice, certain lines will be drawn or certain relationships located, or how the accidental formats of the wall or room will affect the results. The ephemeral, random look of graffiti is wedded to the stable, tectonic look of the actual wall planes on which the drawings temporarily reside, so that the components of the architecture are disolved into the illusory plane of the drawing and vice versa. LeWitt wrote that he "wanted to do a work of art that was as two-dimensional as possible,"[18] but in perceiving this two-dimensionality, the viewer is obliged to reexperience the palpable, often three-dimensional presence of the supporting architecture. As LeWitt has stated, "Most walls have holes, cracks, bumps, grease marks, are not level or square and have various architectural eccentricities,"[19] all of which irregularities are simultaneously veiled and emphasized by the two-dimensional wall drawings upon them. The contradictions are comparable to those we experience in, say, the unsized canvases of Morris Louis, where the vast expanses of unpainted cotton duck that support the painted illusion become, by contrast, all the more literal physically, while being transformed at the same time into the pictorial fiction of a luminous field of open space.

In yet another merging of opposites, LeWitt's wall drawings are at once intensely personal and impersonal. Their image immediately evokes a unique artistic invention, LeWitt's, that we tend to associate with traditions of handcrafted painting and drawing; yet the execution, like that of most architecture, is a result of anonymous hands or, theoretically, even of machines. Again, the crossing of the boundaries of the arts and the confounding of our preconceptions about each art are to the point of LeWitt's liberating view of the limits of the separate media. We recognize his individual imprint not literally, in the actual physical execution, but rather in the conception of the work, just as we may recognize the style of a highly personal architect in the overall idea and look of his building rather than in the personal facture of the physical construction of the parts. Looked at this way, LeWitt is simply applying principles of conceptual emphasis we have always taken for granted in architecture—the architect, after all, thinks up and plots his design, which is then materialized impersonally—and applied them to the domain of drawing and, by extension, painting. And LeWitt's method is equally close to that of the composer, whose symbolic musical instructions are there to be reconstructed in performance by anyone who wishes to hear the work executed. Like musical notation and its potential and variable realizations, LeWitt's written rules for the execution of a wall drawing imply both the enduring and the ephemeral, the conceptual and the sensual. Although LeWitt's is hardly the first assault upon the

prejudice that a drawing or a painting must bear the artist's own physical, and therefore psychological, marks, it is certainly the most original in terms of unsettling the very conventions that used to distinguish for us the differences in the visual arts between transportable drawings or paintings and immobile architecture, between conception and execution, between the permanent and the impermanent. (For as LeWitt has written, "The wall drawing is a permanent installation until destroyed,"[20] which, in fact, has been the destiny of many of these short-lived but always resurrectable works.)

Yet however much these wall drawings may turn topsy-turvy our inherited sense of these distinctions, they gradually begin to suggest as well deep connections with earlier kinds of abstract painting and drawing that, in turn, seemed heretical when first created. Their very vocabulary, so rigorously restricted to fragmented geometric or quasi-geometric parts, like lines and arcs, recalls that of the drawings and prints of the most cerebral moments of Analytic Cubism in 1910–11, as does their frail, linear scaffolding; and these affinities continue in such Cubist-derived, weblike structures and purified linear segments as found in Mondrian's Pier and Ocean and the Plus-and-Minus series. And in a more explicitly geometric, ruler-and-compass way, their alphabet of sharp lines and arcs floating in a boundless space finds precedent in many of Rodchenko's line constructions of the early 1920s.[21] But if the geometric vocabulary of LeWitt's wall drawings is rooted in Cubist-Constructivist traditions, their overall syntax belongs more to a mode of pictorial art that recalls the expansive, open fields of the late Monet and of much American painting from Tobey and Pollock on.

A musical analogy may be apt here. LeWitt's wall drawings, in their detail, have the calculated look of a computer world but soon dissolve into diaphanous veils of a strange, engulfing sensuality. It is a quality found as well in the music of Philip Glass (for whose Music in Twelve Parts, incidentally, LeWitt has designed a record jacket).[22] Glass's music is constructed from what at first may seem monotonous and endlessly repetitive units of rudimentary melodic and rhythmic fragments, electronically amplified in a way that conceals personal style through associations of a mechanical standardization. But if the intellectual order of Glass's work is as rigorous and systematic as that of LeWitt's, yet again, the total effect is not of dry reason. The experience becomes rather a kind of slow immersion in a sonic sea, where the structural anchors of the score, discernible by the intellect's intervention, tend to be washed away by the mounting sensuous force of the cumulative sound. The musical precedents for such a gradual overwhelming of the senses lie in late Impressionism, in the engulfing swells of Debussy and Ravel at their most shimmering, just as the twinkling expansiveness of LeWitt's wall drawings evokes echoes in late Impressionist painting, especially in the panoramic extensions and vibrant fragility of Monet's waterlilies.

It is this quality of potentially infinite, multidirectional expansion, burgeoning into the domain of vast architectural decoration, that locates LeWitt's wall drawings most closely within traditions of American abstract painting from the 1940s on. The development of an "allover" style in Tobey and Pollock provoked the sense that the spectator might be disoriented in a gravity-defiant field of unbounded energies that, pushed one step further, might actually spill over the edges of the canvas into the walls and room. This metaphorical possibility is literally realized in LeWitt's wall drawings, which are often extended to the very ceilings and peripheries of their architectural settings. The "apocalyptic wallpaper" of Abstract Expressionism has left the stretcher and canvas to create an even more encompassing and immaterial visual environment.

Like so much of the best abstract painting of the post-1945 period, LeWitt's wall drawings are based on a rudimentary visual unit that is then amplified to mural dimensions. And despite the simplicity of the given rules for determining each unit, the range of visual possibilities is vast. At times linear arcs of interwoven color may create labyrinthine tangles so fine and yet so dense that in their alternation between hair-breadth thinness and galactic depth they almost offer a 1970s reinterpretation of the spatial complexities of Pollock's own whirling filaments. In other variations, white lines incised on a black ground (or black lines on a white ground) continue to explore, with their constant shuffling of positive and negative marks and spaces, the rich legacy of black-and-white painting and drawing, from Pollock and Kline through Twombly. Elsewhere LeWitt's use of only a single hue in a wall drawing creates a blaze of color so intense that the color fields of Poons, Olitski, or Stella seem recreated in a vivid new language. If abstract painting of the last quarter-century has pushed ever further in the direction of total dematerialization, freeing line from volume, floating color weightlessly in boundless spaces, concealing even the physical stuff of which the image is made, then LeWitt's wall drawings represent one of the most brilliantly original visions in this persistent quest. Indeed, LeWitt's spiderwebs of line can reach such magical near-invisibility that, on one occasion, at the Lucio Amelio Gallery in Naples in 1975, LeWitt superimposed his own wall drawing on a mural stripe painting by Daniel Buren without disturbing the wholeness or the legibility of Buren's underlying image (fig. 244).

As always, strikingly new art that initially unbalances us ends by joining forces with and rejuvenating the past. Thus, at the Venice Biennale of 1976, in "Ambiente" (a historical survey of total interior environments created by artists), a room covered with LeWitt wall drawings stood almost at the end of a long twentieth-century tradition of abstract mural decoration, from Kandinsky and Mondrian on.[23] And as is well known by those who have had the good fortune to see LeWitt wall drawings in situ at the North Italian villa of Count Giuseppe Panza di Biumo, these mural fantasies can even coexist happily in rooms also decorated with late Baroque painted ceilings. Finally, LeWitt's threats to convention are more apparent than real. Like the now assimilated challenges of so many modern masters before him, they become the very means of sustaining the vitality of venerable traditions.

1. Sol LeWitt, "Sentences on Conceptual Art," *Art-Language* (England), May 1969, p. 11. (See page 168 of this book.)
2. Donald B. Kuspit, "Sol LeWitt: The Look of Thought," *Art in America* (New York), September-October 1975, pp. 43–49; with response by Joseph Masheck, "Kuspit's LeWitt: Has He Got Style?" *Art in America* (New York), November–December 1976, pp. 107–111.
3. Lucy R. Lippard, "Sol LeWitt: Non-Visual Structures," *Artforum* (New York), April 1967, p. 46.
4. Visual and evolutionary analogies between Renaissance art and that of LeWitt and his contemporaries have been explored on a more philosophical level by Suzi Gablik in *Progress in Art* (New York: Rizzoli), 1977, pp. 44–45 and passim.
5. LeWitt, "Paragraphs on Conceptual Art," *Artforum* (New York), June 1967, p. 80. (See page 166 of this book.)
6. Kuspit, op. cit., pp. 43–44.
7. The classic discussion of this impulse in modern art is discussed under the heading of "Intellectual Primitivism" in Robert Goldwater, *Primitivism in Modern Art* (New York: Vintage Books), 1967.
8. The situation has been the same with the earlier misreadings of Analytic Cubism, whose complex dissections of line and plane were first rationalized by apologists in vaguely scientific language, but now seem ever more mysterious; or similarly, with changing interpretations of Malevich and Mondrian, whose quasi-geometric vocabularies obscured for decades their ardent, quasi-religious goals.
9. Barbara Rose, "ABC Art," *Art in America* (New York), October-November 1965, pp. 57–69.
10. A. H. [Anne Hoene, now Anne Hoy], "Sol LeWitt," *Arts Magazine* (New York), September–October 1965, pp. 63–64.
11. For further thoughts on these connections with architecture, see Dan Graham, "Models and Monuments: The Plague of Architecture," *Arts Magazine* (New York), March 1967, pp. 32–35.
12. LeWitt, "Ziggurats," *Arts Magazine* (New York), November 1966, pp. 24–25. (See page 172 of this book.)
13. Lawrence Alloway, "Sol LeWitt: Modules, Walls, Books," *Artforum* (New York), April 1975, p. 43.
14. The abstract beauty of philosophical systems as paralleling LeWitt has been mentioned in John N. Chandler, "Tony Smith and Sol LeWitt: Mutations and Permutations," *Art International* (Lugano), September 20, 1968, p. 19.
15. Kuspit, op. cit.
16. Norma Broude, "New Light on Seurat's 'Dot': Its Relation to Photo-Mechanical Color Printing in France in the 1880s," *Art Bulletin* (New York), December 1974, pp. 581–589.
17. Jean-Louis Bourgeois, review, *Artforum* (New York), December 1969, pp. 71–72.
18. LeWitt, "Wall Drawings," *Arts Magazine* (New York), April 1970, p. 45. (See page 169 of this book.)
19. Ibid.
20. Ibid.
21. A specific analogy to Rodchenko's 1921 *Compass Drawings* was suggested by Brooks Adams in his review of *Sol LeWitt: Graphik 1970–75* . . . in *The Print Collector's Newsletter* (New York), September–October 1976, p. 123. In broader terms, LeWitt's art has also been seen as a recent manifestation of a long Constructivist tradition. (See Willy Rotzler, *Constructive Concepts,* Zurich, 1977.)
22. An analogy between Glass and LeWitt has been briefly suggested in Germano Celant's "LeWitt," *Casabella* (Milan), 1972, p. 40.
23. This important exhibition has now been documented and expanded in a book: Germano Celant, *Ambiente/Arte dal Futurismo alla Body Art* (Venice), 1977. For the LeWitt room, see figs. 222–223.

THE STRUCTURES, THE STRUCTURES AND THE WALL DRAWINGS, THE STRUCTURES AND THE WALL DRAWINGS AND THE BOOKS by Lucy R. Lippard

Before reading the following essay, please see: the visual section of this catalog, accompanied by LeWitt's notes on his development (pp. 49–165), the chronology (p. 12) and the artist's own writings (p. 166). I have departed from these points and will not restate them.

SOL LEWITT'S SERIAL AND MODULAR ART is, like all important art that breaks with tradition, a more or less unconscious synthesis of the elements within it and those opposing it. Since his work is characterized by content and dynamic change rather than by perceptual stasis and neutralization, he has also subverted the canons of the "minimal" art with which it has been associated. Integral to the systems that generate LeWitt's art is the "idea," which, he has implied, can be considered synonymous with intuition.[1] He is far more concerned with what things are and how they come about than with how they look. His art is an objective *activity,* related to play in the most profound sense of fundamental creative discovery. The elusive "idea" that delivers his work from academic stagnation is transformation—the catalytic agent that makes it *art* even when the artist plays down its visual powers.

LeWitt's relationship to the art he produces is actually that of a designer. Because he designs "useless" items, art has proved the most receptive context. He intuitively works out ideas for which science, mathematics and philosophy have already provided more sophisticated frameworks, but as art the manipulative intricacy of his process can provide an emotive communication with the viewer impossible in other disciplines. LeWitt has never been a craftsman, and except for finished drawings on paper and the initial installation of a wall drawing, he has not constructed his own art for years now. He designs experiments, creates hypotheses, then hands them on to a mathematician friend, his "Japanese army" of assistants, a printmaker, a printer. He sits at the center of a web of activity thinking up tasks for others to perform and in the process he produces objects and ideas for others to ponder.

While LeWitt does not discover by *making*— the traditional artist's method—he still discovers by *doing.* All of his ideas, he emphasizes, are two-dimensional in origin. With his pen and notebooks he enjoys "drawing out" the evolution of simple ideas, which perhaps explains how his work has maintained its vitality year after year, unlike that of many of his contemporaries. Between the generative concept and the visible result lies the tension of synthesis—the relationship between the apparent inertia of the objects produced and the boundless creative energy that produces them, an energy transmitted not by the artist personally as self-expression, but by the concept, or medium, the artist has chosen.

Far from being convoluted epistemologies so intricate that only the trained mind can unravel them, LeWitt's systems are basic, the three R's. It is what they can do that is significant. (As playwright and artist Michael Kirby has observed, "I don't think Sol's concepts are particularly interesting. But he turns them into great art."[2]) Perhaps the most interesting issue LeWitt's work raises is precisely the fact that it raises so many issues, that these simple ideas made manifest in structures, drawings, prints and books are of so great an interest to so many people. LeWitt gets letters from mathematicians, but he is "not interested in mathematics." As art critic Donald Kuspit correctly assumes, he uses it only "as a discipline for consciousness,"[3] just as he uses the grid for an armature. He represents the intuitive side of mathematical thought, setting up order and then disturbing it into growth, trying things out when an idea occurs to him, not knowing what the results will be. LeWitt has been touted as an early manipulator of forms as morphemes in syntactical visual models, but he is "not interested in linguistics." Philosophers dive right in too; but LeWitt, although a voracious reader of fiction and nonfiction, and although he has been called a transcendental idealist questioning the validity of art as knowledge and seeking the universal meaning of art,[4] is "not interested in philosophy" as such either. "It takes a superior intelligence to forget a lot of things," he has said ironically, bemoaning the kind of art that gets so immersed in borrowings from, say, philosophy, that its own idea is subordinated. He prefers the kind of art (his own, presumably) that is "smart enough to be dumb."[5]

During the years in which LeWitt's work was first made public (from 1963, when he was included in a group show at St. Mark's Church, to 1970, when he had a retrospective exhibition at the Gemeentemuseum in The Hague)—the structures were his major medium, although they were all preceded by working drawings, and even then he always found ways to apply his ideas to several areas.[6] The first wall drawing was made in October 1968 (it had been a book project first), but it took a year to make all the tentatives and fully work out what kind of systems were best adapted to this new setting.[7] For the next four years it was first the wall drawings and prints and then the books that commanded most of LeWitt's attention. Since 1974 all four mediums have been more clearly woven together. The exhibition held that year at the John Weber Gallery in New York provided a good, dense example of how the transformative principle spreads to and connects all of them.

Coming in a drab season a little over a decade after LeWitt

made his first structures, the Weber exhibition combined a 122-piece table sculpture, photographs, isometric drawings and a book, plus a room full of wall drawings. It offered a miraculous display of real, rare, aesthetic energy coming almost unexpectedly from a Minimal "master" whose work by then was so well known it was considered fairly predictable. One room consisted of *Variations of Incomplete Open Cubes* (fig. 144): the 122 permutations of that form in eight-inch modules exhibited on a gridded table, with blanks on the grid for those progressions that by nature die out faster[8] (they have since been made as separate pieces in a forty-three-inch module). The walls were covered with framed pairs, consisting of a photograph (white on black) and an isometric drawing (black on white) of each module, which, far from repeating what one saw on the table, distinguished between the object itself and the object as seen through two different methods of representation—neither of which was a copy of the other because of the distinct perceptual variations in their depiction. The square book comprised the overall graphic scheme on a grid, along with the schemes for each section— from three-part to ten- and eleven-part variations (the one- and two-part variations were omitted because they did not imply a cube)—and photos and isometrics on facing pages. The book, by breaking down the matrix from another approach, offers yet another angle from which to see the idea. All these reflections are parts of the same piece.

In the second room of the gallery was another fully developed series: drawings executed directly on the walls in graphite showing *The Location of a Square* (and of a circle [fig. 258], a triangle, a rectangle, a parallelogram and a trapezoid) within the frames provided by the walls. (This series too exists in book form; there the drawings' dimensions and proportions are determined by size and shape of the page, rather than by that of the architectural settings.) In the labels for each of these wall drawings—straightforward instructions for the execution of the work that double as descriptions of the work—another medium, language, is brought into play. These labels, despite their didactic neutrality, have a highly recognizable style of their own; like LeWitt's writings on art, and even his punning postcards, they fall into a curious, almost humorous, rhythm that complements the drawings themselves:

A rectangle whose left and right sides are two thirds as long as its top and bottom sides and whose left side is located where a line drawn from a point halfway between the midpoint of the top side of the square and the upper left corner to a point halfway between a point halfway between the center of the square and the lower left corner and the midpoint of the bottom side is crossed by two lines, the first of which is drawn from a point halfway between the midpoint of the left side and the upper left corner to a point halfway between the point halfway between the center of the square and the upper right corner and the midpoint of the right side, the second line from a point halfway between the point where the first line ends and a point halfway between the midpoint of the bottom side and the lower right corner to a point halfway between a point halfway between the center of the square and the lower left corner and the midpoint of the left side.[9]

Both Minimal and Conceptual art in their turns have been castigated for surrendering art to criticism and for being dependent on verbal explanations frequently proferred by the artists themselves. In LeWitt's case, his influential writings, "Paragraphs on Conceptual Art" (1967) and "Sentences on Conceptual Art" (1969) (see pp. 166-168) came about because he was "aghast at what was going on in criticism" and wanted a specific way to describe his own work.[10] The former was, according to LeWitt, "more general and theoretical" and the latter was "an operational diagram to automate art." But the place where language is really necessary to LeWitt's work is in these labels, or captions, where the relationship of words to form and to process is unique. "If I do a wall drawing, I have to have the plan written on the wall or label because it aids the understanding of the idea. If I just had lines on the wall, no one would know that there are ten thousand lines within a certain space, so I have two kinds of form—the lines, and the explanation of the lines. Then there is the idea, which is always unstated."[11] The labels not only explain, but they contain the means by which a wall drawing multiplies and transforms itself. "If," Michael Harvey has suggested, "the drawings are like the structural parts of speech, then the wall is the noun. It is the context which concretizes the specific. The same label could provide drawings for fifty walls, and they would be fifty different drawings. . . . So the ubiquity of contexts becomes another variable to the already enormous potential of a very fecund system."[12]

As further variants on this idea, LeWitt has since used time, the personal capacity, taste, or interpretation of the worker executing the wall, directions and primary colors. For example, in Vancouver in January 1970: "Parallel lines, one foot long are drawn with a hard pencil ⅛ inch apart for one minute. One inch under this row of lines, a second set of parallel lines are drawn for ten minutes. One inch under that set of lines, a third row of parallel lines are drawn for one hour"; in Nova Scotia, by mail, in 1969: "A work that uses the idea of error, a work that uses the idea of infinity; a work that is subversive, a work that is not original . . . " (this direction LeWitt did not follow up, perhaps because of its lack of specificity and its similarity to that of more Duchampian Conceptualists); at The Museum of Modern Art's "Information" show, June 1970: four draftsmen with black, yellow, red and blue pencils made four-inch straight lines in four squares for four days four hours a day at four dollars per hour. I disliked the results of this last piece and wrote to LeWitt, who was out of town. He replied: "I have no idea how my MOMA piece looks. Don't particularly care whether it is beautiful or ugly or neither or both. The ugly factor was not built in but the result of the perversity of the draftsmen. I am rather pleased that it is ugly because a lot of recent things I've done are beautiful (I think so, anyway). . . . Anyway if I give the instructions and they are carried out correctly, then the result is ok with me."[13]

Music is, of course, the art that has up until now held sway over seriality, and it is no accident that LeWitt has always listened to a great variety of music, especially Mozart, Bach, and the progressive experiments of Philip Glass and Steve Reich, both of whom are his friends. He has compared his use

of language to listening to music by Bach: "If you were really interested, and could read music, you would go to the score, where you would find out that he's doing all sorts of things you can't hear as sound . . . all these little systems of his own, where he's working them out just like abstract possibilities." Reading the score "would not make the thing sound one bit better, but you'd know his mind, so you'd be getting a message from his mind to your mind through the vehicle of his music."[14] LeWitt aligns himself as an artist with the composer of music rather than with the performer. This was quite literally followed up when performance artist Laurie Anderson set one of his linear serial projects to music.

As in musical composition, the transformative nature of LeWitt's art is not simply about generation, but also about continuous regeneration—the activity of permutation, rotation, mirroring, reversals and cross reversals, juxtaposition and superimposition. A vocabulary of shapes may be permuted to its finite limits within one medium, only to be resurrected in another through which new possibilities are revealed. Seeing exhibitions like that at the John Weber Gallery in 1974, and The Museum of Modern Art retrospective, is like watching the artist's mind at work (and at play)—one of the two great pleasures LeWitt's art has to offer, the other being that element for which, despite opposition, I can find no more learned term than beauty. LeWitt describes his mind as "plodding. . . I have to know A, B, C and D. I can't go from A to D without knowing what is in between. I can't think of the end at the beginning because I'm not sure what the middle is. I can't imagine the thing until it is done."[15] The viewer simply comes to the whole process in reverse, beginning with the object and working back through the concept to the idea that sparked concept and object. Such a multilevel experience is impossible in most artists' work, or at least inaccessible to the merely intelligent audience.

LeWitt is often, as Michael Kirby has suggested, "surprised when he sees the finished work. Words or a sketch or a model may have the same concept as the show, but the results, in terms of experience, are vastly different. I think it is very important to Sol's work that the experience can't be predicted, even by himself."[16] The concept too is unpredictable. LeWitt is often unaware of how far it will take the form. For example, for a structure/book piece now being executed, and resembling Variations of Incomplete Open Cubes, he posed the problem to a mathematician, who discovered some 251 permutations for one part of the piece (five cubes touching each other at least at one corner), and around 571 for the other part (five cubes touching each other at least at one side). The piece is, however, physically very compact, consisting of a thick book and a 30 x 30-inch grid on which five solid cubes can be moved around. The "board," which recalls LeWitt's first movable cube piece, shown at the Kaymar Gallery in 1964,[17] is entirely interdependent with the book (or manual) for fulfillment of its range of transformations.

All transformations involve synthesis, a virtual genetic wedding of polarities that must be present before the activity can take place. LeWitt's work is rich in contradictory material, which operates at times as a mental and at times as a visual construct. He confronts concepts of order and disorder, open and closed, inside and outside, two- and three-dimensionality, finity and infinity, static (modular) and kinetic (serial). For all the overt simplicity of his serial systems, the content of his work is often hermetic. On one level, the concepts themselves may be perfectly accessible, but the viewer needs an overview to understand not only the mechanism of the system, but also the philosophy by which the art was made from that system. It has also been part of what artist Terry Atkinson has called LeWitt's "quiet strategy"[18] to actually hide things, most of which are subsequently revealed by the operations of the same systems that have hidden them. This lends a progressive dimension even to modular works, and further transforms the serial works. LeWitt's work has been tied up with the theme of containment, or enclosure, since the 1962–63 "nested" projections and a fifty-five-inch-high yellow "well," in which the physical extension of the black wooden bars that line its interior aperture are implied rather than actually seen (fig. 18). In 1964 he made the red Box with Holes Containing Something (a small sculpture by Grace Bakst Wapner that could not quite be perceived through the holes) and Wall Structure in Nine Parts, Each Containing a Work of Art by Other Artists (fig. 10). The ultimate tease was in the 1965 "Box Show" at the Byron Gallery. A long, narrow peep-box based on Muybridge, it contained photos of a nude woman growing progressively larger as you moved along the viewing holes, but a flashing light frustrated full scrutiny (fig. 135).

In 1966–67, this idea was subjected to the more complex systems of LeWitt's later work with Serial Project No. 1 (ABCD) (fig. 130), four nine-part pieces on a gridded base that explored the known and unknown within a finite, self-exhausting framework. Here sensuous or perceptual order was firmly neglected in favor of conceptual order, reflecting LeWitt's notion of a "nonvisual" art that could be made (and appreciated) by a blind person. The project as a whole must be read sequentially and conceptually; in some parts the closed elements are contained by open ones so both are visible, but in other parts, the open elements are contained by the closed or the closed by the closed, leaving the viewer to believe what s/he canot see. Juxtaposition of the open comprehensibility of the system and the invisibility of some of the forms it generates was reiterated in the 1968 Five Five-Part Variations with Hidden Cubes, consisting of five identical cubes centered on a grid, the only indication of the increasing number of increasingly smaller cubes nested inside each other being the lines that mark their extensions on the grid. The same year, LeWitt returned to a modular hermeticism in Buried Cube (fig. 273); only the artist and the Visser family, who own it, know what is inside the metal cube buried outside their home in Bergeyk, The Netherlands.

The Dada implications of this piece had been preceded by two unrealized and unrealizable projects also about enclosure: the projected entombment of Cellini's famous jeweled cup and the Empire State Building in blocks of cement, which, as Robert Smithson noted, showed an "almost alchemic fascination with inert properties, but LeWitt perfers to turn gold into cement."[19] Buried in these works is also a sense of the possibilities of the transformational at its most profound—

energy buried in the neutral ("dead") form and activated ("brought to life") by the idea.

The hermetic notion also points up the Conceptual aspect of LeWitt's art because it forces the viewer to think, sometimes to guess, and to decide whether what is inferred is in fact true. *Serial Project No. 1* was, therefore, a highly significant development in the Minimal movement in that it indicated LeWitt's dissatisfaction with the "specific object," or the mute Gestalt. The goal of Minimalism (or in fact of most 1960s art, far more than that of the 1970s) was to find a new way of making art, a new vocabulary and even new forms—something "neither geometric nor organic," as Don Judd put it.[20] While Minimal art succeeded in logically extending the Cubist-Constructivist tradition by divesting it of the expressive touch and compositional subjectivity hitherto associated with art and by making clear that even the most obvious forms, executed by assistants or in a factory, could contain or transmit complex esthetic content,[21] form, or the physical vehicle, still presented a major problem in advance. Being stuck with geometry was not entirely satisfying to the more visually oriented of these artists.

LeWitt, however, saw no need to invent new forms and is still not interested in originality.[22] He was content with the "relatively uninteresting, standard and officially recognized" forms of the square and the cube because "released from the necessity of being significant in themselves, they can be better used as grammatical devices from which the work may proceed." By synthesizing the Cubist-Constructivist tradition with the intelligent perversity of the best of the Surrealist tradition, LeWitt could incorporate both order and disorder, and thereby set up a far more complex *modus operandi* than that offered by the basic Minimalist doctrines, with their sources in Josef Albers, Ad Reinhardt and Jasper Johns. It was in fact Albers's Homage to the Square series, Johns's Flags and Frank Stella's early black striped paintings that were the major fine-art influences on LeWitt in the early 1960s. Combined with the photographic motion studies of Eadweard Muybridge, these works suggested to him the advancing and receding color planes that then became literal in thick and thin paint and actual reliefs, first as applied to a Muybridgean running figure and then to the striped, impastoed projections of the early abstract serial structures, which jutted from walls, ceilings and table surfaces.

Ad Reinhardt's influence on most Minimal artists was, on the other hand, only indirect; his "dogmas" anticipated virtually all of the Minimalist program, although cutting off the Conceptual possibility by insisting on "no idea" along with "no colors," "no space," etc.[23] Yet it was without question Reinhardt who erased the historical blackboard and revealed yet another *tabula rasa* to the next generation. By rejecting just about everything except Art, he closed off the Impressionist-Cubist period of formal art history, beating at their own game the evolutionary formalists who were edging ever closer to the "nature of painting" with no conception of what would happen when they got there. Reinhardt's cyclical view of history, his desire for a quasi-Oriental absolute—a silent, timeless core for his own "ultimate" black square paintings—allowed for no further development in his own line.

Only *after* Reinhardt was the deluge possible—an art that could utilize the intellectual trappings that had consistently accompanied but had never been integrated into the visual arts of the twentieth century. Reinhardt was willing to go only so far into the darkness his own work projected; color and light remained his preoccupations, though he sensed that something else would take their place.[24] Once he was followed into the labyrinth he had constructed, some kind of regeneration was inevitable. As Lawrence Alloway has pointed out, Reinhardt's "ultimate painting" existed only in theory, whereas "there is no gap between theory and performance in LeWitt. His art really is continuous with its formulation."[25]

Such a continuity is ideally what would separate Minimal from Conceptual art. LeWitt was never happy with the rather insulting less-is-less implications of the term Minimalism, which did not apply to the growth principle at the heart of his work. By refusing form the autonomy with which it has been endowed in modernist art in America, he arrived at his own notion of a "nonvisual art," concisely and forcefully articulated in 1967 and 1969 by his "Paragraphs" and "Sentences on Conceptual Art." When that term too became a misused label, he disavowed it, claiming to be only "conceptual with a lowercase c." In any case, form remained only as the *"clue* to the content. The dichotomy between form and content reappeared. . . .The object became just the proof, the spinoff of the piece"; he saw Conceptual art as a "massive reassertion of content," opposed to the formalist assertion that form and content are inseparable.[26]

Yet what LeWitt means when he says "content" is not what the term has come to mean in the 1970s, when so-called post-Conceptual artists have far more enthusiastically rejected formalism. Looking back at most Minimal and Conceptual art, it looks highly abstract and virtually contentless. Certainly LeWitt's content has nothing to do with "humanism," though he is nothing if not a humanist in the less-than-tortured sense, and much of the art being made today that claims to have social relevance is as removed from figurative thinking as his is. A few years ago LeWitt defined two kinds of content: "One is like bottling up someone else's content like a found object; the other is to make your own content." It is the latter with which he himself is involved, with art that comes "from the inside" rather than from the outside.[27]

As artist Mel Bochner pointed out in 1966, in regard to LeWitt's open modular cube: "Old art attempted to make the non-visible (energy, feelings) visual (marks). New art is attempting to make the non-visual (mathematics) visible (concrete)."[28] Thus in 1965 LeWitt stripped away the mellow, lacquered surfaces of his structures and exposed the underlying grids and modules, first with a few black pieces, then with the white pieces that he has preferred ever since—in part because white is less obtrusive on white walls and in part because white avoids the "expressiveness" he attributes to the color black. Nevertheless, the negative, the shadow, like the spatial intervals between the bars, continued to be as important as the components themselves. "In intervals," artist Dan Graham wrote, "LeWitt has structure freed from material content, structure that is no longer the structure of some-

thing."[29] These less controllable elements introduced the specter of disorder, synthesizing homogeneity and variety. The density of the 1966 "Primary Structures" cube (frontispiece) was expressed in terms of a labyrinthine grid of light and shadow. My favorite piece at LeWitt's first Dwan Gallery show (also 1966) was an expansive, square, single-tiered floor piece, always necessarily seen from an aerial and therefore "distorted" viewpoint (fig. 63). At the time, when the prime virtue of structural art was considered to be its deadpan legibility, the complexity of these delicate lattices had to be explained away. For instance, I wrote approvingly that by laying open to view all internal and external elements, the new works were exceptional in having "no secrets. . . .They come as close to not changing the space they fill as anything can."[30]

I don't think I fully understood at the time to what extent LeWitt's work was not about looks but about reality, and to what extent the presence of perceptual disorder was grist to his conceptual mill. The same year he made a visual pun on his methods with two modular cubes shown at the Park Place Gallery—one sixty inches high, the other fifty-eight inches high (fig. 69). Placed about twelve feet apart, they looked identical; but the intervals were different, since they had the same number of modules. (The scale of the modules for all these works was arbitrarily selected; LeWitt wanted it to be regular, and ironically, the decision was a visual one. He went back to the small version of the "Primary Structures" cube which "looked okay," measured the spaces, and used the 8.5:1 ratio from then on.) A similarly systematic irregularity reappears in the new, 1977 modular series—rather awkward configurations with a kind of lopsidedness resulting from the system decreeing that the permutations governing the "steps" on one side progress rapidly (or steeply, in visual terms) while those on the other side be more gradual (figs. 101–118).

It is perhaps important to remember that much of the Minimalist rhetoric insisted upon the fact that the new art did not indulge in "order," which was considered "compositional" or "relational," as in old-fashioned (European) art. Don Judd saw his serial objects as "disordered," or "ordered" only in the sense of an absence of chaos rather than in the implication of any new harmony imposed by the artist. LeWitt, however, was overtly interested in Cartesian order, if not in its perceptual manifestations. Because logic was for him far more important than the "dumbness" of the object, he took steps to amend with published plans and later with unambiguous wall labels the situation Mel Bochner referred to when he wrote: "When one encounters a LeWitt, although an order is immediately intuited, how to apprehend it is nowhere revealed."[31]

Such order is expressed not by the iconic consistency of the Renaissance, still present in contemporary art via formalism, but by what Suzi Gablik, in a recent book applying Jean Piaget's theories of developmental psychology to art history, has called the "formal-operational stage," a move toward propositional thought and "away from the grip of the image." She sees this epitomized by a broad range of Minimal and Conceptual art, which becomes "a developmental activity, not the static objection of perception." However, it is only LeWitt's "reflective abstraction" that fully fits into these theories, only his work that can be said to articulate "the moment in artistic thinking when a structure opens to questioning and reorganizes itself according to a new meaning *which is nevertheless the meaning of the same structure,* but taken to a new level of complexity."[32]

LeWitt has been accused by formalist critics of the "cumbrous, mechanical joining or filling of content with form"[33] and by nonformalist critics of a "totalitarian or autocratic intonation" and "pleasure-principle Conceptualism."[34] From all sides there has been one salient and long-term misunderstanding of what he is doing and its political and aesthetic "radicality." Due to his insistence on the nonvisual basis of his work, it has been assumed that LeWitt is not interested in the objects generated by his concepts, and that by continuing to make structures at all after the impermanent wall drawings and inexpensive books, he is guilty of recidivism, even moral default. Some of the blame for this situation must fall on those who, like myself, had exaggerated illusions about the ability of a "dematerialization of the art object" to subvert the commodity status and political uses to which successful American art has been subjected since the late 1950s. It has become obvious over the last few years that temporary, cheap, invisible or reproducible art has made little difference in the way art and artist are economically and ideologically exploited and that it can hardly be distinguished in that sense from Corten steel sculptures and twenty-foot canvases.

LeWitt has known this all along. He kindly but firmly disagreed with me that "dematerialization" was going to change anything and asserted that the Xerox text and documentary photograph were becoming "the new formalism," that even the thinnest piece of paper was still an object and still commanded commercial status. Accordingly he has never ascribed hierarchical value to any aspect of his own process (although the art market, of course, imposes its own monetary standards—by scale, medium, scarcity, etc.—on his work as on everyone else's; no one has found a way out of that yet). "I'm very interested in the whole chain of events, from the time that you think of what you are doing to the time that it is finished," he said in 1970.[35] Those who see his wall drawings as an evolutionary rejection of the object (rather than as a new and challenging means by which he could explore the infinite growth inherent in his art, and make work that varies in varied spaces and situations) misread his intentions. Similarly, by considering the object the culminating product of the thinking, sketching, building process, one denies a major element of LeWitt's conception, just as one does by considering the prints and books as "minor works" in comparison with the structures. In fact, they (the books in particular) are his most developed work so far—their "objectness," their implicit portability, inexpensiveness and seriality being among their strongest points.

Although in their present form of distribution the books and prints are available only to an educationally, if not always financially, privileged audience, their modest scale and compactness make them accessible. Exactly like the giant modular structures that make such impressive public monuments,

the books are also containers; they too combine the intimacy of communciation of an idea with the detachment of a manufactured item. They are not just spinoffs of LeWitt's "real" art, but offer more art for less. Each book completes a full system, in color or black-and-white photography or drawings, and potentially reproduces more closely the process of creative generation. Nothing is lost between the structures—such as those shown in 1976 in Hammarskjöld Plaza, New York—and the booklet accompanying them except the physical presence that comes with scale.

LeWitt's first book was *Serial Project No. 1,* made for Brian O'Doherty's 1966 issue of the boxed *Aspen Magazine.* In 1968 Seth Siegelaub offered LeWitt twenty-five pages of "The Xerox Book," copublished with Jack Wendler (figs. 152–155). LeWitt saw his contribution as a failure because he "didn't feel either the page or the reproductive technique" and was just "translating from one medium to another" his permutational line series.[36] As he continued to work with books, he became increasingly aware of the relationship of content to vehicle and of how much more he could squeeze out of each concept by transforming (rather than translating) it into book form. For instance, the wall drawing *10,000 Lines* changes drastically in density and intensity when drawn onto the page of a book (figs. 184–188).

Modification of ideas for inclusion in a book, or of book ideas to be drawn on a wall or made as a structure, is one more method of facilitating orderly change. In *The Location of Eight Points* (1974), the progressive complexity of the idea is seen at a browse in the twenty-page booklet. The instructions are handprinted on the left-hand pages and the drawings are on the right. As one moves ahead, the captions get longer and the drawings more complicated, progressing from "the first point is located at the center of the page," facing a simple cross, to a full page and a half of description sandwiching an image of the eighth point and its ten-line, eight-point configuration. *The Location of Straight, Not Straight, and Broken Lines and All Their Combinations* (1976) consists of solid and broken lines and handwritten blocks of words on the lines themselves instead of isolated as captions. As this system gets more involved, and more writing must fit into the drawings, the visual results get wilder and wilder until they approach logical insanity. This is a prime example of the unique manner in which LeWitt has been able to use language as an integral part of his process, providing another, literal way of "reading the artist's mind."

LeWitt's books have also provided an outlet for the clever and ironic side of his wit that is part of his personality but is well hidden in most of his art. (Exceptions to this were his 1975 exhibition at the Lucio Amelio Gallery in Naples, where he worked over the preceding show by Daniel Buren [fig. 244];[37] and his contribution to my section of Siegelaub's Summer 1970 issue of *Studio International,* a chain piece where each artist offered the next one a situation within which to work; LeWitt took the telegram he received from On Kawara—"I am still alive. On Kawara"—and printed in columns all the permutations of those words [fig. 274].) In the books, too, he has occasionally allowed himself to use "found" materials, his only connection to Duchamp, whom

he and all the Minimalists except Morris have held in some scorn.[38] Through the book form LeWitt has also become interested in photography. In 1975 he made a book of fourteen photo-etchings of a great variety of *Stone Walls* (grids) and more photographic books are in the works—one of forty-eight pages of colored photos of grids found in the streets during his international wanderings (fig. 269).

LeWitt uses photographs as elements in linear or modular systems, epitomized by a work-in-progress involving hundreds of photos of the brick wall outside his studio window undergoing cinematic changes of light and shadow (fig. 272). The raw materials chosen from life, like conventional geometric shapes, provide building blocks (bricks) for the construction of his art. However, there is another incomplete work, for which LeWitt has not yet found a final form, that clearly calls for a somewhat different solution, despite its equally obvious tie to the rest of his art. *On the Walls of Lower Manhattan* has so far appeared only as a forty-eight photo series of gridded pages in the November 1976 issue of *Vision.* Intended as "an encyclopedia of art of our time and place," real life in this case offers an infinitely varied and transformable system that includes graffiti, murals, flags, naive art, community projects, stick ball bases, political rhetoric, posters, signs, love notes and ambiguous messages. These walls, unlike the brick wall outside his window, refer to an infinite number of elements outside themselves.

"The walls are the newspaper of the people" is a popular leftist slogan LeWitt refers to in this context. A resident of the Lower East Side of New York for almost twenty years, he is unromantically fond of its crowds and extremes. However, he refuses to consider the possibility of making public art of his own on those walls, partly because the isolated spaces provided in museum/gallery contexts suit him aesthetically; partly because he justly foregoes the use of his art cosmetically and ideologically to "prop up antiquated political structures"; and partly because of what I consider an overmodest conviction that since "all segments of society have their own art forms, art being everything in life in which an aesthetic choice is made," imposition of his own choices upon a public with other outlets would be a patronizing and colonialist gesture.[39] LeWitt has been appalled at those all-too-common arguments between would-be Marxist avant-garde artists about whose work a truck driver would best understand and respond to. Noting that "even bourgeois art critics" often don't understand his work, he hasn't much confidence that a multiclass general public would enjoy it, even though he is also convinced that "there is no optimum perception," that anything existing in the world is perceived in any number of ways by any number of people (including art critics, whose relationship to art he compares to that of the blind men to the elephant—sensing parts but not the whole).[40]

Despite LeWitt's unquestioned political commitment,[41] it is impossible to ascribe political content to his art, and the notion is anathema to him: "I don't think that I know of any art of painting or sculpture that has any kind of real significance in terms of political content," he said in 1968, "and when it does try to have that, the result is pretty embarrassing. . . . Artists live in a society that is not part of society. . . . The art-

ist wonders what he can do when he sees the world going to pieces around him. But as an artist he can do nothing except to be an artist. . . . American life is rapidly breaking down. . . . Middle-class morality is breaking down. . . . There is no reason that the artist should feel he is part of something that is so decadent and so completely without any purpose."[42]

Nevertheless, LeWitt would probably agree with John Berger that "aesthetics are a consequence, rather than a cause,"[43] and he does what he can to be responsible for the uses his art is put to. The unpretentious honesty of LeWitt's work is a product not only of his personal aversion to corruption, but is most certainly affected as well by the social environment—especially that of the 1960s, when the art world's urgent desire to find new ways of generating art paralleled the spirit of political revolt rising from civil rights struggles and the Vietnam war. All that talk about the desirability of nonsalable objects that would no longer fall into the hands of the commodity-traders or of the warmongers offering CIA shows or of the government whitewashers offering writeups in USIS journals did push artists to consider their work in a social light, to examine their goals and the destinations of their art. It would, therefore, be interesting to make this meandering article conform to a circular system, and to review all of LeWitt's art, ideas and development with an eye to the circumstances surrounding them.

NOTES

1. In taped conversations with the author, 1971–72.
2. Michael Kirby in *Sol LeWitt,* Haags Gemeentemuseum, 1970, p. 28. (From here on I will refer to this as "The Hague catalog.")
3. Donald B. Kuspit, "Sol LeWitt: The Look of Thought," *Art in America* (New York), September–October 1975, p. 44.
4. Ibid., p. 44.
5. Unpublished typescript of talk by Sol LeWitt to the "Art Now" class at the Nova Scotia College of Art and Design, Halifax, Nova Scotia, March 20, 1970. (From here on I will refer to this as "NSCAD typescript.")
6. Among them the *Art & Project* bulletins; announcements for his shows, including the full schemes of the work; and the paper pieces, including the folded-paper grids first conceived in 1966 as the announcement of the LeWitt, Smithson and Valledor show at the Park Place Gallery (the folding was done by the printer)—the latter despite critic Robert Pincus-Witten's imputation in a factually inaccurate article on LeWitt that the folded grids were "claimed" to have been "part of LeWitt's production for some three years" (written in 1973).
7. The first wall drawing, done for an antiwar benefit show at Paula Cooper's gallery in 1968, was merely a reproduction of part of the *Drawing Series* of linear permutations found in "The Xerox Book" and was unsatisfactory for the same reason (see below). This series was also drawn on boxes and columns (shown at Dwan Gallery in 1969, and in Europe), resulting in what I consider the least interesting work LeWitt has done. However, when it was expanded into a margin-to-margin wall show at the Ace Gallery, and into a book, it came into its own.
8. Concerning a major earlier piece—*47 Three-Part Variations on Three Different Kinds of Cubes* —in which such blanks occurred, John N. Chandler has quoted LeWitt: "Regular space might also become a metric time element, a kind of regular beat or pulse. When the interval is kept regular whatever is irregular gains more importance." "Tony Smith and Sol LeWitt: Mutations and Permutations," *Art International* (Lugano), September 1968. p. 19.
9. How Kuspit can call this style of writing "purple prose," "effusive and formless" and partaking "of belles lettres" (op. cit.) is beyond me. LeWitt himself refers to the words as "the path to the understanding of the location of the point. The points are verified by the words." In a show of wall drawings at the Lisson Gallery in London, the words "To," "Toward," "Through" were the basic concept.
10. NSCAD typescript.
11. In conversation with the author, 1971–72.
12. Michael Harvey, *Notes on the Wall Drawings of Sol LeWitt* (Geneva: Editions Centre d'Art Contemporain, Salle Patiño & Ecart Publications), 1977. It deals with the axiomatic and contextual aspects of the work. Some 300 wall drawings have been executed to date.
13. Letter from LeWitt to the author, July 21, 1970.
14. NSCAD typescript.
15. Ibid. The transcript of this taped talk reads "plotting" but it is obviously "plodding."
16. Kirby, The Hague catalog.
17. The Kaymar was a commercial "village art" gallery on pre-SoHo West Broadway that Dan Flavin had somehow borrowed to give himself a show; afterward he had some time left over and organized a group show (March 1964) of works by many of his friends, which was one of the first Minimal exhibitions. It included LeWitt, Donald Judd, Robert Ryman, Frank Stella, Jo Baer, Darby Bannard, Larry Poons, Ward Jackson, Irwin Fleminger and Flavin.
18. Terry Atkinson of Art & Language, in The Hague catalog. LeWitt had been in touch with Atkinson and Michael Baldwin since the winter of 1965 or so; he admired their use of maps and linguistic philosophy to generate a unique kind of content. Around this time he also met Hanne Darboven, whose work he immediately admired, in part because they were both on the same track. He has said of her work: "Her content is accessible. It's just adding numbers, very simple numbers, but actually what she is doing is making fantastic structures out of numbers. With just one little idea, she can work for three or four years and do it so many different ways" (conversations with the author, 1971–72).
19. Robert Smithson, "Entropy and the New Monuments," *Artforum* (New York), June 1966, p. 27. The most recent reference to the containment theme is a nonhermetic series unfolding

the possibilities of the six basic geometric forms containing each other.

20. Bruce Glaser interview, "Questions to Stella and Judd," broadcast on WBAI, New York, February 1964; subsequently edited by Lucy R. Lippard and published in *Art News* (New York), September 1966; reprinted in Gregory Battcock, ed., *Minimal Art: A Critical Anthology* (New York: Dutton), 1968, pp. 148-64.

21. There were of course precedents in the twentieth century for this attitude, especially Moholy-Nagy's famous Telephone Pictures series. As Lawrence Alloway has put it, "What the Americans did was to standardize the unit," *Artforum* (New York), April 1975, p. 42.

22. This disinterest in "originality" became something of a *cause célèbre* in 1973, when the Italian artpaper *Flash Art* published an advertisement accusing LeWitt of copying European artists, an accusation LeWitt answered easily. In the process he noted that "there are many works of artists that superficially resemble the works of other artists" but that the only valid comparison is between the total works of any artist. He went on to deny any interest in innovation:
I believe that ideas, once expressed, become the common property of all. They are invalid if not used, they can only be given away and cannot be stolen. Ideas of art become the vocabulary of art and are used by other artists to form their own ideas (even if unconsciously). . . . My art is not of formal invention, the forms I use are only the carrier of the content. I am influenced by all art that I admire (and even art I don't admire). . . . If there are ideas in my work that interest other artists, I hope they make use of them. If someone borrows from me, it makes me richer, not poorer. If I borrow from others, it makes them richer but me no poorer. We artists, I believe, are part of a single community sharing the same language. (Flash Art [Milan], June 1973). Incidentally, Donald Barthelme, writing in *The New Yorker* (February 25, 1975), did a marvelous parody of this situation called "Letters to the Editore" about the work of an artist called LeDuff.

23. Ad Reinhardt in "Twelve Rules for a New Academy," *Art News* (New York), May 1957. LeWitt has interpreted Reinhardt as believing "in an absolute nonintelligence," his work "concentrated on an absolute sublimation" that led him from rationality to irrationality (interview with Achille Bonito Oliva, *Album 9-68.2-71,* Galleria L'Attico, Rome, 1971).

24. For instance, Reinhardt saw color as unnecessary to painting and was interested in a book written in 1923 by Willard Huntington Wright suggesting that there would be a "new art of color" that would leave painting to the Reinhardtian end. I go into the relationship of Reinhardt, Minimalism and "future" art at length in my monograph on Reinhardt (Institute for the Arts, Rice University, 1978).

25. Lawrence Alloway, "Sol LeWitt: Modules, Walls, Books," *Artforum* (New York), April 1975, p. 40.

26. All quotations in this paragraph from conversations with the author, 1971–72.

27. Ibid. One artist whose work epitomized this interior source was, of course, Eva Hesse, who was LeWitt's closest friend for over a decade. She considered them "opposites" as artists, but the transformation of geometry is at the core of both their work. In 1965, while Hesse was in Germany struggling with what was to be the beginning of her major art, LeWitt was her strongest supporter, insisting that she say " 'Fuck You' to the world once in a while" and advising her to "try and tickle something inside you, your 'weird humor.' You belong in the most secret part of you. Don't worry about cool, make your own uncool. . . . You must practice being stupid, dumb, unthinking, empty. Then you will be able to DO! . . . even though you are tormenting yourself, the work you do is very good. Try to do some BAD work . . . " (April 14, 1965; the rest of the letter is printed in my *Eva Hesse,* NYU Press, 1977). This is particularly interesting when you realize that LeWitt himself was just about to have his first show.

28. Mel Bochner, "Primary Structures," *Arts Magazine* (New York), June 1966, p. 34.

29. Dan Graham, earlier version of essay published in The Hague catalog.

30. Lucy R. Lippard, "Rejective Art," *Art International* (Lugano), October 1966, pp. 33–34.

31. Mel Bochner, "Serial Art, Systems, Solipsism," in Gregory Battcock, ed., *Minimal Art* (New York: Dutton), 1968.

32. Suzi Gablik, *Progress in Art* (New York: Rizzoli), 1977, pp. 46, 47, 88. LeWitt himself, on reading this book (and discovering Piaget's theories for the first time) found it amazingly applicable to his own work, which he wryly said was "vindicated" by such solid theoretical background.

33. Rosalind Krauss, "New York," *Artforum* (New York), April 1968, p. 57.

34. Robert Pincus-Witten, "Sol LeWitt: Word ⟷ Object," *Artforum* (New York), February 1973; his article is also the source of the "recidivism" and "moral default" below.

35. NSCAD typescript.

36. Conversations with the author, 1971–72. LeWitt is also a founding member of Printed Matter, which distributes and publishes artists' books as a nonprofit collective.

37. Buren had projected the doors and windows on facing walls. This all recalls Buren's attempt to foil a museum's censorship of Hans Haacke's piece by writing Haacke's texts on his own wall works.

38. On the grounds of sheer ironic opposition, however, it is always tempting to discuss the very differences between Duchamp's and the recent Minimal-Conceptual ideas. John Chandler and I in "The Dematerialization of Art" (*Art International* [Lugano], February 1968) much enjoyed ourselves listing parallels, and Alloway (op. cit.) doesn't resist either. Reinhardt and Duchamp are always being compared too, though the former shared the Minimalist horror of the great Dada.

39. In conversation with the author, July 1977.

40. When we talked about this I argued that art historical and academic and even art school training ill prepares people to understand art and some of the intelligent wo/men in the street might be better equipped to do so. LeWitt's wall drawings, especially the grand Arcs and Circles series, like the white-on-black room at the School of Visual Arts in 1976, are not only on a large scale, easily "transportable," impermanent, collaboratively and inexpensively executed, but are also decorative in the best sense—offering enough visual and intellectual stimulation to draw passersby into scrutiny of the underlying ideas—and would make ideal public art. I would like to see the wall drawings and books and prints be offered at least to hospitals, schools, community colleges, arts projects, firehouses and other places outside their usual domains, not as colonialism but because I strongly believe that the opportunity to work for a non-art audience changes and enriches the work of artists willing to learn from such experiences.

41. Like a few others in the small group of socially conscious abstract artists, LeWitt has supported endless "radical" causes with art and with money. He supported the goals of the Artworkers' Coalition and took part in their published "Open Hearing"; has picketed The Museum of Modern Art, the Whitney and the Guggenheim with the AWC, PASTA-MoMA and the latest New York radical artists' group, Artists Meeting for Cultural Change; and has withdrawn or withheld work from those institutions displaying "arrogance" to artists or oppressed groups. Most of all he has been immensely generous with encouragement and financial support of younger artists as well as of political publishing projects. All of which leaves him no better able than the next artist to cope with the basic problem of contemporary art's relationship to the society in which it exists.

42. *Metro* (Venice), June 1968, p. 44.

43. Quoted by Kuspit in "Kuspit/Masheck (continued)," *Art in America* (New York), January–February 1977, p. 5.

SOL LEWITT AND DRAWING by Bernice Rose

SOL LEWITT MADE HIS FIRST WALL DRAWING on the wall of the Paula Cooper Gallery in 1968. It was not in any sense a tentative work conceptually, nor was it a work conceived as preliminary or subordinate to any other. LeWitt's transposition of his drawings from the restricted if traditional format of a sheet of paper to the architectural space of a wall with which it became absolutely identified was a radical move. It suggests transformation in the role—and the very nature—of the drawing medium, within both his own work and the history of the medium.

LeWitt's move was catalytic, as important for drawing as Pollock's use of the drip technique had been for painting in the 1950s. Both opposed, through radical transpositions in the way in which the thing is made, expectations of the way art ought to look—what it ought to be. (Pollock, in fact, changed all conceptions, at least in the United States, of the way art had looked before.) Pollock's change had been generated by the material itself; the painting became a record of the process by which it had been made. The movement of the painter's own body pouring paint from a can onto a horizontal canvas generated lines that described nothing but that movement and destroyed previous notions of composition. For LeWitt (who deliberately eliminated the record of process and rejected the object itself as the primary artistic achievement) it was the formulation of a predetermined system—an idea that preceded discipline or medium and that could apply to two- and three-dimensional work in all mediums—that was radical and original. LeWitt's article "Paragraphs on Conceptual Art" (1967)[1] was a seminal contribution to the art of the 1960s (see pp. 166–167). These ideas, when applied to drawing, changed attitudes toward that discipline, transforming it from a minor medium to one that played a role equal to that of painting or sculpture. For LeWitt himself, it had been initially necessary to abandon painting. LeWitt had already stated his major preoccupations as an artist and formulated a method of work in three dimensions that was precise, individual, and mature in 1968, when he again approached the problem of working in two dimensions. His move to create major two-dimensional works as a parallel to his three-dimensional works was premeditated; his choice of drawing rather than painting as an alternative two-dimensional discipline was consistent with his work at the time and a response to the complex relationship between the contemporary painting and sculpture then dominant. LeWitt later added that he wanted to create a work of art that was "as two-dimensional as possible." LeWitt's working method at that time—his ambition—could be described as being based on his constant reappraisal of what were the irreducible elements of a work of art and the simplest means of using them.

To LeWitt, whose instinct was always to return to basics, drawing was the fundamental discipline—not simply in terms of planning other works of art but as the basic structural unit of all art. Line, the most basic unit of drawing, held the primary position.

The immediately precipitating causes of LeWitt's initial essay into drawing were seemingly casual, and the development of the two-dimensional work, when it happened, happened all at once, with one idea opening into another in logical sequence. The idea of drawing on the wall was in itself the result of a great deal of forethought. Working directly on the floor or on the wall, without the intervening support of a canvas or a base, was an idea that was "in the air" in the late 1960s. LeWitt had thought for a long time about drawing directly on the wall. When he finally did begin to draw it seemed logical to finally draw on the wall as well.[2] So natural was the unfolding of the work and the interaction of ideas that LeWitt admits no priority between wall drawings, drawings on paper, printed drawings, or books. In 1968 Seth Siegelaub asked LeWitt, along with a number of other artists whose primary work was in three dimensions (Carl Andre, Robert Barry, Douglas Huebler, Joseph Kosuth, Robert Morris, and Lawrence Weiner) to create some drawings for "The Xerox Book." The idea appealed to LeWitt, who had always been, on principle, interested in the widest, least exclusive distribution of art at low prices. Also, the idea of a book appealed to him because it offered a way of presenting a sequence of work as a whole. He wrote, "I thought that there were 24 permutations of 1, 2, 3, 4, plus one summary page."[3]

LeWitt had been making after-the-fact drawings of his three-dimensional structures in isometric perspective. The planes in these drawings had been differentiated by a system of parallel lines drawn in four basic (absolute) directions (one direction for each plane: vertical, horizontal, 45 degrees left, 45 degrees right, plus superimposing, or crosshatching). He transferred these conventional linear patterns to a flat surface using the same kind of systematic reversals and permutations that ruled his three-dimensional work. This method was then available for all types of two-dimensional work: drawings on paper, drawings on the wall, drawings on free-standing three-dimensional objects, and drawings printed in books, catalogs, magazines, and on posters.

The initial work that generated all these possibilities is *Drawing Series I, II, III, IIII* (figs. 152–155), originally called *Drawing Project 1968 (Fours)*. LeWitt's instructions for this work are the model for all work that was to follow, setting the conceptual pattern for the most diverse permutations and variations on the basic theme. (LeWitt himself later wrote about the working drawings for the set, "It is a representative

example of my thinking—in terms of serial systems using all possible permutations in the most simple form.") Each drawing is composed of four squares, which are in turn divided into four squares, each with a different value (1, 2, 3, 4). Each quarter has a 1, 2, 3, and a 4. These series contain all twenty-four permutations of 1, 2, 3, 4.

In answer to a question about the working drawings for the set he wrote: "I would like to complete the project by using the two methods with four colors (yellow, black, red, and blue), each with a different method of line direction and also by superimposition making four methods." LeWitt chose the number four for a number of reasons. Initially he was offered twenty-five pages by Siegelaub, which broke down into a multiple of four plus a composite page. Four was the number of sides of a cube, the module that he used for his sculpture—also of the sides of the squares that form cubes—both extremely stable shapes. Four was also the number of the absolute linear directions; these four lines superimposed produced stasis; LeWitt strongly desired his work to be static. The first wall drawing was simply one part of *Drawing Series I, II, III, IIII* transferred from sheet to wall (figs. 158–159). It was a pair from series B. The instructions were written on a drawing done some six months later (see fig. 161)..[4]

LeWitt's working method for his wall drawings is simple. As Lawrence Alloway described it:
A site becomes available, not necessarily one that the artist has seen in advance. After consideration of the dimensions and physical properties of the walls, LeWitt stipulates a certain kind of mark, and a certain form of distribution of marks by a sketch and/or verbal or written account. The instructions also serve as the work's description after it has been done, so that the wall is bracketed verbally, both before and after execution. The process-record is abbreviated, compressed between identical accounts of conception and completion.[5]

Between the exhibition at the Paula Cooper Gallery in October of 1968 and an exhibition at the Konrad Fischer Gallery in Düsseldorf in April–May 1969, LeWitt made several wall drawings in other locations, using parts of the *Drawing Series* (but parts that could be seen as a whole within the system). For an exhibition in 1969, "When Attitudes Become Form," he did two pairs of drawings; in December 1968 at the Ace Gallery in Los Angeles he drew the set of twenty-four drawings (the B series) that also became a book. All these drawings were done with hard graphite on white walls, creating a discrete silvery-gray tone. It is hard to describe the delicacy and precision of these drawings, or their sheer presence and absolute conviction, or how surprisingly inevitable they seemed the first time one saw them. The size of the drawings was determined by the size of the wall and its physical location. The 1/16-inch interval between the lines was determined by binding the group of leads together so that the lines would be clearly distinguished from one another while an interval was maintained in which neither space nor line dominated. It was important that, while the drawing did not disrupt the "integrity" of the wall surface, it be clearly seen as linear. The tendency with these early drawings was to see them as discrete areas on a planar surface, as if the limit of the format were still determined by the size of a sheet of paper.

At the Konrad Fischer Gallery, LeWitt worked for the first time to integrate the drawings more closely with their architectural support and surroundings. Fischer's gallery was a long, narrow space with two parallel exhibition walls (it had originally been a passage between buildings belonging to the city and been enclosed at each end with glass). On one wall LeWitt drew a square composed of four squares, each one an absolute linear direction. On the opposite wall he ran the long narrow band the length of the wall, adjusting it to average eye height and, in effect, releasing the drawing from the *Drawing Series* format (fig. 160). The instructions read simply, "A band of vertical and crossing diagonal pencil lines 40″ wide from front to back of gallery. 40″ × 480″."[6] The result was that it was seen as part of the function of passing through the long space. Perhaps it was the eccentric nature of the space itself that released him, because later that same spring, in the more conventional space of the Paula Cooper Gallery in New York, he had returned to the more conventional format. A similar drawing used all directions of line, with the instructions now so generalized that they could adapt to any surface: "Lines in four directions (horizontal, vertical, diagonal left, and diagonal right) covering the entire surface of the wall. Note: the lines are drawn with hard graphite (8H or 9H) as close together as possible (1/16″ apart, approximately), and are straight."

For an exhibition at the Dwan Gallery in New York in October 1969 LeWitt again released the drawings from the format of the *Drawing Series*. For the first time he wanted to treat the whole room as a complete entity—as one idea. Relying on a simple series of the four absolute lines in all possible combinations (fifteen are possible), he divided the surfaces of two walls into long vertical panels, using the entire surface of each wall to draw on. The east wall, for instance, was divided into a six-part drawing using the four lines two at a time superimposed one on another. The first panel was vertical/horizontal; the second, vertical/diagonal right-left; the third, vertical/diagonal left-right; the fourth, horizontal/diagonal left-right; the fifth, horizontal/diagonal right-left; and the sixth, diagonal right-left/diagonal left-right. The west wall was a "serial drawing with three kinds of line superimposed in each part." On the remaining north wall there was a drawing in color, "four kinds of line direction, each with a different color (vertical–yellow, horizontal–black, diagonal left to right–red, diagonal right to left–blue) superimposed." These drawings were isolated by bare white surroundings. LeWitt says that at the time he felt that to draw them the same size as the walls might conflict with the black-and-white drawings and interfere with the clarity of the system. He wanted each to be a separate entity and he wanted no ambiguity about the beginning or end. On the south wall he drew four rectangles (separated by the doorway) using the vertical, the horizontal, the diagonal left, and the diagonal right, which were framed by the white walls. In the end the color did not appear to be very different from the tonal drawings; the visual mix of the four primaries itself created a tone more brown than gray. He wanted to exploit all of the possibilities—all of the different ways of all of the different kinds of drawing he had used thus far. He wanted to make a total drawing environment using serial drawings, rectangles, and double and single line com-

positions, each one having a different number of lines done in different ways.

At the Dwan Gallery LeWitt consciously tried to make the main room work as one idea about the nature of drawing. In the main room one was "surrounded" by drawing; in the second room he provided a deliberate contrast. The series of four was drawn on two four-sided rectangular forms so that the spectator now walked around the drawings on their constructed supports (fig. 156). LeWitt's idea was to provide "different forms of the same thing." But the three-dimensional columns seem to be too much of a hybrid—a mix between three-dimensional sculptural concerns and two-dimensional drawing concerns. The drawings were not integrated into the structures in the same way the drawings in the main room were, transforming the environment; his concern, then as now, was that these drawings not be physically assertive and detach themselves from their environment as specific objects, but that they remain distinct and unambiguous. LeWitt's drawings at the Dwan Gallery existed for the first time as works of art identical with their architectural support, with no implied framing device. Also, at the Fischer Gallery, and to a greater degree at the Dwan Gallery, LeWitt treated the gallery as a total art work.

A printed booklet of drawings was published following each of these exhibitions (LeWitt continues this practice to this day), permanently recording the concept that governed each exhibition. (The Lisson Gallery, London, published the color drawings; Studio International published the black-and-white drawings; Sperone Gallery, Turin, published I, II, III, IIII, both A and B, in black-and-white.) As critic Barbara Reise pointed out at the time, a comparison between "The Xerox Book," the booklets following the Dwan Gallery exhibition, and that for a simultaneous exhibition in Krefeld, immediately reveals the difference in the two spatial conceptions.[7] Those in "The Xerox Book," for instance, operate very discreetly within a white framing space, while the drawings in the book that followed the Dwan show expand to fill the page. Margins are perhaps the most important mediator for these drawings, and LeWitt has always been super-sensitive to margins and placement in all of his printed work as well as in his drawings on paper.

There had been an initial difficulty in maintaining the interval between parallel lines. In May 1969 LeWitt solved this technical problem by bundling graphite, using four sticks, one next to another, so that four lines were drawn simultaneously with one movement. Plumb lines and levels were used to establish center verticals; levels were used as guides to horizontal and diagonal lines because walls were never square.

LeWitt did not, however, immediately isolate the line itself as the primary unit. Until 1970 the basic unit for the drawings was the group of parallel lines that worked together in one direction. In two wall drawing shows in 1970 that were executed within two weeks of one another—the first in Paris at the Yvon Lambert Gallery (figs. 177–178), the second in Turin at the Sperone Gallery (fig. 181)—he really focused for the first time on line as an isolated, nondescriptive element. At Sperone he used line to indicate direction from one point to another. The drawing was called simply Lines Connecting

Architectural Points. LeWitt used the architecture of the extremely irregular gallery space as a reference point and, snapping lines with a cord and chalk, drew systematically from beam to beam, pipe to pipe, electrical outlet to beam, beam to wall corner, etc., until he had exhausted the possible permutations and had made the gallery into a total drawing.

Drawings that intervened were continuous explorations of the possibilities inherent in those that had preceded them. For instance, in 1969 he remained in New York and telephoned instructions to an assistant in Chicago to draw a one-inch-grid, and within the grid to draw a vertical, horizontal, or diagonal line. The overall size was 3 feet × 3 feet. The grid was inherent in the earlier drawings and very much a part of his three-dimensional work. LeWitt himself says that the placement of the grid on the floor, as he looks at it now, was a kind of drawing: it was about line, but even then it was two-dimensional. In his work the grid seems always to mediate between two and three dimensions. Beyond this is also his recurrent theme of returning to basics; the lines were, as in the Drawing Series, the absolutes. By this time the system was so well articulated that it could incorporate randomness without sacrificing its integrity. From Vancouver in January 1970 he sent instructions for a drawing to be done at Paula Cooper's Gallery in New York: "Within a 6 foot square 500 vertical black lines, 500 horizontal yellow lines, 500 diagonal (left to right) blue lines, and 500 diagonal (right to left) red lines are drawn at random." At this time he seems to have also begun to focus more on the line itself, and instructions for the "Art of the Mind" exhibition at Oberlin College in April 1970 were: "A straight line is drawn; another straight line is drawn at a right angle to the first; lines are drawn at right angles to each preceding line until the draftsman is satisfied. The lines may cross."

The Drawing Series also generated LeWitt's first serial drawings on paper, using the same system of vertical, horizontal, diagonal left, diagonal right, and systematic layerings of these lines until the final set of the series was composed of all permutations. Color drawings employing the three primary colors and black later completed the set. By establishing system as a method for himself, LeWitt had created a way of working that was almost infinitely elastic and open-ended, one idea leading to another and still another, in intuitive leaps, from suggestions inherent in the work. Later work expanded to incorporate circles and sections of circles (arcs), irregular lines and, later still, a new use of color. The new permutations were systematically exploited to produce new variations.

THE USE AND DISUSE OF SYSTEMS in intellectual history was outlined by John Chandler in a discussion of LeWitt:

The current concern of artists with "systems" recalls the rejection of systems by the eighteenth-century philosophers. The seventeenth-century philosophers, following the model of Euclid's Elements, constructed elaborate systems, long chains of deductive reasoning where every link depended on all those which preceded it and upon which all further links depended. The eighteenth century, following the lead of Newton and natural philosophy, rejected this kind of deduction and rejected a priori systems. Rather than beginning with principles and arriving at particulars, the process was reversed.

Knowledge became more elastic, open-ended and concrete. Since then, attempts to make systems have been negligible, and when they have been formulated, they have been useless. The formulator of a system of aesthetics has nothing to say to working artists because he has not observed the relevant phenomena—in this case, contemporary works of art. Nevertheless, some of the most beautiful of human productions have been these philosophical systems. What is more beautiful than the systems of Aquinas, Spinoza, Hobbes and Descartes? Every part in its appropriate place, deduced from those prior and antecedent to those that follow, the whole being an attempt to reduce the apparent variety to unity. Even their uselessness enhances their aesthetic quality, just as a ruined Gothic cathedral is perhaps more a work of art now than it was when it was functional. Although systems are useless for philosophy and science, their inherent adaptability to art must now be evident. It is perhaps in art that systems have found their proper domain. Not all art should be systematic, but all systems are art. [8]

Systems have other attractions, too. A simple system may yield a complex field. Systems may seem logical but can be used to confound logic when extended to absurdity. Systems have no purpose outside of themselves: they engender purposeless, therefore aesthetic, mental processes.

But the rule-dominated anti-aesthetic system that generates its own style is not new with LeWitt; it is a tradition of modern art. It made its first appearance in literature in the work of the French symbolist poets, especially Mallarmé.[9] LeWitt recalls reading in 1964 an article on Mallarmé and serial thought in *die Reihe,* a German music magazine. LeWitt's recollection is of a description of a book project by Mallarmé in which a book like a cube, as high as it was wide, was to be placed in the middle of a room. The top page would be read aloud by one person and placed aside to then be read by another person and so on. Somewhat later, Raymond Roussel went so far as to provide himself with a set of rules for living—which he extended into a system for writing, intending it to eliminate the possibility of stylistic effects. This kind of rule-making, however, produced its own effects, resulting in a style with a remarkable clarity of its own. Roussel's mania for order was "a need to arrange everything according to rules devoid of any ethical character, rules in their pure state, just as the rules to which he conformed in his writing seem exempt from an aesthetic intention."[10] Roussel's systemizations probably have their roots in the primitivizing strain of early twentieth-century French poetry. His dislocations of phrases and uses of double entendres have a connection with Duchamp's work and image puns—for instance, Duchamp's title *Fresh Widow* for *French Window*.

Duchamp himself might be styled the first Conceptual artist in his use of language images married to visual ones. It was Duchamp's exhortation, in his break with Cubism, to "reduce, reduce, reduce . . . put the mind once again at the service of the eye."[11] Duchamp had gone on to reduce language to "essentials" and to create his own grammatical system. Duchamp's new language joined visual images to linguistic symbols. In *The Green Box* Duchamp provided enigmatic instructions (though not a system) for the creation of a work of art.

LeWitt does not believe in a specifically reductive process whose only goal could be irreducible objects. Giving verbal instructions that are always intellectually consistent with the artist's intention, whether fabricated by him or not, became one of LeWitt's paramount concerns. He was not, however, interested in Duchamp at the time he was developing these ideas nor has he ever been influenced by Duchamp. LeWitt's thinking has been more concerned with serialization in music and modular systems in architecture. In other words, his involvement has been structural and pragmatic, in the American vein. LeWitt's first mature work, however, had been as a Minimalist, constructing sculpture out of rationalized modular components arranged according to simple systems. By 1967 he preferred to refer to his kind of art as Conceptual, used formally as the title for his "Paragraphs on Conceptual Art." By 1967 he had already formulated the rules and systems for generating the work. A 1966 work titled *Wall Structure, Black* (fig. 43) is a simple three-dimensional grid. A 1967 work—*All Three-Part Variations on Three Different Kinds of Cubes.* (fig. 131)—is more complex. The three different kinds of cubes are: completely enclosed, open at two sides, open at one side. They are stacked one on the other, in all possible permutations of stacks and in all possible permutations of axial rotation. *Serial Project No. 1 (ABCD)* (fig. 130), is in some sense a model for the drawing sequence of 1968. The instructions read:

A set of nine pieces is placed in four groups. Each group comprises variations on open or closed forms. The premise is to place one form within another and include all major variations in two and three dimensions. This is to be done in the most succinct manner, using the fewest measurements. It would be a finite series using the square and cube as its syntax. A more complex form would be too interesting in itself and obstruct the meaning of the whole. There is no need to invent new forms. The square and cube are efficient and symmetrical.

LeWitt's recurrent theme is a return to basics—available basic forms, available materials that are widely disseminated culturally and are technologically simple—for example, "colors like those used in printing." In the three-dimensional work, the square and the cube became the fundamental syntax. It took some time, however, for LeWitt to focus on line *per se* as the basic unit for drawing, and it was not until the 1970 drawing *Lines Connecting Architectural Points* that he concentrated on line itself. Later, when LeWitt incorporated the circle and arc into his work, he did so because they also were available, simply identified shapes, "static, in which all parts are equal." These parts could be used as modules. He found them interesting even though the square was an easier shape to use as a modular device and the circle could only be itself.

LeWitt's use of the word "syntax" in this context is interesting. Conceptual art is an art in which language dominates. Although other artists concerned with Conceptual art do not always end with a visual product, LeWitt's work is finally visual—as he notes, the work must have an outcome. Conceptual art put language in a very special relation to art. For the members of Art and Language (a group of Conceptual artists whose primary interest is the history of culture), to whom LeWitt was very close at one point, it is sufficient that the ideas be about art—any idea about art is art. Text is all the visual part necessary. "Obsessed with the idea he must ex-

press, the artist takes appearances only as accessory," stated Chandler.[12] LeWitt himself wrote, "All ideas are art if they are concerned with art and fall within the conventions of art," although he did carefully qualify his article "Sentences on Conceptual Art" (see p. 168) by concluding, "These sentences comment on art, but are not art." Lawrence Alloway noted that LeWitt's drawings were bracketed by their verbal description. It would seem apt to compare LeWitt's single lines—the single strokes—with the basic components of grammar, to say they are the syntax (in the earlier drawings the syntax would be the four basic directions rather than the single stroke, arc, or circle). The origins of conceptualization are complex since the verbal and visual are bound together very closely. The problem for modern philosophy has been to distinguish their boundaries—to determine if visualization is prior to, anterior to, or simultaneous with verbalization, and if the verbal and the visual are independently structured and conceived or interdependently. Do our verbal structures supply us with our "picture" of the world and do they, as postulated, form the very basis of all our social structures, even to the extent of determining our kinship systems?

In the 1960s these possibilities were argued at length. Philosphers like Ludwig Wittgenstein were widely read and discussed, as were the French structural anthropologists and phenomenologists Claude Levi-Strauss and Maurice Merleau-Ponty. The sixties saw the beginnings of a criticism based on the speculations of those philosophers whose premise was that the structure of culture is in fact determined by the grammatical structure of language. Syntax determines form in the most fundamental sense. If Conceptual art put language in a special relation to art, it did so particularly with reference to drawing. Written words and letters of the alphabet stand in relation to verbal utterance as drawing in relation to sight. Words and drawings have a common origin as symbolizations of experience, symbols for things. (The association of writing and drawing—hieroglyphics, the extension of writing into calligraphy, the elaboration of drawing by written inscription, and the elaboration of written text by illustration—is evident in the oldest traditional expression in literate societies.) One may infer, therefore, from LeWitt's use of the word "syntax" that the problem was one of determining the most basic visual units to form a "visual grammar" that would then supply a world view—one that would be infinitely extendible, although "locally" finite, and in which idea would be prior to execution. In that sense, it would have to be linguistically determined, or "bracketed." More simply, LeWitt's idea was that all the planning for a work takes place in advance, all the decisions are made before the work is begun—his work is not a cumulative record of the process of its making, as is Pollock's, but the result of a series of logical prior choices systematically carried out. The decisions that determine the visual outcome are projected verbally, as in music sounds are projected graphically on the score by the system of musical notation.

LeWitt has explained this in a caption for this book:
The wall is understood as an absolute space, just like the pages of a book. One is public, the other private. Lines, points, figures, etc., are located in these spaces by the use of words. The words are the paths to understanding of the location of the points. The points are verified by the words.

AT THE HEART OF CONCEPTUAL ART is the ambition to return to the roots of experience, to recreate the primary experience of symbolization uncontaminated by the attitudes attached to traditional visual modes, whether representational or abstract. For LeWitt, system was one means of achieving an art as free from previous stylistic associations as could be conceived at that moment.

Sol LeWitt began his career as a painter just at a moment when the possibility of painting at all was being profoundly questioned. Jackson Pollock, Barnett Newman, and Jasper Johns (among others) had seriously undermined the idea of a painting as a representative picture of the world projected onto a two-dimensional canvas that was, in effect, a window through which to look at the painter's clever illusion. From the Renaissance on, the space of that illusion had grown shallower. In the 1860s the Impressionists declared that a painting was in reality a two-dimensional surface with shapes arranged on it in a certain way. To emphasize the surface, Impressionists like Monet and Post-Impressionists like Seurat, breaking the paint stroke away from its description of objects, painted in myriad little strokes more or less evenly distributed on the surface of the canvas. By painting in this way they created a kind of dialogue between the three-dimensional object depicted and the two-dimensional surface of the canvas, emphasizing that the representation was only an illusion and the real object was the two-dimensional canvas. In the first years of the twentieth century the Cubists also questioned the illusion, breaking objects themselves into facets and planes to "fit" the fictive space of the illusion.

In the 1950s Jasper Johns had identified the tactile object in the Renaissance window with the canvas itself: instead of pictures of objects (specifically a flag) Johns made his image identical in size and shape with the canvas itself. If the primary illusion is tactile—that is to say, if objects are rendered on the two-dimensional plane with such descriptive clarity and physicality that they appear to us "so real we can touch them"—then Johns's identification of object and surface as if both were one and the same created the question of what was object and what was illusion. For painters following, it became a question of the identification of painting on the one hand with illusionism and on the other with objects, in a literal way.

Frank Stella, following clues inherent in Johns's work, made paintings whose inner structure was deduced from the edge of the canvas itself—an echo of the outer shape. He moved gradually into making shaped canvases based on geometric figures that generated complex internal structures. To Stella the important point was that the structure be nonrelational; relational meant balance, "You do something in one corner and balance it with something in the other."[13] The idea was to avoid "compositional effects," to have a sense of wholeness. Stella wanted in painting "only what was necessary to make a painting." He worked systematically and in numerically predetermined closed series. His paintings were made on stretchers deeper than usual; they looked like objects. Stella wanted to stress the surface, since his painting is

about surface. But he also said, "Any painting is an object, and anyone who gets involved enough in this finally has to face up to the objectness of whatever it is that he is doing. He is making a thing. . . . All I want anyone to get out of my paintings . . . is the fact that you can see the whole idea without any confusion. . . . What you see is what you see." This crisis about illusionism was also stated in terms of reduced means. Stella was explicit in his wish to get the sentiment out of painting and outspoken against drawing in painting as personal handwriting, seeing drawing as unnecessary to painting, complicating it and mitigating the quality of paint as paint.

For Sol LeWitt and for Donald Judd, as for several others, the issue became one of opening an alternative to painting. Judd (who wrote extensively in the middle 1960s and was one of the chief spokesmen for the group of artists that first came to general public attention in a group show called "Primary Structures" at the Jewish Museum in 1966) felt that the options within painting and sculpture were closed off. He wrote that both were identifiable forms with fairly definite qualities; the motivation was "to get clear of these forms." His objection to painting was that he didn't want to do again what had been done well enough already. He was referring to painters such as Jackson Pollock, Barnett Newman, Clyfford Still, Mark Rothko, Ad Reinhardt, and Kenneth Noland, who, it seemed to him, had already "established a singleness of format" in painting that, he wrote, was "only a beginning and [had] a better future outside of painting." The alternative seemed to be to make a work of art that was neither a painting nor a sculpture, but simply a three-dimensional art work. Stella's ideas about wholeness and nonrelational structures, carried out literally, were important (and probably the reason for the focus on Judd's and LeWitt's three-dimensions); however, Judd himself states the case against painting and sculpture as it had begun to seem around 1963 in a seminal essay written in 1965, "Specific Objects":

The main thing wrong with painting is that it is a rectangular plane placed flat against the wall. A rectangle is a shape itself; it is obviously the whole shape; it determines and limits the arrangement of whatever is on or inside of it Except for a complete and unvaried field of color or marks, anything placed on a rectangle and on a plane suggests something in and on something else, something in its surround . . . Fields are also usually not limited and they give the appearance of sections cut from something indefinitely larger . . . oil and canvas are familiar and, like the rectangular plane, have a certain quality and have limits. The quality is especially identified with art.[14]

His objections are pointed. Any painting, no matter how shallow the space or broad the field, will be illusionistic; paint itself is a material associated with art as illusionism. Art was to be totally new, divorced from illusionism, not "spatial." Painting was unavoidably spatial; if "sculptural," it was to be divorced from the traditional relational construction of sculpture.

The traditional relational structure of art is one in which the various elements are arranged in related groupings according to a dominant element, or master plan, to which they are subordinate. This arrangement is usually hierarchical, the range of elements variously subordinated to one another as well as to the overall plan. The new work, however, was to be whole, literal, singular in form, and nonrelational, although it could be composed additively or serially of equal parts. For LeWitt, since color was proper to painting—although attempts had been made to appropriate it for sculpture (Judd's work used color, but it was industrial color: the color of automobiles, not the color of painting)—color should be neutral, or basic white, because that was most visible, clearest.

At the same time, painters such as Robert Ryman were trying to escape the objectness of painting—its illusionism, as stated by Judd—by narrowing the stretcher and making the painting lie as flat against the wall as possible. Ryman painted systematically, using only one direction of brush stroke for each painting and eliminating color in favor of modulating the surface through paint facture. If painting was about surface, the idea was to stress surface by eliminating what was distracting and seemingly inappropriate to the surface itself.

This was a truly reductive idea of art. The reductive principle insofar as it had implied impersonal surface was already operational in the work of Pop artists such as Andy Warhol and Roy Lichtenstein. In sculpture, John Chamberlain had used hard-surface automobile parts in the early 1950s. Early Minimal work was projected according to simple systems with a basis in geometry. LeWitt's grid was implied in Cubism, intrinsic in Pollock, a basis for some of Johns's early work, and was explicit in the work of early rationalist painters such as Agnes Martin, whose pencil grids on painted canvas played a key role in the projection of the grid image that came to dominate the 1960s. Projected into three dimensions, the grid became the key to the rational placement of units in Minimal art. LeWitt himself mentions Martin's pencil grids as an important influence on his drawing, the final difference being that Martin confined herself to a format in which the grid hovered in a spatial surround on a canvas. The grid was one of the formal devices that proved most useful for implementing new work. Initially, however, what was more problematic was opening up the possibility of a new or different way of thinking about how to make art, and many ideas from very disparate sources were widely discussed by young artists. According to LeWitt, all of these combined to form a sort of "subconscious" reference material when it came to the actual making of the work.

Lawrence Alloway has suggested a number of these possible influences for LeWitt: Ad Reinhardt (already cited by Judd) and Constructivism. LeWitt recalls that Camilla Gray's book on Constructivism, *The Great Experiment: Russian Art 1863–1922* (1962), led to a widespread discussion of Constructivism around 1964. LeWitt read those Constructivist texts quoted in Camilla Gray's book. At this time he was also interested in Theo van Doesburg's work, in the De Stijl and Bauhaus movements, and in Vladimir Tatlin's *Monument to the IIIrd International*. He had the feeling that the work of the Russian Constructivist and Suprematist artists such as Rodchenko and Malevich, or even van Doesburg himself, was still too composed, that is, too hierarchically and centrifugally organized—unlike their pronouncements of what art ought to be. However, LeWitt did not think about these

things except as a kind of passing confirmation of his own rather different approach. Theo van Doesburg was one of the signers of a 1922 statement by the De Stijl group.[15] Specifically the statement called for a "monumental art of the present" that was to be compositionally decentralized; it renounced "subjective arbitrariness in the means of expression . . . plastic art must be a question not of 'artistic composition' but rather of 'problematic construction.'" In a statement of 1923 he went on: "What we demand of art is explicitness, and this demand can never be fulfilled if artists make use of individualized means. Explicitness can result only from discipline of means . . . discipline leads to the generalization of means." Van Doesburg called also for an objective system for making art: "To construct a new thing we need a new method."[16]

The basic Constructivist text was *The Realistic Manifesto,* written by the brothers Naum Gabo and Antoine Pevsner in Russia in 1920. Written in a visionary style, it announced the Constructivist break with the plastic tradition that had dominated Western art for "1000 years." It called for a new way to make art and attempted to bring the "archaic and useless" activity of art into alignment with modern technology and social revolution:

The realization of our perceptions of the world in the forms of space and time is the only aim of our pictorial and plastic art. In them we do not measure our works with the yardstick of beauty, we do not weigh them in pounds of tenderness and sentiments. The plumb-line in our hand, in a spirit as taut as a compass . . . we construct our work as the universe constructs its own, as the engineer constructs his bridges, as the mathematician his formula of the orbits . . . in painting we renounce color as a pictorial element . . . color is accidental and has nothing in common with the essence of a thing. We affirm the tone of a substance, i.e., its light absorbing material body as its only pictorial reality. We renounce in line its descriptive value . . . we affirm the line only as a direction of the static forces . . . we renounce volume . . . we affirm depth as the one form of space . . . we renounce in sculpture the mass as a sculptural element . . . we take four planes and we construct with them the same volume as four tons of mass. Thus we bring back to sculpture the line as a direction and in it we affirm depth as the one form of space.[17]

What seems most important in terms of Constructivism in work of the 1960s, aside from certain randomly selected specific ideas as reference, was the stimulus to an alternate way of thinking—a reminder of a tradition of art wholly different from the one then dominant. It seems to have been most useful as an aide to crystallizing ideas already in formation. However, to attempt to identify the complex of motivations at that time simply in terms of specific "influence," whether of ideas or individual personalities, is erroneous. By the 1960s the tradition of modernism was well established. LeWitt, Judd, Morris, and their peers were working within a network of established ideas and precedents—with shared experience. This experience operates within modern art as an available heritage. The question for them was to identify which elements or complex of elements of that tradition were useful—capable of reinvention and logical extension.

Among those who formed part of the complex of LeWitt's sources is Jasper Johns. Along with his profound questioning of the nature of illusionism Johns had also initiated a process

of rationalizing the making of art, reorganizing the internal structure of the work so that it was nonhierarchical. The flag was the first image that Johns used, then the target; but the alphabet and numbers, because their serial order is naturally nonhierarchical, were most successful. Johns arranged his numbers and alphabet letters on a grid, repeating them serially across and up and down in logical order. At the same time he reorganized and reordered the "fast and loose" brush stroke of Abstract Expressionism (in much the same way Seurat had reordered the freer brush stroke of Impressionism). The process is most apparent in Johns's graphic work, which he seems to use almost analytically in relation to the process of painting. Johns's nondescriptive line, used for building tone, is confined to specific areas and composed of small repeated gestures. The line itself is always seen as line even as it merges with other lines to build tone. LeWitt may have felt especially drawn to Johns's attitude about what was real, that is, what was knowable in terms of the work. Johns had expressed his attitude toward what was knowable as: "I used things the mind already knows. That gave me room to work on other levels." This attitude toward pregiven formats is echoed by LeWitt's decision to insist on having all the planning take place in advance, leaving room to work on the other levels. There is also a reflection of "things the mind already knows"[18] in LeWitt's use of "available" forms: cubes, squares, lines, circles, arcs. Johns had introduced the literal image, the literal object (in sculpture), and literal scale; LeWitt's work, or his intention for his work, is that it be literal. The literal image in Johns and in Pop art was figurative. LeWitt himself depends on line independent of figurative description, tone as opposed to color (in early work), nonhierarchical structure, serial order, and avoidance of climax; he denies the notion of a single masterpiece. Both establish a visual as well as conceptual continuity across mediums and disciplines, Johns by using the same image for two- and three-dimensional work, by returning constantly to the same image and by repeating the same work in several mediums and in two and three dimensions, and by making drawings after paintings of the same image (and in an interesting case of the originator being influenced, Johns now uses several mediums, oil, encaustic, gouache, serially within one painting). LeWitt had followed a course of rationalization that led first from painting into three dimensions to making "real," irreducible objects. Dissatisfaction with producing artifacts led him to analyze his own attitudes toward making art and led to a conceptualization of his own process that was more intellectually nuanced, flexible, and open-ended, even though couched in absolute terms.

DURING THE 1960s, as I have written elsewhere, drawing as a preliminary step to work in another medium—that is, "cutlery drawings," drawings of instructions to fabricators, working drawings—assumed a vital role. LeWitt's transfer of the conventional rendering of his after-the-fact drawings of structures to use as finished drawings is a concrete example of the direct transposition of an ancillary idea to independent, creative ends. The problem at the time was essentially one of how to produce a two-dimensional work that was as uncom-

promising illusionistically and compositionally as the three-dimensional structures. The link between three-dimensional and two-dimensional work was inherent in LeWitt's premise for *Serial Project No. 1, 1966.* The grid arrangement of that work had been posited on projecting a two-dimensional grid framework into three dimensions by laying it on the floor. Robert Morris noted that the connection between the two-dimensional and three-dimensional aspects of Minimal art was more causal than the simple notation of an idea might indicate.[19] He noted that the three-dimensional objects of Minimal art had been made from two-dimensional diagrams and the three-dimensional forms were actually constructed from flat, planar elements. To Morris, Minimal art's most "compelling" aspect was that it "mediated" between our knowledge of the relationships between two- and three-dimensional art; that is, it "balanced" our systems for the notation of ideas in two dimensions with the way in which we construct, deploy, and eventually see three-dimensional objects in depth. But as Morris pointed out, this kind of "mediation" worked only for fairly simple systems; more complex relationships destroyed the autonomy of objects, so that work that involved more complex instructions (more "information") became involved with flatter modes—whether it moved onto the wall (as wall drawings or word art) or onto the floor (as floor sculpture).

The projection of drawing as the major two-dimensional work of the late 1960s is established, then, more as a function of the discipline of drawing and the logical development of ideas within current work itself than as a "failure" of painting. But the position of drawing in the two preceding decades had been complex and ambiguous. Drawing itself had been in disrepute among the avant-garde for some time. Among Abstract Expressionist painters there had been the feeling that drawing, in the traditional sense of making preliminary pencil studies, was "Renaissance"; one did not draw, one painted. Jasper Johns was almost unique in drawing as constantly as he painted and in conceiving of his drawings as complete works of art (Oldenburg was just beginning to show his drawings). Rauschenberg had also begun to use drawing in a very important way, but it was subsumed for the most part in his painting.

The important objection to drawing had been that it was an acquired skill. As Peter Plagens has pointed out, "one paints, but one knows how to draw." Draftsmanship with all its academic baggage was instantly conjured by the word "drawing." But drawing, understood in a completely other sense, one more real and creative, had been in constant use and absolutely vital to the development of American art. Small paintings on paper and drawings with brush and ink were made during the 1950s, but drawing itself was part of the work process—incorporated into the finished work. However, the idea of "finish" itself in Abstract Expressionistic painting was problematic; it was a function of the intense subjectivity of the work—the painter as his own subject. The idea of finish in painting has become more fluid since the nineteenth century, when finish indeed meant "finished": cleaned and polished, with all traces of the struggle and of all the steps leading to the final work eliminated. Cézanne had been attacked

as "unfinished": his sketches were separate, preparatory works. They could look unfinished, fragmentary; in fact, they were valued as clues to both the artist's working process and his artistic temperament. Drawings have been traditionally valued in this sense. But the generation of Abstract Expressionists brought the issue of finish to a clear head in their work, and in doing so initiated a rethinking of the possibilities of drawing. If all the steps, all the struggle and thinking leading to a so-called finished work could be incorporated into that work, remaining a visible and vital part of that work—if a painting could be unfinished and "incomplete" in the sense that sketches are unfinished—then sketches and paintings could be afforded equal status, and drawing could, and did, cease to function merely as a step along the way to painting. (This subsuming of drawing was so successful that when studies did appear again in the 1960s it was as if they were a whole new discovery.)

The personal struggle, the biographic markings of the sketch, appear in the works of Jackson Pollock, Willem de Kooning, and Franz Kline as the source and subject of the work itself. These painters understood that drawing, freed from the limits of the preliminary, could generate independent works. In Pollock's mature work he subverts line to make painting, but it is in his black-and-white canvases of 1951–52 that he blows the scale of drawing right up to the monumental. Drawing in dripped black paint from one work to the next on a continuous strip of white canvas instead of a sketch pad, Pollock provides a series of drawings that rival paintings in their breadth of scale and ambition. They set the precedent for the scale of LeWitt's later wall drawings. For Pollock, line operates always in the most tenuous and delicate balance between the descriptive and nondescriptive functions of line—and for a brief time it breaks free of contour in Pollock's paintings. In contemporary drawing, the generation of autonomous line, the use of nondescriptive lines as modular units, and the compression of gesture are all formal devices inherent in these prior uses of gesture and line.

For them the incorporation of drawing into painting released a range of works in which there is little distinction between drawing and painting in terms of technique—in which finish is decided in subjective rather than objective terms. If the subject is the painter's psyche, there is no criterion for finish; the painting is as finished or unfinished as the painter's psyche from moment to moment—and the finished painting is the sum of the processes by which it is made.

Perhaps the greatest literary figure to use his own psyche as subject was a French contemporary of the Abstract Expressionists, Antonin Artaud. Artaud's ideas about theater eventually generated the first "happenings" in the United States and some of his ideas, though transposed dramatically, became important. For instance, Artaud totally excluded the idea of beauty. For him the work of art was a metaphor for consciousness; works of art were useless in themselves—only fragments—in relation to the "totality of consciousness."[20] Artaud's own work shows us that the ambition to keep projecting masterpieces cannot succeed in practice, that subjectivity itself undermines this idea. In painting it did not lead to work that was self-cancelling, but rather to work that tended

to modify its ambitions and look in different directions. To make drawing useful again the intense subjectivity had to be expunged and the distinctions between drawing and painting had to be reestablished. But the wholistic image and the autonomous, nondescriptive line became basic to the work that followed. LeWitt admired the Zen element of the work, the fast, free, expressive brush stroke, which was fluid, automatic, and clear—a good way to look at drawing—and it led him to look more at Oriental art.

The seeds of doubt had been sown even as the heroics of Abstract Expressionism demanded, one after the other, the mastery of consciousness. The idea of the masterpiece—the single great culminating work—had been steadily undermined. Doubt in a single statement had been implied in Johns's constant reworking of the same themes, and it was explicitly stated by Stella in his serial paintings.

WHAT INTERESTS LEWITT is the multiplicity of things, and his systems continued to multiply new ideas. The earliest wall drawings were dependent upon tonality; even color had been ultimately subsumed by tone. (His tonal fields in fact suggest a kind of relation to Color Field painting—they seem almost a direct response to Newman—but are probably in reality more related to large Pollock canvases such as *Number 1, 1948,* and *Autumn Rhythm.*) But LeWitt has taken up the use of color, as ground, for his recent wall drawings. Once again returning to basics, the three primary colors and black, LeWitt began to paint a single wall in each of the primary colors, drawing now on a colored ground.

In the first wall drawings white functioned as in traditional drawing, as the ground that reflects light through the overdrawing. The first "color"-ground wall drawing was in white chalk on a black-painted wall—a blackboard, in effect. Black functioned as the fourth absolute or final color; black is the opposite of white in that it represents the absence of light. The use of black as a negative led to the idea of color, and LeWitt began to use the colors red, yellow, and blue, plus black as grounds, drawing with white chalk. The first color-ground drawing of any size was for the Baltimore Museum in May 1975, *Lines from the Center of the Wall to Specific Points.* It was drawn in white chalk on a pencil grid on a yellow wall. A complete set of three wall drawings in color for the San Francisco Museum, *Lines to Points on a Grid* (July 1975) (figs. 260–262), reveals that he is interested wherever possible in maintaining the integrity of the complete sequence. One wall was red with white lines from the corners; the second, yellow with white lines from the center; the third, blue with white lines from the sides. All were drawn on a pencil grid. A drawing for The Museum of Modern Art in 1976 used black and superimposed all of these lines. In this exhibition LeWitt executed his first drawings using colored lines on a colored wall.

The color-ground drawings once again raise a question as to the location of the dividing line (if there is one) between drawing and painting. Can a work 33 × 17 feet, which totally dominates by means of color although its image is drawn, maintain an identity as a drawing? The fact that there are linear definitions within a work does not make it automatically a drawing. LeWitt's new color work raises a question

once again about the autonomy of various modes, but it is mooted in LeWitt's case in that his system is meant to operate on the "interchangeability" of media. If drawing can now be used to generate "painting," he has once again brought the two modes into the sort of alignment found in the work of Pollock, although on totally different terms.

This is not to say that there is not, however, an important distinction between the way drawn lines function and the way painted lines function in terms of the physical differences of the medium. Drawn lines remain distinct (and LeWitt has kept lines always distinct); fluid paint lines blend and melt into one another if the pigment of both is wet; if one is dry and one wet, they are still viscous and cover one another and they have the physical, three-dimensional properties of the paint, its weight and density. LeWitt's wall drawing retains the crisp, hard, flat-surfaced quality of a dry medium and of a line drawn with a hard tool and a straight edge.

To displace the idea of the master work is, in one sense, to displace the idea of the master (at least as a craftsman), in that his touch is no longer vital to the authenticity of the work. One condition of the master work has always been authenticity of touch; in drawing, authenticity of touch is equal to autobiography. In a brilliant article on LeWitt, Lawrence Alloway first noted the connection between LeWitt's work and the historical concept of *diségno*[21] (although LeWitt himself knew nothing of the concept). *Diségno*—the word embraces both design and drawing—in this sense is the same as drawing with "invention." That is, drawing is equated with the "engendering of" the idea or the form of things before and, even independent of, any concrete realization. This definition of *diségno,* in its pure form "idea" alone, is called *diségno interno.* It was thought of as the idea that exists in the mind of the creator prior to the act of creation. God the Father was its source; the idea was present in man's mind as a spark of the divine mind. A second meaning of *diségno* refers to the work itself. Both concepts have coexisted since the sixteenth century, although "ideas" have seldom been wholly divorced from their concrete realizations. For the sixteenth century, speculation about the dual nature of drawing produced a rationale about the relationship between art and nature. If *diségno* was the generating source of artistic representation, the human intellect "by virtue of its participation in God's ideational ability and similarity to the divine mind as such" proceeded in the same way in producing a work of art as nature did in producing reality. This led to the conclusion that there was "an objective correspondence between [the artists'] products and those of nature."[22]

Alloway pointed out that the notion of *diségno* as primarily ideational was an idea about drawing that placed "the artist at his most rigorously intellectual. In this sense drawing is the projection of the artist's intelligence in its least discursive form: line is the gist, the core of art." He went on to observe, "LeWitt's drawings propose a new relation between drawing as touch and drawing as intellectual context." LeWitt employs draftsmen for wall drawings and supplies instructions to do the work. They are always identified as having made the work. As long as he is in control he does not care whether or not he is the direct agent in the sense that his hand

is involved. He is not indifferent, however, to the visual quality of the work as it emerges. He is quite insistent, for instance in the first drawings, on clarity and reticence, and in that sense his drawings, hand-executed by individuals, have a great deal to do with sensuous touch—even though it may not be his. Questions of touch have been a persistent issue since Abstract Expressionism. Jackson Pollock's handprints appear in the margins of *Number 1, 1948;* Jasper Johns uses the imprint of his as his subject in his most important drawing, *Diver.* With each the issue becomes more about literally "touching" the surface plane, a question about touch and the nature of illusion, about the artist's presence in the picture. A LeWitt drawing is not established as a LeWitt through recognition of the artist's touch—the single signatory line that has been a legend since the time of the Greek master Appelles, whose hand, it was said, could be recognized even by a single line. Rather, as Alloway writes, "LeWitt demonstrates the possibility of drawing as pure ratiocination . . . control is not a matter of manual participation but rather of setting up a system within which the execution of his system can only produce a LeWitt." This is what makes a LeWitt capable of being repeated, redrawn more than once; the system for a single wall drawing is adaptable to a variety of spaces and pregiven conditions—it is open-ended.

LeWitt was anxious to avoid subjective decisions in order to remove the obstacle of ideas of quality (in the work itself) and in order to think in terms of kind. Therefore he made the initial intention more important than the execution. He wanted to concentrate on sensitivity of decision and so he made it a rule not to deviate from original decisions; he refused the idea of changing a work because it didn't look right. His view is that the same thing can look different on different days, one day right, one day wrong. He wanted to concentrate on the whole conception rather than on the day-to-day decisions.

LeWitt has written that drawings look different when done by different draftsmen. Those in which the instructions allow no individual decision as to placement look different because of different touch. Those in which the draftsman is left to decide on the placement of the lines within the system will look completely different each time there is a change of draftsman or location. The fact that this will happen is something that LeWitt finds interesting—and he finds these pieces more interesting than they would be if he drew them and redrew them, even with variations. It is one way of admitting chance into the work. Sometimes LeWitt likes the surprises, sometimes he doesn't, but he finds them equally interesting. The draftsman is, in any case, an "agent" not a surrogate for the artist.[23] LeWitt's attitude toward the draftsman's role was revealed in an introduction to an exhibition at the Pasadena Museum: "The draftsman and the wall enter a dialogue. The draftsman becomes bored but later through this meaningless activity finds peace or misery. The lines on the wall are the residue of this process. Each line is as important as each other line. All of the lines become one thing. The viewer of the lines can see only lines on the wall. They are meaningless. This is art.'[24]

Although this is offered as a deadpan joke, it is nevertheless a significant statement about LeWitt's own feeling about making art—how art looks to the artist on a day-to-day basis if he doesn't keep the larger issue in mind. Lines themselves have always been meaningless; LeWitt's strike at formalism is a deliberate reminder that it is always and has always been the idea that is important, even more than the emotion. Only the unifying idea that creates the structure of the work can make the work manifest. This precedes the content of any work; in LeWitt's case it is identical to the content.

On one level LeWitt asserts man as a rational, thinking being. On yet another level, LeWitt's art is in some way deeply ritualistic. The physical process of making the work, as well as its underlying conceptions, suggest this reading. The stylized work process described by David Shulman (footnote 23) is eventually forced on anyone trying to execute a LeWitt. LeWitt insists on an unemotional, almost perfunctory, execution of his work, and the tedium of the work process enforces almost automatic behavior according to preordained rules. The use of language as a systematic regulatory device for the work enforces a reading of LeWitt's work as ritualistic. Ritual is "a symbolic system of acts based on arbitrary rules"[25] just as "language is an arbitrary symbol system based on arbitrary rules." Ritual and verbal behavior in man exhibit "striking parallels." Drawing—art—itself is said by anthropologists to originate in ritual as part of performance rites—for instance, the shaman drawing in the sand while chanting and dancing. The purpose of ritual is to insure that the world works. Ritual has no connection with individual emotion; it is not expressionistic, but is a formalized cultural expression. Artaud cried with anguish to assert his individuality; Pollock, more subjective than LeWitt, also used his psyche as subject. That is no longer our style.

The 1960s started out with art that was self-assured and had a tendency toward public scale: work that was concrete and physically assertive of its own reality. Robert Morris described it as follows:

Large, open and had an impulse for public scale, was informed by a logic in its structure, sustained by a faith in the significance of abstract art and a belief in an historical unfolding of formal modes which was very close to a belief in progress. The art of that decade was one of dialogue: the power of the individual artist to contribute to public, relatively stable formats. . . . Midway into the seventies one energetic part of the art horizon has a completely different profile where the private replaces the public impulse. Space itself has come to have another meaning. Before it was centrifugal and tough, capable of absorbing monumental impulses. Today it is centripetal and intimate, demanding demarcation and enclosure. Deeply skeptical of experiences beyond the reach of the body, the more formal aspect of the work in question provides a place in which the perceiving self might take measure of certain aspects of its own physical existence. Equally skeptical of participating in any public enterprise, its other side exposes a single individual's limit in examining, testing, and ultimately shaping the interior space of the self.[26]

Morris, more subjective and physical than LeWitt would ever care to be, does, however, offer some suggestion as to the mood in which LeWitt's change from Minimal to Conceptual work took place. Morris's analysis describes the dual nature of LeWitt's work as it relates to both public and private

modes, ranging from public wall drawings to intimate books. Morris suggests an aspect of meaning that LeWitt refuses to discuss, letting the work stand for itself. But ultimately we ask for meaning, for relevance in terms of the world. I have already suggested that LeWitt's work is ritualistic—intended to ensure that the world works. In another place I have also compared LeWitt's wall drawings to *sinopie*—the underdrawings for late Medieval and Renaissance frescoes—also works that were drawn according to a system. I remarked on their relation to a new image of consciousness in relation to the art of the past (and I had in mind LeWitt's earliest wall drawings in particular):

The sinopie of frescoes have an affecting existence as fragments, totally and forever unfinished. Romanticism raised the fragmentary and unfinished to the level of a cult; the ultimate fragment was the segment of a line—once again signatory and revealing. LeWitt's wall drawings are finished, but in relation to the art of the past they are fragments; they end where art was accustomed to begin. Early works are essences. Like veils that threaten to dissolve before our eyes, to notice them at all demands attention. Fundamental to these works is their low level of perceptibility.[27]

The more assertive later work still offers relatively reduced emotional content. At first reticent in its assertions, LeWitt's later work is quicker to demand attention. Large in scale, LeWitt's wall drawings become segments—fragments—of the actual environment; but while the art takes up more of the space of the world, our reaction to it occurs much less in relation to the world and much more in a space somewhere in the "mind's eye." They impose on the public space a need to focus in, to close out the objects of the world that impinge on consciousness, in order to create a private space for contemplation. Too much information creates indifference; our problem is to see deeply. When everything looks alike or all things pretend to be equal, the sensibility loses the ability to make distinctions. LeWitt is very close to the bone in mimicking our apparent loss of individuality—in projecting an image of the world that is seemingly lacking in variety and narrow in its visual focus—but LeWitt asserts the multiplicity in apparently similar things. By asking us to focus on *kind,* he forces us to differentiate.

The Romantic sensibility had led us to believe that the only subject for art was the private fantasy, objectified by the artist. Surrealism freed the unconscious, and the automatic drawing of Surrealism, carried over into Abstract Expressionism, made the psyche itself a subject for art. We were offered the self incarnate in an anguished fight against growing uniformity; but we have now reached a situation in which even to think of the individual self amidst all the noise and leveling impact of interchangeable parts is difficult. If we cannot, as before, distinguish ourselves from other selves, we cannot believe in the psyche as subject anymore. What we are being offered is intelligence as a clue to differentiation, a new balance in which intuition in concert with rational ordering creates "a significant space" in which to recover our senses. "For art and philosophy there is no choice," Saul Bellow wrote; "if there is no significant space, there is no judgment, no freedom, we determine nothing for ourselves individually."[28] LeWitt's wall drawings, reduced to the "absolute" and addressed to our immediate perception rather than to our conventional responses, preserve the contemplative and rationalizing functions that were always the special privilege of drawing, asserting them as a real part of the world.

NOTES

1. Sol LeWitt, "Paragraphs on Conceptual Art," *Artforum* (New York), June 1967, pp. 79–80.
2. The Museum of Modern Art, Artist's Questionnaire. September 9, 1971.
3. Ibid.
4. Collection, The Museum of Modern Art.
5. Lawrence Alloway, "Sol LeWitt: Modules, Walls, Books," *Artforum* (New York), April 1975, pp. 38–45.
6. This instruction and all instructions for wall drawings following are from the list of Sol LeWitt wall drawings on file at the John Weber Gallery, New York.
7. Barbara Reise, "Sol LeWitt Drawings, 1968–69," *Studio International* (London), December 1969, p. 222.
8. John N. Chandler, "Tony Smith and Sol LeWitt: Mutations and Permutations," *Art International* (Lugano), September 1968, pp. 16–19.
9. Hans Rudolf Zeller, "Mallarmé and Serialist Thought" (trans. by Margaret Shenfield), *die Reihe,* no. 6 (Speech and Music), Theodore Presser Co. (Bryn Mawr, Pa.), 1960.

 "Mallarmé and Serialist Thought" is so dense with ideas and descriptions of Mallarmé's book and its correspondence to serial music, that its possible points of reference to LeWitt are too complex to be adequately summarized in a footnote. Very briefly, however, Mallarmé's basic poetic "dictum" was that "poems are made not of ideas but of words"—ordinary words "transposed" to take on new meanings. The transposition of words necessitated a structural design as a context. Mallarmé's book was a three-dimensional structure. The book was designed to be "performed" (read) in sections; it is the readers—agents—who activate various sections of the complex master-book. The book was divided into micro- and macrostructures, and the performance sequence could be regulated by given permutations within which there were areas of free choice. "The performer is in possession of keys to the work, as it were; by applying the rules of play either simultaneously or successively he opens the work up and puts together one of its possible configurations. . . . Giving performance the same status as composition meant, in the final analysis, taking account of its natural limitations in the compositional planning—the given wall for wall drawings, for instance." (It is also clear that LeWitt's references to the work—wall drawings—being performed like music is meant as an exact, not a casual, parallel.)

 Even the most superficial reading of the article suggests that it may well have been one of the most important sources for LeWitt's subsequent development of conceptually projected and organically integrated two- and three-dimensional art that, rather than taking as its model traditional ideas of sculptural or painterly form, grows out of the ideas of a rule-dominated structure *before* it is a painting or a sculpture or a drawing. This way of looking at the art object has some correspondences to

Constructivism, but is more radical in that it totally generalizes the visual elements involved and uses them after the fact of the pre-ruled structure. The work of art is seen as formed by a structural model that is verbally projected; or to put it the other way round, the Mallarmé article may have been instrumental in suggesting a work of art made of basic elements that could be exchange structurally, ad infinitum, within agreed rules—like building blocks or a tinker toy. The visual elements in LeWitt's work, this article would suggest, follow from the need to find the simplest elements with which to form a structure that would then fit the most elementary "minimal" description of a visual work of art. This work of art would then have structural correspondences with other disciplines—poetry, music. It would be a work that would also involve "performers."

10. Michel Leiris, "Conception and Reality in the Work of Raymond Roussel," trans. Kenneth Koch, *Art and Literature* (Lausanne), Summer 1964, pp. 27–39.

11. From an interview with Marcel Duchamp by James Johnson Sweeney, "Eleven Europeans in America," *Museum of Modern Art Bulletin* (New York), vol. 13, nos. 4–5, 1946, p. 20.

12. Chandler, "The Last Word in Graphic Art," *Art International* (Lugano), November 1968, pp. 25–28.

13. Bruce Glaser interview "Questions to Stella and Judd," broadcast on WBAI, New York, February 1964; subsequently edited by Lucy R. Lippard and published in *Art News* (New York), September 1966; reprinted in Gregory Battcock, ed., *Minimal Art: A Critical Anthology* (New York: Dutton), 1968, pp. 148–164.

14. Donald Judd, "Specific Objects," *Contemporary Sculpture: Arts Yearbook 8* (New York: Art Digest, Inc., 1965), pp. 74–82; reprinted in Gerd de Vries, ed., *On Art* (Cologne: DuMont Schauberg, 1974), pp. 148–64; reprinted in Kasser Koenig, ed., "The Nova Scotia Series Source Materials of the Contemporary Arts" *Donald Judd: Complete Writings 1959–1975*. (Halifax: The Press of the Nova Scotia College of Art and Design, 1975), pp. 181–189.

15. "Statement by the De Stijl Group," from *De Stijl* (Amsterdam), vol. V, no. 4, 1922; reprinted in Stephen Bann, ed., *The Tradition of Constructivism* (New York: The Viking Press), 1974, pp. 64–66.

16. Theo van Doesburg, "Elemental Formation," *G*, July 1923; reprinted in Bann, pp. 91–96.

17. Naum Gabo and Antoine Pevsner, *The Realistic Manifesto*, 1920; reprinted in Bann, pp. 5–11.

18. Quoted in Leo Steinberg, *Jasper Johns* (New York: Wittenborn), 1963.

19. Robert Morris, "Aligned with Nazca," *Artforum* (New York), October 1975, pp. 26–39.

20. Susan Sontag, ed., *Antonin Artaud: Selected Writings,* trans. Helen Weaver (New York: Farrar, Straus and Giroux), 1976.

21. Alloway, op. cit.

22. Erwin Panofsky, "Mannerism," *Idea: A Concept in Art Theory* (New York: Harper and Row), 1968, pp. 71–99. Originally published in German, 1924.

23. David Schulman, "First Person Singular—1: Bay No. 37," *The Art Gallery Magazine* (New York), April 1971, pp. 19–21. Employed by the Guggenheim Museum to execute a LeWitt drawing, artist David Shulman has recorded his working processes and reactions:

Lines, not short, not straight, crossing and touching, drawn at random, using four colors (yellow, black, red and blue) uniformly dispersed with maximum density covering the entire surface of the wall.

Started January 26, having no idea how long it would take to reach a point of maximum density. A very ambiguous point. Being paid $3.00 per hour, trying to let my financial needs have little effect on the amount of time I work. I begin the drawing working as random as possible. I had consulted with the museum carpenters to erect a simple scaffolding, allowing me total freedom to move across the surface of the wall beyond my reach and to avoid working in one area for any length of time. The

problem: to constantly change colors and keep the length of lines as "not short" as possible, which was the height and width of the wall. The museum did not come through with the scaffolding. I was exhausted after 3 days of working without the slightest intimation of density. Having only one mechanical pencil, even the energy expended changing leads had an accumulative tiring effect. Projecting the amount of lines drawn in the first 3 days into the time remaining to complete the drawing, I realized I was working at too slow a pace to reach a "maximum density." Wanting to complete the drawing myself, I pushed to get the lines down faster while keeping them as "not short" as "not straight" and as crossing, touching and random as possible. I decided to use one color at a time, and use that color until it reached a point I considered one-quarter "maximum density." Starting with yellow, the waxiest of the four colors, because it smears any color it's drawn over.

I covered the entire wall in 3 stages (one for each color) doing as much as I could sitting on the floor, as much as I could standing and reaching and the rest reached on a ladder. Each of the 3 has its own anatomical hardships, but has the greatest strain on my arm and shoulder. A strain which became the most important factor in determining how long I worked on the drawing each day (an average of 4½ to 5 hours a day for fourteen days). Signals of discomfort became an unconscious time clock determining when I would stop and step back from the drawing.

Walking up the ramp to look at the drawing from a distance provided momentary relief from the physical strains of the drawing. From a distance, each color had a swarming effect as it slowly worked its way across a portion of the wall. For each color, it was necessary to keep the pencil constantly rotating for an even thickness of line.

Using yellow on a predominantly blank white wall was visually exhausting. Keeping an even distribution of yellow was difficult because of the diffusion into the non-contrasting surface of the white wall and the overall blurred effect caused by staring at this diffused surface. Completing yellow, I had a very accurate idea how long it would take using an equal amount of each color to reach the desired density, thus enabling me to rest accordingly. Black was the next color. It often became the dominant color in other drawings. I wanted to keep it under as many colors as possible. There was no difficulty keeping an even dispersement of black. The next color was blue. The more dominant of the two remaining colors. It was difficult to keep the density of blue equal to black because the two colors look very much alike. The only way of keeping an even density of blue was by mentally isolating the area I was working in. The final color was red, to keep it evenly dispersed and equally dense to yellow, black, and blue, was too visually confusing. Mentally isolating an area was not enough. I found this by focusing my eyes beyond the surface of the wall. I would pick up only the lines I was drawing and visually block out all previously drawn lines. Something like playing an instrument in a band and audibly blocking out all sounds but your own.

The drawing in ways was paradoxical. The even density and dispersement of the lines took on a very systematic effect.

Once the individual difficulties of each color were determined, any thought as to how the lines were going down in relation to lines previously drawn gradually diminished until there was no conscious thought given to the lines being drawn. The lines began to put themselves down.

Doing the drawing I realized that totally relaxing my body was only one way of reaching a deep level of concentration. Another was in the mindless activity of doing the drawing. Keeping my body totally active in an almost involuntary way in a sense totally relaxed my mind. When my mind became relaxed, thoughts would flow at a smoother and faster pace.

24. In *Sol LeWitt*, Pasadena Art Museum, November 17, 1970–January 3, 1971.

25. (Ha. P.) "Ritual," *The Encyclopedia Britannica* (Chicago: The Encyclopedia Britannica, Inc.), 1974, Macropedia, vol. 15, pp. 863–867.

26. Morris, op. cit.

27. Bernice Rose, *Drawing Now* (New York: The Museum of Modern Art), 1976, p. 76.

28. Saul Bellow, "A World Too Much with Us," *Critical Inquiry* (Chicago), Autumn 1975, pp. 1–9.

LIST OF ILLUSTRATIONS

46. FLOOR STRUCTURE. 1965. Painted wood, 48 x 84 x 84 in (122 x 213.4 x 213.4 cm). Destroyed (P: unknown)

47. WALL PIECE ("Hockey Stick"). 1964. Painted wood, 66 x 12 x 2 in (167.6 x 30.5 x 5.1 cm). Collection Lucy R. Lippard, New York (P: Allyn Baum, New York)

48. WALL PIECE ("I"). 1965. Painted wood, 40 x 18 x 2 in (101.6 x 45.7 x 5.1 cm). Collection Paula Cooper, New York (P: Allyn Baum, New York)

49. WALL/FLOOR PIECE ("Three Squares"). 1966. Painted steel, each square 48 x 48 in (121.9 x 121.9 cm). Sperone Westwater Fischer, Inc., New York (P: Bevan Davies, New York)

50. WALL GRID (3 x 3). 1966. Painted wood, 71 x 71 x 7 in (180.3 x 180.3 x 17.8 cm). Collection Benar Venet, New York (P: Carles Fontseré, Paris)

51. WALL PIECE ("Bent Stick"). 1965. Painted wood, 2 x 2 x 72 in (5.1 x 5.1 x 182.9 cm). Destroyed (P: John D. Schiff, New York)

52. PROGRESSIVE SPIRAL. 1972. Painted wood, 33 x 29 x ½ in (83.8 x 73.6 x 1.3 cm). Galerie Yvon Lambert, Paris (P: unknown)

53. MODULAR WALL STRUCTURE 1968. Painted aluminum, 88½ x 88½ x 10 in (224.8 x 224.8 x 25.4 cm). Collection Virginia Dwan, New York (P: Akira Hagihara, New York)

54. MODULAR WALL PIECE WITH CUBE. 1965. Painted wood, 18 x 18 x 84 in (45.8 x 45.8 x 213.4 cm). Destroyed (P: Walter Russell, New York)

55. WALL STRUCTURE. 1969. Painted steel, 72 x 72 x 1½ in (182.9 x 182.9 x 3.8 cm). Private collection, Germany (P: Dorothee Fischer, Düsseldorf)

56. WALL STRUCTURE. 1969. Painted wood, 6 ft 4⅜ in x 16¾ in x 1⅝ in (194 x 42.5 x 4 cm). Collection Daniella Dangoor, London (P: André Morain, Paris)

57. WALL STRUCTURE. 1976. Aluminum, 76⅜ x 76⅜ x 1⅝ (194 x 194 x 4 cm). Whereabouts unknown (P: unknown)

58. WALL STRUCTURE. 1972. Painted steel, 76 x 76 x 1½ in (193 x 193 x 3.8 cm). Collection Babette Neuberger, New York (P: Walter Russell, New York)

59. WALL STRUCTURE. 1972. Painted steel, 76 x 76 x 1½ in (193 x 193 x 3.8 cm). Konrad Fischer Gallery, Düsseldorf (P: Walter Russell, New York)

60–62. THREE DRAWINGS FOR PAINTED WOOD WALL STRUCTURES. 1977. Pen and ink on vellum, each 15 x 19 in (38 x 48.2 cm). Collection Martin Visser, Bergeyk, The Netherlands

63. MODULAR FLOOR STRUCTURE. 1966. Painted wood, 25¼ x 141½ x 141½ in (64.2 x 359.5 x 359.5 cm). Destroyed (P: John D. Schiff, New York)

64. DOUBLE MODULAR CUBE. 1966. Wood, 108 x 55 x 55 in (274.4 x 139.8 x 139.8 cm). Destroyed (P: John D. Schiff, New York)

65. MODULAR CUBE/BASE. 1968. White painted steel, cube 19⅝ x 19⅝ x 19⅝ in (49.9 x 49.9 x 49.9 cm); base 1 x 58½ x 58½ in (2.5 x 148.6 x 148.6 cm). Private collection, New York (P: Akira Hagihara, New York)

66. FLOOR/WALL GRID. 1966. Painted wood, 108 x 108 x 33 in (274.3 x 274.3 x 83.8 cm). Collection Virginia Dwan, New York (P: John D. Schiff, New York)

67. CUBE/BASE. 1969. Painted steel, multiple edition of 25, cube 3½ x 3½ x 3½ in (9 x 9 x 9 cm); base 10 x 10 x ¼ in (25.5 x 25.5 x .6 cm). (P: Walter Russell, New York)

68. CUBIC MODULAR FLOOR PIECE. 1965. Baked enamel on steel, 92 x 110 x 20 in (233.7 x 279.4 x 50.8 cm). Courtesy John Weber Gallery, New York (P: Walter Russell, New York)

69. MODULAR CUBE. 1966. Painted aluminum, 60 x 60 x 60 in (152.4 x 152.4 x 152.4 cm). Art Gallery of Ontario, Toronto (P: Norman Goldman, New York)

70. CUBE STRUCTURE BASED ON FIVE MODULES. 1971–74. Painted wood, 19½ x 33¾ x 33¾ in (49.5 x 85.7 x 85.7 cm). Charles Kriwin Gallery, Brussels (P: Sadayuki Kato, Tokyo)

71. CUBE STRUCTURE BASED ON FIVE MODULES. 1971–74. Painted wood, 14¾ x 14¾ x 24 in (37.5 x 37.5 x 61 cm). Louisiana Museum, Humlebaek, Denmark (P: Sadayuki Kato, Tokyo)

72–75, 77, 79–82, 84. CUBE STRUCTURES BASED ON FIVE MODULES. 1971–74. Painted wood, 24½ x 24¼ x 24¼ in (62.2 x 61.6 x 61.6 cm) Whereabouts unknown (P: Sadayuki Kato, Tokyo)

76, 78, 83. (Second row, right; third row, left of center; bottom row, right of center) CUBE STRUCTURES BASED ON FIVE MODULES. 1971–74. Painted wood, 24½ x 24¼ x 24¼ in (62.2 x 61.6 x 61.6 cm). Charles Kriwin Gallery, Brussels (P: Sadayuki Kato, Tokyo)

85–89. CUBE STRUCTURES BASED ON FIVE MODULES. 1971–74. Painted wood, 24¼ x 24¼ x 48 in (61.6 x 61.6 x 122 cm). National Gallery of Scotland, Edinburgh (P: Akira Hagihara, New York)

90. CUBE STRUCTURE BASED ON FIVE MODULES. 1971–74. Painted wood, 24¼ x 33 x 29 in (61.6 x 83.8 x 73.7 cm). National Gallery of Scotland, Edinburgh (P: Akira Hagihara, New York)

91–96, 98–99. CUBE STRUCTURES BASED ON FIVE MODULES. 1971–74. Painted wood, 24¼ x 24¼ x 24¼ in (61.6 x 61.6 x 61.6 cm). Whereabouts unknown (P: Sadayuki Kato, Tokyo)

97. (Bottom left) CUBE STRUCTURE BASED ON FIVE MODULES. 1971–74. Painted wood, 24¼ x 24¼ x 24¼ in (61.6 x 61.6 x 61.6 cm). Collection Salvatore Ala, Milan (P: Sadayuki Kato, Tokyo)

100. (Bottom right) CUBE STRUCTURE BASED ON FIVE MODULES. 1971–74. Painted wood, 24¼ x 24¼ x 24¼ in (61.6 x 61.6 x 61.6 cm). Collection Ann Gerber, Seattle (P: Sadayuki Kato, Tokyo)

101–103, 105, 107–109, 112, 114–115. CUBE STRUCTURES BASED ON NINE MODULES. 1976–77. Painted wood, 43¼ x 43¼ x 43¼ in (109.8 x 109.8 x 109.8 cm). Courtesy John Weber Gallery, New York (P: Akira Hagihara, New York)

104. (p. 20, center left) CUBE STRUCTURE BASED ON NINE MODULES. 1976–77. Painted wood, 43¼ x 43¼ x 43¼ in (109.8 x 109.8 x 109.8 cm). Museum Boymans Van Beuningen, Rotterdam, The Netherlands (P: Akira Hagihara, New York)

106. (p. 20, center right) CUBE STRUCTURE BASED ON NINE MODULES. 1976–77. Painted wood, 43¼ x 43¼ x 43¼ in (109.8 x 109.8 x 109.8 cm). Smith College Museum of Art, Northampton, Mass. (P: Akira Hagihara, New York)

110. (p. 21, top left) CUBE STRUCTURE BASED ON NINE MODULES. 1976–77. Painted wood, 43¼ x 43¼ x 43¼ in (109.8 x 109.8 x 109.8 cm). Collection Mr. and Mrs. Morton Neumann, Chicago (P: Akira Hagihara, New York)

111. (p. 21, top center) CUBE STRUCTURE BASED ON NINE MODULES. 1976–77. Painted wood, 43¼ x 43¼ x 43¼ in (109.8 x 109.8 x 109.8 cm). Detroit Institute of Arts (P: Akira Hagihara, New York)

113. (p. 21, center left) CUBE STRUCTURE BASED ON NINE MODULES. 1976–77. Painted wood, 43¼ x 43¼ x 43¼ in (109.8 x 109.8 x 109.8 cm). Musée d'Art et d'Histoire, Geneva, Switzerland (P: Akira Hagihara, New York)

116. (p. 21, bottom left) CUBE STRUCTURE BASED ON NINE MODULES. 1976–77. Painted wood, 43¼ x 43¼ x 43¼ in (109.8 x 109.8 x 109.8 cm). Collection Robert Orton, Cincinnati (P: Akira Hagihara, New York)

117. *(p. 21, bottom center)* CUBE STRUCTURE BASED ON NINE MODULES. 1976–77. Painted wood, 43¼ x 43¼ x 43¼ in (109.8 x 109.8 x 109.8 cm). Weatherspoon Art Gallery, University of North Carolina, Greenboro, N.C. (P: Akira Hagihara, New York)

118. *(p. 21, bottom right)* CUBE STRUCTURE BASED ON NINE MODULES. 1976–77. Painted wood, 43¼ x 43¼ x 43¼ in (109.8 x 109.8 x 109.8 cm). Courtesy John Weber Gallery, New York (P: John A. Ferrari, New York)

119. LARGE MODULAR CUBE. 1969. Baked enamel on steel, 63 x 63 x 63 in (160 x 160 x 160 cm). Emanuel Hoffman Foundation, Kunstmuseum Basel (P: Kunstmuseum Basel)

120. THREE-PART MODULAR CUBE. 1969. Steel, 63 x 63 x 177 in (160 x 160 x 445.6 cm). Collection P. Agrati, Milan (P: Korn, Krefeld)

121. DOUBLE MODULAR CUBE. 1969. Steel, 120 x 63 x 63 in (304.8 x 160 x 160 cm). Collection Virginia Dwan, New York (P: Akira Hagihara, New York)

122. THREE-PART MODULAR CUBE. 1969. Steel, 63 x 120 x 120 in (160 x 304.8 x 304.8 cm). Louisiana Museum, Humlebaek, Denmark (P: Frank J. Thomas, Los Angeles)

123. FOUR-PART MODULAR CUBE. 1975. Steel, 120 x 120 x 120 in (304.8 x 304.8 x 304.8 cm). Courtesy John Weber Gallery, New York (P: Akira Hagihara, New York)

124. FOUR-PART MODULAR CUBE (Square). 1969. Steel, 63 x 120 x 120 in (160 x 304.8 x 304.8 cm). Courtesy John Weber Gallery, New York (P: Akira Hagihara, New York)

125. FOUR-PART MODULAR CUBE (Corner). 1974. Wood, 10 x 10 x 10 in (25.4 x 25.4 x 25.4 cm). San Francisco Museum of Modern Art (P: Akira Hagihara, New York)

126. EIGHT-PART MODULAR CUBE. 1976. Baked enamel on aluminum, 10 ft 6 in x 10 ft 6 in x 10 ft 6 in (320.1 x 320.1 x 320.1 cm). Courtesy John Weber Gallery, New York (P: Akira Hagihara, New York)

127. SIX-PART MODULAR CUBE. 1976. Baked enamel on aluminum, 10 ft x 15 ft 6 in x 15 ft 6 in (304.8 x 411.5 x 411.5 cm). Courtesy John Weber Gallery, New York (P: Akira Hagihara, New York)

128. DRAWING FOR SEVEN STRUCTURES. 1977. Pen and ink on tracing paper, 15⅛ x 16½ in (38.3 x 41.8 cm). Private collection, courtesy New Britain Museum of American Art, New Britain, Conn. (P: unknown)

129. SERIAL PROJECT NO. 1 (ABCD). 1966. Announcement for exhibition, Dwan Gallery, Los Angeles, 1967.

130. SERIAL PROJECT NO. 1 (ABCD). 1966. Steel, 20⅛ in x 6 ft 6¾ in x 6 ft 6¾ in (51 cm x 2 m x 2m). Whereabouts unknown (P: Leonardo Bezzola, Bätterkinden, Switzerland)

131. ALL THREE-PART VARIATIONS ON THREE DIFFERENT KINDS OF CUBES. 1969. Pen and ink, pencil, 29 x 23 in (73.5 x 58.4 cm). Collection Donald Judd, New York (P: Robert E. Mates and Paul Katz, New York)

132. 47 THREE-PART VARIATIONS ON THREE DIFFERENT KINDS OF CUBES. 1967. Aluminum, 45 x 300 x 195 in (104.3 x 762 x 495.3 cm). Destroyed (P: Walter Russell, New York)

133. SEVEN-PART VARIATIONS ON TWO DIFFERENT KINDS OF CUBES. 1968. Pen and ink, pencil. 18½ x 18½ in (47 x 47 cm) Gloria Cortella, Inc., New York (P: Robert E. Mates and Paul Katz, New York)

134. SEVEN-PART VARIATIONS ON TWO DIFFERENT KINDS OF CUBES (Small version). 1968. Polystyrene, 9 x 23 x 23 in (22.9 x 58.5 x 58.5 cm). Paula Cooper Gallery, New York (P: Walter Russell, New York)

135. MUYBRIDGE I (Schematic Representation). 1964. Painted wood with ten compartments, each 10¾ x 9⅝ x 9⅝ in (27.3 x 24.5 x 24.5 cm), containing photographs by Barbara Brown, Los Angeles, and flashing lights, 10¾ x 96 x 9⅝ in (27.3 x 243.9 x 24.5 cm). Private collection, courtesy Wadsworth Atheneum, Hartford (P: unknown)

136. FIVE BOXES WITH STRIPES IN FOUR DIRECTIONS. 1972. Painted aluminum, each 80 x 40 x 40 in (203.2 x 101.6 x 101.6 cm). Collection S. Perelstein, Antwerp (P: Kunsthalle Bern)

137. FOUR-PART MODULAR WALL SERIES. 1976. Painted brass, each part 38 x 38 x 38 in (96.5 x 96.5 x 96.5 cm). Konrad Fischer Gallery, Düsseldorf (P: Dorothee Fischer, Düsseldorf)

138. PROGRESSIVE COLORS ON FOUR WALLS. 1970. Colored paper, one room, approximately 12 x 30 x 30 ft (365.8 x 914.4 x 914.4 cm). Private collection, courtesy Wadsworth Atheneum, Hartford (P: Eizaburō Hara, Tokyo)

139. CUBES WITH HIDDEN CUBES. 1977. Baked enamel on aluminum, 24⅞ x 74½ in x 31 ft 8 in (63 x 189 x 965 cm). Collection Friedrich E. Rentschler, Laupheim, West Germany (P: Doris Quarella, Zollikerberg, Switzerland)

140. CUBES WITH HIDDEN CUBES. 1968. Pen and ink, 12¼ x 25¼ in (31.2 x 64.2 cm). Gloria Cortella, Inc., New York (P: unknown)

141. CUBES WITH HIDDEN CUBES (Working Drawing). 1968. Pen and ink, 8½ x 11 in (21.6 x 28 cm). Private collection, courtesy New Britain Museum of American Art, New Britain, Conn. (P: Walter Russell, New York)

142. VARIATIONS OF INCOMPLETE OPEN CUBES (Working Drawing). 1973. Pen and ink, colored pencils, 8½ x 11 in (21.6 x 28 cm). Private collection, courtesy New Britain Museum of American Art, New Britain, Conn.

143. VARIATIONS OF INCOMPLETE OPEN CUBES (Schematic Drawing). 1974. Pen and ink, 16 x 16 in (40.6 x 40.6 cm). Private collection, courtesy New Britain Museum of American Art, New Britain, Conn.

144. VARIATIONS OF INCOMPLETE OPEN CUBES. 1974.

145. FIVE CUBES/TWENTY-FIVE SQUARES (Sides Touching). 1977. Plastic, each cube 6 x 6 x 6 in (15.2 x 15.2 x 15.2 cm); base 1 x 33 x 33 in (2.5 x 83.8 x 83.8 cm). Private collection, courtesy Wadsworth Atheneum, Hartford (P: Akira Hagihara, New York)

146. FIVE CUBES/TWENTY-FIVE SQUARES (Corners Touching). 1977. Plastic, each cube 6 x 6 x 6 in (15.2 x 15.2 x 15.2 cm); base 1 x 33 x 33 in (2.5 x 83.8 x 83.8 cm). Private collection, courtesy Wadsworth Atheneum, Hartford (P: Akira Hagihara, New York)

147. LINES IN FOUR DIRECTIONS, EACH IN A QUARTER OF A SQUARE. 1969. Pen and ink, 8 x 8 in (20.3 x 20.3 cm). Private collection (P: unknown)

148. LINES IN FOUR DIRECTIONS, SUPERIMPOSED PROGRESSIVELY, EACH IN A QUARTER OF A SQUARE. 1969. Pen and ink, 8 x 8 in (20.3 x 20.3 cm). Private collection (P: unknown)

149. LINES IN FOUR DIRECTIONS, SUPERIMPOSED. 1971. Pen and ink, 14 x 14 in (35.5 x 35.5 cm). Collection John and Kay Weber, New York (P: Robert E. Mates and Paul Katz, New York)

150. COMPOSITE: LINES IN FOUR DIRECTIONS IN SINGLE, DOUBLE, TRIPLE, AND QUADRUPLE COMBINATIONS. 1969. Pen and ink, 14 x 14 in (35.6 x 35.6 cm). Collection Hanne Darboven, Hamburg (P: unknown)

151. FOUR BASIC KINDS OF STRAIGHT LINES AND ALL THEIR COMBINATIONS IN FIFTEEN PARTS. 1969. Pen and ink, each part 8 x 8 in (20.3 x 20.3 cm)

152–155. DRAWING SERIES I, II, III, IIII. 1969–70. Pen and ink, each 12 x 12 in (30.5 x 30.5 cm). Whereabouts unknown (P: Walter Russell, New York)

156. BOXES WITH DRAWING SERIES I, II, III, IIII. 1970. Pencil on painted aluminum, each box 6 x 4 x 4 ft (172.9 x 122 x 122 cm). *Left:* Collection Giuseppe Panza di Biumo, Milan. *Right:* Paula Cooper Gallery, New York (P: Walter Russell, New York)

157. VERTICAL AND HORIZONTAL LINES. 1970. Pen and ink, 13¾ x 10¼ in (35 x 26 cm). Collection Ruth Vollmer, New York (P: Robert E. Mates and Paul Katz, New York)

158. WALL DRAWING from DRAWING SERIES I, II, III, IIII. 1968. Pencil, two parts, each part 4 x 4 ft (122 x 122 cm). Collection Charles Saatchi, London (P: Walter Russell, New York)

159. WALL DRAWING from DRAWING SERIES I, II, III, IIII. 1968. Pencil, two parts, each part 4 x 4 ft (122 x 122 cm). Collection Charles Saatchi, London (P: Walter Russell, New York)

160. WALL DRAWING USING VERTICAL AND TWO DIAGONAL LINE DIRECTIONS. 1969. Pencil, 39⅜ in x 32 ft (1 x 15 m). Collection Giuseppe Panza di Biumo, Milan (P: Dorothee Fischer, Düsseldorf)

161. PLAN FOR WALL DRAWING, PAULA COOPER GALLERY, NEW YORK. 1969. Pen and ink, pencil, 20⅞ x 20¾ in (53 x 52.7 cm). The Museum of Modern Art, New York. D. S. and R. H. Gottesman Foundation (P: James Mathews, New York)

162. WALL MARKINGS. 1968. Pen and ink, ca. 16 x 16 in (40.6 x 40.6 cm). Lost (P: Walter Russell, New York)

163. WALL DRAWING. 1969. Pencil. Courtesy John Weber Gallery, New York (P: Shunk-Kender, New York)

164. STRAIGHT LINES IN FOUR DIRECTIONS, SUPERIMPOSED (Detail of Wall Drawing). 1969. Pencil, 12 ft x 26 ft 9½ in (365.8 x 816.7 cm). The Museum of Modern Art, New York. Purchase. (P: Kate Keller, New York)

165. SIX-PART COLOR COMPOSITE WITH TWO COLORS IN EACH PART. 1970. Pen and colored ink, 18¾ x 18¾ in (47.6 x 47.6 cm). Collection Dorothy and Herbert Vogel, New York (P: Kate Keller, New York)

166. ALL SINGLE, DOUBLE, TRIPLE, AND QUADRUPLE COMBINATIONS OF LINES IN FOUR DIRECTIONS IN ONE-, TWO-, THREE-, AND FOUR-PART COMBINATIONS. 1969. Pen and ink, 14¾ x 19⅝ in (37.5 x 49.9 cm). Collection Dr. Luca A. Dosi-Delfini, New York

167. ALL SINGLE, DOUBLE, TRIPLE, AND QUADRUPLE COMBINATIONS OF LINES AND COLOR IN ONE-, TWO-, THREE-, AND FOUR-PART COMBINATIONS. 1970. Pen and colored ink, 20⅛ x 35½ in (51 x 90 cm). Collection Mr. and Mrs. M. Boulois, Paris (P: David Allison, New York)

168. PLAN FOR WALL DRAWING, VISSER HOUSE, BERGEYK, HOLLAND. 1970. Pen and colored ink, 14⅛ x 20⅛ in (35.7 x 51.1 cm). Private collection, courtesy New Britain Museum of American Art, New Britain, Conn. (P: Stedelijk Museum, Amsterdam)

169. SUCCESSIVE ROWS OF HORIZONTAL, STRAIGHT LINES FROM TOP TO BOTTOM, AND VERTICAL, STRAIGHT LINES FROM LEFT TO RIGHT. 1972. Pen and ink, 14⅝ x 14⅝ in (37 x 37 cm). Collection Dr. and Mrs. Lorenzo Bonomo, Bari, Italy (P: Kate Keller, New York)

170. ALL THREE-PART COMBINATIONS OF LINES IN FOUR DIRECTIONS (HORIZONTAL, VERTICAL, DIAGONAL RIGHT, AND DIAGONAL LEFT) IN THREE COLORS (YELLOW, RED, AND BLUE). 1975. Pen and colored ink, pencil on tracing paper, 18⅛ x 24 in (45.9 x 60.8 cm). Collection Giuseppe Panza di Biumo, Milan (P: Kate Keller, New York)

171. COME AND GO. 1969. Pen and ink, 18 x 22¼ in (45.7 x 56.5 cm). Private collection, courtesy New Britain Museum of American Art, New Britain, Conn.

172. FOUR-COLOR DRAWING. 1970. Pen and ink, 14 x 10½ in (30.5 x 26.7 cm). Private collection, courtesy New Britain Museum of American Art, New Britain, Conn. (P: Kate Keller, New York)

173. LINES NOT SHORT, NOT STRAIGHT, CROSSING AND TOUCHING (Wall Drawing). 1971. Colored pencils. Collection Dorothy and Herbert Vogel, New York (P: unknown)

174. LINES NOT LONG, NOT STRAIGHT, NOT TOUCHING (Detail of Wall Drawing). 1971. Colored pencils. Courtesy John Weber Gallery, New York (P: Robert E. Mates and Paul Katz, New York)

175. VERTICAL LINES, NOT STRAIGHT, NOT TOUCHING. 1977. Pen and ink, 14¾ x 13¼ in (37.5 x 33.7 cm). Private collection, courtesy New Britain Museum of American Art, New Britain, Conn.

176. SCRIBBLE DRAWING. 1970. Pen and colored ink, pencil, 18⅛ x 6⅛ (46 x 15.4 cm). Collection Dorothea Rockburne, New York (P: Mali Olatunji, New York)

177. STRAIGHT LINES, 24 CM LONG, NOT TOUCHING (Detail of Wall Drawing). 1970. Pencil. Courtesy Galerie Yvon Lambert, Paris (P: André Morain, Paris)

178. STRAIGHT LINES, SHORTER THAN 24 CM, NOT TOUCHING (Detail of Wall Drawing). 1970. Pencil. Courtesy Galerie Yvon Lambert, Paris (P: André Morain, Paris)

179. LINES NOT STRAIGHT, NOT TOUCHING, DRAWN ON A BRICK WALL (Detail of Wall Drawing). 1971. Pencil. Collection Lucy R. Lippard, New York (P: Robert E. Mates and Paul Katz, New York)

180. WITHIN THE SIX-INCH SQUARES, STRAIGHT LINES FROM EDGE TO EDGE USING YELLOW, RED, AND BLUE PENCILS (Wall Drawing). 1971. Pencil. Courtesy Lisson Gallery, London (P: unknown)

181. LINES CONNECTING ARCHITECTURAL POINTS (Wall Drawing). 1970. Pencil. Courtesy Galleria Sperone, Turin (P: unknown)

182. LINES CONNECTING ARCHITECTURAL POINTS (Wall Drawing). 1970. Pencil. Courtesy Galleria Sperone, Turin (P: Rampazzi, Turin)

183. FROM THE WORD(S) "ART"; BLUE LINES TO FOUR CORNERS, GREEN LINES TO FOUR SIDES, AND RED LINES BETWEEN THE WORDS. 1972. Pen and colored ink on printed page, 8⅝ x 9 in (21.8 x 22.8 cm). Private collection, courtesy New Britain Museum of American Art, New Britain, Conn. (P: Kate Keller, New York)

184–187. TEN THOUSAND LINES, ONE INCH LONG, EVENLY SPACED ON SIX WALLS EACH OF DIFFERING AREA (Four Details of Wall Drawing). 1972. Pencil. Courtesy John Weber Gallery, New York (P: Sadayuki Kato, Tokyo)

188. TEN THOUSAND LINES, FIVE INCHES LONG, WITHIN AN AREA OF 6¾ x 5½ INCHES. 1971. Pencil, 9½ x 9½ in (24.2 x 24.2 cm). Private collection, courtesy New Britain Museum of American Art, New Britain, Conn. (P: unknown)

189. TORN PAPER PIECE. R 1. 1971. Paper, ca. 12 x 12 in (30.5 x 30.5 cm). Private collection, Italy (P: Giorgio Colombo, Milan)

190. FOLDED PAPER PIECE. 1969. Paper, ca. 12 x 12 in (30.5 x 30.5 cm). Whereabouts unknown (P: unknown)

191. SQUARE WITH UPPER LEFT CORNER TORN OFF. R 748. 1977. Paper, 3½ x 3½ in (8.7 x 8.7 cm). Private collection, courtesy New Britain Museum of American Art, New Britain, Conn.

192. SQUARE WITH RIGHT SIDE TORN OFF. R 749. 1977. Paper, 3½ x 3½ in (8.7 x 8.7 cm). Private collection, courtesy New Britain Museum of American Art, New Britain, Conn.

193. ALTERNATE PARALLEL, STRAIGHT, NOT-STRAIGHT, AND BROKEN LINES. 1973. Pen and ink, 11¼ x 11¼ in (28.6 x 28.6 cm). Courtesy John Weber Gallery, New York

194. ALTERNATE PARALLEL, STRAIGHT, NOT-STRAIGHT, AND BROKEN LINES OF RANDOM LENGTH, FROM THE LEFT SIDE OF THE PAGE.

1972. Pen and ink, 11 x 11 in (28 x 28 cm). Courtesy John Weber Gallery, New York (P: unknown)

195. PARALLEL, HORIZONTAL, BROKEN LINES OF RANDOM LENGTH FROM THE LEFT AND RIGHT SIDES OF THE PAGE. 1972. Pen and ink, 10 x 10 in (25.4 x 25.4 cm). Courtesy John Weber Gallery, New York (P: unknown)

196. PARALLEL, STRAIGHT, HORIZONTAL LINES ON THE LEFT; PARALLEL, STRAIGHT, VERTICAL LINES ON THE RIGHT. 1972. Pen and ink, 11½ x 11½ in (29.3 x 29.3 cm). Courtesy John Weber Gallery, New York (P: unknown)

197. CIRCLES, GRIDS, ARCS FROM FOUR CORNERS AND FOUR SIDES. 1972. Pen and ink, 14⅝ x 14⅝ in (37.1 x 37.1 cm). Collection Dr. and Mrs. Lorenzo Bonomo, Bari, Italy

198. CIRCLES, GRIDS, ARCS FROM FOUR CORNERS AND SIDES (Detail of Wall Drawing). 1973. Pencil. Kunstmuseum Basel (P: Giorgio Piredda, Rome)

199. ARCS FROM TWO OPPOSITE SIDES OF THE WALL (Wall Drawing). 1971. Pencil, 9 x 14 ft (213.5 x 426.8 cm). Collection Dr. and Mrs. Lorenzo Bonomo, Bari, Italy (P: Lucarini, Spoleto)

200. ARCS FROM ONE CORNER. 1972. Pen and ink, pencil, 14⅝ x 14⅝ in (37.1 x 37.1 cm). Collection Dr. and Mrs. Lorenzo Bonomo, Bari, Italy

201. CIRCLES AND GRID. 1972. Pen and ink, 14⅝ x 14⅝ in (37.1 x 37.1 cm)

202. ARCS FROM FOUR CORNERS AND FOUR SIDES. 1972. Pen and ink, 14⅝ x 14⅝ in (37.1 x 37.1 cm)

203. CIRCLES, GRIDS, AND ARCS FROM TWO OPPOSITE SIDES. 1972. Pen and ink, 14⅝ x 14⅝ in (37.1 x 37.1 cm)

204. CIRCLES. 1971. Pen and ink, pencil, 16 x 16 in (40.6 x 40.6 cm). Private collection (P: Kate Keller, New York)

205. CIRCLES (Wall Drawing). 1971. Pencil, 8 x 9 ft (244 x 274.4 cm). Collection Dr. and Mrs. Lorenzo Bonomo, Bari, Italy (P: Lucarini, Spoleto)

206. STRAIGHT AND NOT-STRAIGHT LINES. 1972. Pen and ink, one sheet with no. 207: 13⅞ x 15½ in (34.8 x 39.4 cm). Stedelijk Museum, Amsterdam

207. ARCS FROM CORNERS AND SIDES. 1972. Pen and ink, one sheet with no. 206: 13⅞ x 15½ in (34.8 x 39.4 cm). Stedelijk Museum, Amsterdam

208. LINES AND ARCS. 1972. Pen and ink, 13¾ x 13¾ in (35 x 35 cm). Stedelijk Museum, Amsterdam

209. ALL COMBINATIONS OF ARCS FROM CORNERS AND SIDES; STRAIGHT LINES, NOT-STRAIGHT LINES, AND BROKEN LINES. 1973. Pen and ink, pencil, 17 x 17 in (43.2 x 43.2 cm). Whereabouts unknown (P: Robert E. Mates and Paul Katz, New York)

210–215. ALL COMBINATIONS OF ARCS FROM CORNERS AND SIDES; STRAIGHT, NOT-STRAIGHT, AND BROKEN LINES (Wall Drawing). 1973. Blue chalk. Collection Giuseppe Panza di Biumo, Milan (P: Kathan Brown, Oakland)

216. ALL COMBINATIONS OF ARCS FROM CORNERS; STRAIGHT, NOT-STRAIGHT, AND BROKEN LINES (Wall Drawing). 1973. Black chalk. Collection Giuseppe Panza di Biumo, Milan (P: Lucarini, Spoleto)

217–218. ARCS AND LINES, LINES AND LINES (Wall Drawing). 1972. Chalk. Collection Friedrich E. Rentschler, Laupheim, West Germany (P: Dorothee Fischer, Düsseldorf)

219. ARCS AND LINES, LINES AND LINES (Plan). 1972. Announcement, 4¼ x 6 in (10.8 x 15.2 cm)

220. ALL COMBINATIONS OF ARCS FROM CORNERS AND SIDES; STRAIGHT, NOT-STRAIGHT, AND BROKEN LINES (Wall Drawing). 1972. Blue chalk. Collection Giuseppe Panza di Biumo, Milan (P: Leonardo Bezzola, Bätterkinden, Switzerland)

221. ALL COMBINATIONS OF ARCS FROM CORNERS AND SIDES; STRAIGHT, NOT-STRAIGHT, AND BROKEN LINES (Wall Drawing). 1975. White chalk on black wall, 16½ x 95 in (42 x 241.4 cm). Courtesy Daniel Weinberg Gallery, San Francisco (P: Rudy Bender, San Francisco)

222. ALL COMBINATIONS OF ARCS FROM CORNERS AND SIDES; STRAIGHT, NOT-STRAIGHT, AND BROKEN LINES (Wall Drawing). 1976. White chalk on black wall. Courtesy Saman Gallery, Genoa (P: Daniel Vittet, Geneva)

223. ALL COMBINATIONS OF ARCS FROM CORNERS AND SIDES; STRAIGHT, NOT-STRAIGHT, AND BROKEN LINES (Wall Drawing). 1976. White chalk on black wall. Courtesy Saman Gallery, Genoa (P: Paolo Pellion di Persano, Turin)

224. STRAIGHT LINES IN ONE OF FOUR DIRECTIONS DRAWN WITHIN A GRID RANDOMLY (Wall Drawing). 1977. White chalk on black wall. Courtesy John Weber Gallery, New York (P: Ron Erde, Tel-Aviv)

225. RED LINES SIX FEET LONG, WITHIN EIGHT-FOOT BLACK SQUARE. A Horizontal Line from the Midpoint of the Left Side toward the Midpoint of the Right Side (Wall Drawing). 1973. Black and red crayon. Courtesy Lisson Gallery, London (P: Nicholas Logsdail, London)

226. RED LINES SIX FEET LONG, WITHIN EIGHT-FOOT BLACK SQUARE. A Horizontal Line Centered between the Midpoints of the Right and Left Sides (Wall Drawing). 1973. Black and red crayon. Courtesy Lisson Gallery, London (P: Nicholas Logsdail, London)

227. RED LINES SIX FEET LONG, WITHIN EIGHT-FOOT BLACK SQUARE. A Diagonal Line from the Upper Left Corner toward the Lower Right Corner (Wall Drawing). 1973. Black and red crayon. Courtesy Lisson Gallery, London (P: Nicholas Logsdail, London)

228. RED LINES SIX FEET LONG, WITHIN EIGHT-FOOT BLACK SQUARE. A Diagonal Line Centered between the Upper Left and Lower Right Corners (Wall Drawing). 1973. Black and red crayon. Collection Harvey Wagner, London (P: Nicholas Logsdail, London)

229. RED LINES SIX FEET LONG, WITHIN EIGHT-FOOT BLACK SQUARE. A Diagonal Line from the Lower Left Corner toward the Upper Right Corner, and a Line Centered between the Upper Left and Lower Right Corners (Wall Drawing). 1973. Black and red crayon. Courtesy Lisson Gallery, London (P: Nicholas Logsdail, London)

230. RED LINES SIX FEET LONG, WITHIN EIGHT-FOOT BLACK SQUARE. Diagonal Lines from the Lower Left and Right Corners toward the Upper Right and Left Corners (Wall Drawing). 1973. Black and red crayon. Courtesy Lisson Gallery, London (P: Nicholas Logsdail, London)

231. RED LINES SIX FEET LONG, WITHIN EIGHT-FOOT BLACK SQUARE. A Diagonal Line Centered between the Upper Left and Lower Right Corners, and a Diagonal Line Centered between the Lower Left and Upper Right Corners (Wall Drawing). 1973. Black and red crayon. Courtesy Lisson Gallery, London (P: Nicholas Logsdail, London)

232. RED LINES SIX FEET LONG, WITHIN EIGHT-FOOT BLACK SQUARE. A Horizontal Line from the Midpoint of the Left Side and a Vertical Touching the End with its Midpoint (Wall Drawing). 1973. Black and red crayon. Courtesy Lisson Gallery, London (P: Nicholas Logsdail, London)

233. RED LINES SIX FEET LONG, WITHIN EIGHT-FOOT BLACK SQUARE. A Horizontal Line Centered between the Midpoints of the Right and Left Sides and a Diagonal Line Centered between the Lower Left and Upper Right Corners (Wall drawing). 1973. Black and red crayon. Courtesy Lisson Gallery, London (P: Nicholas Logsdail, London)

234–237, 239. LOCATION OF TWO LINES (Wall Drawings). 1973. Black chalk. Courtesy L'Attico Gallery, Rome (P: Kathan Brown, Oakland)

238, 240. ARCS WITH STRAIGHT, NOT-STRAIGHT, AND BROKEN LINES (Wall Drawings). 1973. Black chalk. Courtesy Cusack Gallery, Houston, Texas (P: Hickey & Robertson, Houston, Texas)

241. LINES THROUGH, TOWARD, AND TO POINTS. Lines from Four Corners and the Midpoints of Four Sides toward the Center of the Wall. A Line through the Center of the Wall toward the Upper Left Corner and a Line from the Center of the Wall to the Upper Right Corner. Lines through the Center of the Wall toward Midpoints of Four Sides and Four Corners (Wall Drawings). 1973. Crayon. Courtesy Lisson Gallery, London (P: Nicholas Logsdail, London)

242–243. RED, YELLOW, AND BLUE LINES FROM SIDES, CORNERS, AND CENTER OF THE WALL TO POINTS ON A GRID. Red Lines from Four Sides, Yellow Lines from the Center of the Wall. Blue Lines from Four Corners, Yellow Lines from the Center of the Wall. Red Lines from Four Sides, Blue Lines from Four Corners. Blue Lines from Four Corners to Points on a Grid (Wall Drawings). 1975. Crayon. Courtesy The Israel Museum, Jerusalem (P: The Israel Museum, Jerusalem)

244. LINES ONE METER LONG, FROM THE MIDPOINTS OF STRAIGHT LINES TOWARD SPECIFIED POINTS ON THE WALL (Wall Drawing over a piece by Daniel Buren). 1975. Crayon. Courtesy Lucio Amelio Gallery, Naples (P: Lo Jodice, Naples)

245–246. RED, YELLOW, AND BLUE LINES FROM SIDES, CORNERS, AND CENTER OF THE WALL TO POINTS ON A GRID. Blue Lines from Four Corners to Points on a Grid. Red Lines from Four Sides, Blue Lines from Four Corners, Yellow Lines from the Center of the Wall to Points on a Grid (Wall Drawings). 1975. Crayon. Courtesy The Israel Museum, Jerusalem (P: The Israel Museum, Jerusalem)

247–248. LINES FROM THE MIDPOINT OF THE LEFT SIDE OF TWO FACING WALLS TO POINTS ON A GRID (Wall Drawing). 1975. White chalk on black wall. Courtesy Konrad Fischer Gallery, Düsseldorf

249–250. LINES FROM MIDPOINTS OF THE TOP AND BOTTOM OF OPPOSITE SIDES OF THE SAME WALL TO POINTS ON A GRID (Wall Drawing WALLS TO POINTS ON A GRID (Wall Drawing). 1975. White chalk on black wall. Courtesy Konrad Fischer Gallery, Düsseldorf (P: 247-250, Dorothee Fischer, Düsseldorf)

251. LINES FROM THE CENTER OF THE WALL, FOUR CORNERS, AND FOUR SIDES TO POINTS ON A GRID (Wall Drawing). 1976. White chalk on black wall. Courtesy John Weber Gallery, New York (P: unknown)

252. LINES FROM THE CENTER OF THE WALL TO SPECIFIC POINTS (Wall Drawing). 1975. White chalk on black wall. Courtesy Daniel Weinberg Gallery, San Francisco, 1975 (P: unknown).

253. TWENTY-FOUR LINES FROM THE CENTER OF THE WALL, TWELVE LINES FROM EACH MIDPOINT OF FOUR SIDES, TWELVE LINES FROM EACH OF FOUR CORNERS TO POINTS ON A SIX-INCH GRID and TWELVE LINES FROM EACH OF FOUR CORNERS TO POINTS ON A SIX-INCH GRID (Wall Drawings). 1976. White chalk on black wall. Courtesy John Weber Gallery, New York (P: unknown)

254. TWENTY-FOUR LINES FROM THE CENTER OF THE WALL TO POINTS ON A SIX-INCH GRID and TWELVE LINES FROM EACH OF FOUR SIDES TO POINTS ON A SIX-INCH GRID and TWENTY-FOUR LINES FROM THE CENTER, TWELVE LINES FROM EACH SIDE, AND TWELVE LINES FROM EACH CORNER TO POINTS ON A SIX-INCH GRID (Wall Drawings). 1976. White chalk on black wall. Courtesy John Weber Gallery, New York (P: unknown)

255. LINES FROM POINTS TO POINTS. 1975. Pen and ink on acetate, 18 x 18 in (45.5 x 45.5 cm). Private collection, courtesy New Britain Museum of American Art, New Britain, Conn.

256. THE LOCATION OF YELLOW AND RED STRAIGHT, NOT-STRAIGHT, AND BROKEN LINES. 1976. Silkscreen print, 14 x 14 in (35.6 x 35.6 cm). Collection David and Sue Workman, New York

257. THE LOCATION OF YELLOW AND BLUE STRAIGHT, NOT-STRAIGHT, AND BROKEN LINES. 1976. Silkscreen print, 14 x 14 in (35.6 x 35.6 cm). Collection David and Sue Workman, New York

258. THE LOCATION OF A CIRCLE. 1974. Courtesy MTL Gallery, Brussels

259. LOCATION OF GEOMETRIC FIGURES. 1977. Pen and ink, pencil, 14⅛ x 14⅝ in (35.8 x 36.9 cm). Collection Laura Grisi, Rome

260. LINES FROM FOUR CORNERS TO POINTS ON A GRID (Wall Drawing). 1975. White chalk on red wall, 147 x 259 in (373.4 x 657.9 cm). Courtesy Daniel Weinberg Gallery, San Francisco (P: Bob Shankar, San Francisco)

261. LINES FROM FOUR SIDES TO POINTS ON A GRID (Wall Drawing). 1975. White chalk on blue wall, 147 x 259 in (373.4 x 657.9 cm). Courtesy Daniel Weinberg Gallery, San Francisco (P: Bob Shankar, San Francisco)

262. LINES FROM THE CENTER OF THE WALL TO POINTS ON A GRID (Wall Drawing). 1975. White chalk on yellow wall, 147 x 200 in (373.4 x 508 cm). Courtesy Daniel Weinberg Gallery, San Francisco (P: Bob Shankar, San Francisco)

263. WHITE LINES TO POINTS ON A GRID. On Yellow from the Center, On Red from the Sides, On Blue from the Corners, On Black from the Center, Sides, and Corners (Four-part Wall Drawing). 1977. Chalk, 10 x 40 ft (304.8 x 1,217.2 cm). Courtesy John Weber Gallery, New York (P: unknown)

264. SIX GEOMETRIC FIGURES WITHIN SIX GEOMETRIC FIGURES, SUPERIMPOSED (Wall Drawing). 1976. White chalk on black wall. Courtesy John Weber Gallery, New York (P: John A. Ferrari, Staten Island, New York)

265. CIRCLE (Wall Drawing). 1977. White chalk on brown wall. Collection Mr. and Mrs. Albrecht Saalfield, Concord, Mass. (P: Akira Hagihara, New York)

266. YELLOW AND RED STRAIGHT, NOT-STRAIGHT, AND BROKEN LINES ON YELLOW AND RED. 1975

267. ALL COMBINATIONS OF SIX GEOMETRIC FIGURES (Circle, Square, Triangle, Rectangle, Trapezoid, and Parallelogram within Six Geometric Figures). 1976. Pen and ink, 15⅞ x 15⅞ in (40.4 x 40.4 cm). Collection Dr. and Mrs. Aaron H. Esman, New York

268. ALL COMBINATIONS OF SIX GEOMETRIC FIGURES SUPERIMPOSED IN PAIRS (Fifteen-part Wall Drawing). 1977. White chalk on black wall. Courtesy John Weber Gallery, New York (P: Akira Hagihara, New York)

269. Double page from book *Photogrid*. 1977. Colored photos, each page 10½ x 10½ in (26.8 x 26.8 cm). (P: Sol LeWitt, New York)

270. PHOTO OF FLORENCE. R 609. 1976. Cut paper drawing, 24½ x 27 in (62.3 x 68.6 cm). Private collection, courtesy New Britain Museum of American Art, New Britain, Conn. (P: Kate Keller, New York)

271. PHOTO OF CENTRAL MANHATTAN. R 730. 1977. Cut paper drawing, 16 x 16 in (40.5 x 40.5 cm). Private collection, courtesy New Britain Museum of American Art, New Britain, Conn.

272. BRICK WALL. 1977. Two black-and-white photographs, each 10⅞ x 8⅝ in (27.7 x 22 cm). Courtesy New Britain Museum of American Art, New Britain, Conn. (P: Sol LeWitt, New York)

273. BURIED CUBE CONTAINING AN OBJECT OF IMPORTANCE BUT LITTLE VALUE. 1968. Steel, ca. 10 x 10 x 10 in (25.4 x 25.4 x 25.4 cm). Collection Martin Visser, Bergeyk, The Netherlands

ILLUSTRATIONS: WORKS BY SOL LEWITT, 1962-1977, WITH HIS COMMENTARIES

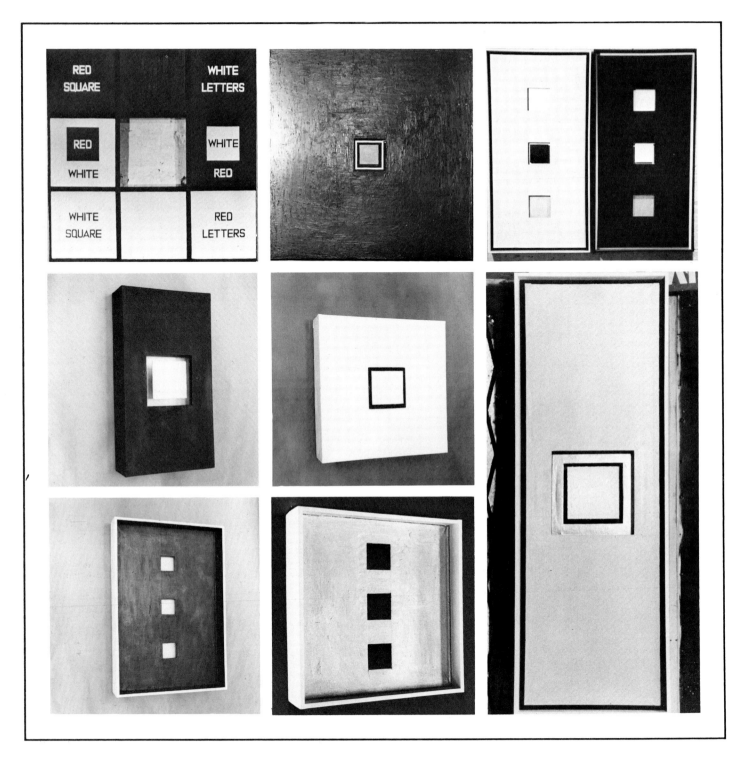

STRUCTURES

1. Top left: RED SQUARE, WHITE LETTERS. 1962. Oil on canvas, 36 x 36 in (91.4 x 91.4 cm).

2. Top center: WALL STRUCTURE, BLUE. 1962. Oil on canvas and painted wood, 62¼ x 62¼ x 9¾ in (158.1 x 158.1 x 24.8 cm).

3. Top right: DOUBLE WALL PIECE. 1962. Oil on canvas and painted wood, two parts, each 50 x 24 x 10 in (127 x 61 x 25.4 cm).

4. Middle left: WALL STRUCTURE. 1962. Oil on canvas and painted wood, 29 x 16 x 6 in (50.9 x 40.6 x 15.2 cm).

5. Middle center: WALL STRUCTURE. 1962. Oil on canvas and painted wood, 24 x 24 x 6 in (61 x 61 x 15.2 cm).

6. Bottom left: WALL STRUCTURE. 1962. Oil on canvas and painted wood, 33 x 23 x 6 in (83.8 x 58.4 x 15.2 cm).

7. Bottom center: WALL STRUCTURE. 1962. Oil on canvas and painted wood, 21 x 21 x 6 in (53.3 x 53.3 x 15.2 cm).

8. Far right: WALL STRUCTURE. 1962. Oil on canvas and painted wood, 50 x 18 x 10 in (127 x 45.8 x 25.4 cm).

Before doing this work, I did three-dimensional paintings using words and figures. These figures were taken from single frames of Muybridge's serial photographs. As the colors advanced and receded visually the forms did so physically, projecting from the frontal plane or receding behind it. These pieces are referred to as structures because they are neither paintings nor sculptures, but both.

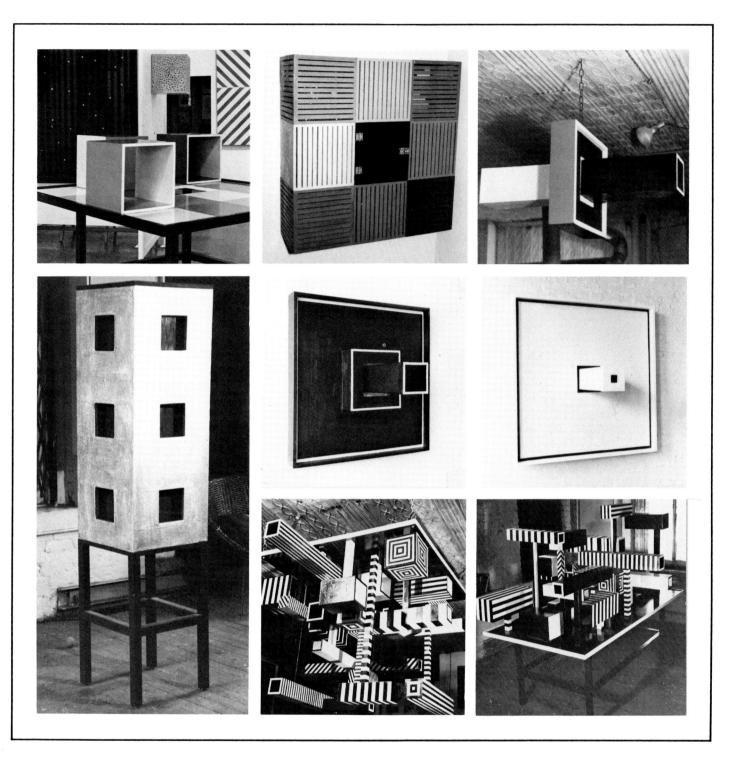

9. *Top left:* Installation, Kaymar Gallery, New York, 1964: *(Foreground)* TABLE PIECE WITH THREE CUBES. 1963. Painted wood; table, 28 x 40 x 40 in (71.1 x 101.6 x 101.6 cm); cubes, each 12 x 12 x 12 in (30.5 x 30.5 x 30.5 cm). Destroyed. *(Background above)* CUBE WITH RANDOM HOLES CONTAINING AN OBJECT. 1964 Wood, 12 x 12 x 12 in (30.5 x 30.5 x 30.5 cm). Destroyed.

10. *Top center:* WALL STRUCTURE IN NINE PARTS, EACH CONTAINING A WORK OF ART BY OTHER ARTISTS. 1963. Painted wood (other materials inside), 36 x 36 x 12 in (91.4 x 91.4 x 30.5 cm).

11. *Top right:* HANGING STRUCTURE. 1962. Oil on canvas and painted wood, 17½ x 17½ x 37 in (44.4 x 44.4 x 94 cm). Destroyed.

12. *Far left:* FLOOR STRUCTURE. 1962. Oil on canvas and painted wood, 74 x 17½ x 17½ in (188 x 44.4 x 44.4 cm).

13. *Middle center:* WALL STRUCTURE, BLACK. 1962. Oil on canvas and painted wood, 39 x 39 x 23½ in (99.1 x 99.1 x 59.7 cm).

14. *Middle right:* WALL STRUCTURE, WHITE. 1962. Oil on canvas and painted wood, 45 x 44½ x 19½ in (114.3 x 113 x 49.5 cm).

15. *Bottom center:* HANGING STRUCTURE (With Stripes). 1963. Painted wood, 55 x 55 x 30 in (139.7 x 139.7 x 76.2 cm). Destroyed.

16. *Bottom right:* TABLE STRUCTURE (With Stripes). 1963. Painted wood, 72 x 30 x 20 in (182.9 x 76.2 x 50.8 cm). Destroyed.

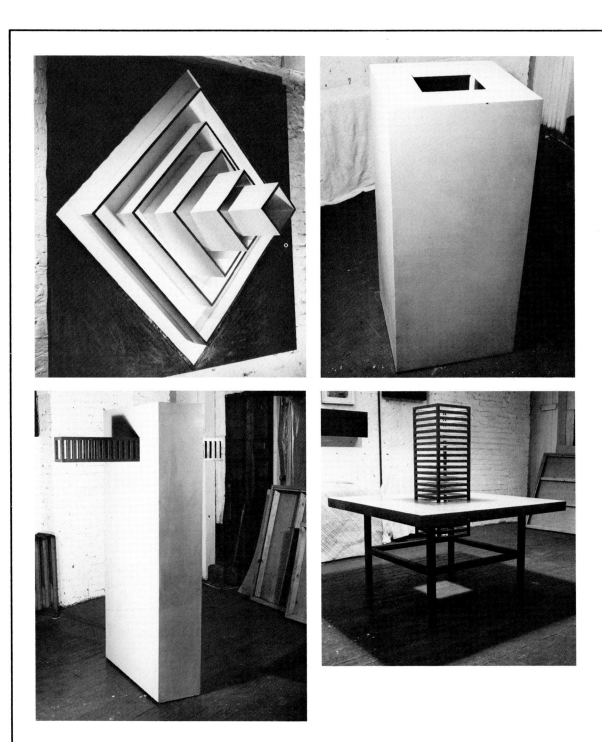

17. *Top left:* WALL STRUCTURE. 1963. Oil on canvas and painted wood, 62 x 62 x 25 in (157.5 x 157.5 x 63.5 cm).

18. *Top right:* FLOOR STRUCTURE ("Well"). 1963. Painted wood (also steel), 55 x 28 x 28 in (139.7 x 71.1 x 71.1 cm).

19. *Bottom left:* FLOOR STRUCTURE. 1963. Painted wood (also steel), 72 x 48 x 30 in (182.9 x 122 x 76.2 cm).

20. *Bottom right:* TABLE STRUCTURE. 1963. Painted wood, 48 x 48 x 55 in (122 x 122 x 139.7 cm). Destroyed.

These pieces continue the idea of working with the picture plane in three dimensions by piercing or building out from it. The piece at the upper left was the first serial attempt, although it was not very precise in its measurements. The projections and intervals, however, expanded and contracted in a controlled sequence. The boxlike piece on the upper right ("Well") has a series of parallel black bars placed in rows at twelve-inch intervals downward; one can see only the first couple of rows, but the others are inferred. Later I would work more with the idea of seeing and knowing and the idea of inferring the unknown by clues from the known.

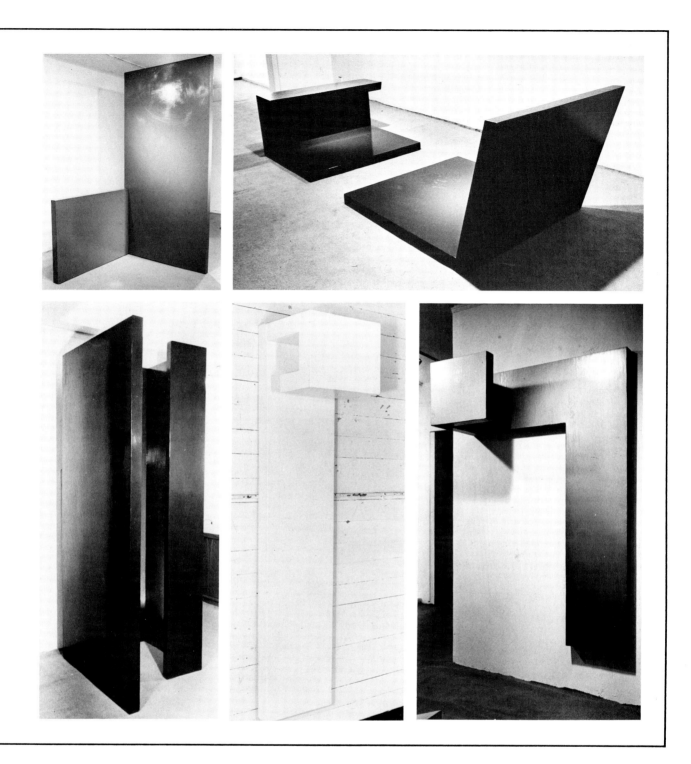

21. *Top left:* FLOOR STRUCTURE. 1965. Painted wood, 96 x 96 x 48 in (243.9 x 243.9 x 122 cm).

22. *Top right:* DOUBLE FLOOR STRUCTURE. 1964. Painted wood, 30 x 48 x 144 in (76.2 x 122 x 365.8 cm). Destroyed.

23. *Bottom left:* FLOOR/WALL STRUCTURE ("Telephone Booth"). 1964. Painted wood, 96 x 32 x 42 in (243.9 x 81.3 x 106.7 cm).

24. *Bottom center:* WALL STRUCTURE. 1965. Painted wood (also steel), 72 x 16 x 12 in (182.9 x 40.6 x 30.5 cm).

25. *Bottom right:* WALL STRUCTURE. 1965. Painted wood (also steel), 72 x 48 x 12 in (182.9 x 122 x 30.5 cm).

When looking for a job at the school of Visual Arts, I showed photos of my work to Don Nice, the personnel director; he said he did not have a job for me, but referred me to a new gallery, the John Daniels Gallery, run by David Herbert and Dan Graham. I showed them the photos and later that year I showed some work there. Dan Graham, who was particularly interested in new work, was showing Robert Smithson, Forest Myers, Jo Baer, Will Insley, and others while doing some very significant work himself. The gallery lasted about five months. The pieces I showed there were fairly large and simple slabs. Using lacquer, much work was done to make the surface look hard and industrial. This was negated by the grain of the wood. They should have been made in metal, as some of them later were, but I could not afford it then.

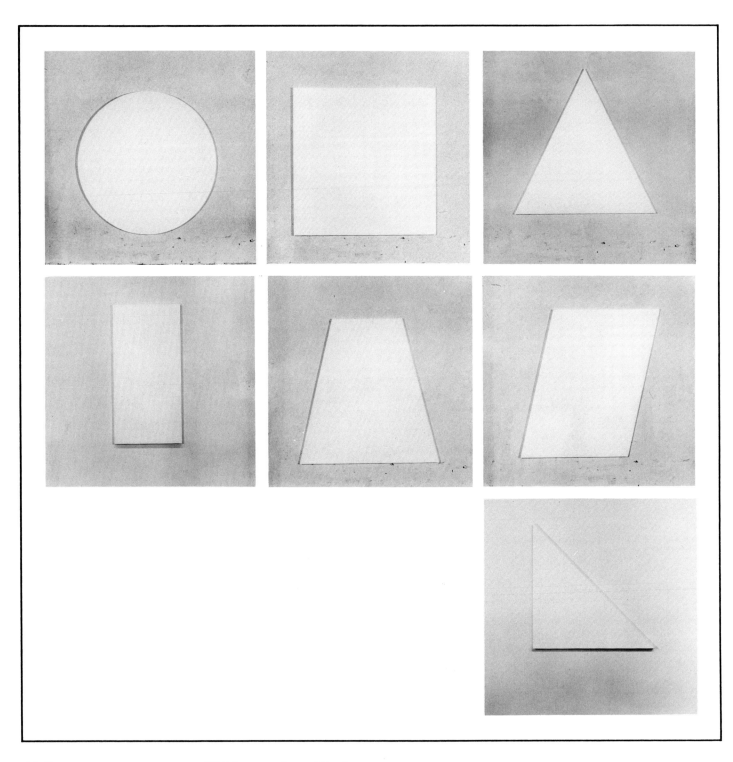

26–32. GEOMETRIC FIGURES, SOLID (Wall Structures). 1977. Wood,
nos. 26–28, 30–32, 60 x 60 x 1 in (152.4 x 152.4 x 2.5 cm); no. 29 *(center left)*,
60 x 30 x 1 in (152.4 x 76.2 x 2.5 cm).

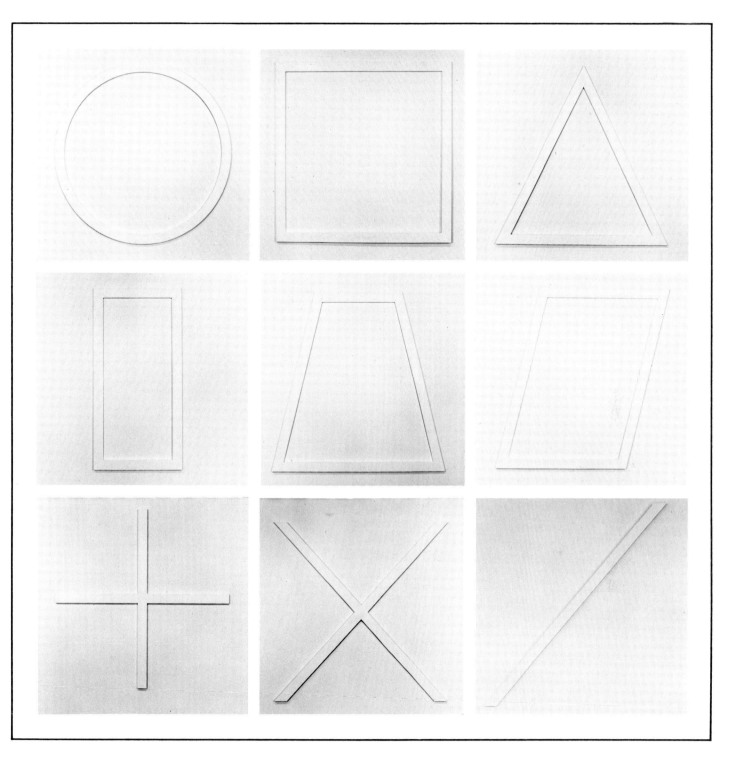

33–41. GEOMETRIC FIGURES, OPEN (Wall Structures). 1977. Wood, nos. 33–35, 37–40, 8 x 8 ft x 1 in (243.9 x 243.9 x 2.5 cm); no. 36 *(center left)*, 8 ft x 4 ft x 1 in (243.9 x 122 x 2.5 cm); no.41 *(bottom right)*, 60 x 60 x 1 in (152.4 x 152.4 x 2.5 cm).

These pieces were made twelve years after the preceding work; they too are three-dimensional reliefs (paintings/structures). The use of geometric figures is a way of continuing the simple forms of the earlier pieces. They were made by Michael Shorr.

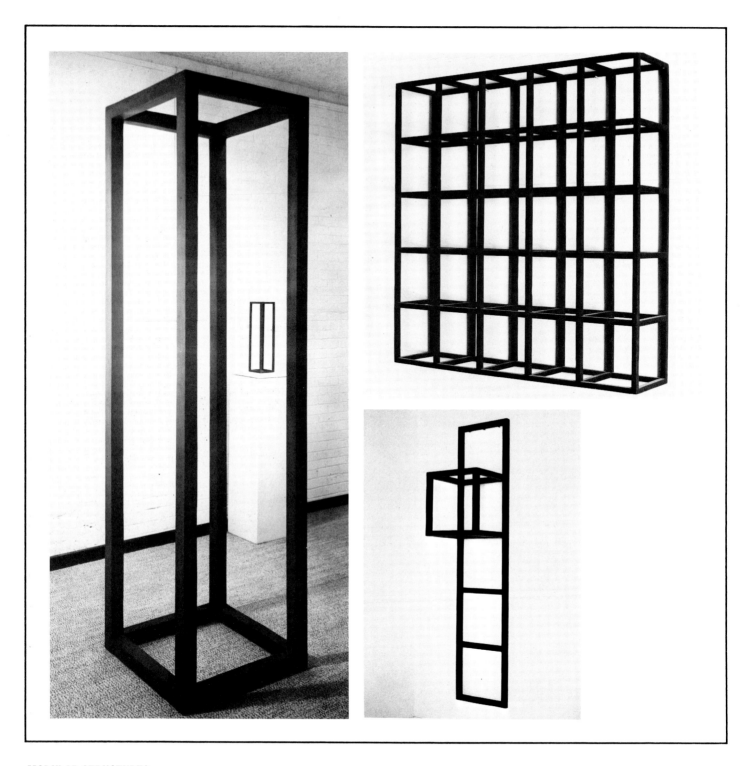

MODULAR STRUCTURES

42. Left: STANDING OPEN STRUCTURE, BLACK. 1964. Painted wood (also steel), 96 x 25½ x 25¾ in (243.9 x 64.8 x 65.4 cm).

43. Top right: WALL STRUCTURE, BLACK. 1966. Painted wood, 43½ x 43½ x 9½ (110.3 x 110.3 x 24 cm).

44. Bottom right: WALL STRUCTURE: FIVE MODULES WITH ONE CUBE, BLACK. 1965. Painted wood, 72 x 12 x 12 in (182.9 x 30.5 x 30.5 cm).

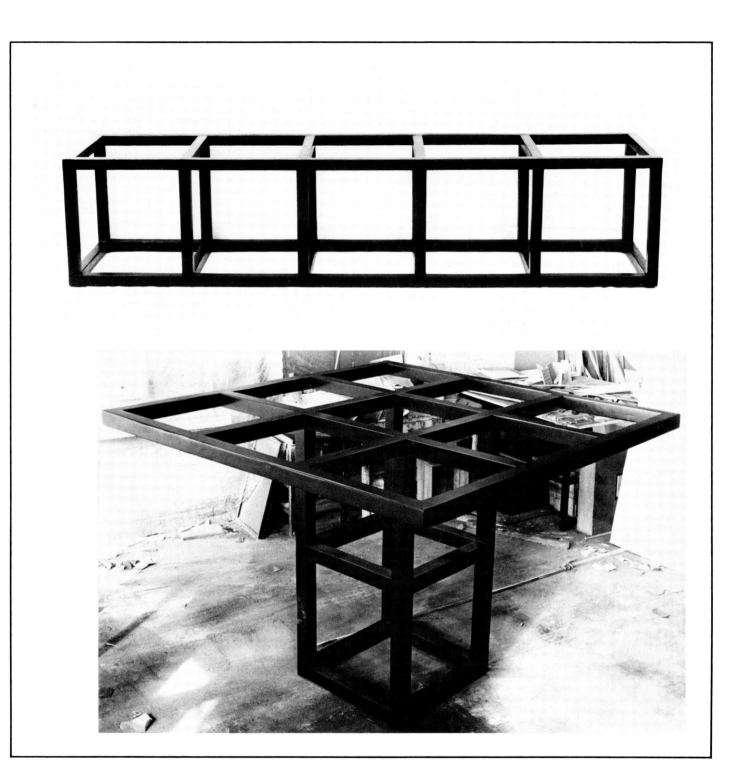

45. *Top:* FLOOR STRUCTURE, BLACK. 1965. Painted wood, 20 x 20 x 72 in (55.8 x 55.8 x 182.9 cm).

46. *Bottom:* FLOOR STRUCTURE. 1965. Painted wood, 48 x 84 x 84 in (122 x 213.4 x 213.4 cm). Destroyed, remade 1975.

Disturbed by the inconsistency of the grain of the wood in the Daniels Gallery pieces, and by the emphasis on surface (not only in appearance, but in the long hours of work needed to achieve the correct luster), I decided to remove the skin altogether and reveal the structure. Then it became necessary to plan the skeleton so that the parts had some consistency. Equal, square modules were used to build the structures. In order to emphasize the linear and skeletal structure, they were painted black.

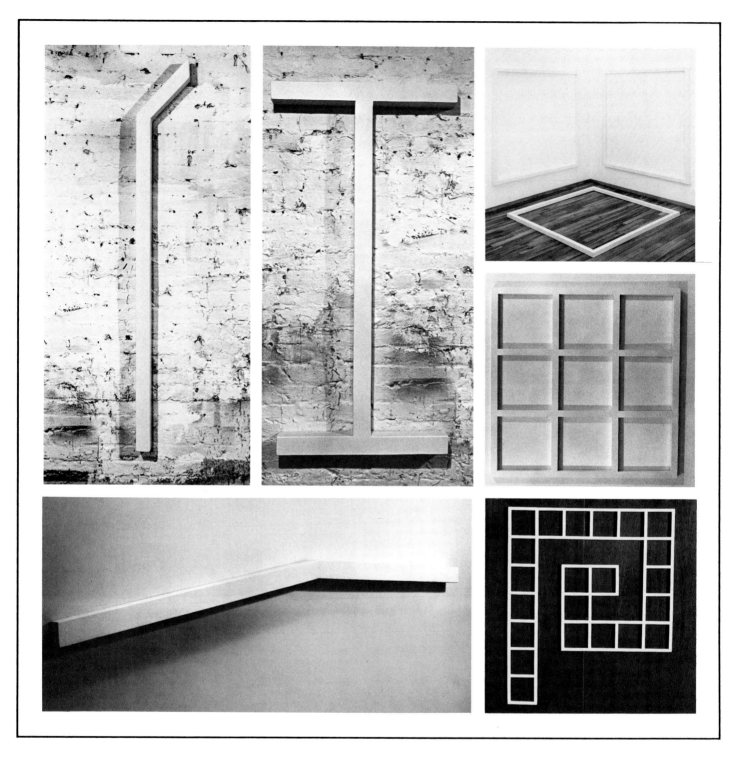

47. *Top left:* WALL PIECE ("Hockey Stick"). 1964. Painted wood (also steel), 66 x 12 x 2 in (167.6 x 30.5 x 5.1 cm).

48. *Top center:* WALL PIECE ("I"). 1965. Painted wood (also steel), 40 x 18 x 2 in (101.6 x 45.7 x 5.1 cm). Destroyed.

49. *Top right:* WALL/FLOOR PIECE ("Three Squares"). 1966. Painted steel (also wood), each square 48 x 48 in (121.9 x 121.9 cm). Wood version destroyed. Another steel version, each square 40 x 40 in (101.6 x 101.6 cm).

50. *Center right:* WALL GRID (3 x 3). 1966. Painted wood (also steel), 71 x 71 x 7 in (180.3 x 180.3 x 17.8 cm).

51. *Bottom left:* WALL PIECE ("Bent Stick"). 1965. Painted wood, 2 x 2 x 72 in (5.1 x 5.1 x 182.9 cm). Destroyed, remade 1976.

52. *Bottom right:* PROGRESSIVE SPIRAL. 1972. Painted wood, 33 x 29 x ½ in (83.8 x 73.6 x 1.3 cm).

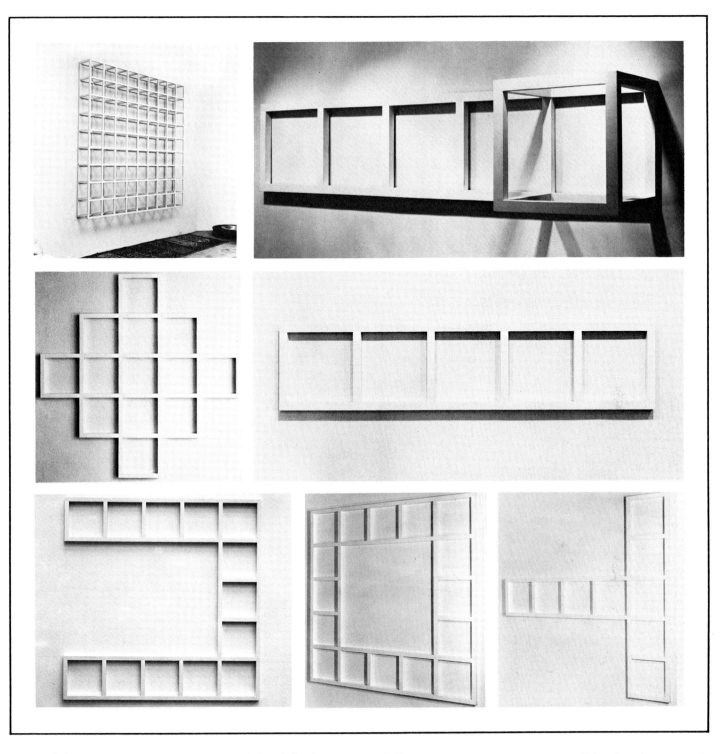

53. *Top left:* MODULAR WALL STRUCTURE. 1968. Painted aluminum, 88½ x 88½ x 10 in (224.8 x 224.8 x 25.4 cm).

54. *Top right:* MODULAR WALL PIECE WITH CUBE. 1965. Painted wood (also steel), 18 x 18 x 84 in (45.8 x 45.8 x 213.4 cm). Destroyed, remade 1977.

55. *Center left:* WALL STRUCTURE. 1969. Painted steel, 72 x 72 x 1½ in (182.9 x 182.9 x 3.8 cm).

56. *Center right:* WALL STRUCTURE. 1969. Painted wood (also steel), 6 ft 4⅜ in x 16¾ in x 1⅝ in (194 x 42.5 x 4 cm).

57. *Bottom left:* WALL STRUCTURE. 1976. Aluminum, 76⅜ x 76⅜ x 1⅝ in (194 x 194 x 4 cm).

58. *Bottom center:* WALL STRUCTURE. 1972. Painted steel, 76 x 76 x 1½ in (193 x 193 x 3.8 cm).

59. *Bottom right:* WALL STRUCTURE. 1972. Painted steel, 76 x 76 x 1½ in (193 x 193 x 3.8 cm).

By the end of 1965 the pieces were painted white instead of black. This seemed more appropriate for the forms and mitigated the expressiveness of the earlier black pieces. The white wall structures were visually more a part of a white wall. About this time also, a ratio of 8.5:1 between the material (wood or metal) and the spaces between it was decided upon. As with the white color, the 8.5:1 ratio was an arbitary decision, but once it had been decided upon, it was always used.

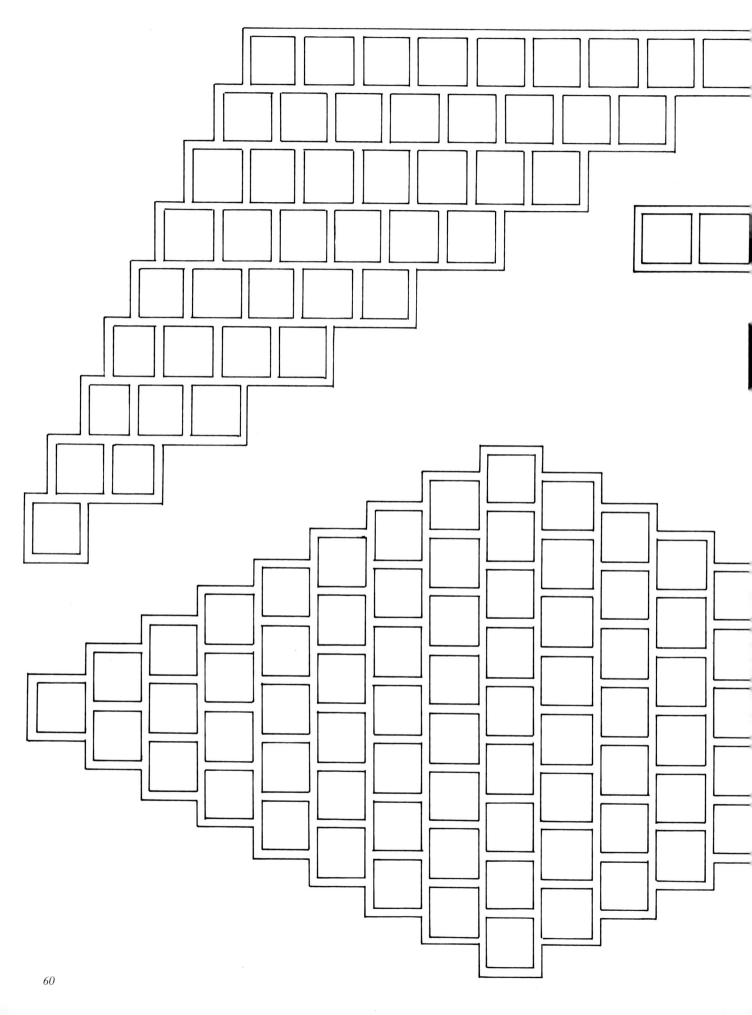

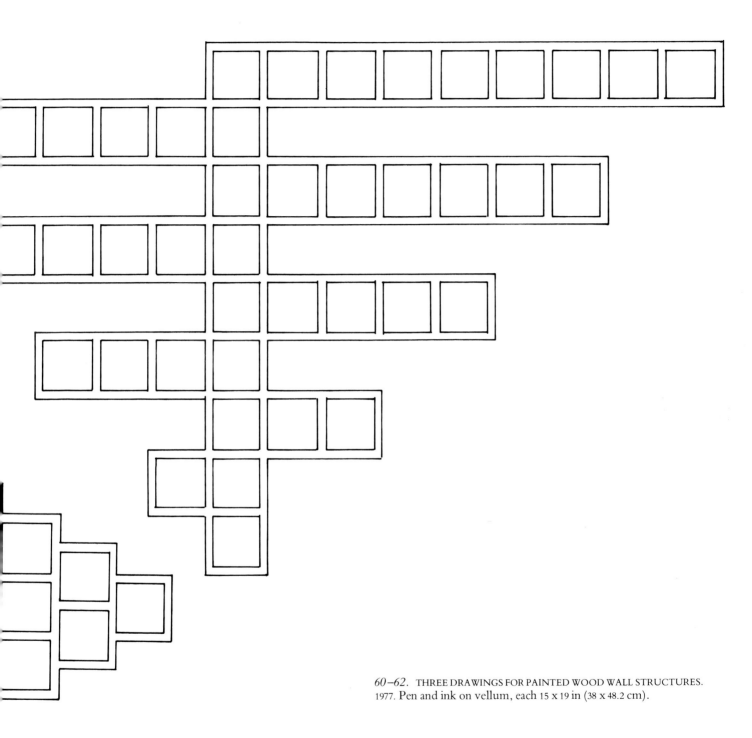

60–62. THREE DRAWINGS FOR PAINTED WOOD WALL STRUCTURES. 1977. Pen and ink on vellum, each 15 x 19 in (38 x 48.2 cm).

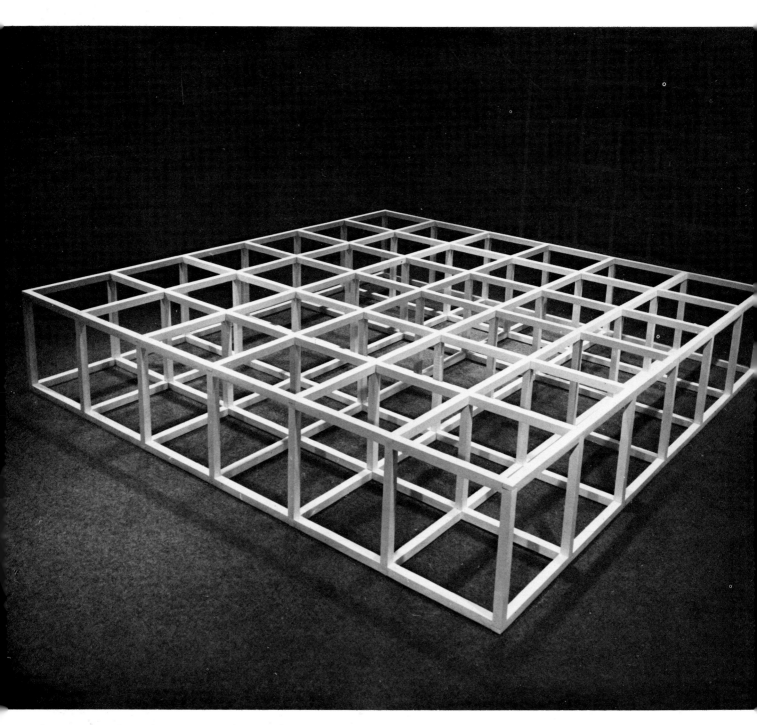

63. MODULAR FLOOR STRUCTURE. 1966. Painted wood, 25¼ x 141½ x 141½ in (64.2 x 359.5 x 359.5 cm). Destroyed, remade in steel 1968.

64. *Opposite page:* Installation, Dwan Gallery, New York, 1966. *Foreground:* DOUBLE MODULAR CUBE. 1966. Wood, 108 x 55 x 55 in (274.4 x 139.8 x 139.8 cm). Destroyed, remade in steel 1970.

The pieces above were done for the show at the Dwan Gallery in 1966, which included wall and floor pieces investigating the idea of open modular cubic structures. They were made with the assistance of Werner Buser. Although the space of the gallery was a guide to the size of the work, the pieces did not work absolutely with the space.

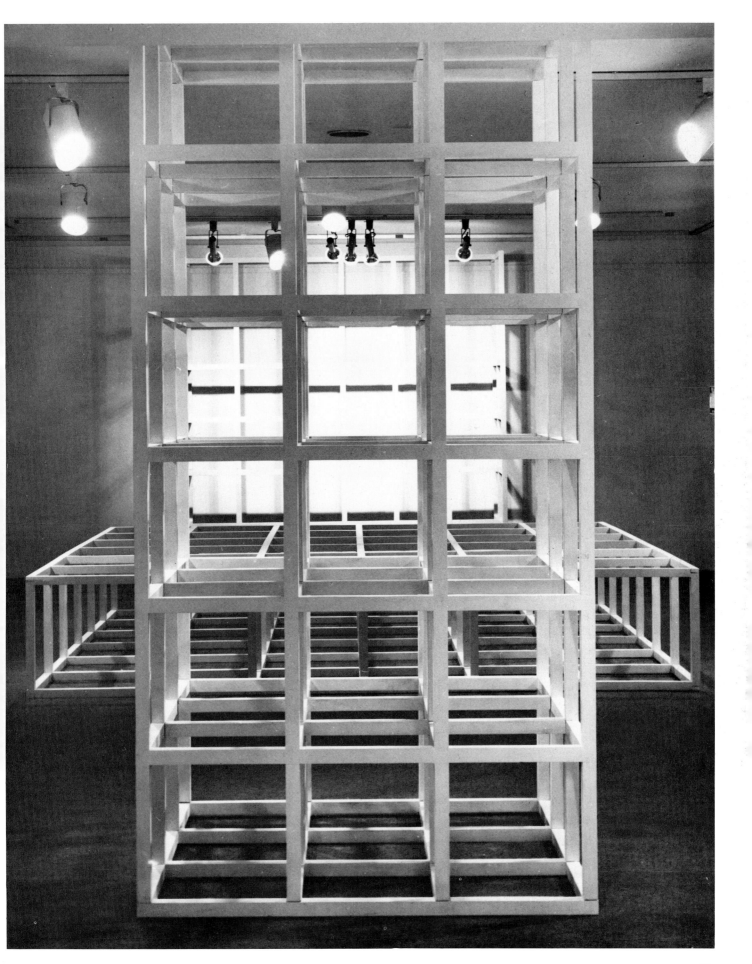

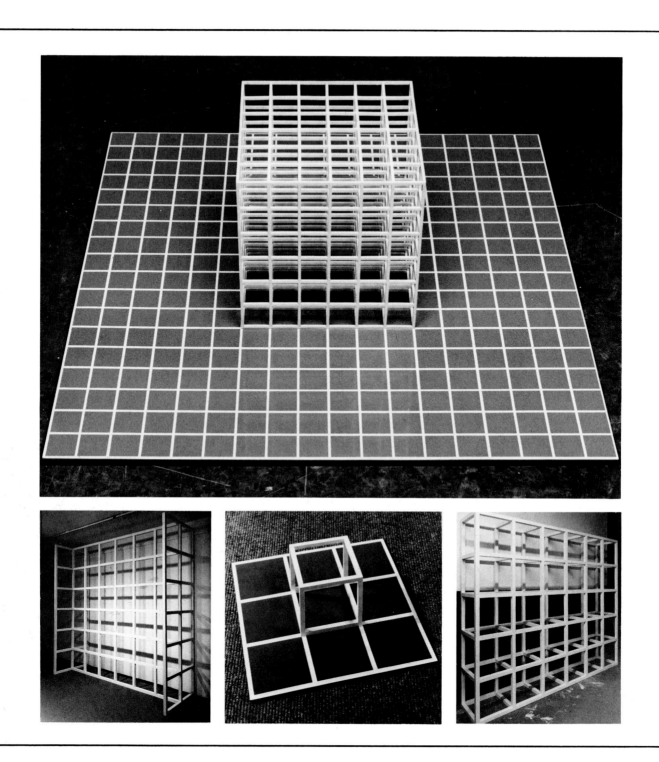

65. *Top:* MODULAR CUBE/BASE. 1968. White painted steel, cube 19⅝ x 19⅝ x 19⅝ in (49.9 x 49.9 x 49.9 cm); base 1 x 58½ x 58½ (2.5 x 148.6 x 148.6 cm). Also made in a slightly smaller version.

66. *Bottom left:* FLOOR/WALL GRID. 1966. Painted wood, 108 x 108 x 33 in (274.3 x 274.3 x 83.8 cm).

67. *Bottom center:* CUBE/BASE. 1969. Painted steel, multiple edition of 25, cube 3½ x 3½ x 3½ in (9 x 9 x 9 cm); base 10 x 10 x ¼ in (25.5 x 25.5 x .6 cm).

68. *Bottom right:* CUBIC MODULAR FLOOR PIECE. 1965. Baked enamel on steel, 92 x 110 x 20 in (233.7 x 279.4 x 50.8 cm).

69. *Opposite page:* MODULAR CUBE. 1966. Painted aluminum, 60 x 60 x 60 in (152.4 x 152.4 x 152.4 cm). Also made 58 x 58 x 58 in (147.4 x 147.4 x 147.4 cm).

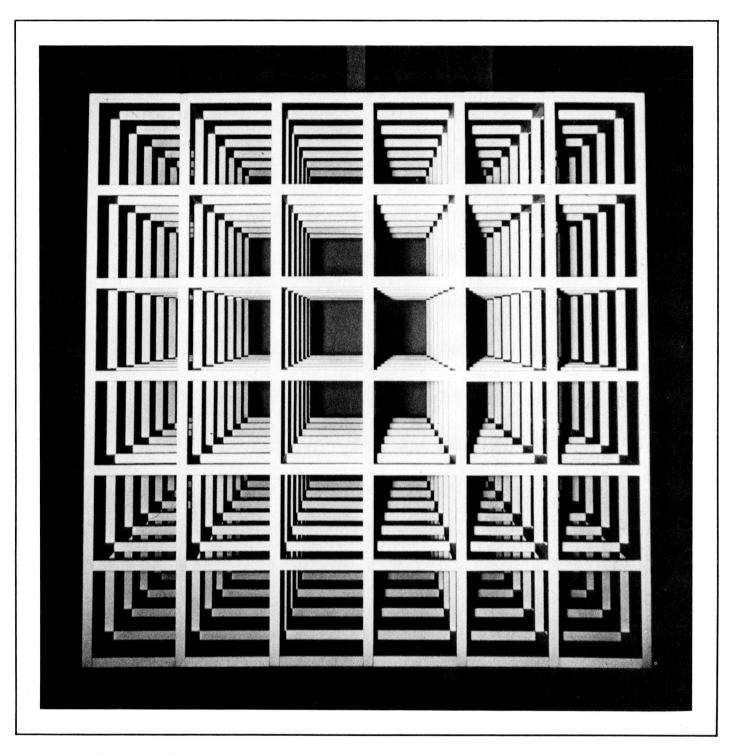

Further studies of the cube included the relation of the grid to the modular
cube. The grid and the cube had the same ratio of line (matter) to interval
(space). The three-dimensional object grew out of a two-dimensional grid.
In the piece on the lower left a strong light was used to cast dark shadows
against the wall, almost obliterating the white structure. The stronger the
light, the less one would see of the structure and the more one would see of the
shadow. This cube was one of two almost identical cubes, one of sixty inches,
the other of fifty-eight inches. They were placed about twelve feet apart and
looked exactly the same, but since they had the same number of modules the
space between the bars was different.

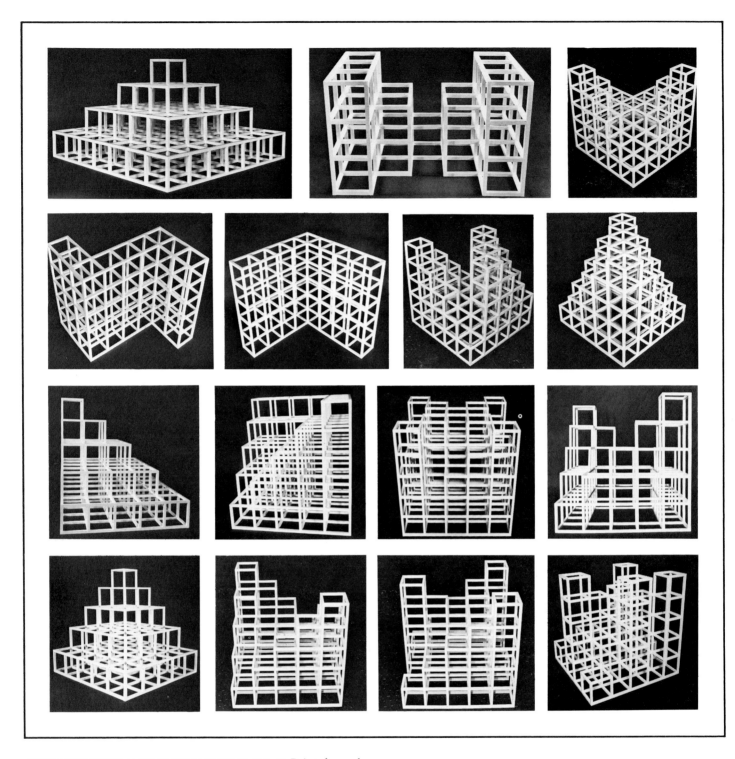

CUBE STRUCTURES BASED ON FIVE MODULES. 1971–74. Painted wood.

70. *Top left:* 19½ x 33¾ x 33¾ in (49.5 x 85.7 x 85.7 cm).

71. *Top center:* 14¾ x 14¾ x 24 in (37.5 x 37.5 x 61 cm).

72–84. *All other pieces on this page:* 24½ x 24¼ x 24¼ in (62.2 x 61.6 x 61.6 cm).

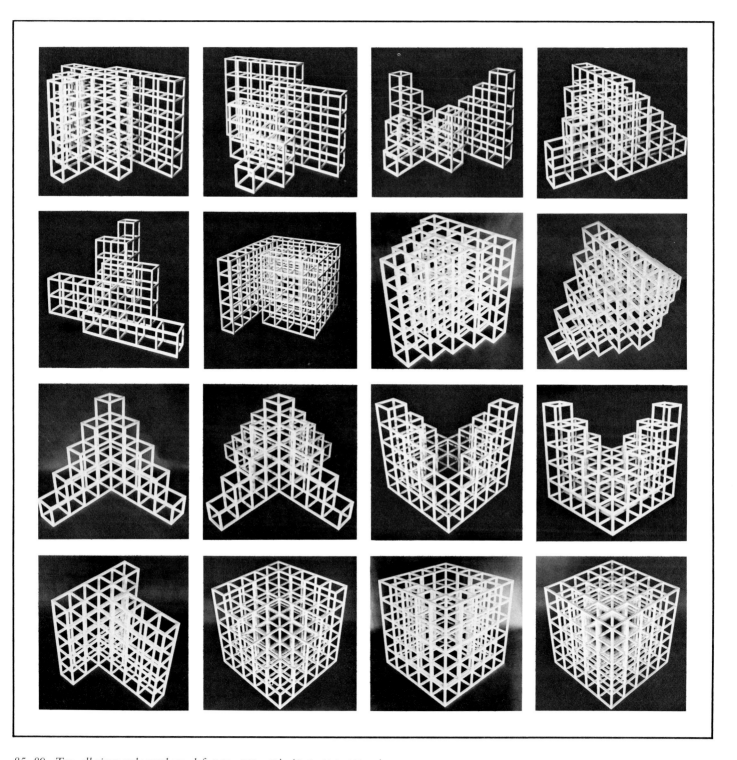

85–89. *Top, all pieces and second row, left:* 24¼ x 24¼ x 48 in (61.6 x 61.6 x 122 cm).

90. *Second row, left of center:* 24¼ x 33 x 29 in (61.6 x 83.8 x 73.7 cm).

91–100. *All other pieces on this page:* 24¼ x 24¼ x 24¼ in (61.6 x 61.6 x 61.6 cm).

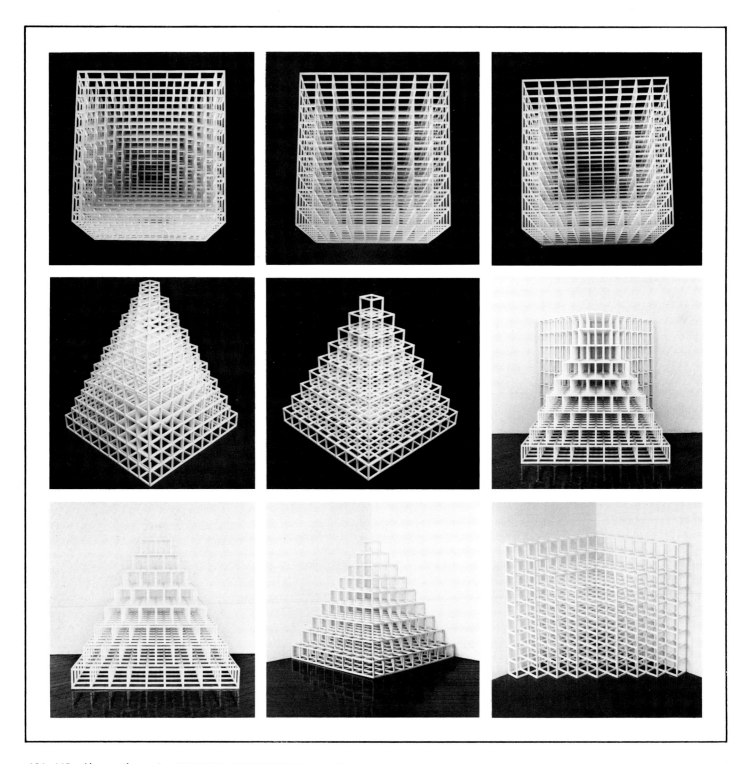

101–118. Above and opposite: CUBE STRUCTURES BASED ON NINE
MODULES. 1976–77. Painted wood, 43¼ x 43¼ x 43¼ in (109.8 x 109.8 x
109.8 cm).

*These structures and those on the two preceding pages were made by K.
Miyamoto, A. Hagihara, J. Tsuji, M. Harvey, and others.*

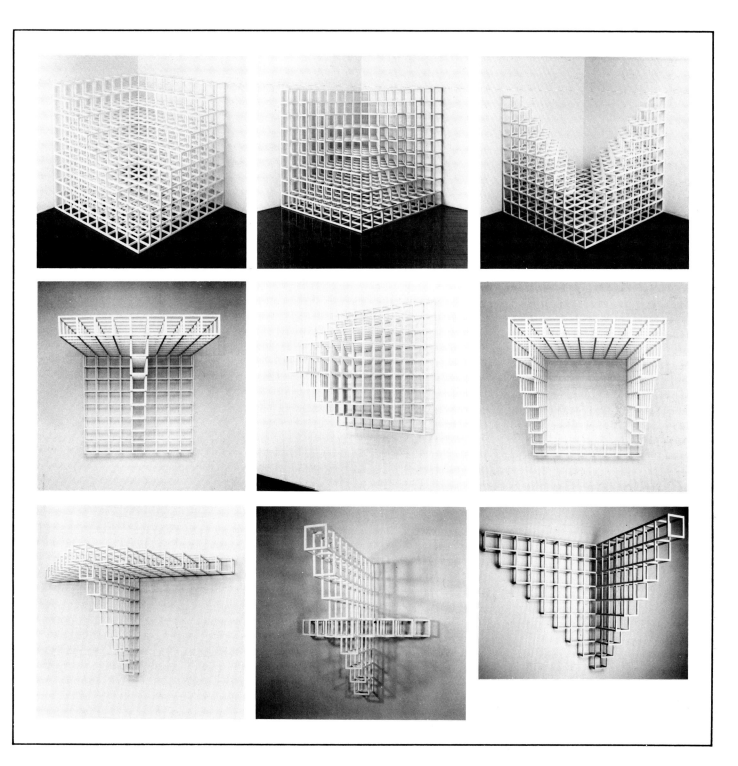

69

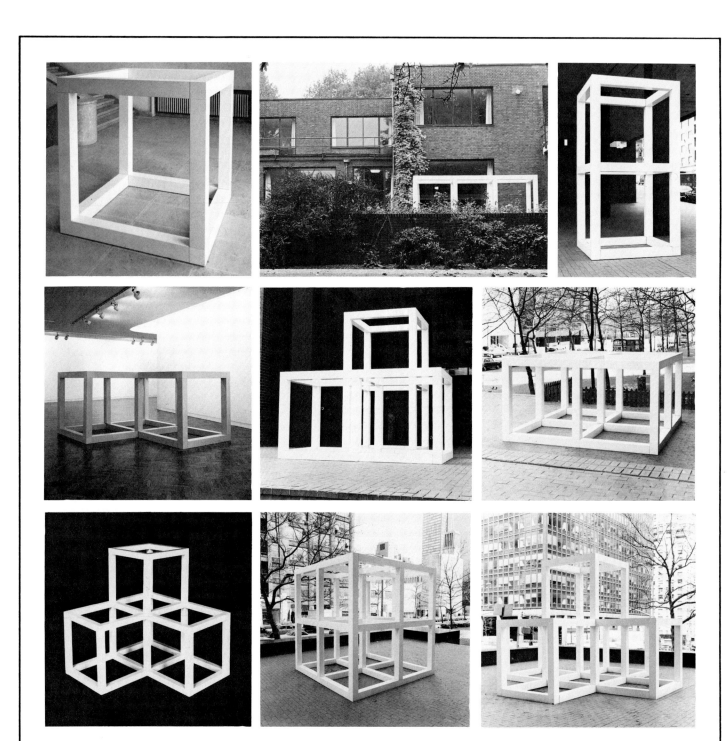

119. *Top left:* 1969. Baked enamel on steel, 63 x 63 x 63 in (160 x 160 x 160 cm).

120. *Top center:* 1969. Steel, 63 x 63 x 177 in (160 x 160 x 445.6 cm). Installation, Haus Lange, Krefeld, 1970.

121. *Top right:* 1969. Steel, 120 x 63 x 63 in (304.8 x 160 x 160 cm). Installation, Dag Hammarskjöld Plaza, New York, 1976.

122. *Middle left:* 1969. Steel, 63 x 120 x 120 in (160 x 304.8 x 304.8 cm). Installation, Pasadena Art Museum, 1971.

123. *Middle center:* 1975. Steel, 120 x 120 x 120 in (304.8 x 304.8 x 304.8 cm). Installation, Dag Hammarskjöld Plaza, New York, 1976.

124. *Middle right:* 1969. Steel, 63 x 120 x 120 in (160 x 304.8 x 304.8 cm). Installation, Dag Hammarskjöld Plaza, New York, 1976.

125. *Bottom left:* (Model). 1974. Wood, 10 x 10 x 10 in (25.4 x 25.4 x 25.4 cm).

126. *Bottom center:* 1976. Baked enamel on aluminum, 10 ft 6 in x 10 ft 6 in x 10 ft 6 in (320.1 x 320.1 x 320.1 cm). Installation, Dag Hammarskjöld Plaza, New York, 1976.

127. *Bottom right:* 1976. Baked enamel on aluminum, 10 ft x 15 ft 6 in x 15 ft 6 in (304.8 x 411.5 x 411.5 cm). Installation, Dag Hammarskjöld Plaza, New York, 1976.

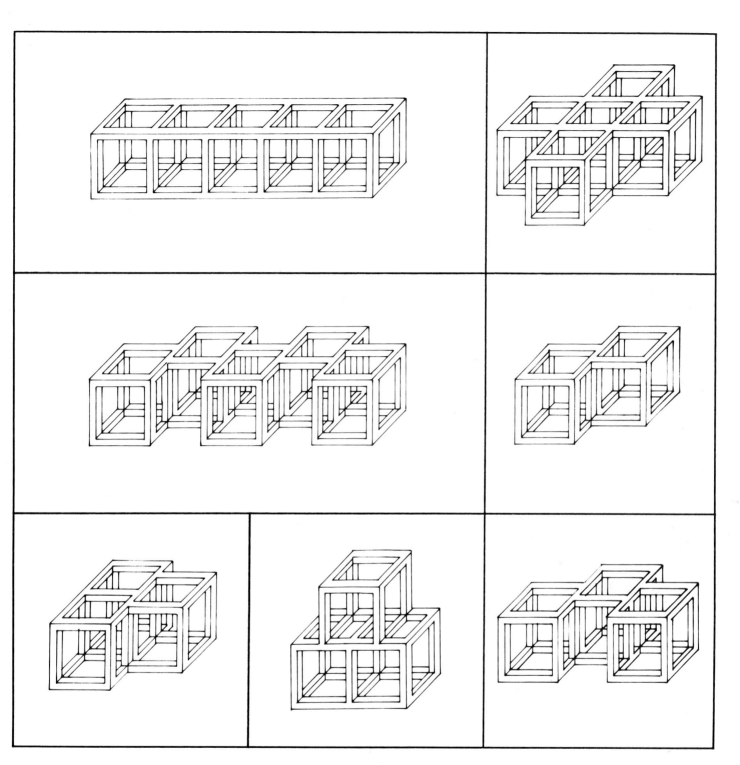

These pieces were made between 1969 and 1976 by NEBATO NV, Bergeyk, The Netherlands (with the exception of the cube in the bottom row center and the piece to its right, which were made in 1976 by Treital and Gratz of Long Island City, New York). The bars are made of six-inch-square steel or aluminum tubing, the space between is fifty-one inches, a ratio of 8.5:1. The height of each cube is sixty-three inches, or approximately eye level. One sees the second tier as above eye level. They were made in sections so that they could be taken apart and reassembled. The joints are apparent so that the viewer will be able to see the method of assembly.

128. DRAWING FOR SEVEN STRUCTURES. 1977. Pen and ink on tracing paper, 15⅛ x 16½ in (38.3 x 41.8 cm). The dates of the steel structures are as follows: *Top left:* 1970, Storm King Art Center, New York. *Top right:* 1970, Centre National d'Art et de Culture Georges Pompidou, Musée National d'Art Moderne, Paris. *Center left:* 1972, Grenoble Museum, France. *Center right:* 1972, The Tate Gallery, London. *Bottom left:* 1972, Albright-Knox Art Gallery, Buffalo. *Bottom center:* 1972, Konrad Fischer Gallery, Düsseldorf. *Bottom right:* 1972, Moderna Museet, Stockholm.

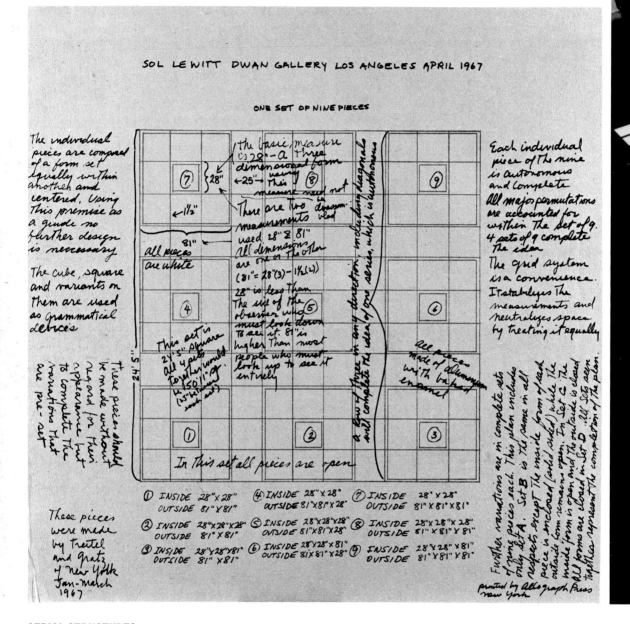

The following is handwritten text contained within the image:

SOL LEWITT DWAN GALLERY LOS ANGELES APRIL 1967

ONE SET OF NINE PIECES

The individual pieces are composed of a form set equally within another and centered. Using this premise as a guide no further design is necessary

The cube, square and variants on them are used as grammatical devices

These pieces should be made without regard for their appearance but to complete the variation that are pre-set

These pieces were made by Treitel and Gratz of New York Jan-March 1967

the basic measure is 28" – a three dimensional form using this measure need not be

There are two measurements used 28" & 81" All dimensions are one or the other (81" = 28"(3) – 1½(2))

28" is less than the size of the observer who must look down to see it. 81" is higher than most people who must look up to see it entirely

This set is 24'5" square all 4 parts together would be 50'11"sq (55'6½" including roads and)

All pieces are white

Each individual piece of the nine is autonomous and complete

All major permutations are accounted for within the set of 9. 4 sets of 9 complete the idea

The grid system is a convenience. It stabilizes the measurements and neutralizes space by treating it equally

All pieces made of aluminum with baked enamel

A row of three in any direction, including diagonal and complete the idea of our series, which is autonomous

In this set all pieces are open

① INSIDE 28" X 28"
 OUTSIDE 81" X 81"

② INSIDE 28" X 28" X 28"
 OUTSIDE 81" X 81"

③ INSIDE 28" X 28" X 81"
 OUTSIDE 81" X 81"

④ INSIDE 28" X 28"
 OUTSIDE 81" X 81" X 28"

⑤ INSIDE 28" X 28" X 28"
 OUTSIDE 81" X 81" X 28"

⑥ INSIDE 28" X 28" X 81"
 OUTSIDE 81" X 81" X 28"

⑦ INSIDE 28" X 28"
 OUTSIDE 81" X 81" X 81"

⑧ INSIDE 28" X 28" X 28"
 OUTSIDE 81" X 81" X 81"

⑨ INSIDE 28" X 28" X 81"
 OUTSIDE 81" X 81" X 81"

Further variations are in complete sets of nine pieces each. This plan includes only set A. Set B is the same in all respects except the inside form of each piece is enclosed (walled in/over) while the outside form remains open. In Set C the inside form is open and the outside is closed. All forms are closed in Set D. All sets seen together represent the completion of the plan.

printed by Allo graph Press new York

SERIAL STRUCTURES

129. SERIAL PROJECT NO. 1 (ABCD). Announcement for exhibition,
Dwan Gallery, Los Angeles, 1967.

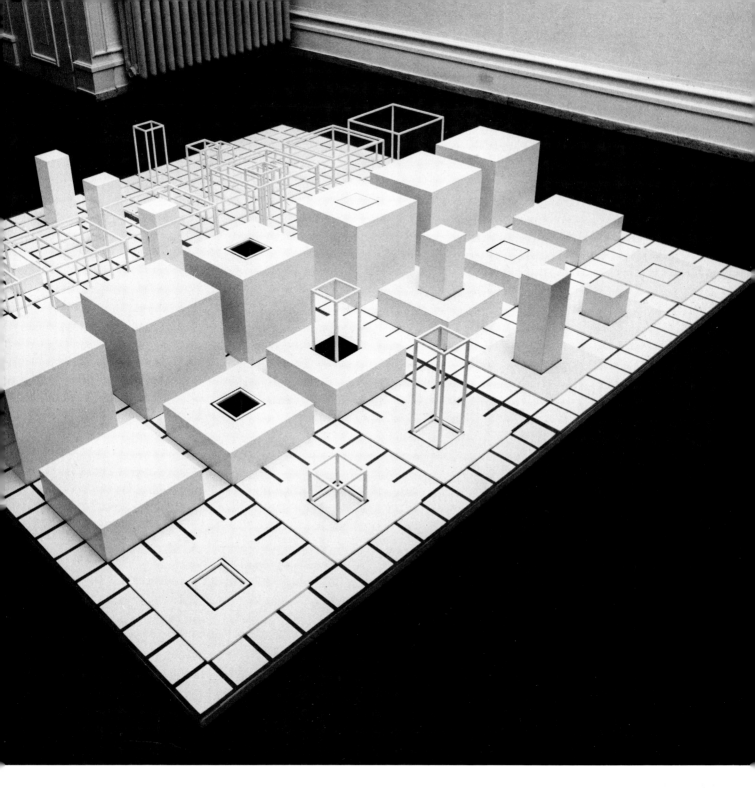

130. SERIAL PROJECT NO. 1(ABCD). 1966. Steel, 20⅛ in x 6 ft 6¾ in x 6 ft
6¾ in (51 cm x 2 m x 2 m). Installation, Kunsthalle Bern, 1972. Another
version made. (See pp. 170–171.)

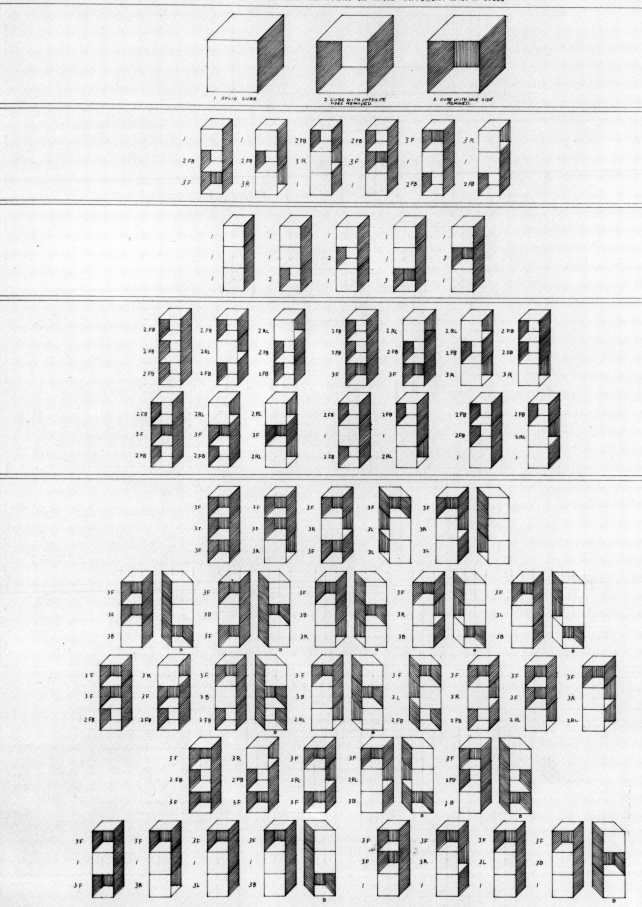

ALL THREE-PART VARIATIONS ON THREE DIFFERENT KINDS OF CUBES

1. SOLID CUBE 2. CUBE WITH OPPOSITE SIDES REMOVED. 3. CUBE WITH ONE SIDE REMOVED.

F, B, R & L : FRONT, BACK, RIGHT & LEFT AND REFER TO OPEN SIDES OF THE CUBES. BACK VIEWS ARE SHOWN WHEN NECESSARY. SOL LEWITT

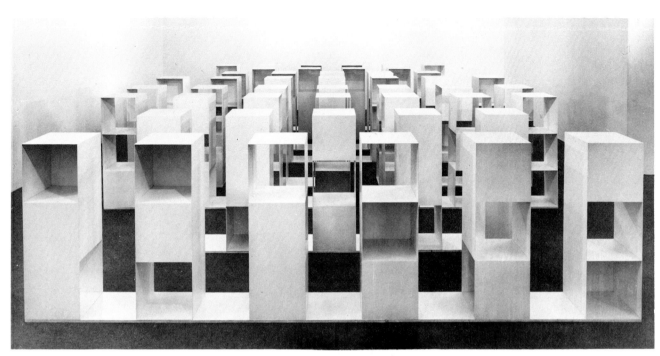

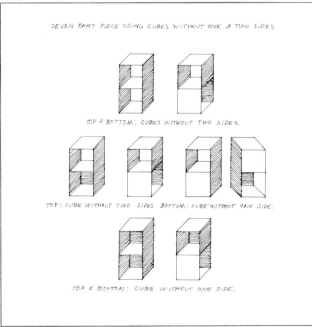

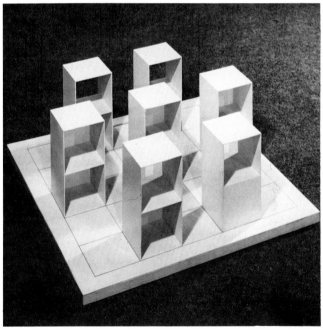

131. ALL THREE-PART VARIATIONS ON THREE DIFFERENT KINDS OF CUBES. 1969. Pen and ink, pencil, 29 x 23 in (73.5 x 58.4 cm).

132. *Top:* 47 THREE-PART VARIATIONS ON THREE DIFFERENT KINDS OF CUBES, 1967. Aluminum, 45 x 300 x 195 in (104.3 x 762 x 495.3 cm). Installation, Dwan Gallery, New York, 1968. Destroyed, remade in steel, 1974.

133. *Bottom left:* SEVEN-PART VARIATIONS ON TWO DIFFERENT KINDS OF CUBES. 1968. Pen and ink, pencil, 18½ x 18½ in (47 x 47 cm).

134. *Bottom right:* SEVEN-PART VARIATIONS ON TWO DIFFERENT KINDS OF CUBES (Small version). 1968. Polystyrene, 9 x 23 x 23 in (22.9 x 58.5 x 58.5 cm).

At first there were forty-seven variations. Later nine more were discovered. When the piece was remade in steel (1974) these were added. The steel version was made a little larger than the aluminum. Each stack of three was sixty inches high, instead of forty-five inches high. The aluminum set was not well constructed; the welds tended to separate and the sides to buckle. Each row is autonomous and can function independently of the entire piece while still implying the other rows. There are also larger groups containing cubes predominantly of one kind (see drawing).

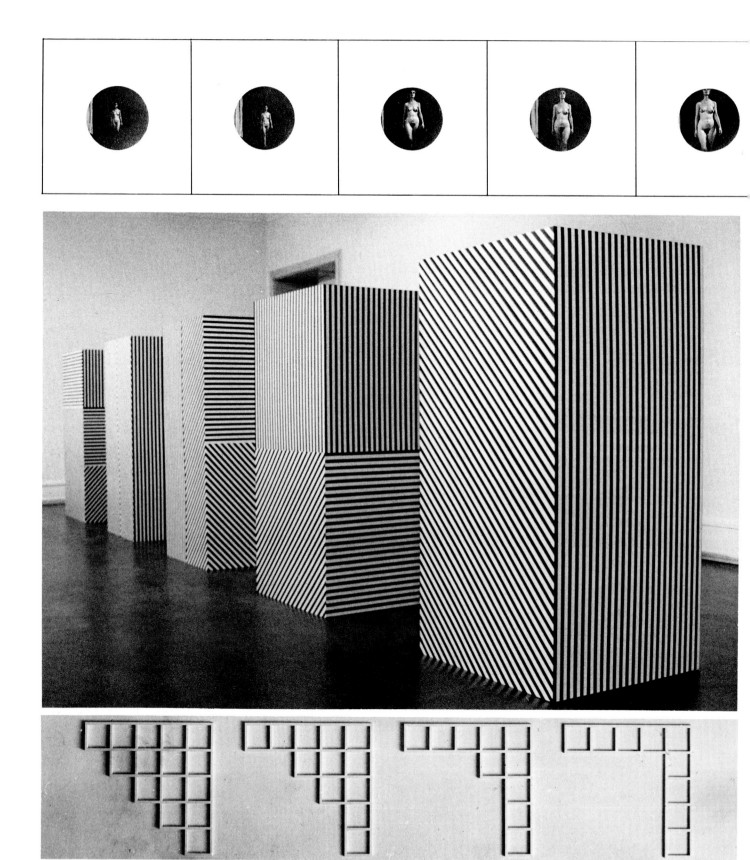

135. *Top:* MUYBRIDGE I (Schematic Representation). 1964. Painted wood with ten compartments, each 10¾ x 9⅝ x 9⅝ in (27.3 x 24.5 x 24.5 cm), containing photographs by Barbara Brown, Los Angeles, and flashing lights, 10¾ x 96 x 9⅝ in (27.3 x 243.9 x 24.5 cm).

136. *Center:* FIVE BOXES WITH STRIPES IN FOUR DIRECTIONS. 1972. Painted aluminum, each 80 x 40 x 40 in (203.2 x 101.6 x 101.6 cm).

137. *Bottom:* FOUR-PART MODULAR WALL SERIES. 1976. Painted brass, each part 38 x 38 x 38 in (96.5 x 96.5 x 96.5 cm).

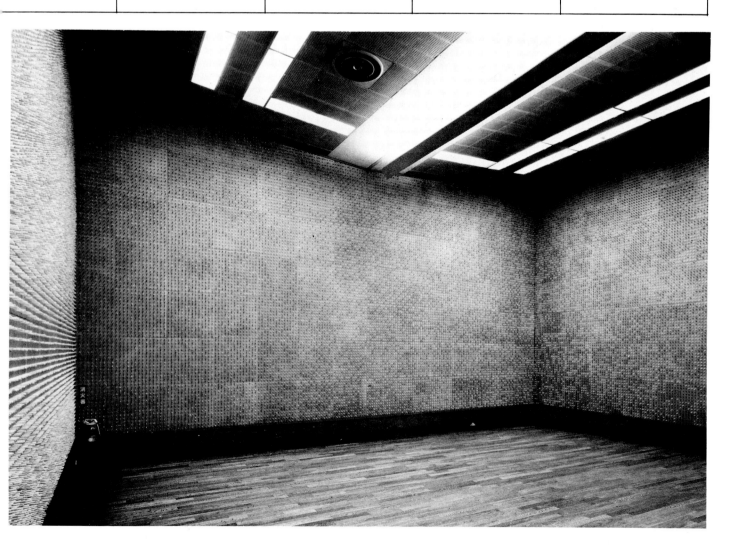

138. PROGRESSIVE COLORS ON FOUR WALLS. 1970. Colored paper, one room, approximately 12 x 30 x 30 ft (365.8 x 914.4 x 914.4 cm). Installation, Tokyo Biennale.

The work of Eadweard Muybridge has had a great impact on my thinking. This piece was done after some years of thought and experimentation and was the source of much of the serial work. At this time there was a search for a more objective method of organization as a reaction against the idea that art was composed with great sensitivity by the artist throughout the production of the work. This reaction eventually led to a theory of art that offered the idea that the original conception (perhaps intuition) of the work of art was of primary importance; the work would be carried through without deviation. It proposed the notion of the artist as a thinker and originator of ideas rather than a craftsman. Others, perhaps more able, could carry out the artist's design. If one used an analogy to music, this would place the artist in the role of a composer rather than player. Of course, the artist could also carry out the idea.

On the first wall to the left as one enters, pieces of rolled white paper 4 cm x 4 cm would be inserted into each of the holes that covers the facing of the wall. All the holes would be used. On the second wall adjacent to the first, white and yellow squares of paper 4 cm x 4 cm would be rolled and placed at random in the holes. The white and yellow pieces should be of equal number, and all of the holes should be filled. On the third wall, an equal number of white, yellow, and red squares of paper 4 cm x 4 cm would be inserted into the holes, all of which should be used. On the fourth wall, the same procedure would be used as in the other three but using an equal number of white, yellow, red, and blue rolled pieces of paper. When the project is completed all of the holes will have paper projecting from them. The colors should be inserted at random with no thought of arrangement or design.

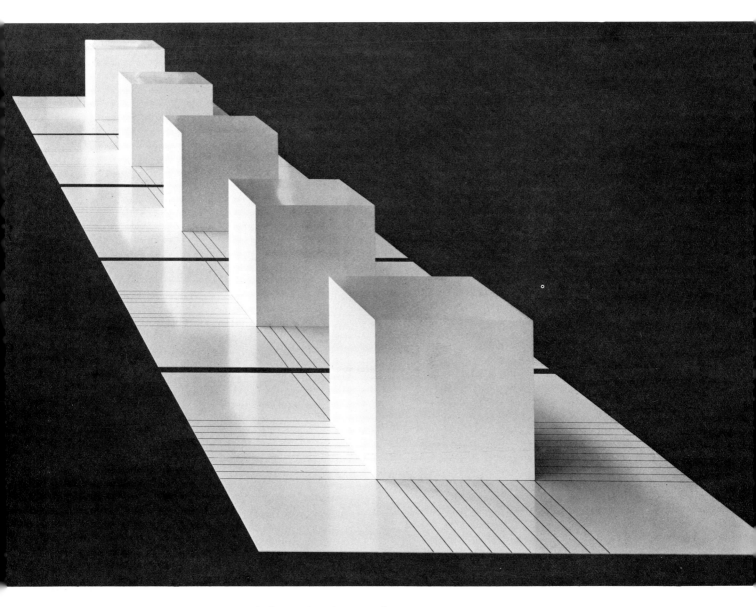

139. CUBES WITH HIDDEN CUBES. 1977. Baked enamel on aluminum,
24⅞ x 74½ in x 31 ft 8 in (63 x 189 x 965 cm).

140. *Top:* CUBES WITH HIDDEN CUBES. 1968. Pen and ink, 12¼ x 25¼ in (31.2 x 64.2 cm).

141. *Bottom:* CUBES WITH HIDDEN CUBES (Working Drawing). 1968. Pen and ink, 8½ x 11 in (21.6 x 28 cm).

When Serial Project No. 1 (ABCD) *was done, some of the pieces in parts C & D (outside closed) contained elements not seen but implied by the logic of the piece.* Cubes with Hidden Cubes *was a further investigation of the idea. The first version (later destroyed) was a made to fit the space of Konrad Fischer's Gallery in Düsseldorf, January 1968. It proposed that one needn't actually see things to understand their form and placement. In all cases the hidden elements were actually in place, even if they were not verifiable visually.*

7

1 X 2 Y

3 X

NO. 37-38 SAME

8 9 10 11

8 X 9 X 10 X 11 X

4 5 6 7

6 12 X 10,13 X X 14 13 X 16 X 17 X

28 29 X 30 X 31 32

37 38 35 36

18 X 19 X 22 X 23 X 24 X 25 X 26 X 27 X

20 X 21 X

39 39 40 41

33 34

42 43

X DON'T R?

Variations of Incomplete Open Cubes

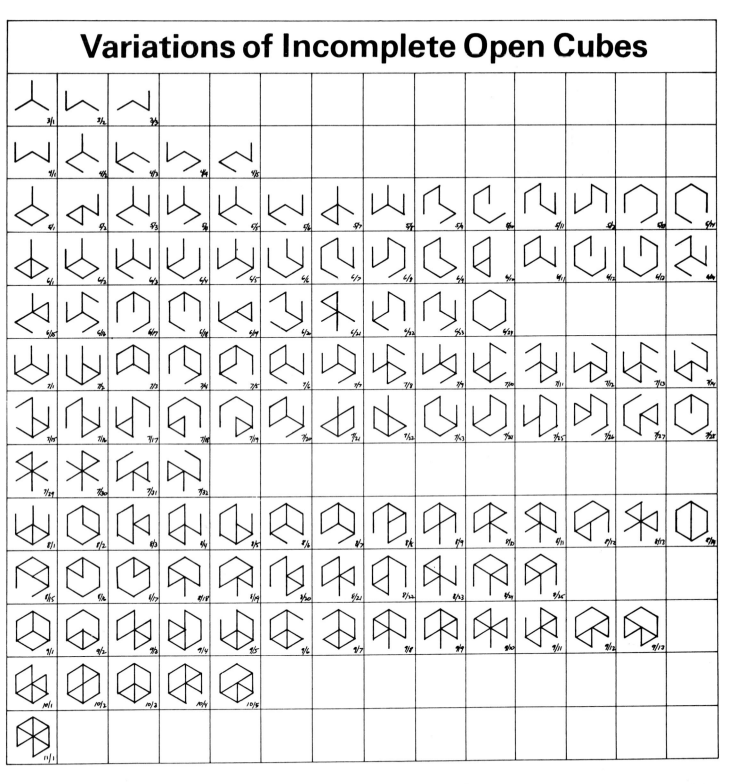

VARIATIONS OF INCOMPLETE OPEN CUBES. 1974

142. Opposite page: (Working Drawing). 1973. Pen and ink, colored pencils, 8½ x 11 in (21.6 x 28 cm).

143. Top: (Schematic Drawing). 1974. Pen and ink, 16 x 16 in (40.6 x 40.6 cm).

Although at first I thought it was not a complex project, this piece provided more problems than anticipated. Eventually all of the elements were worked out empirically and verified by Dr. Erna Herrey, a mathematician and physicist, and confirmed by Arthur Babakhanian of the graduate school of the Mathematics Department at the University of Illinois. The series started with three-part pieces because a cube implies three dimensions and, of course, ends with one eleven-part piece (one bar removed). In this case, if one understands the idea of a cube, one may mentally reconstruct the cube, filling in the missing bars. The book that is a part of the piece works in conjunction with the three-dimensional forms, showing photographs and isometric drawings of each part.

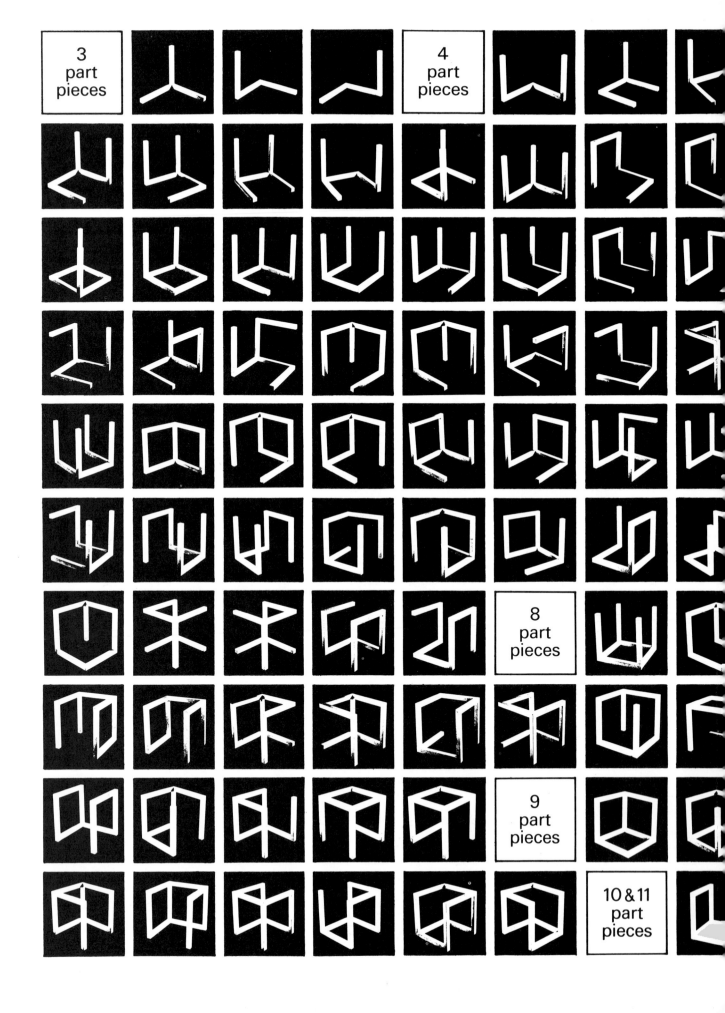

3
part
pieces

4
part
pieces

8
part
pieces

9
part
pieces

10 & 11
part
pieces

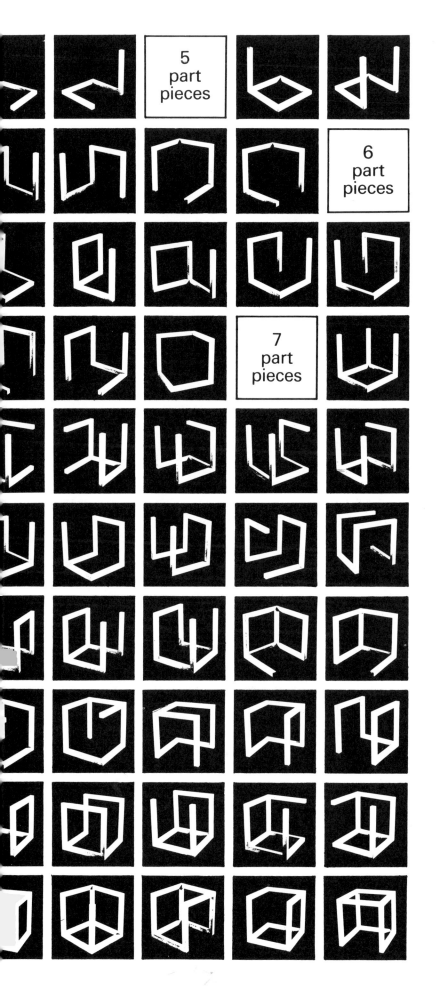

144. VARIATIONS OF INCOMPLETE OPEN CUBES. 1974.
Large version, each structure 43 x 43 x 43 in (109.2 x 109.2
x 109.2 cm). Small version, each structure 8 x 8 x 8 in
(20.3 x 20.3 x 20.3 cm). All 122 constitute one piece. From
Art & Project, bulletin 88.

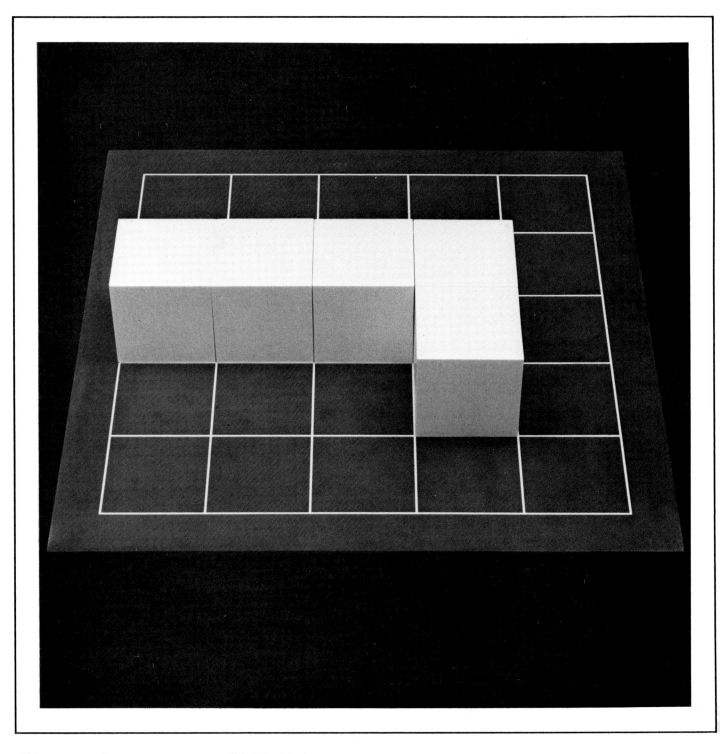

145. FIVE CUBES/ TWENTY-FIVE SQUARES (Sides Touching). 1977.
Plastic (also steel), each cube 6 x 6 x 6 in (15.2 x 15.2 x 15.2 cm); base 1 x 33
x 33 in (2.5 x 83.8 x 83.8 cm). All combinations of five cubes on a
five-by-five square base that touch one another at least on one side.
Two versions, one steel, one plastic, and a book to show all varia-
tions (571 possibilities).

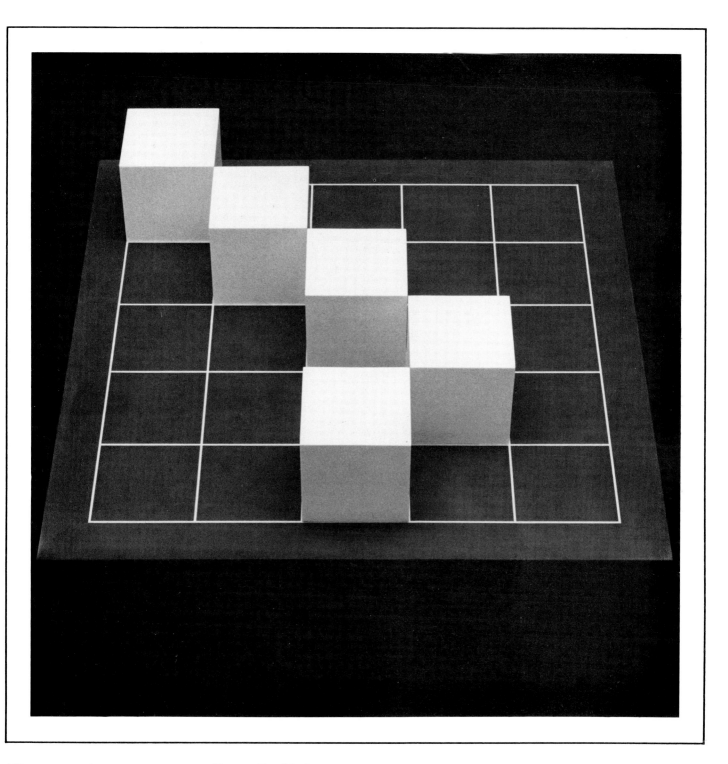

146. FIVE CUBES/TWENTY-FIVE SQUARES (Corners Touching). 1977.
Plastic (also steel), each cube 6 x 6 x 6 in (15.2 x 15.2 x 15.2 cm); base 1 x 33
x 33 in (2.5 x 83.8 x 83.8 cm). All combinations of five cubes on a
five-by-five square base that touch one another at least on one
corner. Two versions, one steel, one plastic, and a book to show all
variations (251 possibilities).

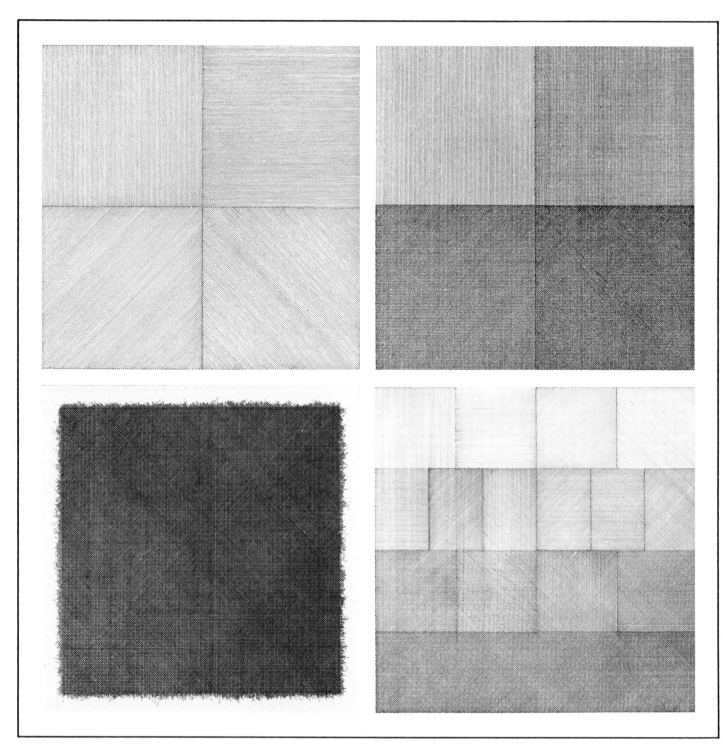

SERIAL DRAWINGS

147. Top left: LINES IN FOUR DIRECTIONS, EACH IN A QUARTER OF A SQUARE. 1969. Pen and ink, 8 x 8 in (20.3 x 20.3 cm).

148. Top right: LINES IN FOUR DIRECTIONS, SUPERIMPOSED PROGRESSIVELY, EACH IN A QUARTER OF A SQUARE. 1969. Pen and ink, 8 x 8 in (20.3 x 20.3 cm).

149. Bottom left: LINES IN FOUR DIRECTIONS, SUPERIMPOSED. 1971. Pen and ink, 14 x 14 in (35.5 x 35.5 cm).

150. Bottom right: COMPOSITE: LINES IN FOUR DIRECTIONS IN SINGLE, DOUBLE, TRIPLE, AND QUADRUPLE COMBINATIONS. 1969. Pen and ink, 14 x 14 in (35.6 x 35.6 cm).

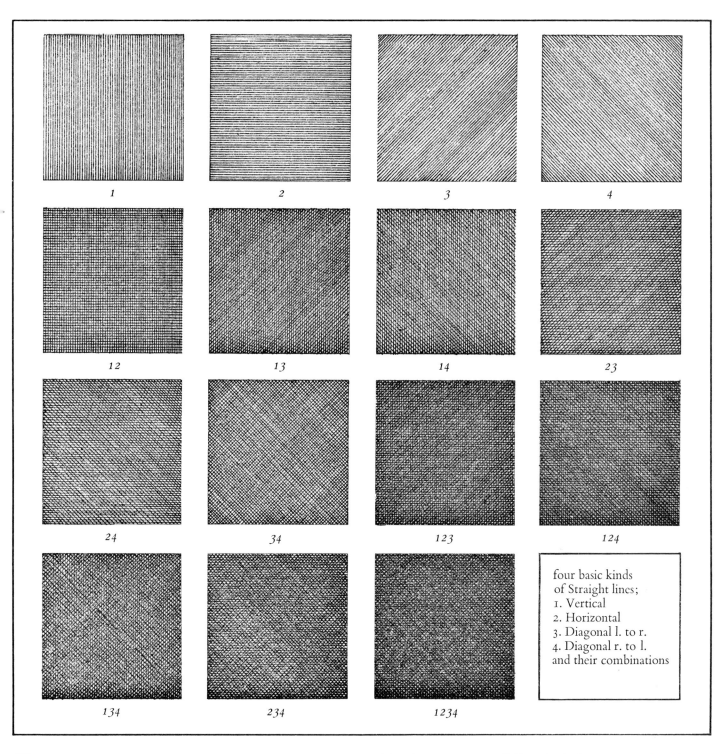

1 2 3 4

12 13 14 23

24 34 123 124

134 234 1234

four basic kinds
of Straight lines;
1. Vertical
2. Horizontal
3. Diagonal l. to r.
4. Diagonal r. to l.
and their combinations

151. FOUR BASIC KINDS OF STRAIGHT LINES AND ALL THEIR COMBI-NATIONS IN FIFTEEN PARTS. 1969. Pen and ink, each part 8 x 8 in (20.3 x 20.3 cm). From book *Four Basic Kinds of Straight Lines*, 1969.

These drawings, using parallel lines closely drawn, were used to make a finite series. They also provided the vocabulary for further series. Later four colors were used with the four lines. The directions of the lines (vertical, horizontal, and two 45-degree diagonals) were absolute possibilities. The colors used were the three primary colors (yellow, red, and blue) plus black. The page was white. Superimpositions of line and color provided progressive gradations of tone and color. In 1969 Peter Townsend, the editor of Studio International, *published a book in which I made each page as a single variation, making a complete, finite series. Later the color version of this book was published in 1971 by the Lisson Gallery, London.*

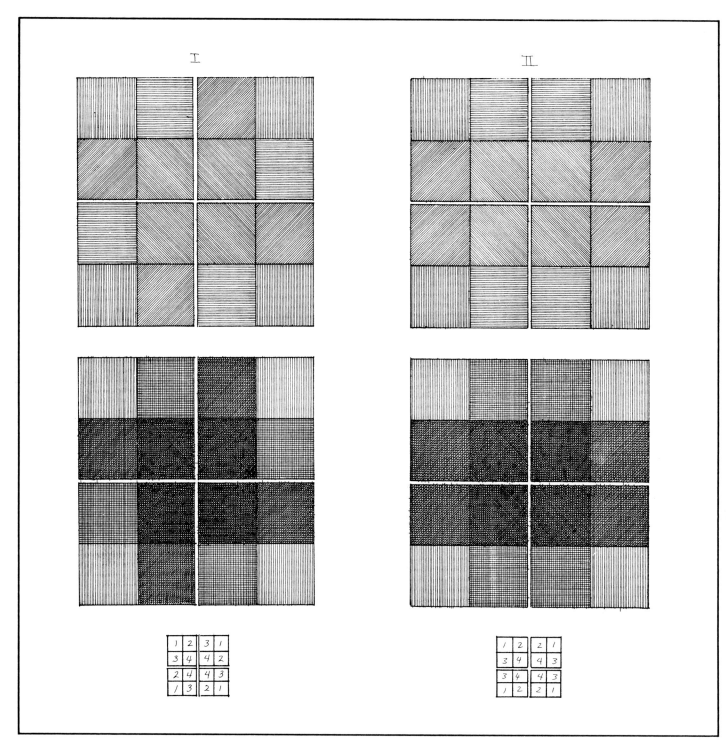

152–155. DRAWING SERIES I, II, III, IIII. 1969–70. 192 pen and ink drawings, each 12 x 12 in (30.5 x 30.5 cm).

Top row: Series A (simple). *Bottom row:* Series B (superimposed).

Seth Siegelaub asked me to contribute twenty-five pages to a book to be reproduced by Xerox. I worked out a system of twenty-four permutations of 1, 2, 3, 4 using the linear system. The changes were made by rotating the numbers in four sections of four. Each example was drawn in the simple (not superimposed) method. Then, I wanted to make a more complete statement of this system and used four different methods of change: I Rotation, II Mirror, III Cross & Reverse Mirror, IIII Cross Reverse. Each group of twenty-four was done two ways, simple and superimposed, making a total of 192 variations. The drawings were later published in book form by Gian Enzo Sperone and Konrad Fischer, using the simple form on the left-hand page and the superimposed method on the right-hand page. The book also contained composites of all of the systems, which were very well printed by Petrino in Turin.

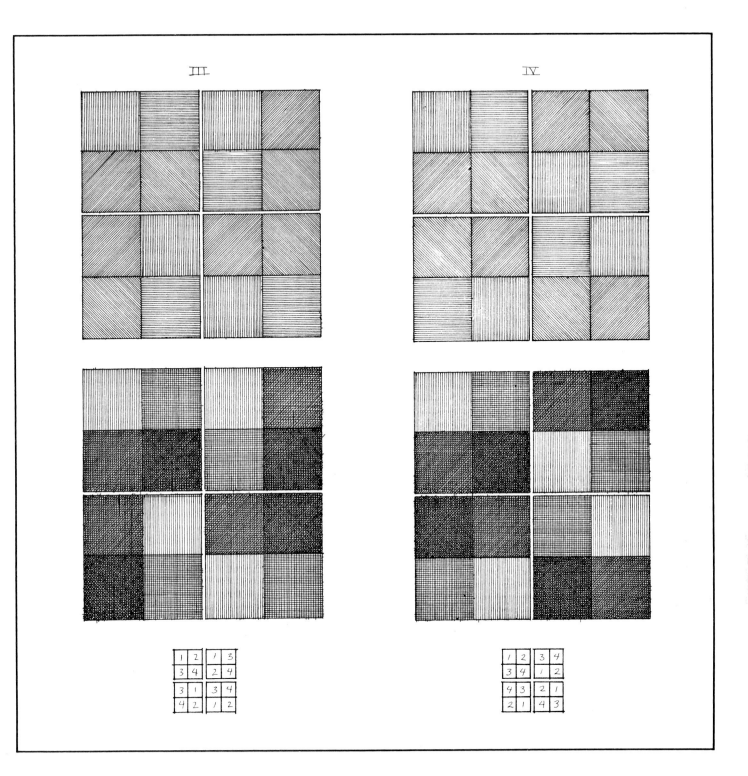

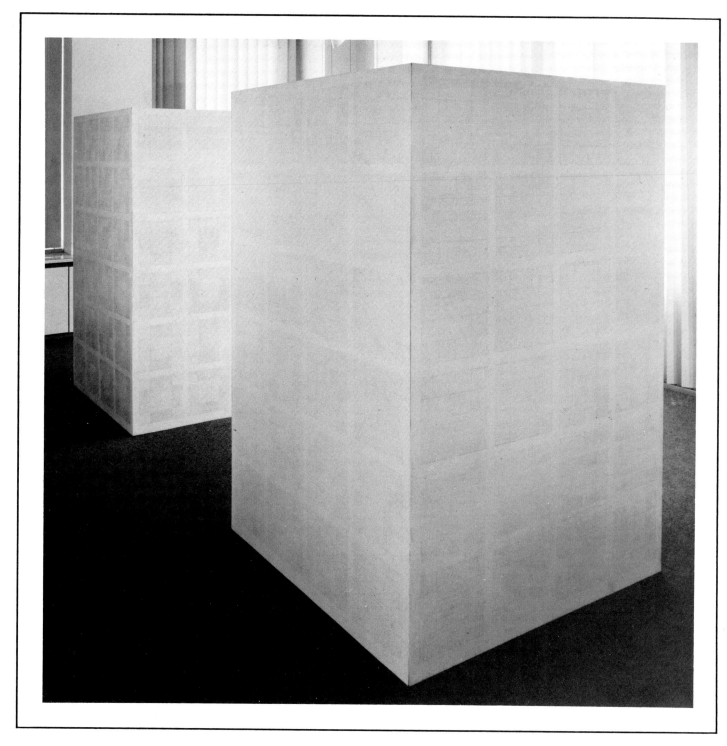

156. BOXES WITH DRAWING SERIES I, II, III, IIII. 1970. Pencil on painted aluminum, each box 6 x 4 x 4 ft (172.9 x 122 x 122 cm). Draftsman: Adrian Piper.

Left: Series B (superimposed). *Right:* Series A (simple).

157. *Opposite page:* VERTICAL AND HORIZONTAL LINES. 1970. Pen and ink, 13¾ x 10¼ in (35 x 26 cm).

Continuing the idea of using four as a determinant for the series, two boxes were made, one for the simple, the other for the superimposed method. On the face of each was drawn (by Adrian Piper) each series. The boxes were to be placed so that each complimentary series would face in the same direction.

Feb 13, 1970
Sol LeWitt

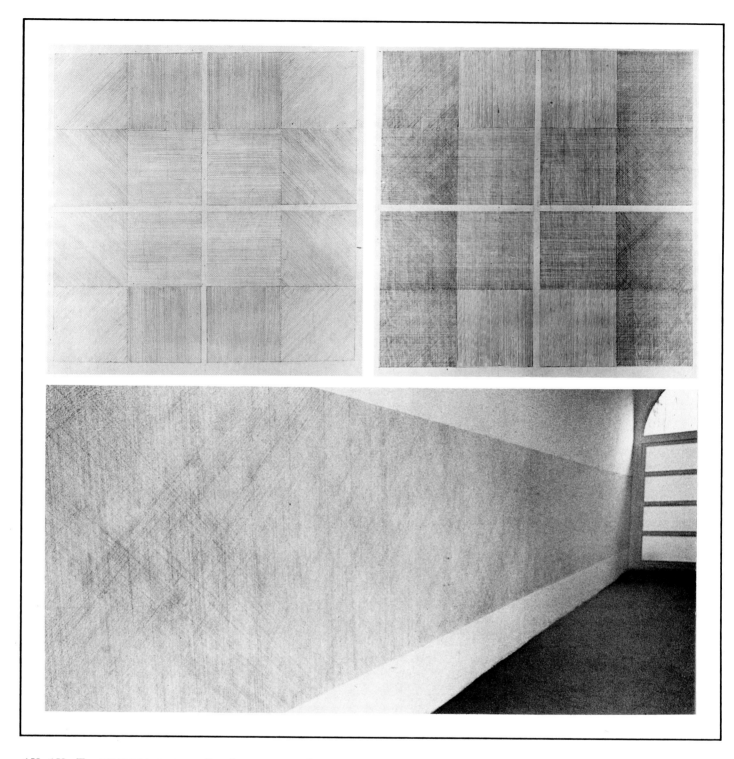

158–159. *Top:* WALL DRAWING. 1968. Pencil, two parts, each part 4 x
4 ft (122 x 122 cm). Installation, Paula Cooper Gallery, New York.
Draftsman: S. LeWitt. From DRAWING SERIES I, II, III, IIII.

160. *Bottom:* WALL DRAWING USING VERTICAL AND TWO DIAGONAL
LINE DIRECTIONS. 1969. Pencil, 39⅜ in x 32 ft (1 x 15 m). Installation,
Konrad Fischer Gallery, Düsseldorf. Draftsmen: H. Hermann and
assistants.

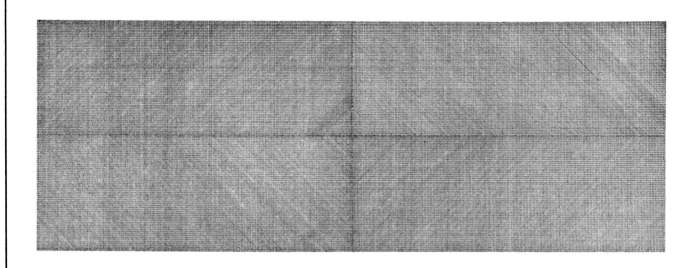

This wall drawing was executed by Adrian Piper, Jerry Orter and Sol LeWitt on the south wall of the smaller room of the Paula Cooper Gallery, 96 Prince St. It is part of an exhibition for the benefit of the Art Workers Coalition and was compiled by Lucy Lippard. This drawing is 16'8" X 6', composed of four sections, each 8'4" X 3', and was drawn with 9H graphite sticks. The drawing is the width of the wall, the height of each section (3') is dictated by the maximum length that a line can be easily drawn using a 45° right triangle as a guide. Each of the four sections has three crossing lines superimposed on one another (vertical, horizontal, diagonal left to right, and diagonal right to left-45°; representing the basic directions that lines can be drawn). These lines are drawn as lightly and as close together as possible (1/16"). The tonality of the drawing should be equal since there are an equal number of lines in each segment. However the properties of the wall, in some cases, dictate the darkness of the line (e.g. if there is a trace of grease or foreign substance, or if the wall bulges out). The pressure exerted by the draftsmen is not always equal, nor is the distance between lines always the same accounting for darker areas. These deviations are acceptable and beyond the scope of planning, they are inherent in the method. The wall drawing is perceived first as a light tonal mass - light enough to preserve the integrity of the wall plane - and then as a collection of lines. Neither the wall drawing, this drawing in ink, or the photographic record of the wall drawing are definitive but all are of equal importance. The wall drawing is temporary and will be removed at the discretion of the Paula Cooper Gallery. Sol LeWitt May 20, 1969

161. PLAN FOR WALL DRAWING, PAULA COOPER GALLERY, NEW YORK. 1969. Pen and ink, pencil, 20⅞ x 20¾ in (53 x 52.7 cm).

Now the drawing technique being used on paper was also being drawn on walls, and in many cases also used in the books. Most of the wall drawings were done with a very hard pencil so that they would remain a visual part of the wall. Later, however, it was found that even with a crayon the integrity of the wall was maintained. The entire wall was used in later drawings, but at first, when the Drawing Series was used, only a square (usually about 4 x 4 feet) was drawn.

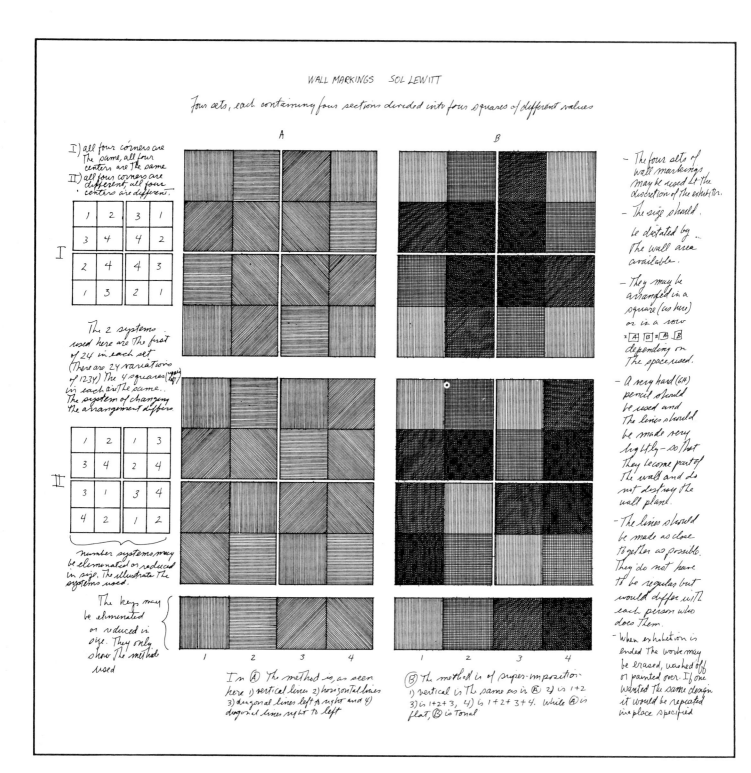

162. WALL MARKINGS. 1968. Pen and ink, ca. 16 x 16 in (40.6 x 40.6 cm).

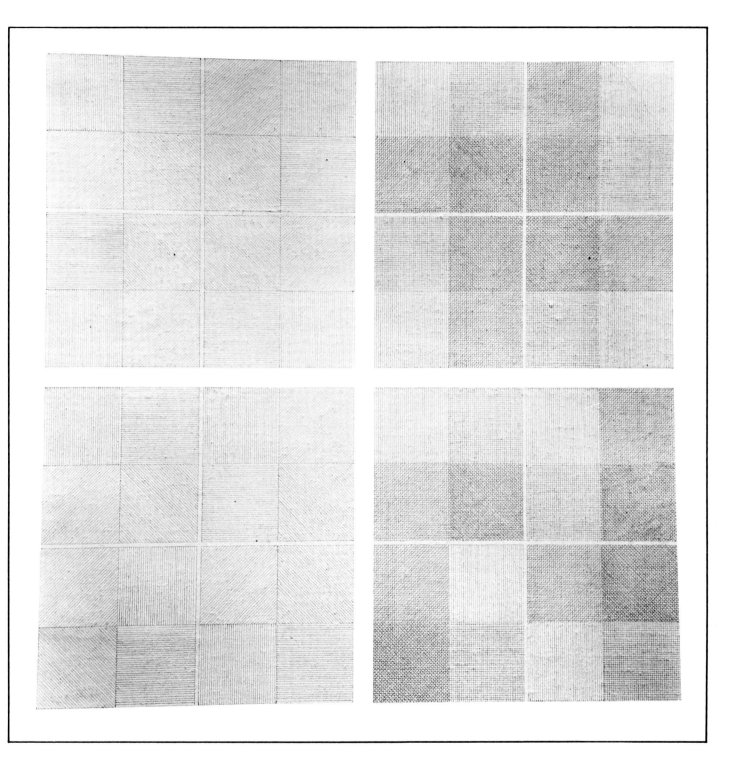

163. WALL DRAWING. 1969. Pencil. Installation, Kunsthalle Bern. "When Attitudes Become Form" exhibition, 1969. Draftsman: M. Raetz.

These drawings were taken from the Drawing Series I, II, III, IIII. *The wall drawing was done exceptionally well by the Swiss artist Markus Raetz in Bern. These wall drawings are very difficult to photograph because of the pale line. A hard pencil was used to keep the line a visual part of the wall and to maintain the plane of the wall. Wall drawings are to be considered ideas rather than objects. They can be moved by being painted out and then redrawn (not necessarily by the same person or the same size) on another wall.*

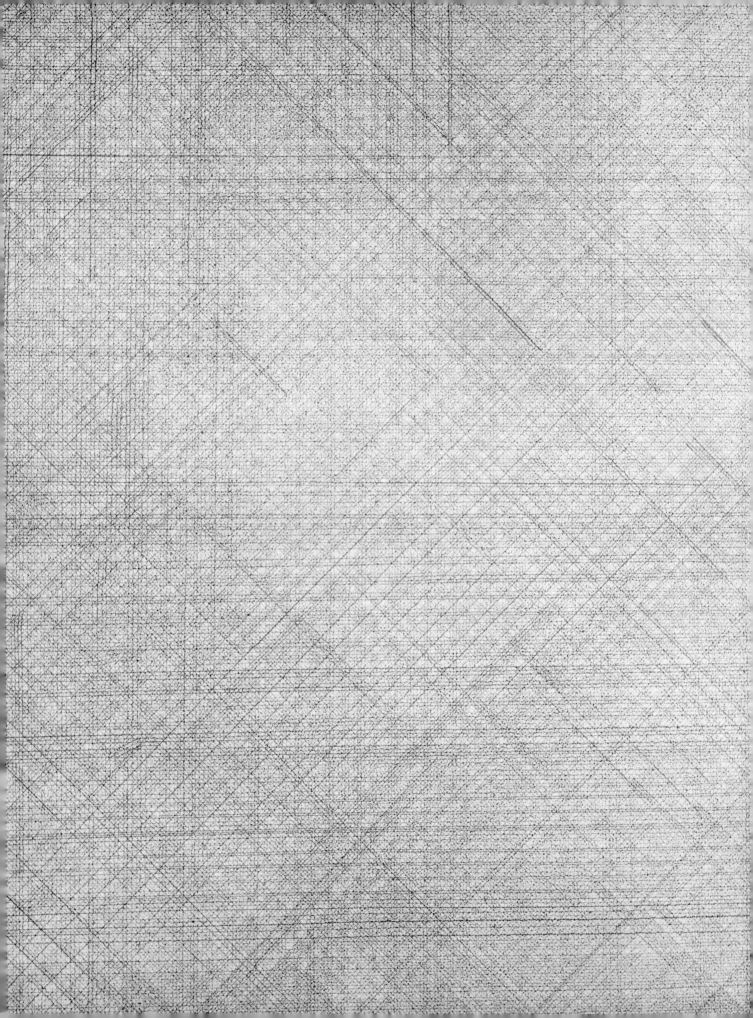

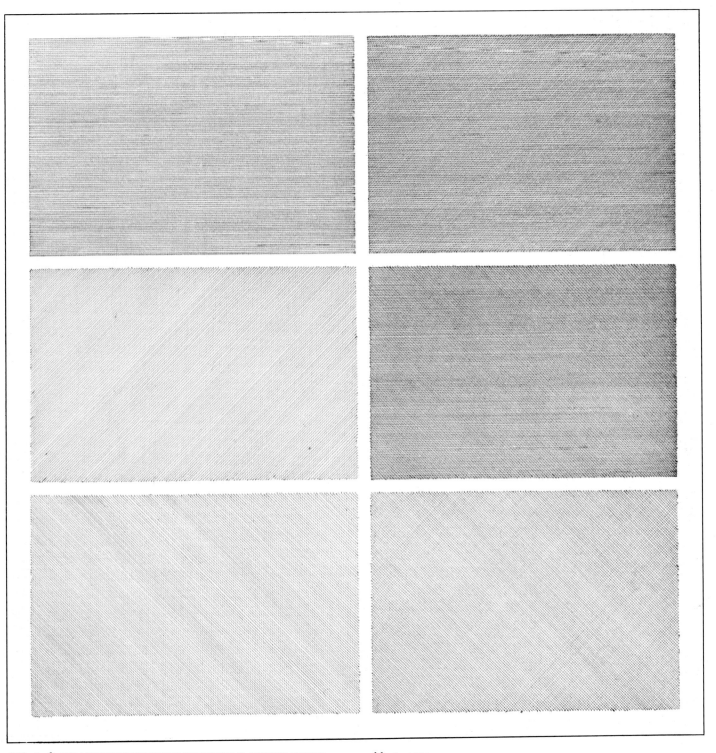

164. *Left:* STRAIGHT LINES IN FOUR DIRECTIONS, SUPERIMPOSED (Detail of Wall Drawing). 1969. Pencil, 12 ft x 26 ft 9½ in (365.8 x 816.7 cm). Installation, The Museum of Modern Art, New York, 1974. Draftsmen: K. Miyamoto, J. and R. Watanabe, and others.

165. *Above:* SIX-PART COLOR COMPOSITE WITH TWO COLORS IN EACH PART. 1970. Pen and colored ink, 18¾ x 18¾ in (47.6 x 47.6 cm).

Next pages:

166. ALL SINGLE, DOUBLE, TRIPLE, AND QUADRUPLE COMBINATIONS OF LINES IN FOUR DIRECTIONS IN ONE-, TWO-, THREE-, AND FOUR-PART COMBINATIONS. 1969. Pen and ink, 14¾ x 19⅝ in (37.5 x 49.9 cm). From *Art & Project,* bulletin 18.

167. ALL SINGLE, DOUBLE, TRIPLE AND QUADRUPLE COMBINATIONS OF LINES AND COLOR IN ONE-, TWO-, THREE-, AND FOUR-PART COMBINATIONS. 1970. Pen and colored ink, 20⅛ x 35½ in (51 x 90 cm).

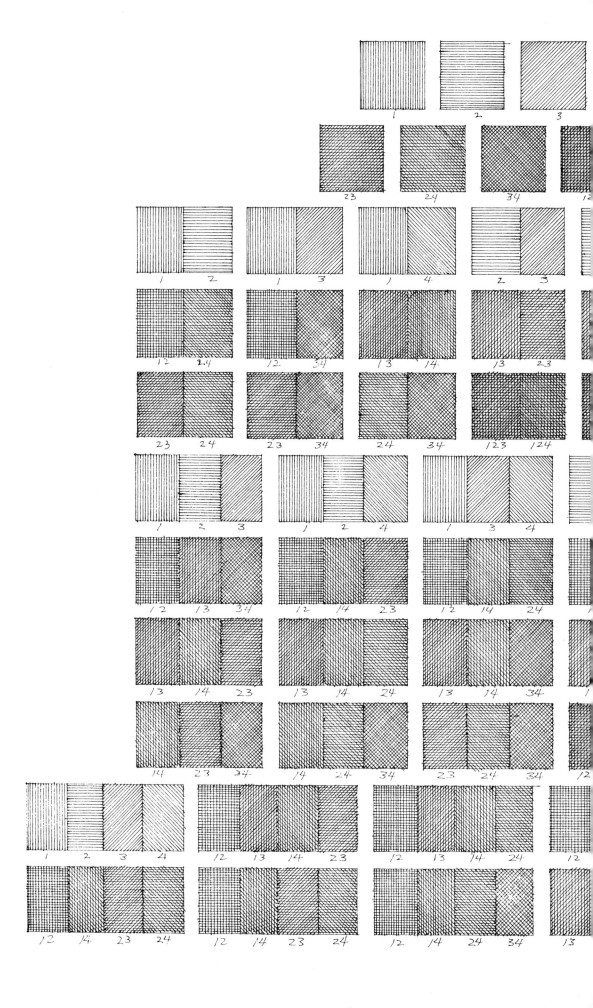

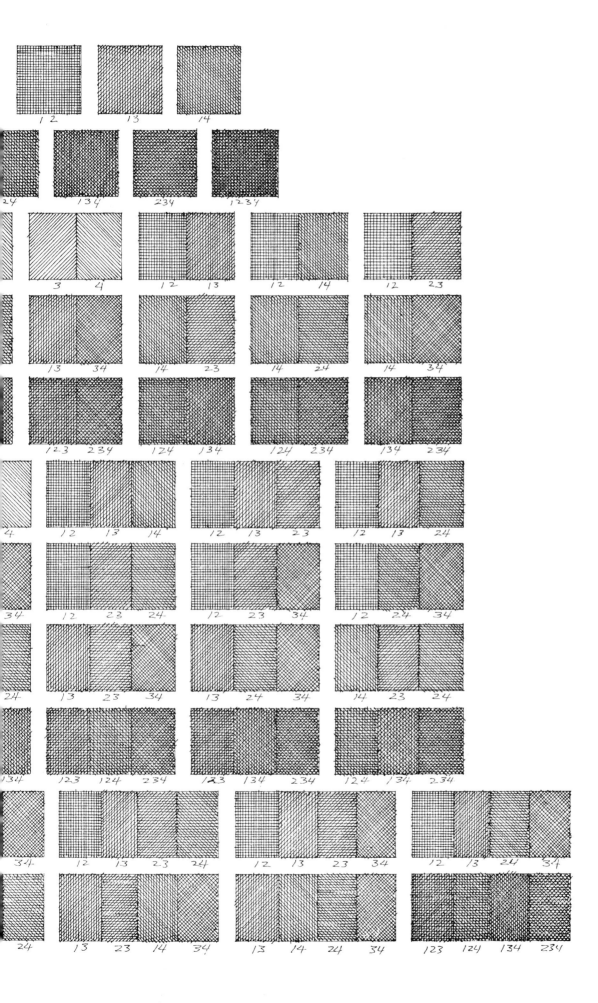

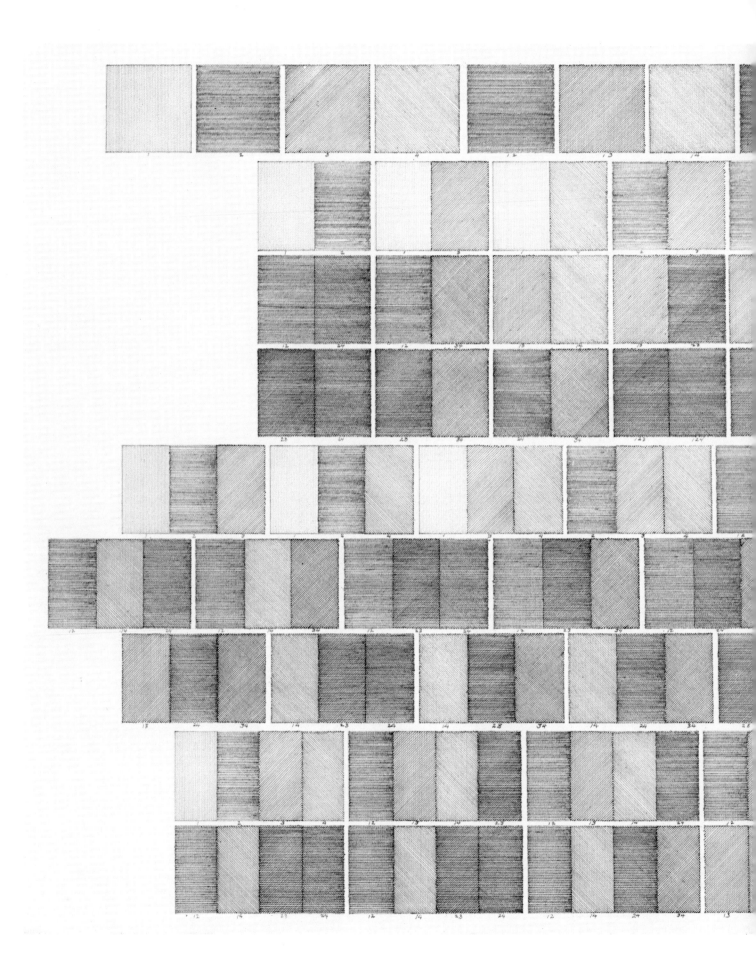

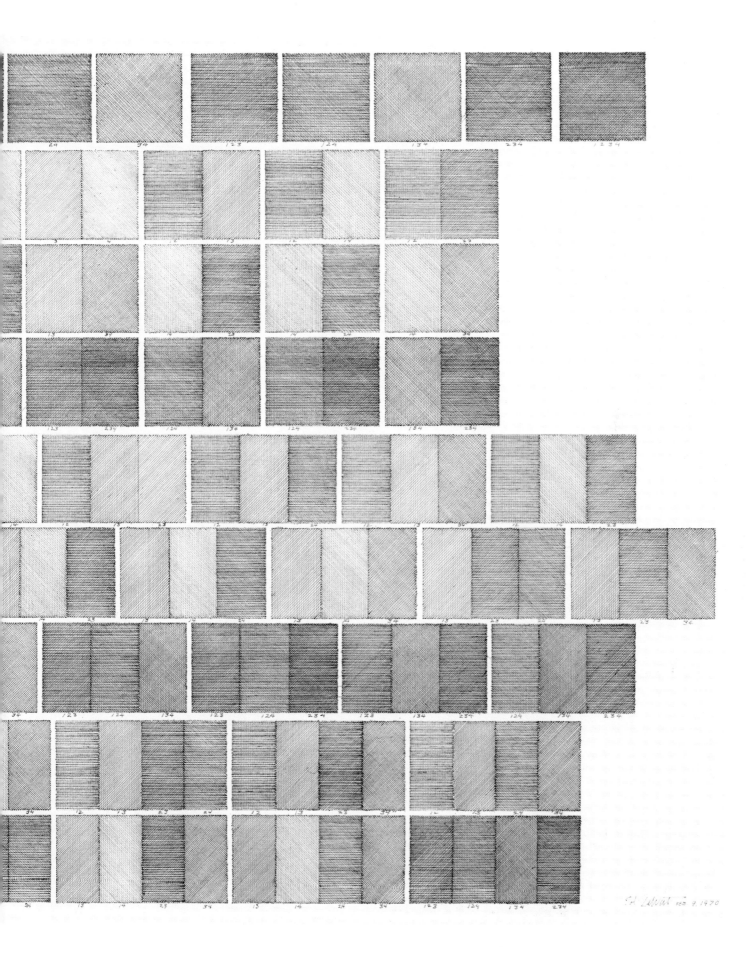

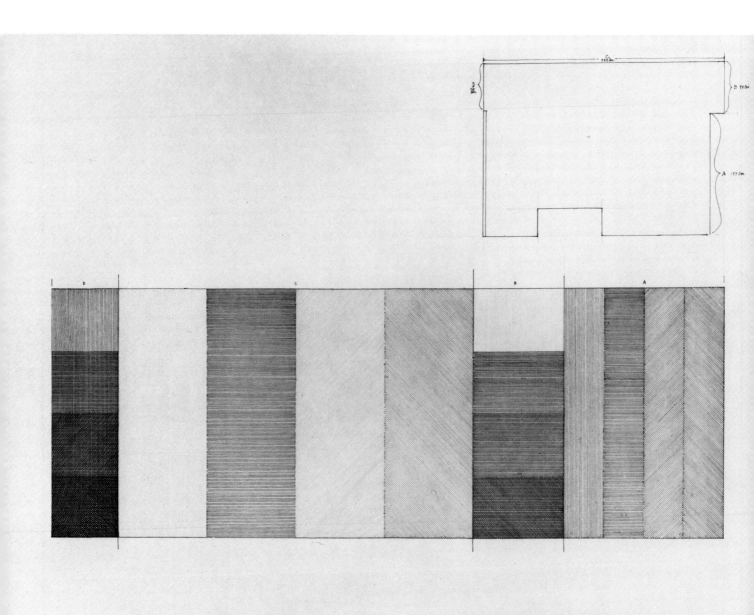

PLAN FOR WALL DRAWING/ VISSER HOUSE, BERGEYK, HOLLAND / *Sol LeWitt* SEPTEMBER 5, 1971

168. PLAN FOR WALL DRAWING, VISSER HOUSE, BERGEYK, HOLLAND.
1970. Pen and colored ink, 14⅛ x 20⅛ in (35.7 x 51.1 cm).

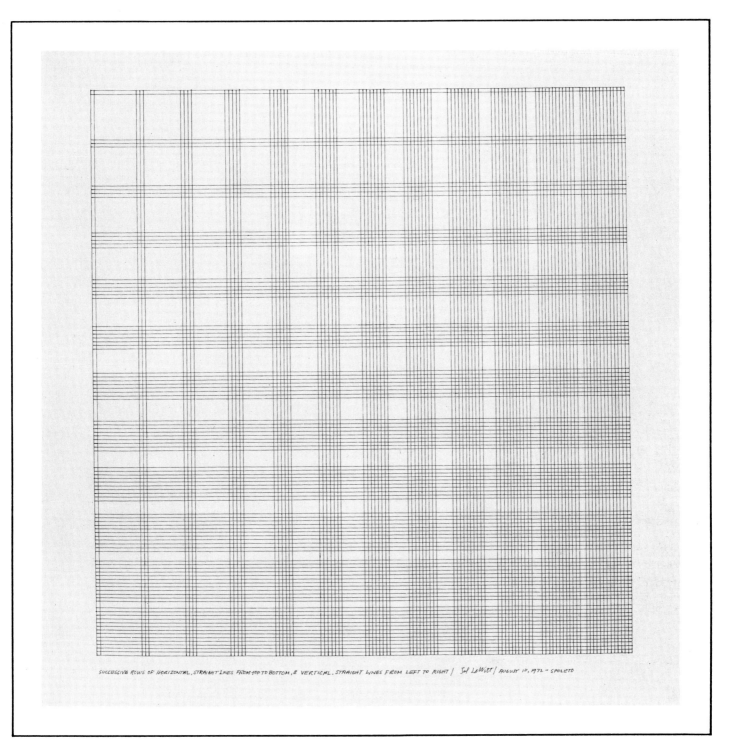

169. SUCCESSIVE ROWS OF HORIZONTAL, STRAIGHT LINES FROM
TOP TO BOTTOM, AND VERTICAL, STRAIGHT LINES FROM LEFT TO
RIGHT. 1972 Pen and ink, 14⅝ x 14⅝ in (37 x 37 cm).

I. HORIZONTAL, VERTICAL, DIAGONAL RIGHT

HORIZ. / VERT. / DIAG RT / DIAG. L.							
Yellow / Yellow / Yellow	Yellow / Yellow / Red	Yellow / Yellow / Blue	Yellow / Red / Yellow	Yellow / Red / Red	Yellow / Red / Blue	Yellow / Blue / Yellow	Ye… / B… / Y…
Red / Yellow / Yellow	Red / Yellow / Red	Red / Yellow / Blue	Red / Red / Yellow	Red / Red / Red	Red / Red / Blue	Red / Blue / Yellow	
Blue / Yellow / Yellow	Blue / Yellow / Red	Blue / Yellow / Blue	Blue / Red / Yellow	Blue / Red / Red	Blue / Red / Blue	Blue / Blue / Yellow	

HORIZ / VERT / DIAG. RT / DIAG. L							
Yellow / Yellow / Yellow	Yellow / Yellow / Red	Yellow / Yellow / Blue	Yellow / Red / Yellow	Yellow / Red / Red	Yellow / Red / Blue	Yellow / Blue / Yellow	Y… / B…
Red / Yellow / Yellow	Red / Yellow / Red	Red / Yellow / Blue	Red / Red / Yellow	Red / Red / Red	Red / Red / Blue	Red / Blue / Yellow	
Blue / Yellow / Yellow	Blue / Yellow / Red	Blue / Yellow / Blue	Blue / Red / Yellow	Blue / Red / Red	Blue / Red / Blue	Blue / Blue / Yellow	B…

II. HORIZONTAL, VERTICAL, DIAGONAL LEFT

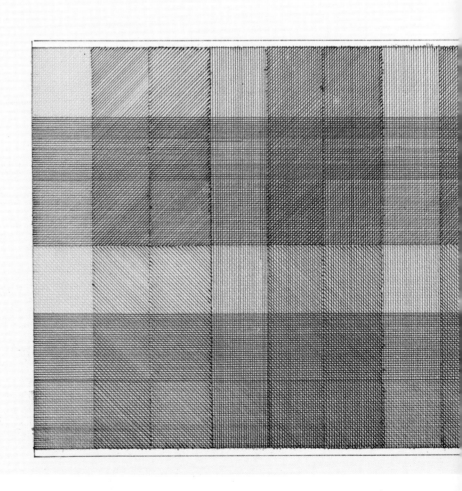

170. ALL THREE-PART COMBINATIONS OF LINES IN FOUR DIRECTIONS (HORIZONTAL, VERTICAL, DIAGONAL RIGHT, AND DIAGONAL LEFT) IN THREE COLORS (YELLOW, RED, AND BLUE). 1975. Pen and colored ink, pencil on tracing paper, 18⅛ x 24 in (45.9 x 60.8 cm).

171. *Following two pages:* COME AND GO. Drawing for play of Samuel Beckett, *Harper's Bazaar,* April 1969. Pen and ink, 18 x 22¼ in (45.7 x 56.5 cm).

172. *Page 108:* FOUR-COLOR DRAWING. 1970. Pen and ink, 14 x 10½ in (30.5 x 26.7 cm).

III HORIZONTAL, DIAGONAL LEFT, DIAGONAL RIGHT

Key			1	2	3	4	5	6	7	8	9	
I HORIZONTAL VERTICAL DIAG RIGHT	**III** HORIZONTAL DIAG. RIGHT DIAG. LEFT		Yellow	Yellow	Yellow	Yellow	Yellow	Yellow	Yellow	Yellow	Yellow	HORIZ VERT
			Yellow Yellow	Yellow Red	Yellow Blue	Red Yellow	Red Red	Red Blue	Blue Yellow	Blue Red	Blue Blue	DIAG.RT DIAG.L.
II HORIZONTAL VERTICAL DIAGONAL LEFT	**IV** VERTICAL DIAG. RIGHT DIAG. LEFT		Red	Red	Red	Red	Red	Red	Red	Red	Red	HORIZ VERT
			Yellow Yellow	Yellow Red	Yellow Blue	Red Yellow	Red Red	Red Blue	Blue Yellow	Blue Red	Blue Blue	DIAG.RI DIAG.L.
			Blue	Blue	Blue	Blue	Blue	Blue	Blue	Blue	Blue	HORIZ VERT
			Yellow Yellow	Yellow Red	Yellow Blue	Red Yellow	Red Red	Red Blue	Blue Yellow	Blue Red	Blue Blue	DIAG.RT DIAG.L.
			Yellow Yellow Yellow	Yellow Yellow Red	Yellow Yellow Blue	Yellow Red Yellow	Yellow Red Red	Yellow Red Blue	Yellow Blue Yellow	Yellow Blue Red	Yellow Blue Blue	HORIZ VERT DIAG.RT DIAG.L.
			Red Yellow Yellow	Red Yellow Red	Red Yellow Blue	Red Red Yellow	Red Red Red	Red Red Blue	Red Blue Yellow	Red Blue Red	Red Blue Blue	HORIZ VERT DIAG.RT DIAG.L.
			Blue Yellow Yellow	Blue Yellow Red	Blue Yellow Blue	Blue Red Yellow	Blue Red Red	Blue Red Blue	Blue Blue Yellow	Blue Blue Red	Blue Blue Blue	HORIZ VERT DIAG.RT DIAG.L.

IV VERTICAL, DIAGONAL RIGHT, DIAGONAL LEFT

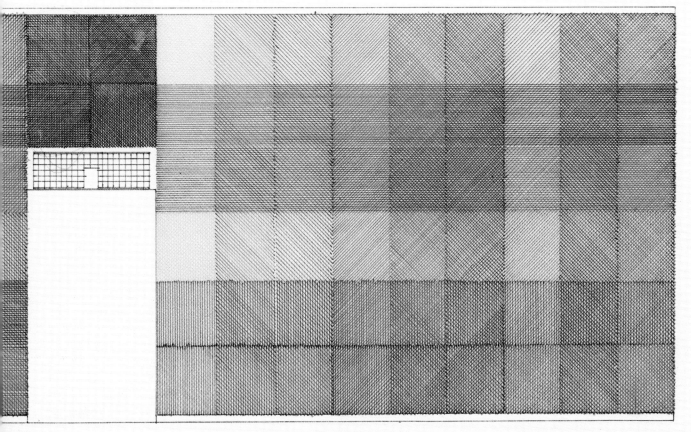

105

COME AND GO

A Dramaticule

For
John Calder

Characters

FLO
VI
RU

Age
undeterminable

*Sitting
center
by side
stage right
to left
FLO, VI, and
RU. Very
erect,
facing front,
hands
clasped in
laps.*

side.

VI: Ru.
RU: Yes.
VI: Flo.
FLO: Yes.
VI: When did we three last meet?
RU: Let us not speak.

> *Silence.*
> *Exit VI right.*
> *Silence.*

FLO: Ru.
RU: Yes.
FLO: What do you think of Vi?
RU: I see little change.
> *(FLO moves to center seat,
> whispers in Ru's ear. Appalled.)*
> Oh! *(They look at each other.
> FLO puts her finger to her lips.)*
> Does she not realize?
FLO: God grant not.

> *Enter VI. FLO and RU
> turn back front, resume pose. VI
> sits right. Silence.*

FLO· Just sit toge-
ther as we used
to. in the
playground at
Miss Wade's
RU· On the log.

> *Silence*
> *Exit FLO left.*
> *Silence.*

RU: Vi.
VI: Yes.
RU: How do you find Flo?
VI: She seems much the same.
> *(RU moves to center seat, whispers in Vi's
> ear. Appalled.)* Oh! *(They look at each other. RU puts
> her finger to her lips.)* Has she not been told?
RU: God forbid.

> *Enter FLO. RU and VI turn back front, resume
> pose. FLO sits left. Silence.*

RU: Holding hands . . . that way.
FLO: Dreaming of . . . love.

Silence.

Drawing by Sol LeWitt

BY SAMUEL BECKETT

NOTES

Successive
positions

1	Flo	Vi	Ru
2	{ Flo		Ru
		Flo	Ru
3	Vi	Flo	Ru
4	{ Vi		Ru
	Vi	Ru	
5	Vi	Ru	Flo
6	{ Vi		Flo
		Vi	Flo
7	Ru	Vi	Flo

Silence.
Exit RU right.
Silence.

VI: Flo.

FLO: Yes.

VI: How do you think
 Ru is looking?

FLO: One sees little in this light.
 *(VI moves to center seat, whispers in Flo's
 ear. Appalled.)* Oh! *(They look at each other. VI puts her
 finger to her lips.)* Does she not know?

VI: Please God not.

*Enter RU. VI and FLO
turn back front, resume
pose. RU sits right.
Silence.*

VI: May we not speak
 of the old days?
 (Silence.) Of what
 came after?
 (Silence.) Shall
 we hold hands in the
 old way?

*After a moment
they join hands as
follows: Vi's right
hand with Ru's
right hand, Vi's left
hand with Flo's
left hand, Flo's right
hand with Ru's left
hand. Vi's arms being
above Ru's left arm
and Flo's right
arm. The three pairs
of clasped hands rest
on the three laps.
Silence.*

Hands

*(Continued on
page 198)*

FLO: I can feel the rings.

Silence.

FOUR COLOR DRAWING FEB. 18, 1970 S. LeWitt

LINES

173. Previous page: LINES NOT SHORT, NOT STRAIGHT, CROSSING AND TOUCHING (Wall Drawing) 1971. Colored pencils. Installation, Clocktower, New York, March 1975. Draftsman: J. Watanabe.

174. LINES NOT LONG, NOT STRAIGHT, NOT TOUCHING (Detail of Wall Drawing). Colored pencils. Installation, Guggenheim Museum VI International, New York, February 2, 1971. Draftsman: K. Miyamoto.

175. Opposite page: VERTICAL LINES, NOT STRAIGHT, NOT TOUCH-ING. 1977. Pen and ink, 14¾ x 13¼ in (37.5 x 33.7 cm).

Done in five bays at the Guggenheim Museum's VI International in 1971, these wall drawings were a survey of the uses of lines. The titles had become more and more descriptive and important. The draftsmen and women were given the widest latitude in doing these drawings. In every case the results differed when the same drawing was done by another person, even though the same plan was followed. In that way the artist and those doing the drawings became collaborators, and the result was better than either could achieve alone.

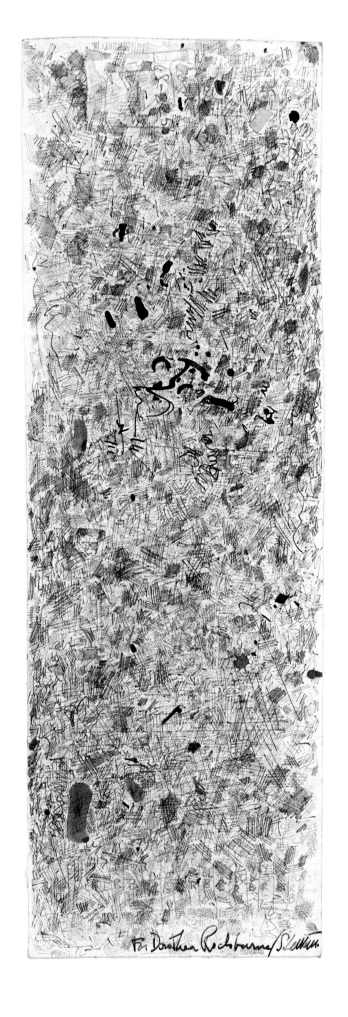

For Dorothea Rockburne / S. Leitner

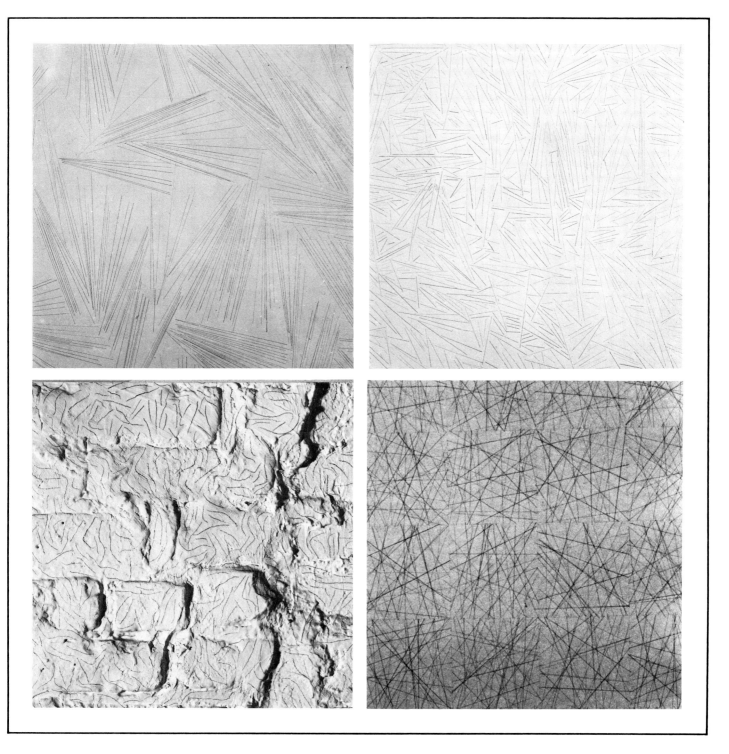

176. *Opposite page:* SCRIBBLE DRAWING. 1970. Pen and colored ink, pencil, 18⅛ x 6⅛ in (46 x 15.4 cm).
This drawing was actually a page to test the ink pens I was using to make the other drawings. It was not composed for an aesthetic result.

177. *Top left:* STRAIGHT LINES, 24 CM LONG, NOT TOUCHING. (Detail of Wall Drawing). 1970. Pencil. Installation, Galerie Yvon Lambert, Paris. Draftsmen: Calatchi, Pacquement, Doychescu, Cadere, Lambert, Kemeny.

178. *Top right:* STRAIGHT LINES, SHORTER THAN 24 CM, NOT TOUCHING (Detail of Wall Drawing). 1970. Pencil. Installation, Galerie Yvon Lambert, Paris. Draftsmen: Calatchi, Pacquement, Doychescu, Cadere, Lambert, Kemeny.

179. *Bottom left:* LINES NOT STRAIGHT, NOT TOUCHING, DRAWN ON A BRICK WALL (Detail of Wall Drawing). 1971. Pencil. Installation, Lippard Residence, New York. Draftsman: S. LeWitt.

180. *Bottom right:* WITHIN THE SIX-INCH SQUARES, STRAIGHT LINES FROM EDGE TO EDGE USING YELLOW, RED, AND BLUE PENCILS (Wall Drawing). 1971. Pencil. Installation, Lisson Gallery, London. Draftsmen: A. Davies, J. Stezaker, D. Mann, S. Rome, M. Peach, E. McDonnell, J. F. Walker.

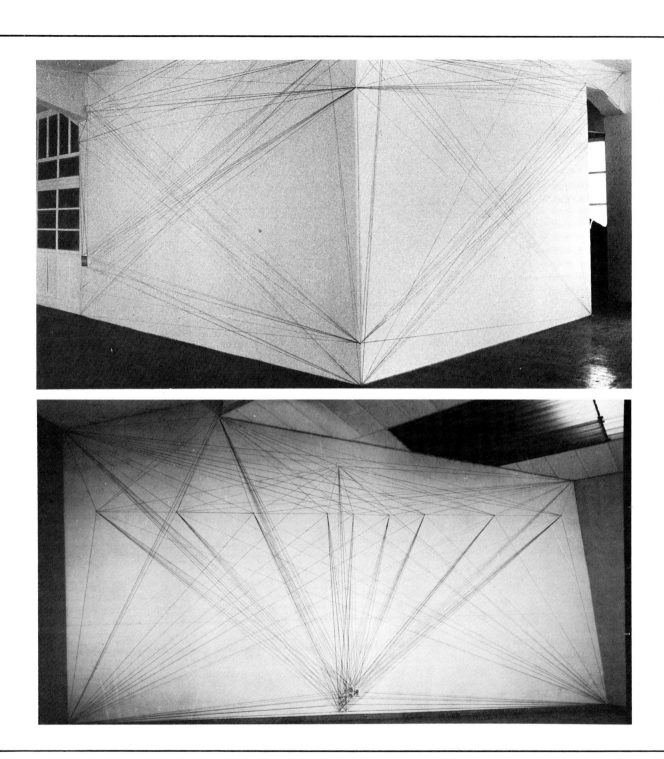

The two wall drawings at the top of the previous page were done at The Yvon Lambert Gallery in Paris. The show was dedicated to Eva Hesse, who had died a few days before. I was a close friend of hers and felt the loss greatly. It was my friendship with Eva that made me aware of the problems that women artists face in a world dominated by a male hierarchy (critics, editors, museum and gallery administrators). There seems to be an implicit rule (even among female critics, etc.) that a woman can never be considered the dominant practitioner of a style or idea. When the time came for the kind of work that Eva Hesse was doing (a reaction to Minimalism, it was called "anti-form," whatever that may be) to be officially recognized, she was relegated to a minor role. Only later did the mistake become evident. But even now, women artists face the same intellectual blindness and sexist "put-down."

181. Top: LINES CONNECTING ARCHITECTURAL POINTS (Wall Drawing). 1970. Pencil. Installation, Galleria Sperone, Turin. Draftsmen: Giamaso, Mosca, Giacchi.

182. Bottom: LINES CONNECTING ARCHITECTURAL POINTS (Wall Drawing). 1970. Pencil. Installation, "Land Art, Conceptual Art, Arte Povera" exhibition, Museo di Torino. Draftsmen: Giamaso, Mosca, Giacchi.

Technology is not subverting art without opposition. The New Combine, to put it another way, has its enemies, honorable enemies—many of them deeply involved, on every level, with contemporary work. Their complaints, whatever the source or the vocabulary, reveal at base certain familiar dispositions—to see technology as an alien, inhuman force, to associate its use in art with mere "gimmickry," and, finally, to fear any surrender of control by the artist himself over the technological materials involved in his work.

To oppose technology in art is to oppose it in life, for technology is as much a part of man as his home or his road or his clothes; in company with all these, technology is surely *nonhuman*, but man alone can render it *inhuman*. It is man alone, moreover, who reduces material of any kind to the level of gimmickry. There is nothing inherently superficial in a light bulb, as there is nothing inherently noble in pigment. If the oceans of oil wasted upon imitation of the great abstract painters in the 1950s did not wash away this fallacy, nothing ever will. It seems we must learn again that art can incorporate *any* material and *any* process, when employed in the service of the imagination.

That technology is a neutral, not a negative tool, is conceded by the best of the humanists, by those engaged in a rearguard defense of Western art and civilization against what they consider the excesses of the present, both in politics and in art. When Lewis Mumford, the dean of these guardians, compared technology to the walls of a prison, he also took pains to add that *we* built the walls, "even condemned ourselves to a life-term. . . . But those . . . walls are not eternal."

On the difficult issue of "human control," however, the split between new and old is profound. It is no accident that the literary and critical establishments reserved their greatest scorn over so long a period for John Cage, who has distilled in his articles and lectures, as well as his music, the ideas most repellent to the humanists; they are ideas, moreover, that have been realized in the work of many artists, among them Robert Rauschenberg, Jasper Johns, Allan Kaprow, Robert Whitman, the choreographer Merce Cunningham and a whole train of young composers. When Cage recommends, to take just one example, the use of chance methods in composition—the flipping of a coin to determine the order of sounds in music—on the ground that such procedure "brings us closer to nature in her manner of operation," he strikes at the root of Western esthetics as it has been defined since the Renaissance. (To Mumford, for example, one of art's central tasks is to "arrest life in its perpetual flux . . . detach itself . . . in its [art's] final perfection.")

46

Cage has not been the only influence on the movement variously described as neo-dada, to be sure; surrealism, Oriental philosophy, Marcel Duchamp, all have contributed, as well as dada. There are wide differences of approach between Cage and Duchamp, Rauschenberg and Kaprow, dada and surrealism, but the net effect of the work produced by them has been an erosion of the line between art and life, between, in effect, greater and lesser degrees of subjective control. The "found objects" in a combine by Rauschenberg turn us out toward the world, away from art, as do the "found sounds" in a Cage concert; when we perform in a happening, we perform as ourselves, not as created (and therefore arrested) characters.

Poetry, mystery and pleasure

It is only natural, then, that these artists—and all those influenced by them, deeply or slightly, from Robert Morris to Charles Frazier—should embrace technology with undisguised lust. For the machine offers the best of all roads away from the self and its inherent limitations. Let the computer then provide us with tables of random numbers, let random sound waves light our dance, let the evening's television fare provide us with images for our large screens (as in Robert Whitman's "Two Holes of Water—3," presented as a part of "Nine Evenings"). The more independence we can cede the machine, from a Cagean point of view, the more interesting, indeed, the more *fun*, it becomes, for it takes forms no earthbound ego might imagine. Recall that Billy Klüver concluded his preparatory remarks for "Nine Evenings" with a reference to the Chinese fireworks of three thousand years ago as "maybe the first use of advanced technology to give poetry, mystery and pleasure to the people. I feel that our performances will have some affinity to these long-forgotten forerunners."

If it is difficult for the humanist to endorse this position, he can—and must—come to terms with its historicity. There is not only the whole tradition of anti-art behind it, but also certain analogous responses, responses based so deeply in our sensibilities that they barely admit rational explanation. When we play the machine for its own sake—and enjoy it on the same basis—we merely confirm on a new level that love for the thing itself implicit in abstract expressionism as well as the found object. The abstract painters taught us to discard the search for illusion and for meaning in a canvas, to look upon form only as form, color only as color; it is a lesson transferable to computer graphics. The disposition to enjoy the *Ding an sich* is beyond recall; no amount of lecturing in defense of meaning can stay its course.

There is, for all that, a strong countercurrent on the issue of

FROM THE WORD "ART": BLUE LINES TO 4 CORNERS, GREEN LINES TO 4 SIDES & RED LINES BETWEEN THE WORDS / S. LeWitt 10/23/72

183. FROM THE WORD(S) "ART"; BLUE LINES TO FOUR CORNERS,
GREEN LINES TO FOUR SIDES, AND RED LINES BETWEEN THE WORDS. 1972.
Pen and colored ink on printed page, 8⅝ x 9 in (21.8 x 22.8 cm).

184–187. TEN THOUSAND LINES, ONE INCH LONG, EVENLY SPACED ON SIX WALLS EACH OF DIFFERING AREA (Four Details of Wall Drawing). 1972. Pencil. Installation, Finch College, N.Y. Draftsmen: S. Kato, K. Miyamoto, R. Watanabe.

In the Orient the number ten thousand traditionally implies a large number. These drawings are part of a group. The size of the wall or the page on which a drawing is made determines the density of the lines.

188. TEN THOUSAND LINES, FIVE INCHES LONG, WITHIN AN AREA OF
6¾ X 5½ INCHES. 1971. Pencil, 9½ x 9½ in (24.2 x 24.2 cm).

189. *Top left:* TORN PAPER PIECE. R 1. 1971. Paper, ca. 12 x 12 in (30.5 x 30.5 cm).

190. *Top right:* FOLDED PAPER PIECE. 1969. Paper, ca. 12 x 12 in (30.5 x 30.5 cm).

191. *Bottom left:* SQUARE WITH UPPER LEFT CORNER TORN OFF. R 748. 1977. Paper, 3½ x 3½ in (8.7 x 8.7 cm).

192. *Bottom right:* SQUARE WITH RIGHT SIDE TORN OFF. R 749. 1977. Paper, 3½ x 3½ in (8.7 x 8.7 cm).

The first folded paper piece was done in 1966 as the announcement for a show with Leo Valledor and Robert Smithson at the Park Place Gallery, New York. Later I started to do torn paper pieces also. It was another way of making grids with no drawn lines. The torn paper pieces are all numbered in the order that they were made.

193. Top left: ALTERNATE PARALLEL, STRAIGHT, NOT-STRAIGHT, AND BROKEN LINES. 1973. Pen and ink, 11¼ x 11¼ in (28.6 x 28.6 cm).

194. Top right: ALTERNATE PARALLEL, STRAIGHT, NOT-STRAIGHT, AND BROKEN LINES OF RANDOM LENGTH, FROM THE LEFT SIDE OF THE PAGE. 1972. Pen and ink, 11 x 11 in (28 x 28 cm).

195. Bottom left: PARALLEL, HORIZONTAL, BROKEN LINES OF RANDOM LENGTH FROM THE LEFT AND RIGHT SIDES OF THE PAGE. 1972. Pen and ink, 10 x 10 in (25.4 x 25.4 cm).

196. Bottom right: PARALLEL, STRAIGHT, HORIZONTAL LINES ON THE LEFT; PARALLEL, STRAIGHT, VERTICAL LINES ON THE RIGHT. 1972. Pen and ink, 11½ x 11½ in (29.3 x 29.3 cm).

These drawings were a continuation of the serial drawings, with the distance between the lines increased to about ⅛ inch. Not-straight and broken lines were now used along with the straight lines.

ARCS, CIRCLES, AND GRIDS

197. CIRCLES, GRIDS, ARCS FROM FOUR CORNERS AND FOUR SIDES. 1972. Pen and ink, 14⅝ x 14⅝ in (37.1 x 37.1 cm). No. 195 from book *Arcs, Circles & Grids,* 1972.

198. Right: CIRCLES, GRIDS, ARCS FROM FOUR CORNERS AND SIDES, (Detail of Wall Drawing). 1973. Pencil. Installation, L'Attico Gallery, Rome. Draftsmen: Climbo, Piccari, Battista, Pranovi.

By increasing the distance between the lines (paper drawings to about 1/8 inch, wall drawings to about 1 inch) it was possible to add arcs to the straight lines, as well as circles. No. 197 is the last of the series of all the possible combinations of grids, arcs, and circles. These drawings were a logical continuation of previous work. There was a later controversy caused by these drawings. The French artist François Morrellet had previously done drawings using grids with a similar spacing. Although at the time I was unfamiliar with his work, it was possible that I had seen one reproduced or on view at The Museum of Modern Art's "The Responsive Eye" exhibition. When I became aware of the similarities of our work, I abandoned mine. I am sorry if I caused him discomfort, since I regard him as an able artist.

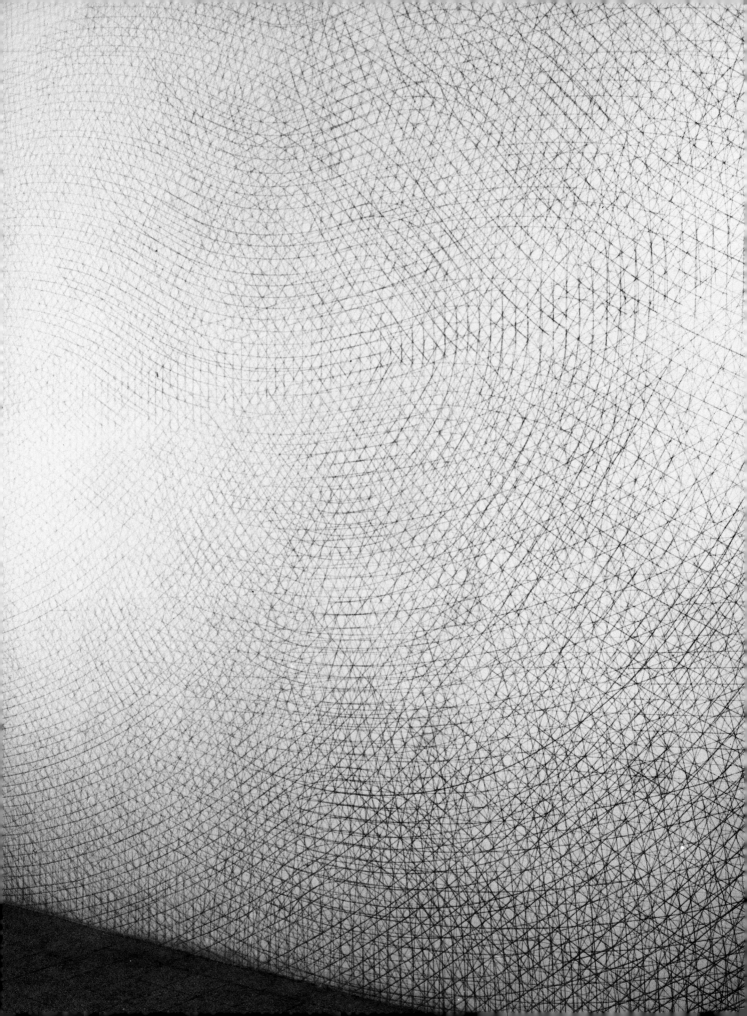

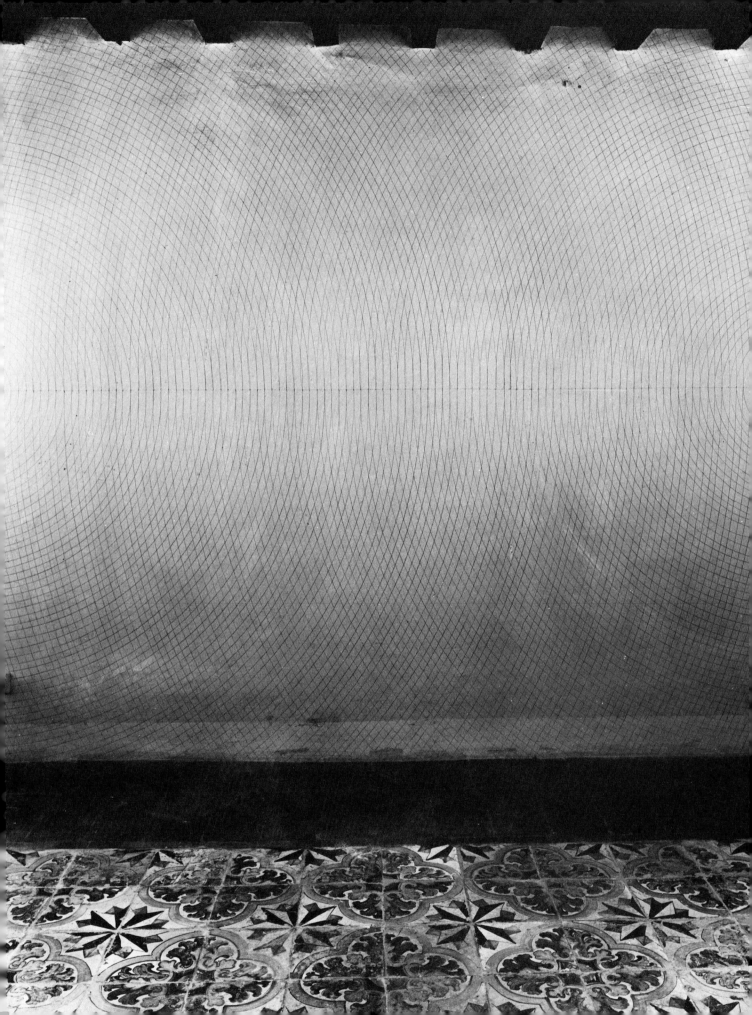

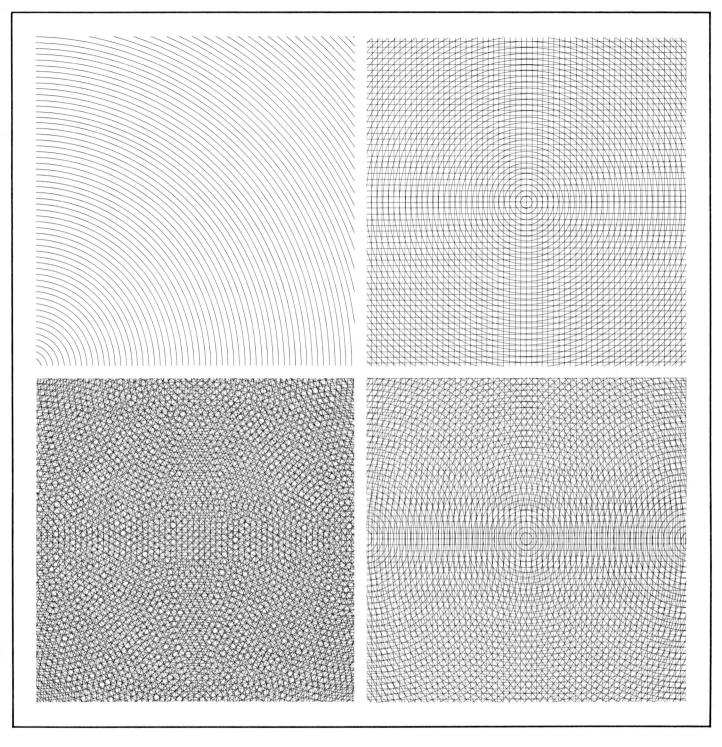

199. *Opposite page:* ARCS FROM TWO OPPOSITE SIDES OF THE WALL (Wall Drawing). 1971. Pencil, 9 x 14 ft (213.5 x 426.8 cm). Installation, Bonomo Residence, Spoleto. Draftsmen: M. Bochner, S. LeWitt.

200. *Top left:* ARCS FROM ONE CORNER. 1972. Pencil, pen and ink, 14⅝ x 14⅝ in (37.1 x 37.1 cm). No. 1 from book *Arcs, Circles & Grids,* 1972.

201. *Top right:* CIRCLES AND GRID. 1972. Pen and ink, 14⅝ x 14⅝ in (37.1 x 37.1 cm). No. 147 from book *Arcs, Circles & Grids,* 1972.

202. *Bottom left:* ARCS FROM FOUR CORNERS AND FOUR SIDES. 1972. Pen and ink, 14⅝ x 14⅝ in (37.1 x 37.1 cm). No. 48 from book *Arcs, Circles & Grids,* 1972.

203. *Bottom right:* CIRCLES, GRIDS, AND ARCS FROM TWO OPPOSITE SIDES. 1972. Pen and ink, 14⅝ x 14⅝ in (37.1 x 37.1 cm). No. 155 from book *Arcs, Circles & Grids,* 1972.

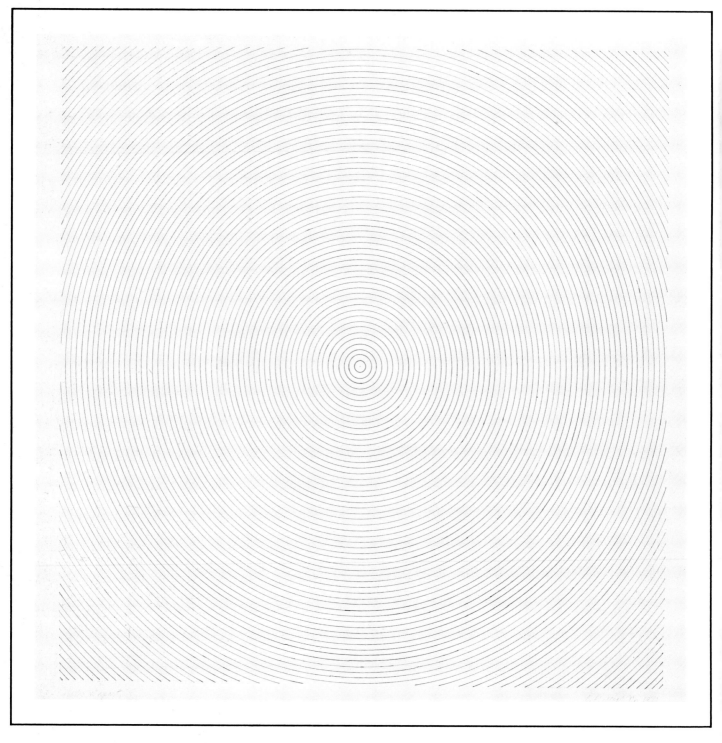

204. CIRCLES. 1971. Pen and ink, pencil, 16 x 16 in (40.6 x 40.6 cm).

205. *Right:* CIRCLES (Wall Drawing). 1971. Pencil, 8 x 9 ft (244 x 274.4 cm). Installation, Bonomo Residence, Spoleto. Draftsman: S. LeWitt.

A number of wall drawings were made in a restored Franciscan retreat on a hill overlooking the city of Spoleto. Also in the house were important installations by Mel Bochner.

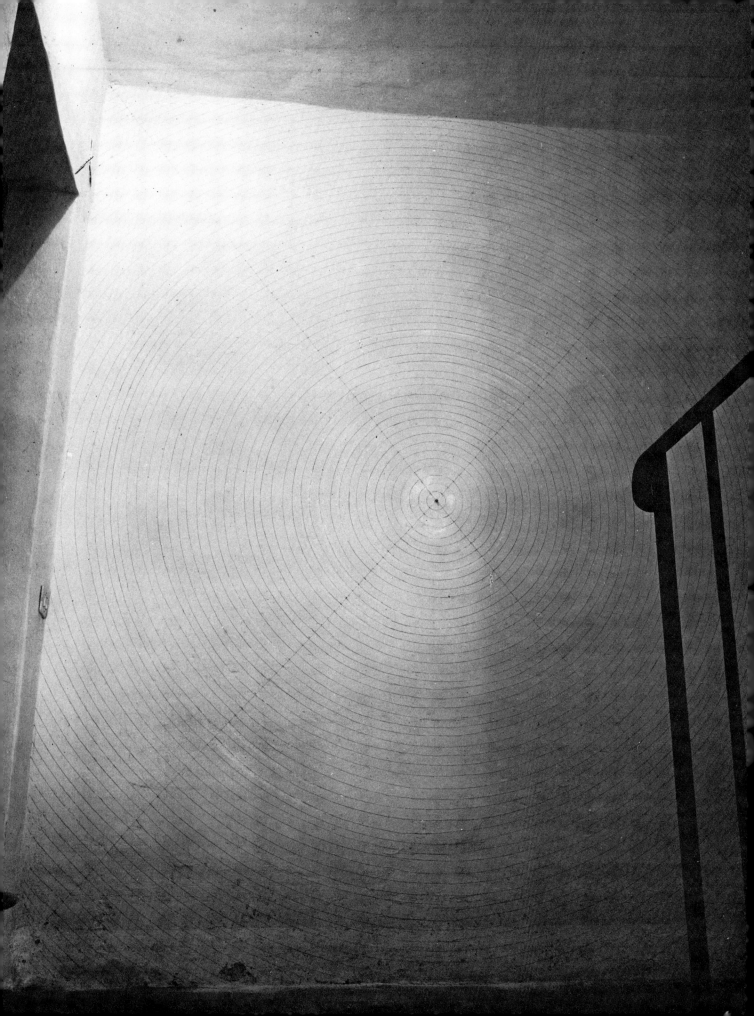

STRAIGHT & NOT-STRAIGHT LINES	STRAIGHT VERTICAL LINES	STRAIGHT HORIZONTAL LINES	STRAIGHT DIAGONAL (L) LINES	STRAIGHT DIAGONAL (R) LINES	NOT-STRAIGHT VERTICAL LINES	NOT-STRAIGHT HORIZONTAL LINES	NOT-STRAIGHT DIAGONAL (L) LINES	NOT-STRAIGHT DIAGONAL (R) LINES
STRAIGHT VERTICAL LINES								
STRAIGHT HORIZONTAL LINES								
STRAIGHT DIAGONAL (L) LINES								
STRAIGHT DIAGONAL (R) LINES								
NOT-STRAIGHT VERTICAL LINES								
NOT-STRAIGHT HORIZONTAL LINES								
NOT-STRAIGHT DIAGONAL (L) LINES								
NOT-STRAIGHT DIAGONAL (R) LINES								

ARCS AND LINES

206. STRAIGHT AND NOT-STRAIGHT LINES. 1972. Pen and ink. From
Art & Project, bulletin 60.

ARCS FROM CORNERS AND SIDES	ARCS FROM THE LOWER LEFT CORNER	ARCS FROM THE UPPER LEFT CORNER	ARCS FROM THE UPPER RIGHT CORNER	ARCS FROM THE LOWER RIGHT CORNER	ARCS FROM THE MID LEFT SIDE	ARCS FROM THE MID TOP SIDE	ARCS FROM THE MID RIGHT SIDE	ARCS FROM THE MID BOTTOM SIDE
ARCS FROM THE LOWER LEFT CORNER								
ARCS FROM THE UPPER LEFT CORNER								
ARCS FROM THE UPPER RIGHT CORNER								
ARCS FROM THE LOWER RIGHT CORNER								
ARCS FROM THE MID LEFT SIDE								
ARCS FROM THE MID TOP SIDE								
ARCS FROM THE MID RIGHT SIDE								
ARCS FROM THE MID BOTTOM SIDE								

207. ARCS FROM CORNERS AND SIDES. 1972. Pen and ink. From *Art & Project,* bulletin 60. Both drawings on one sheet, 13⅞ x 15½ in (34.8 x 39.4 cm).

One way of making a complete finite series is to use a cross-reference grid. On these pages are lines with lines and arcs with arcs.

208. LINES AND ARCS. 1972. Pen and ink, 13¾ x 13¾ in (35 x 35 cm).
From *Art & Project*, bulletin 60.

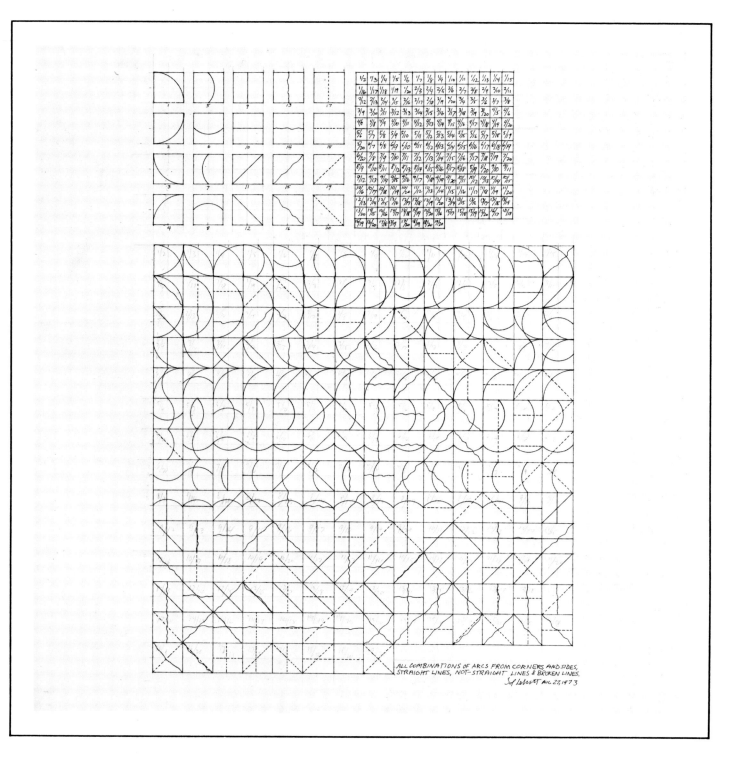

209. ALL COMBINATIONS OF ARCS FROM CORNERS AND SIDES; STRAIGHT LINES, NOT-STRAIGHT LINES, AND BROKEN LINES. 1973. Pen and ink, pencil, 17 x 17 in (43.2 x 43.2 cm).

This basic series was used for many wall drawing installations. Each is different because of the shape and size of the walls. The encyclopedia of line and arc forms progresses from total curves to total linear forms, and can be easily read as a series.

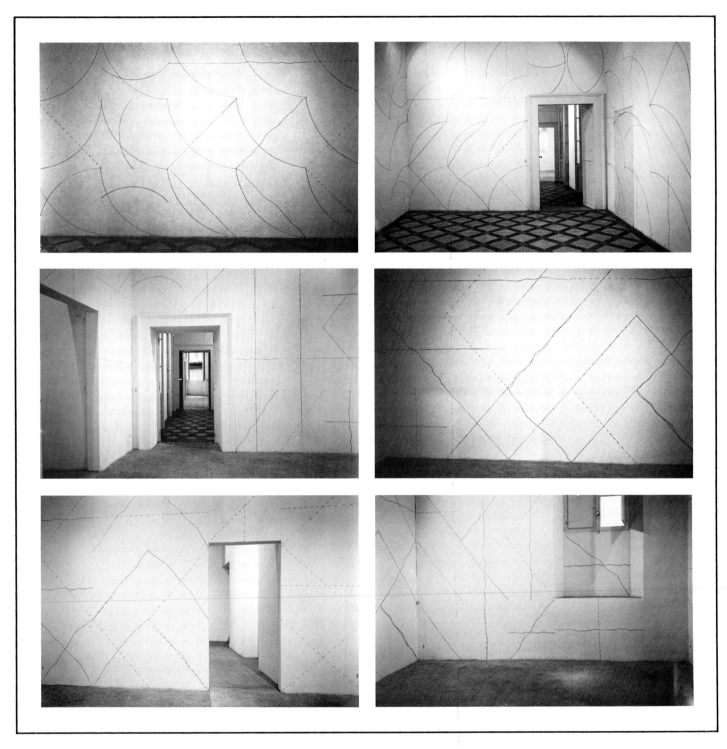

210–215. ALL COMBINATIONS OF ARCS FROM CORNERS AND SIDES; STRAIGHT, NOT-STRAIGHT, AND BROKEN LINES (Wall Drawing). 1973. Blue chalk. Installation, L'Attico Gallery, Rome. Draftsman: S. LeWitt.

These are the three basic kinds of lines: straight, not-straight, and broken, and the two kinds of arcs: from the corners and from the midpoints of the sides. The system uses them in combinations of two. Depending on the size of the wall, one or more of these devices may be omitted (such as the arcs from sides, or the broken lines). The length of the module is determined by the average person's reach to draw an arc (about a yard or meter). This limits the line to the capabilities of the draftsman or woman and keeps it on a human scale. The grid is drawn in pencil, the lines in black or blue chalk. The lines make unforeseen combinations, visually unimpeded by the grid. No matter how many times the piece is done it is always different visually if done on walls of differing sizes.

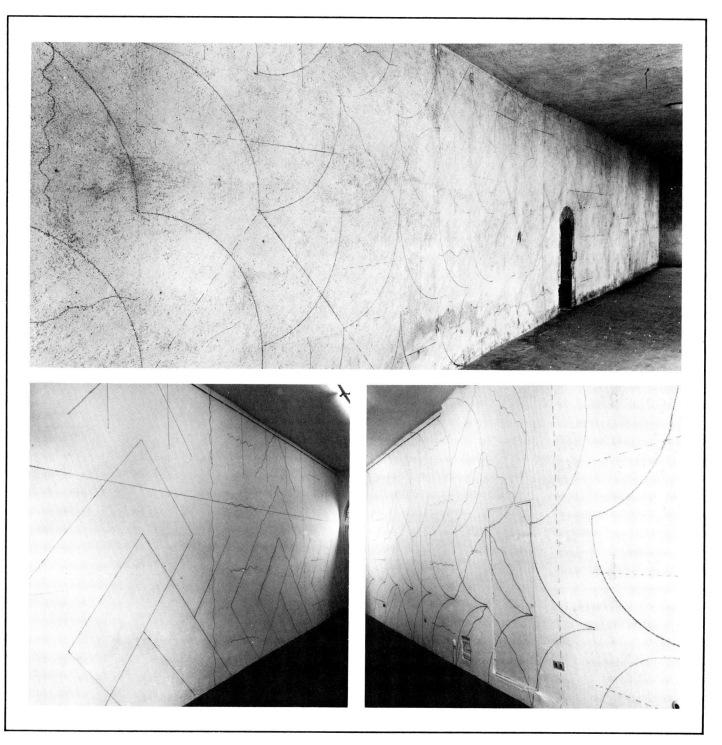

216. *Top:* ALL COMBINATIONS OF ARCS FROM CORNERS; STRAIGHT, NOT-STRAIGHT, AND BROKEN LINES (Wall Drawing). 1973. Black chalk. Installation, Cloister of St. Nicola, Spoleto. Draftsmen: J. Taub, R. Taub, L. Faten, R. di Smartino.

217–218. *Bottom:* ARCS AND LINES, LINES AND LINES (Wall Drawing). 1972. Chalk. Installation, Konrad Fischer Gallery, Düsseldorf. Draftsmen: M. Scharn, K. Fischer, G. Nabakovski, S. LeWitt.

219. *Right:* ARCS AND LINES, LINES AND LINES (Plan). 1972. Announcement, 4¼ x 6 in (10.8 x 15.2 cm).

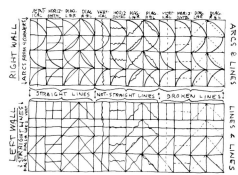

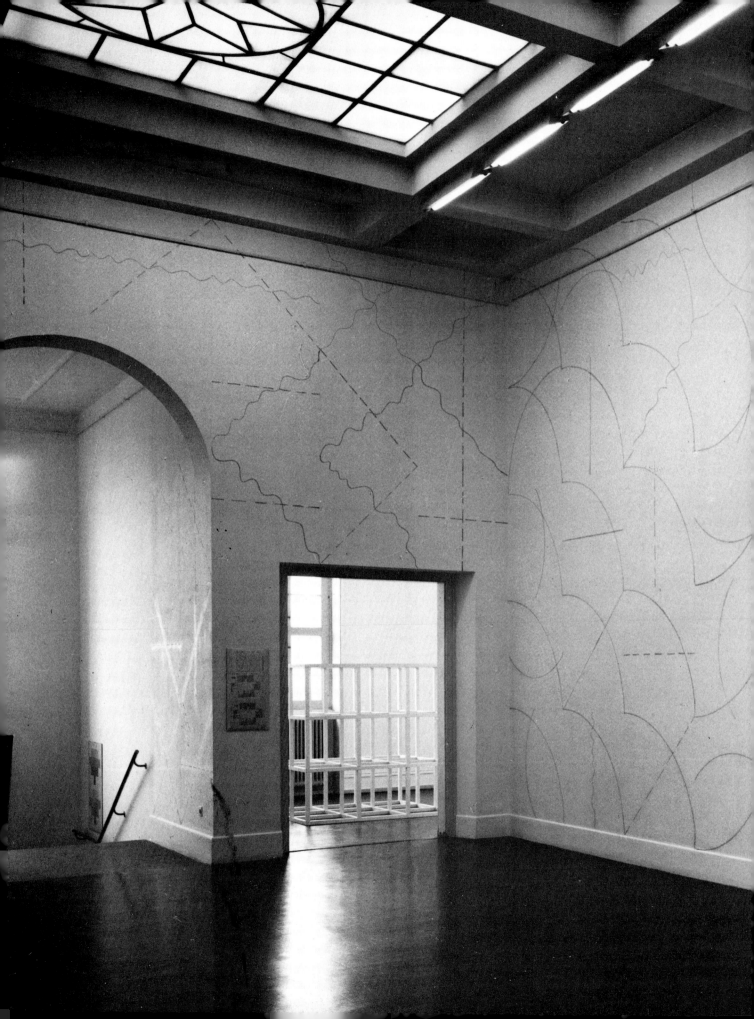

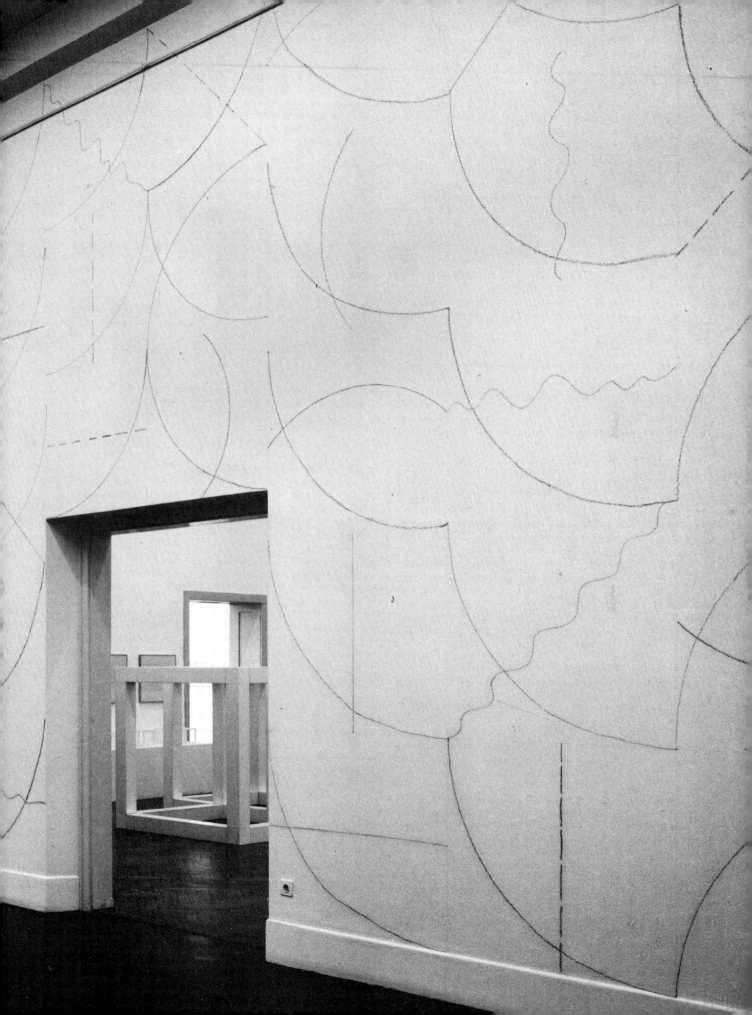

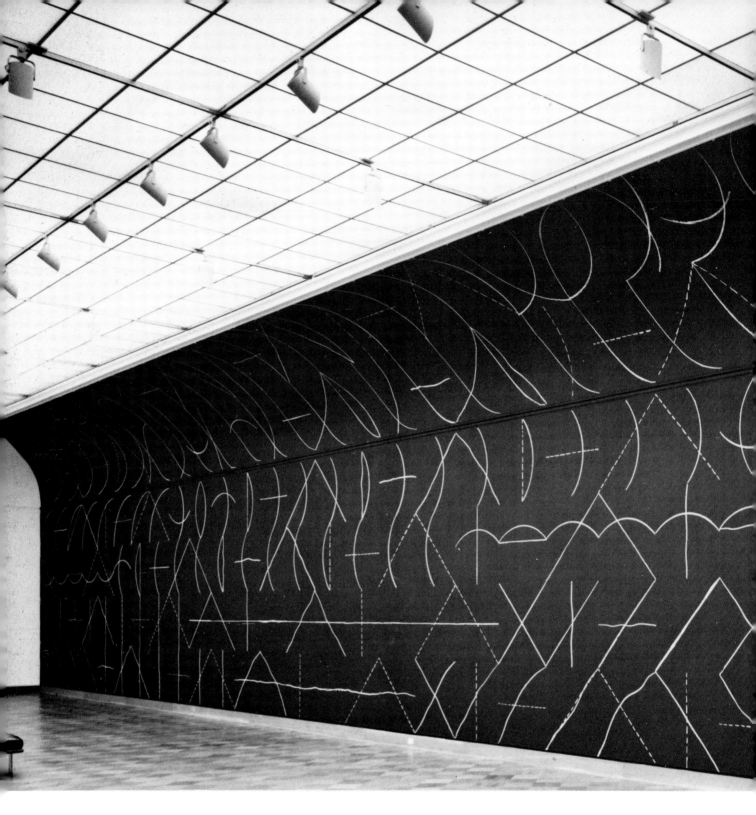

220. Preceding pages: ALL COMBINATIONS OF ARCS FROM CORNERS
AND SIDES; STRAIGHT, NOT-STRAIGHT, AND BROKEN LINES (Wall
Drawing). 1972. Blue chalk. Installation, Kunsthalle Bern.
Draftsmen: B. Biasi, E. Martin, B. Schlup, P. Siegenthaler, S.
Widmer, S. LeWitt.

221. ALL COMBINATIONS OF ARCS FROM CORNERS AND SIDES;
STRAIGHT, NOT-STRAIGHT, AND BROKEN LINES (Wall Drawing).
1975. White chalk on black wall, 16½ x 95 in (42 x 241.4 cm). Installa-
tion, San Francisco Museum of Modern Art. Draftsman: S. LeWitt.

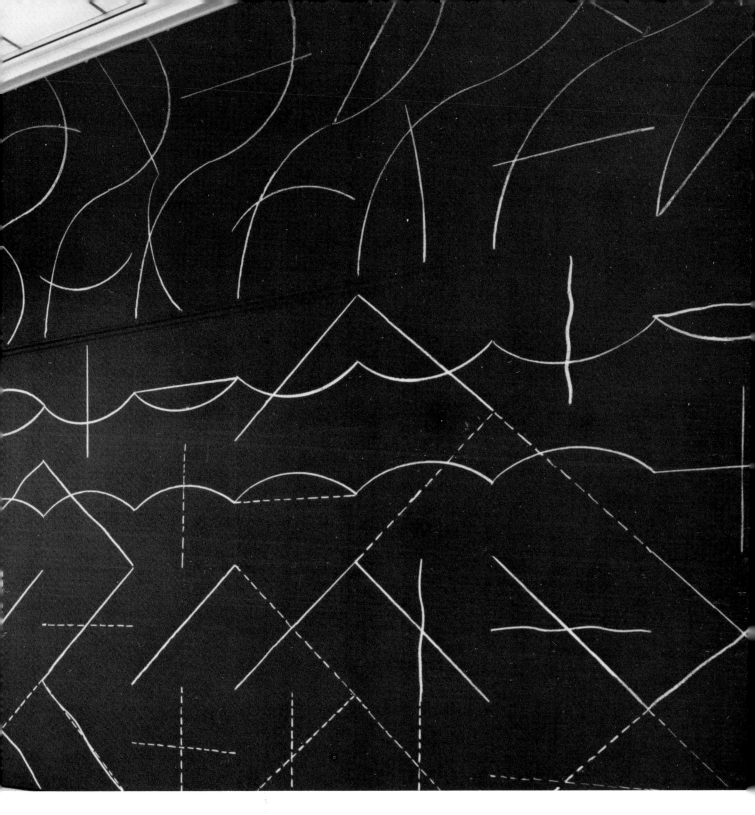

When a black wall with white lines and a large wall or a whole room is used, the architectural space encloses the viewer and the lines unite in different ways. Even though the system is the same, the space is different, making the combinations of lines different. The black wall gives a feeling of enclosure. The white lines maintain their grid and by changing offer clues to the system. The plan is always presented so that the viewer will know that the changes are not capricious but systematic, becoming a language and a narrative of shapes. In the San Francisco piece the movement is read from top to bottom, and in Venice (next page) the movement is read progressively around the room.

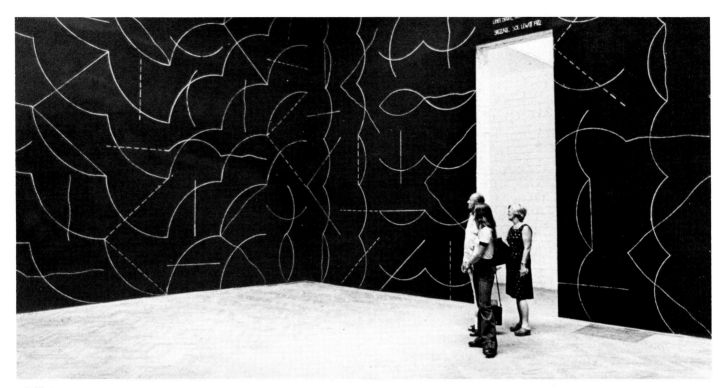

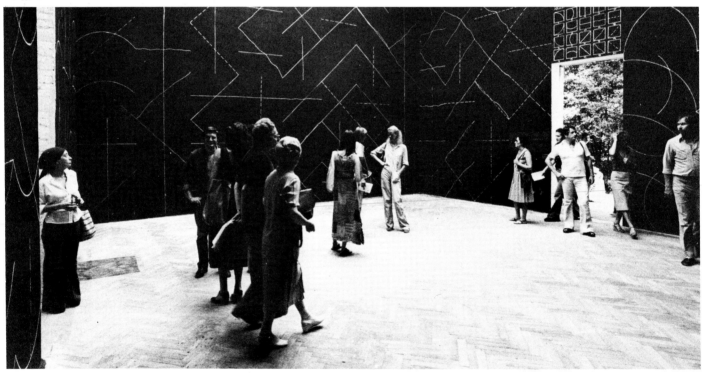

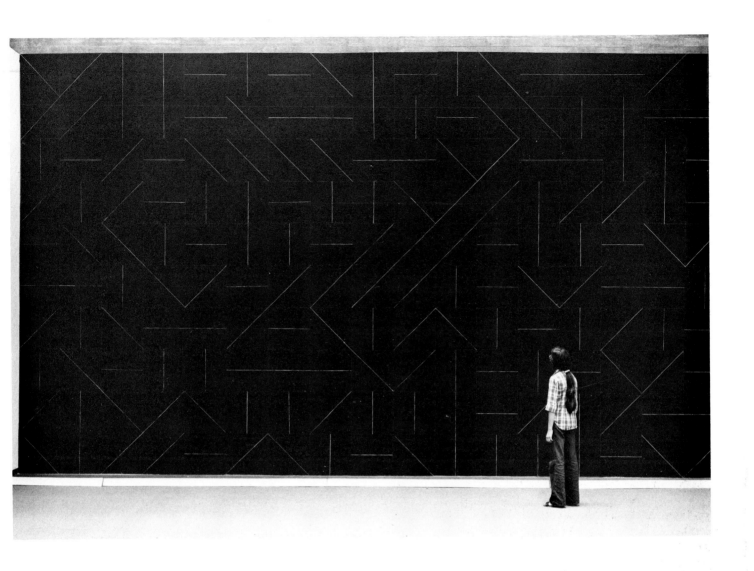

222–223. *Opposite, top and bottom:* ALL COMBINATIONS OF ARCS
FROM CORNERS AND SIDES; STRAIGHT, NOT-STRAIGHT, AND BROKEN
LINES (Wall Drawing). 1976. White chalk on black wall. Installation,
Venice Biennale, 1976. One room.

224. *Above:* STRAIGHT LINES IN ONE OF FOUR DIRECTIONS DRAWN
WITHIN A GRID RANDOMLY (Wall Drawing). 1977. White chalk on
black wall. Installation, "Drawing Now" exhibition, Tel Aviv
Museum.

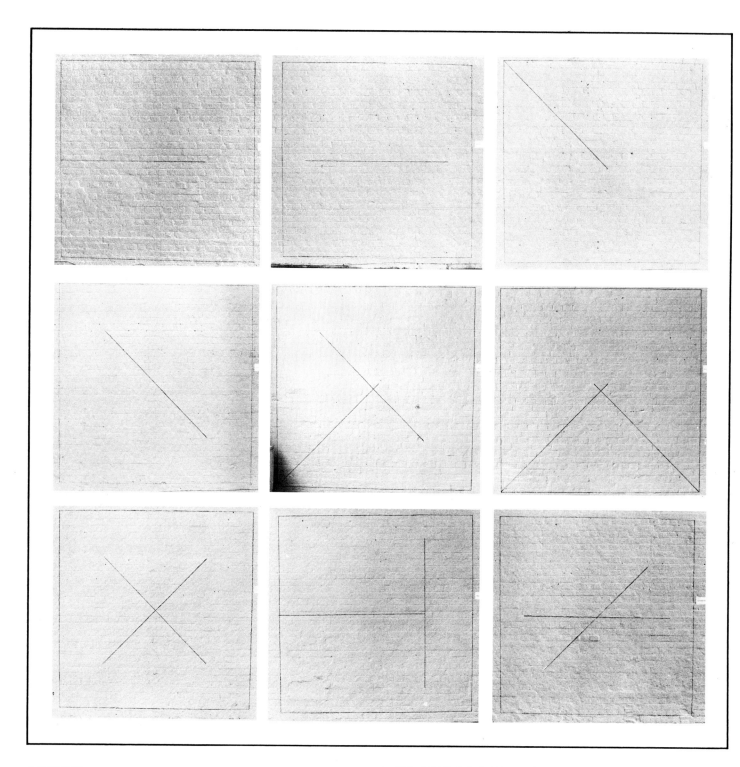

LOCATION

RED LINES SIX FEET LONG, WITHIN EIGHT-FOOT BLACK SQUARE (Wall Drawings). 1973. Black and red crayon. Installation, The Museum of Modern Art, Oxford, England. Draftsmen: N. Logsdail, S. LeWitt.

225. Top left: A Horizontal Line from the Midpoint of the Left Side toward the Midpoint of the Right Side.

226. Top center: A Horizontal Line Centered between the Midpoints of the Right and Left Sides.

227. Top right: A Diagonal Line from the Upper Left Corner toward the Lower Right Corner.

228. Middle left: A Diagonal Line Centered between the Upper Left and Lower Right Corners.

229. Middle center: A Diagonal Line from the Lower Left Corner toward the Upper Right Corner, and a Line Centered between the Upper Left and Lower Right Corners.

230. Middle right: Diagonal Lines from the Lower Left and Right Corners toward the Upper Right and Left Corners.

231. Bottom left: A Diagonal Line Centered between the Upper Left and Lower Right Corners, and a Diagonal Line Centered between the Lower Left and Upper Right Corners.

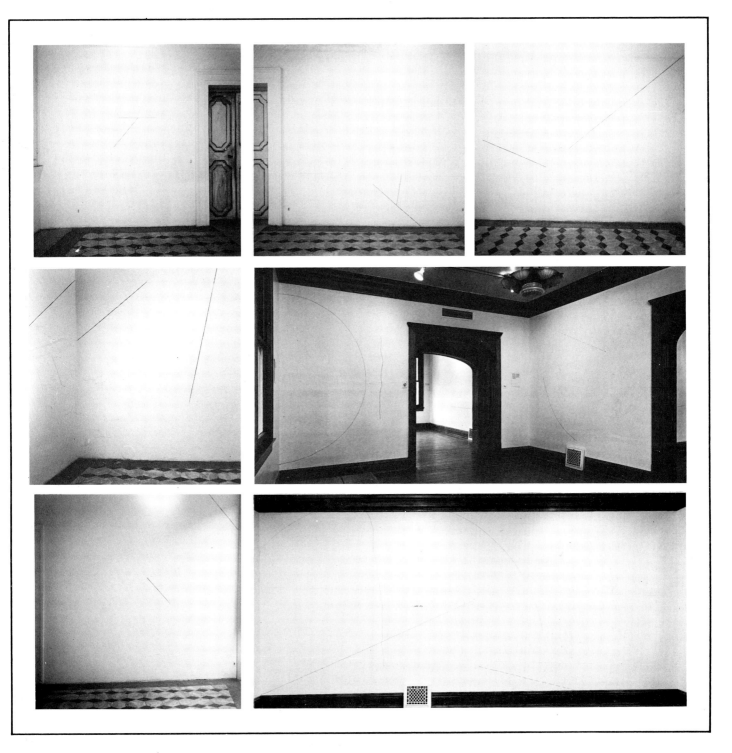

232. *Opposite page, bottom center:* A Horizontal Line from the Midpoint of the Left Side and a Vertical Touching the End with its Midpoint.

233. *Opposite page, bottom right:* A Horizontal Line Centered between the Midpoints of the Right and Left Sides and a Diagonal Line Centered between the Lower Left and Upper Right Corners.

234–236, 237, 239. *Top, center left, bottom left:* LOCATION OF TWO LINES (Wall Drawings). 1973. Black chalk. Installation, L'Attico Gallery, Rome. Draftsmen: Climbo, Piccari, Battista, Pranovi.

238, 240. *Center right* and *bottom right:* ARCS WITH STRAIGHT, NOT-STRAIGHT, AND BROKEN LINES (Wall Drawings). 1973. Black chalk. Installation, Cusack Gallery, Houston, Texas. Draftsman: S. LeWitt.

The wall is understood as an absolute space, like the page of a book. One is public, the other private. Lines, points, figures, etc., are located in these spaces by words. The words are the paths to the understanding of the location of the point. The points are verified by the words.

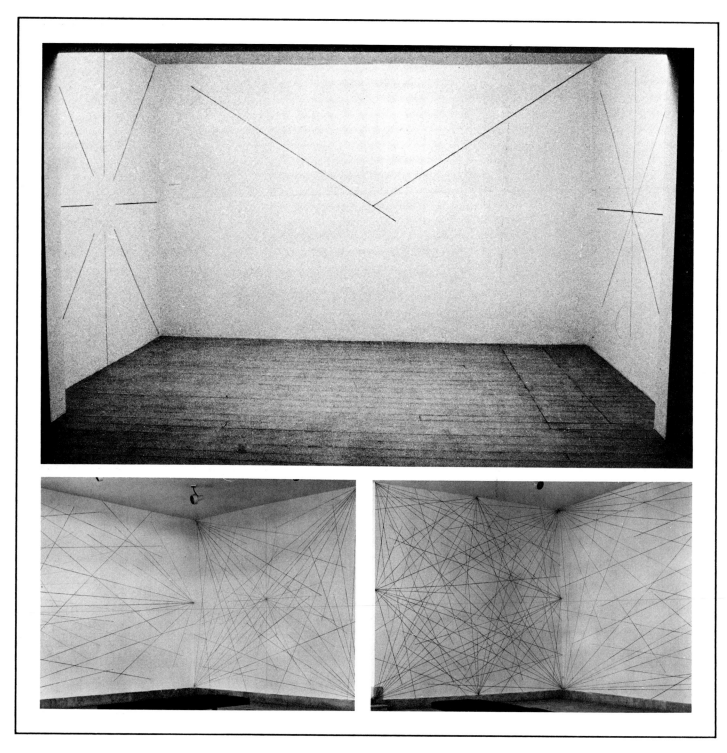

241. *Top:* LINES THROUGH, TOWARD, AND TO POINTS (Wall Drawings). 1973. Crayon. Installation, Lisson Gallery, London. Draftsmen: N. Logsdail, S. LeWitt.

Left wall: Lines from Four Corners and the Midpoints of Four Sides toward the Center of the Wall.

Center wall: A Line through the Center of the Wall toward the Upper Left Corner and a Line from the Center of the Wall to the Upper Right Corner.

Right wall: Lines through the Center of the Wall toward Midpoints of Four Sides and Four Corners.

242–243. *Bottom:* RED, YELLOW, AND BLUE LINES FROM SIDES, CORNERS, AND CENTER OF THE WALL TO POINTS ON A GRID (Wall Drawings). 1975. Crayon. Installation, The Israel Museum, Jerusalem. Draftsmen: P. Bender, L. Comess, M. Rappaport, A. Ben-David, S. Spitzer, H. Tamir, A. and M. Tlalim, Y. Fischer.

Left (to the left): Red Lines from Four Sides, Yellow Lines from the Center of the Wall; *(to the right):* Blue Lines from Four Corners, Yellow Lines from the Center of the Wall.

Right (to the left): Red Lines from Four Sides, Blue Lines from Four Corners; *(to the right):* Blue Lines from Four Corners to Points on a Grid.

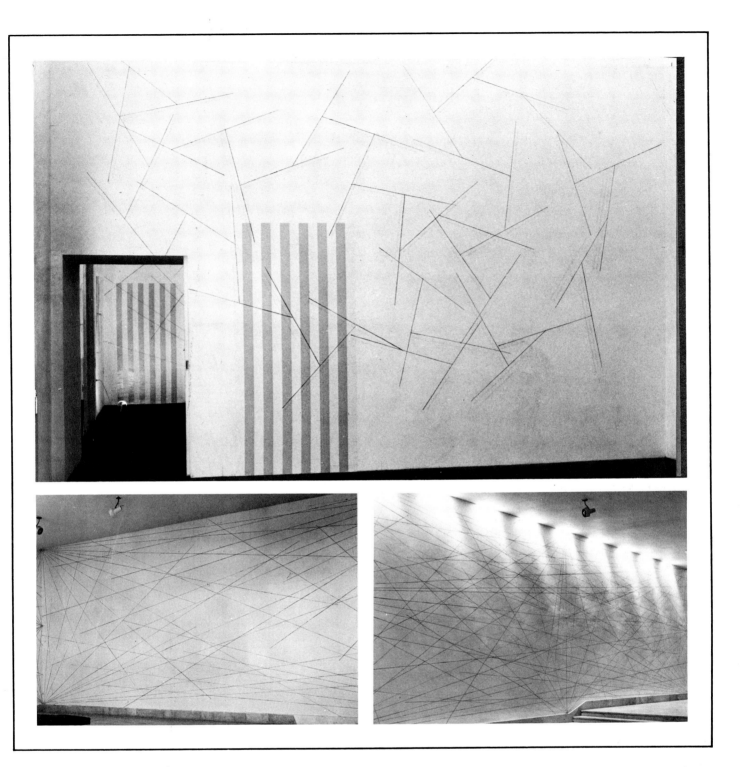

244. *Top:* LINES ONE METER LONG, FROM THE MIDPOINTS OF STRAIGHT LINES TOWARD SPECIFIED POINTS ON THE WALL. (Wall Drawing over a piece by Daniel Buren). 1975. Crayon. Installation, Lucio Amelio Gallery, Naples. Draftsman: S. LeWitt.

245–246. *Bottom:* RED, YELLOW, AND BLUE LINES FROM SIDES, CORNERS, AND CENTER OF THE WALL TO POINTS ON A GRID (Wall Drawings). 1975. Crayon. Installation, The Israel Museum, Jerusalem. Draftsmen: P. Bender, L. Comess, M. Rappaport, A. Ben-David, S. Spitzer, H. Tamir, A. and M. Tlalim, Y. Fischer.

Left: Blue Lines from Four Corners to Points on a Grid.

Right: Red Lines from Four Sides, Blue Lines from Four Corners, Yellow Lines from the Center of the Wall to Points on a Grid.

The work done at the Lisson Gallery in London centered on the idea of using the terms TO, TOWARD, and THROUGH, with reference to points and lines of the architectural setting. As in later drawings, it is both geographic and linguistic. The work done in Jerusalem used colors to define the functions of lines in relation to points on a grid drawn on the wall.

When I was to do some work at the Lucio Amelio Gallery in Naples, I knew that Daniel Buren had had the previous show. I saw Daniel in Paris, and asked him if it was possible to work with his work. He looked somewhat dubious, but agreed. As it was, his system was left intact (he projected the doorways and windows on facing walls). I superimposed my work on his.

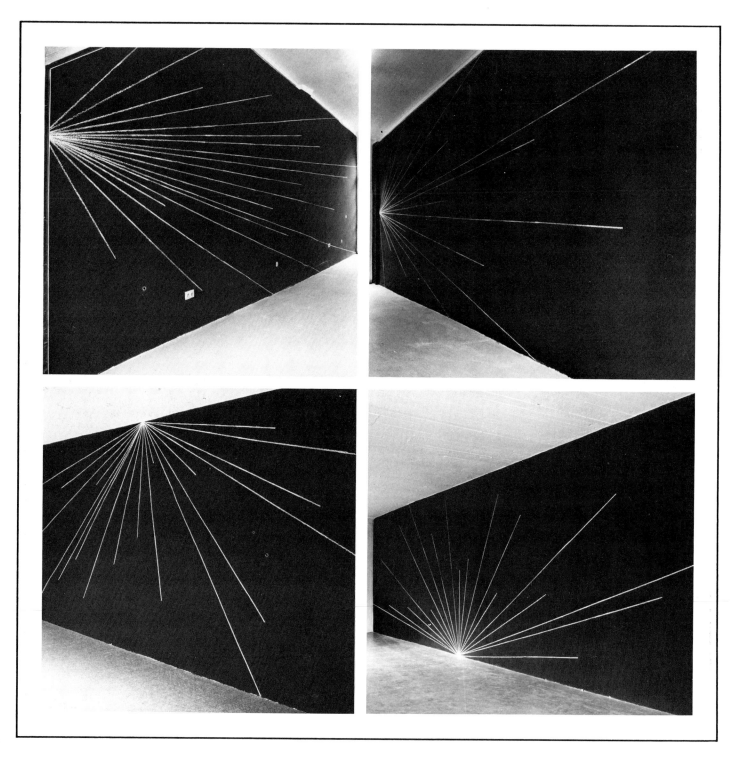

FOUR-PART WALL DRAWING

247–248. Top left and right: LINES FROM THE MIDPOINT OF THE
LEFT SIDE OF TWO FACING WALLS TO POINTS ON A GRID. 1975. White
chalk on black wall. Installation, Konrad Fischer Gallery, Düssel-
dorf. Draftsmen: K. Fischer, S. LeWitt.

249–250. Bottom left and right: LINES FROM MIDPOINTS OF THE TOP
AND BOTTOM OF OPPOSITE SIDES OF THE SAME WALL TO POINTS ON
A GRID. 1975. White chalk on black wall. Installation, Konrad Fischer
Gallery, Düsseldorf. Draftsmen: K. Fischer, S. LeWitt.

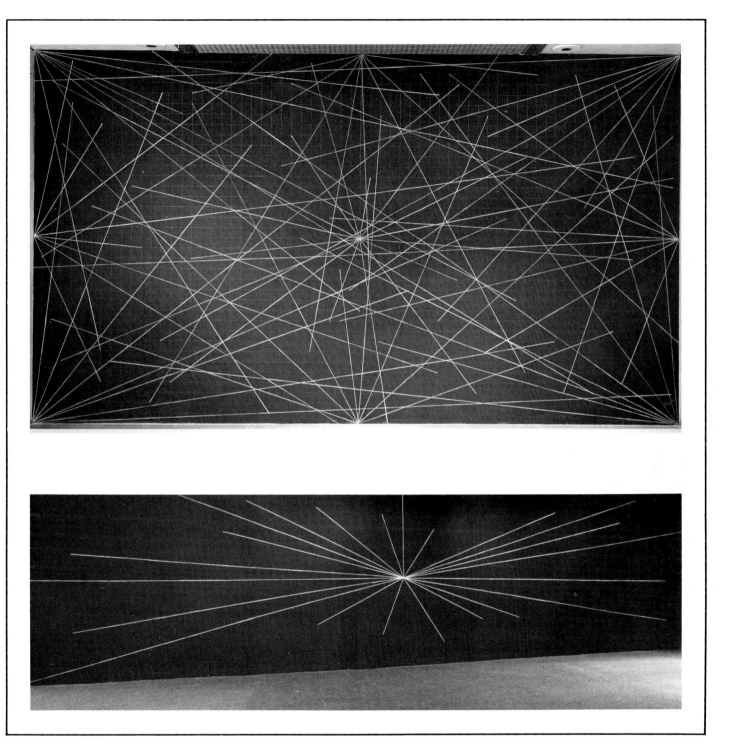

251. *Top:* LINES FROM THE CENTER OF THE WALL, FOUR CORNERS, AND FOUR SIDES TO POINTS ON A GRID (Wall Drawing). 1976. White chalk on black wall. Installation, "Drawing Now" exhibition, The Museum of Modern Art, New York. Draftsmen: J. and R. Watanabe.

252. *Bottom:* LINES FROM THE CENTER OF THE WALL TO SPECIFIC POINTS (Wall Drawing). 1975. White chalk on black wall. Installation, Daniel Weinberg Gallery, San Francisco. Draftsmen: V. Trindade, S. LeWitt.

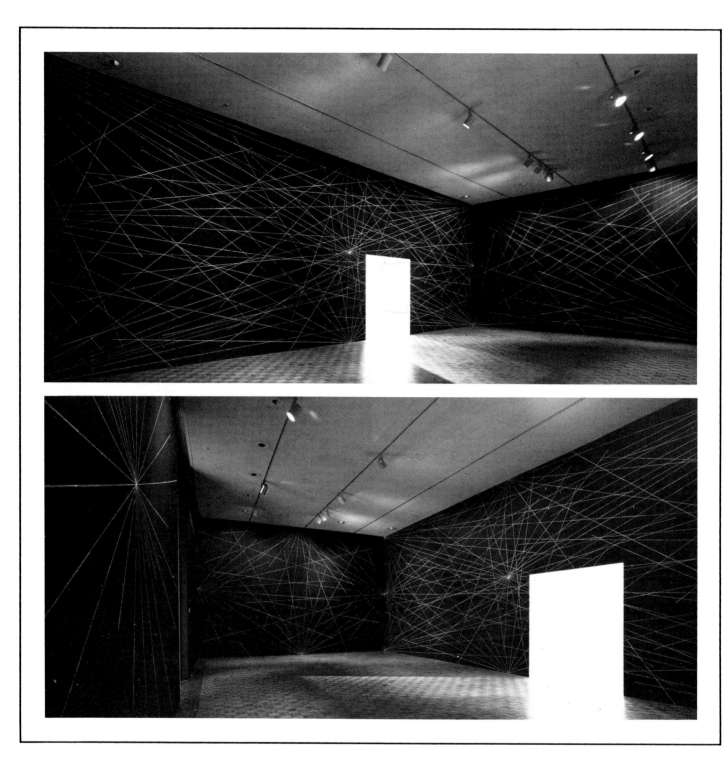

Wall Drawings installed at exhibition "American Artists: A New Decade," Detroit Institute of Arts. 1976. White chalk on black wall. Draftsman: J. Watanabe.

253. *Top, left wall:* TWENTY-FOUR LINES FROM THE CENTER OF THE WALL, TWELVE LINES FROM EACH MIDPOINT OF FOUR SIDES, TWELVE LINES FROM EACH OF FOUR CORNERS TO POINTS ON A SIX-INCH GRID. *Right wall:* TWELVE LINES FROM EACH OF FOUR CORNERS TO POINTS ON A SIX-INCH GRID.

254. *Bottom, left wall:* TWENTY-FOUR LINES FROM THE CENTER OF THE WALL TO POINTS ON A SIX-INCH GRID. *Center wall:* TWELVE LINES FROM EACH OF FOUR SIDES TO POINTS ON A SIX-INCH GRID. *Right wall:* TWENTY-FOUR LINES FROM THE CENTER, TWELVE LINES FROM EACH SIDE, AND TWELVE LINES FROM EACH CORNER TO POINTS ON A SIX-INCH GRID.

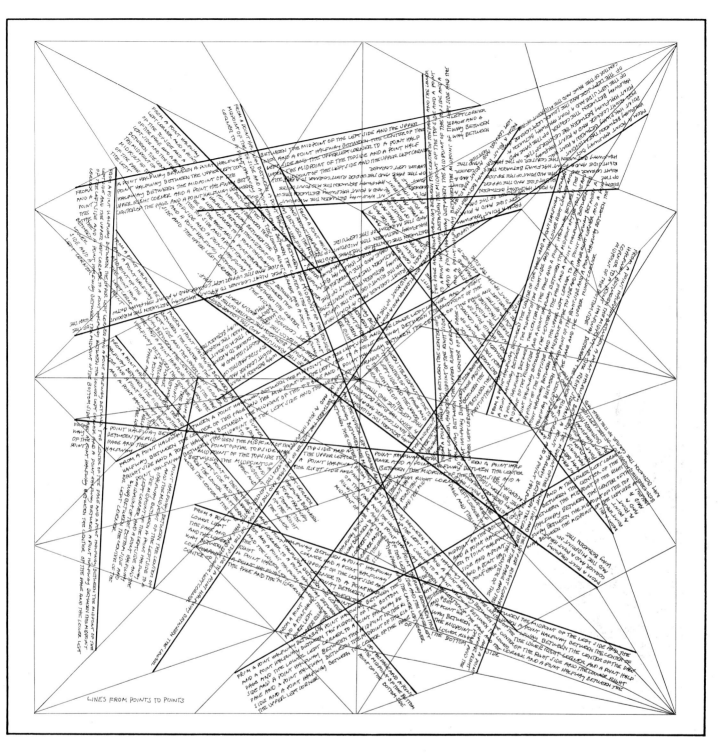

LINES FROM POINTS TO POINTS

255. LINES FROM POINTS TO POINTS. 1975. Pen and ink on acetate, 18
x 18 in (45.5 x 45.5 cm).

256. THE LOCATION OF YELLOW AND RED STRAIGHT, NOT-
STRAIGHT, AND BROKEN LINES. 1976. Silkscreen print, 14 x 14 in (35.6 x
35.6 cm). Printed by J. Watanabe, New York.

257. THE LOCATION OF YELLOW AND BLUE STRAIGHT, NOT-
STRAIGHT, AND BROKEN LINES. 1976. Silkscreen print, 14 x 14 in (35.6 x
35.6 cm). Printed by J. Watanabe, New York.

258. THE LOCATION OF A CIRCLE. 1974. From publication *Location of Three Geometric Figures,* 1974, Brussels.

259. *Opposite page:* LOCATION OF GEOMETRIC FIGURES. 1977. Pen and ink, pencil, 14⅛ x 14⅝ in (35.8 x 36.9 cm).

Next pages:

260. *Top:* LINES FROM FOUR CORNERS TO POINTS ON A GRID (Wall Drawing). 1975. White chalk on red wall, 147 x 259 in (373.4 x 657.9 cm). Installation, San Francisco Museum of Modern Art. Draftsmen: V. Trindade, R. Williams, B. Mealins.

261. *Bottom:* LINES FROM FOUR SIDES TO POINTS ON A GRID (Wall Drawing). 1975. White chalk on blue wall, 147 x 259 in (373.4 x 657.9 cm). Installation, San Francisco Museum of Modern Art. Draftsmen: V. Trindade, R. Williams, B. Mealins.

262. *Top:* LINES FROM THE CENTER OF THE WALL TO POINTS ON A GRID (Wall Drawing). 1975. White chalk on yellow wall, 147 x 200 in (373.4 x 508 cm). Installation, San Francisco Museum of Modern Art. Draftsmen: V. Trindade, R. Williams, B. Mealins.

263. *Bottom:* WHITE LINES TO POINTS ON A GRID. On Yellow from the Center, On Red from the Sides, On Blue from the Corners, On Black from the Center, Sides, and Corners (Four-part Wall Drawing). 1977. Chalk, 10 x 40 ft (304.8 x 1,217.2 cm). Installation, National Gallery of Victoria, Melbourne, Australia. Draftsmen: I. Barberis, J. Pertzel, B. Reynolds.

A parallelogram whose top and bottom sides are the same length as the radius of the circle and whose left and right sides are one and a half times the length of a side of the square and whose bottom side is drawn...

A circle whose center is located at a point halfway between a point halfway between the midpoint of the right side of the page and a point halfway between the midpoint of the left side of the page and a point halfway between the center of the page and the upper left arm and whose radius is the same as half the distance between the center of the page and a point halfway between the midpoint of the right side and the lower right corner...

A trapezoid whose bottom side is the same length as the distance between the center of the circle and the upper right corner of the square and is drawn from a point halfway between the right side of the page on a line drawn through the point where the line crosses the right side of the parallelogram and the top side of the square from a point halfway between the upper left corner of the parallelogram and the lower left corner of the square and whose left side is the same length as the distance between the center of the circle and the lower left side of the square drawn in the direction of the point halfway between the midpoint of the top side of the page and the upper right corner of the page.

A square whose...

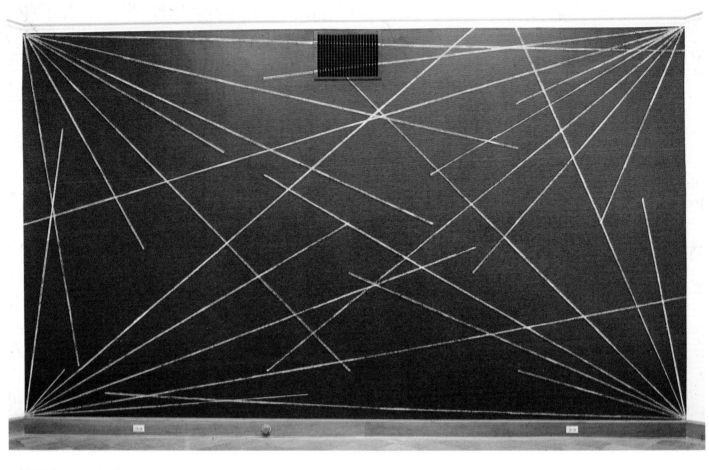

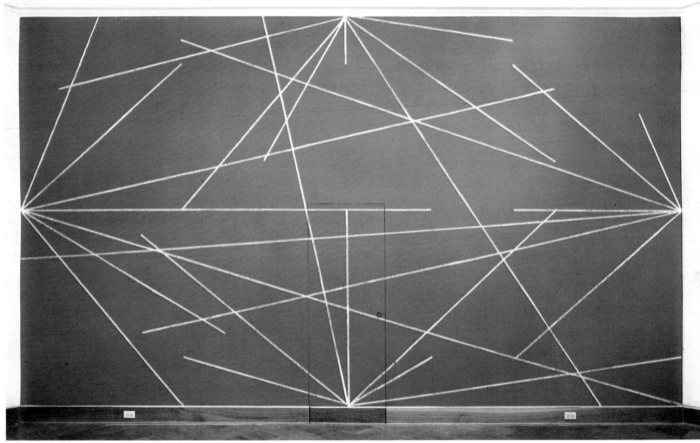

150

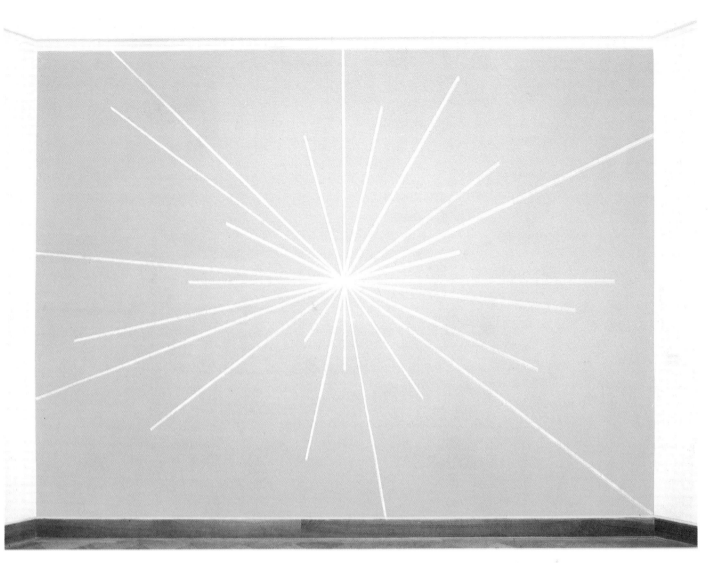

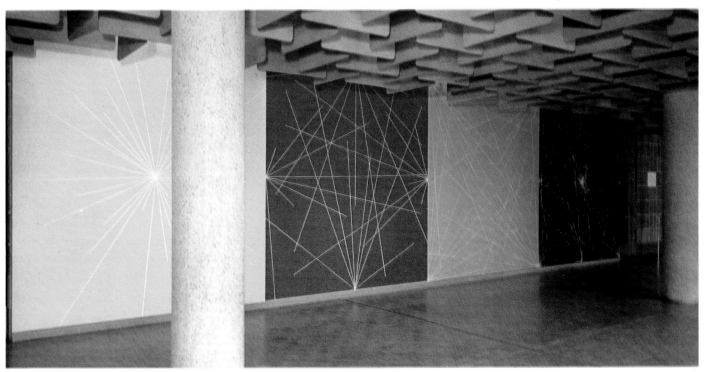

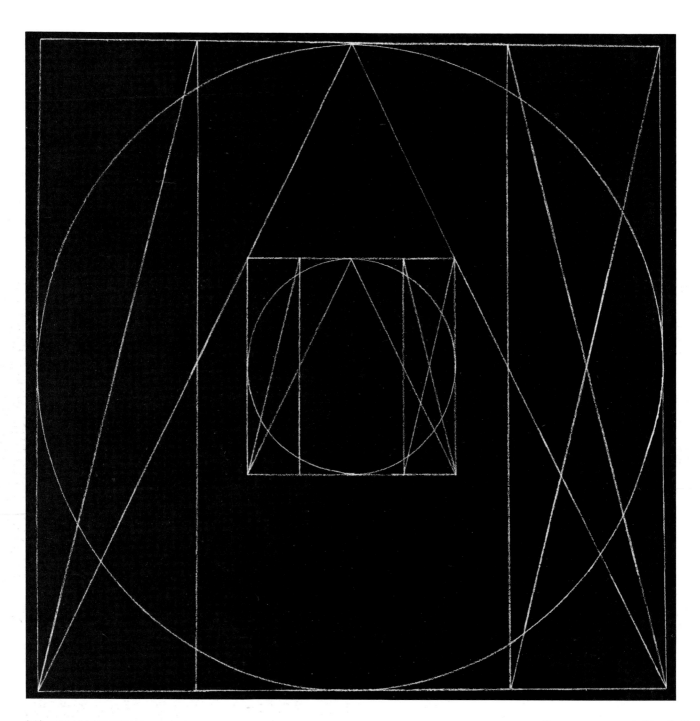

264. SIX GEOMETRIC FIGURES WITHIN SIX GEOMETRIC FIGURES, SUPERIMPOSED (Wall Drawing). 1976. White chalk on black wall. Installation, John Weber Gallery, New York. Draftsmen: K. Miyamoto and A. Sansotta.

265. *Opposite page:* CIRCLE (Wall Drawing). 1977. White chalk on brown wall. Installation, Saalfield Residence, New York. Draftsmen: J. Watanabe and A. Hagihara.

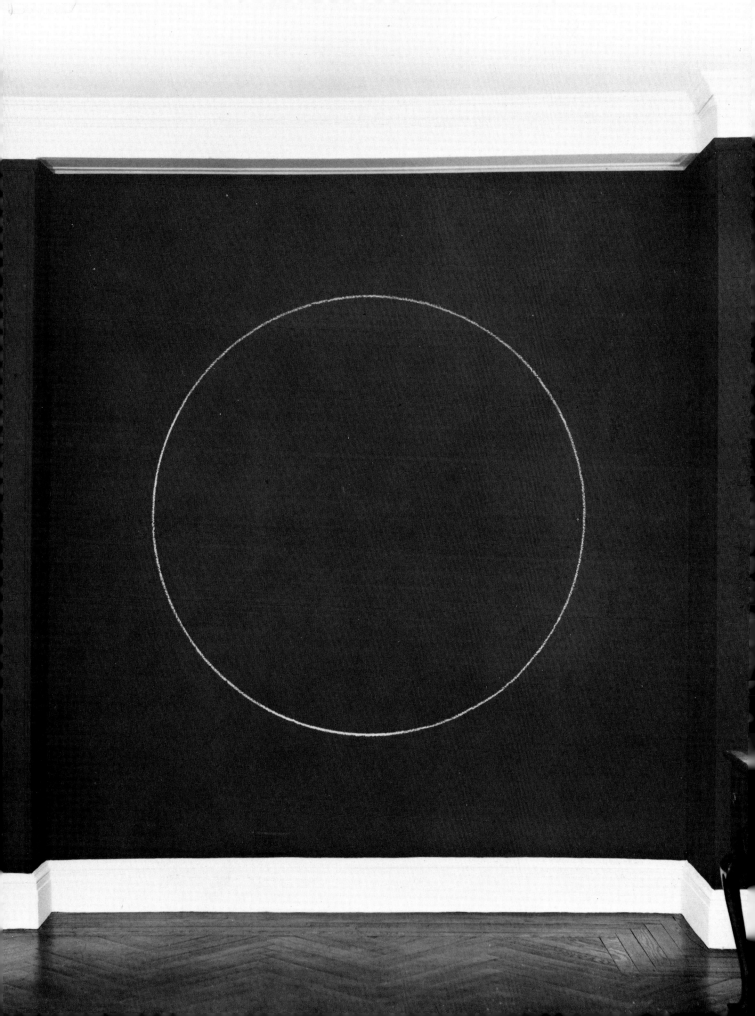

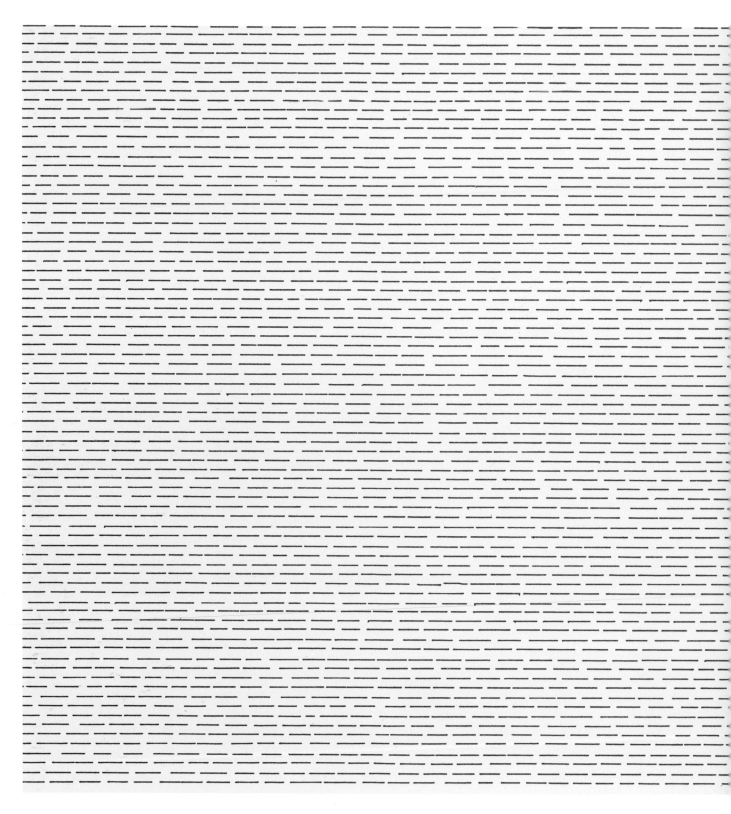

266. YELLOW AND RED STRAIGHT, NOT-STRAIGHT, AND BROKEN
LINES ON YELLOW AND RED. From book *Lines & Color,* 1975.

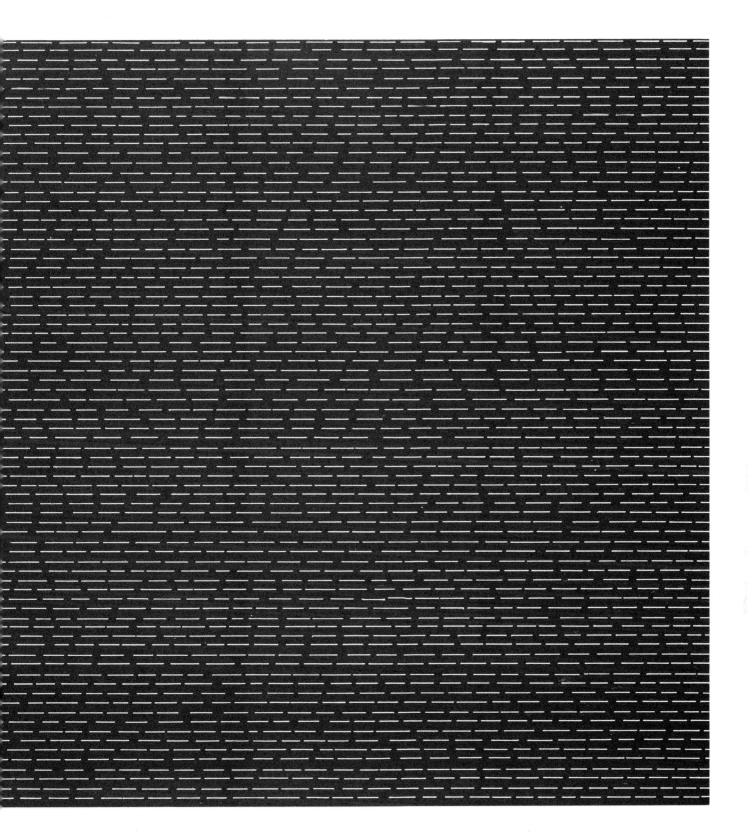

155

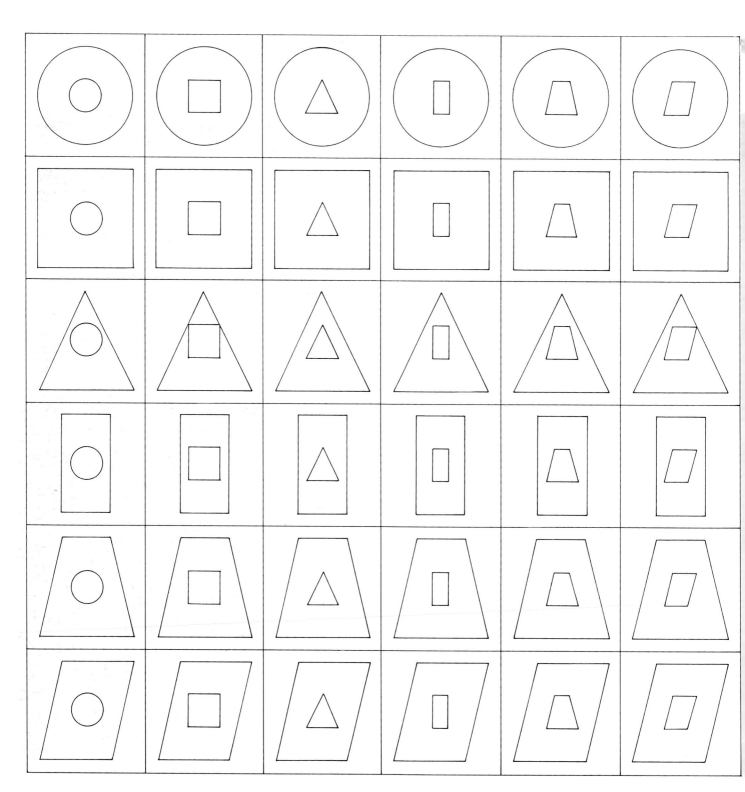

267. ALL COMBINATIONS OF SIX GEOMETRIC FIGURES
(Circle, Square, Triangle, Rectangle, Trapezoid, and Parallelogram
within Six Geometric Figures). 1976. Pen and ink, 15⅞
x 15⅞ in (40.4 x 40.4 cm).

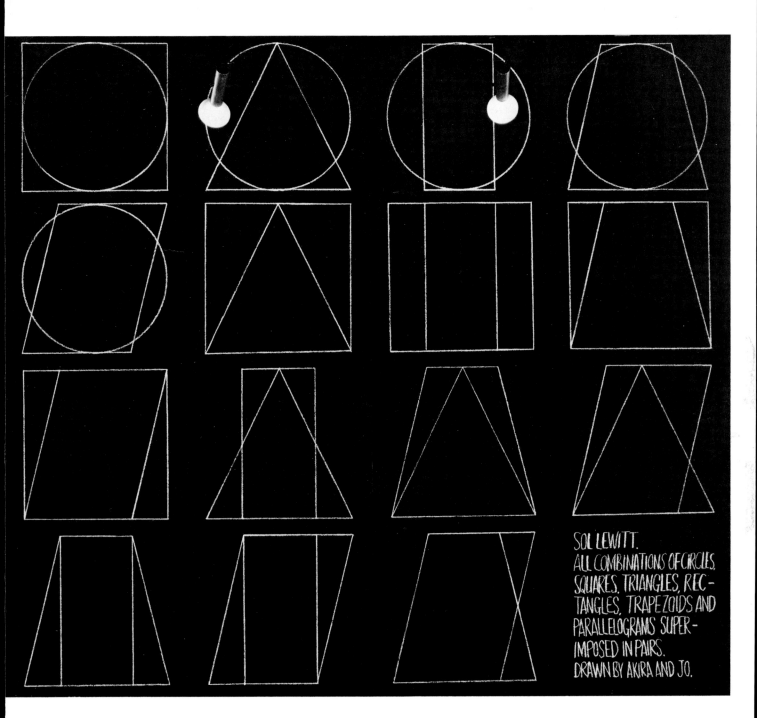

The text within the drawing reads:

SOL LEWITT.
ALL COMBINATIONS OF CIRCLES,
SQUARES, TRIANGLES, REC-
TANGLES, TRAPEZOIDS AND
PARALLELOGRAMS SUPER-
IMPOSED IN PAIRS.
DRAWN BY AKIRA AND JO.

268. ALL COMBINATIONS OF SIX GEOMETRIC FIGURES SUPERIM-
POSED IN PAIRS (Fifteen-part Wall Drawing). 1977. White chalk on
black wall. Installation, Hundred Acres Gallery, New York.
Draftsmen: A. Hagihara, J. Watanabe.

PHOTOGRAPHIC PIECES

269. Double page from book *Photogrid.* 1977. Colored photos, each page 10½ x 10½ in (26.8 x 26.8 cm).

No matter where one looks in an urban setting there are grids to be seen. Whether decorative or functional, grids provide a kind of order. While traving around doing wall drawings in many places, I found grids to photograp Each city made sewer covers, for instance, that while serving the same pupose are designed in a different way. It is a kind of art made without art i mind (I suppose). On the following pages are photographic projects usin, the grid of cities and of a wall. This wall is outside the window of the place have lived in for the past seventeen years. It changes each time I see it and h a constant beauty no matter when seen.

AEROFOTOGRAFIA DELLA CITTÀ DI FIRENZE ESEGUITA NELL'ANNO 1972

270. PHOTO OF FLORENCE with the area between Piazza S.
Marco, via Cavour, via Guelfa, via de' Ginori, Borgo S. Lorenzo,
via Roma, via d' Posinghi, via Calsamoli, via Speziali, Piazza Della
Republica, via Calimala, via Por S. Maria, Piazza de Pesce, Lun-
garno Archibuse, Lungarno Generale Diaz, via del Benci, via
Ghibelluca, via del Proconsolo, Piazza Duomo, via del Servi, Piazza
delle SS. Annuziata, via C. Battisti and via Ricasoli removed. R 609.
1976. Cut paper drawing, 24½ x 27 in (62.3 x 68.6 cm).

271. PHOTO OF CENTRAL MANHATTAN without the area between the places where Sol LeWitt has lived: 115 East 34th St., 185 Ave. C, 42 Montgomery St., and 117 Hester St. R 730. 1977. Cut paper drawing, 16 x 16 in (40.5 x 40.5 cm).

272. *Next two pages:* BRICK WALL. 1977. Two black–and–white photographs, each 10⅞ x 8⅝ in (27.7 x 22 cm).

273. BURIED CUBE CONTAINING AN OBJECT OF IMPORTANCE BUT LITTLE VALUE. 1968. Steel, ca. 10 x 10 x 10 in (25.4 x 25.4 x 25.4 cm). Made by Dick van der Net.

Each person, being different, conceives of art differently. There is no high or low art or good or bad art, but different kinds of art to satisfy the aesthetic needs of all. Whatever one understands to be art is art. When art is commercialized, it is trivialized. No artist can fail to realize that compromising the integrity of his or her concept weakens it. (Even commercial artists hate to see their ideas mangled by corporate directors.) Gertrude Stein said a work of art was either priceless or worthless. The art system trivializes art by assigning monetary values to it, thus turning art into a commodity. If art were truly a commodity, the owner would be free to change it to suit his taste. But the collector has the moral obligation to be a trustee of the work and pass it on in the same condition that it was received. The collector would also imperil his investment if he vandalized the piece. Since artists, except on rare occasions, do not make their work for private collections or individuals, the work of the time should be available to all the people of that time. The function of museums is to preserve the art of the past, but also to make the art of the present available to all. The artists' ideas come from the experience of the world in which they live and are returned to that society in the form of works of art. These works are a history and commentary on that time, and should be understood as documents of that time.

Walls are public and large, books are small and private. They can each give the same information. Anyone can own books and look at them any time. When one sees a wall, it is the impact of the whole that is understood at once—emotionally more than intellectually. It is only by reading the wall that the viewer understands it fully.

ON KAWARA TO SOL LEWITT:
NHA 022 09) BD 129 NK 107
NN NFR 007 VW MIN NL PDC NFR
NEW YORK NY 5
SOL LEWITT, D Y 75
117 HESTER STREET NYK
I AM STILL ALIVE
ON KAWARA

I AM STILL ALIVE, ON KAWARA
I AM STILL, ON KAWARA
I AM STILL ON KAWARA
I AM ALIVE, ON KAWARA
I AM ON KAWARA
I AM, ON KAWARA
I AM ON, KAWARA
I AM STILL ALIVE
I AM STILL ON
I AM STILL
I AM STILL, ALIVE
I AM ALIVE
I AM, STILL
I AM ON KAWARA
I AM ON
I AM STILL KAWARA
I AM STILL, KAWARA
I AM KAWARA
AM I STILL ALIVE, ON KAWARA?
AM I STILL, ALIVE?
AM I STILL, ON KAWARA?
AM I STILL ON KAWARA?
AM I STILL ON?
AM I STILL ALIVE?
AM I ALIVE, STILL?
AM I STILL, ALIVE, ON KAWARA?
AM I ALIVE?
AM I STILL?
AM I ON KAWARA?
AM I ON?
AM I?
I?
I, ON KAWARA, AM ALIVE
I, ON KAWARA, AM STILL
I, ON, AM KAWARA
I, ON, AM STILL KAWARA
I, KAWARA, AM ON

I, KAWARA, AM STILL ON
ON KAWARA, I AM STILL ALIVE
ON KAWARA, I AM STILL
ON, KAWARA I AM, STILL
ON KAWARA, I AM ALIVE
ON KAWARA, I AM STILL?
ON KAWARA, AM I ALIVE?
KAWARA, AM I ALIVE?
KAWARA, AM I STILL?
KAWARA, AM I ON?
KAWARA, I AM ON
KAWARA, I AM ALIVE
KAWARA, I AM STILL
ON KAWARA AM I
ON KAWARA, AM I?
ON KAWARA, I AM
ON KAWARA AM I STILL?
ON KAWARA, I AM STILL
KAWARA, AM I STILL ON?
KAWARA, I AM STILL ON
STILL, I AM ALIVE, ON KAWARA
STILL, I AM ON KAWARA
STILL, I AM ALIVE
STILL, I AM ON
STILL, I AM KAWARA
STILL ON, I AM KAWARA
STILL KAWARA, I AM ALIVE
STILL, AM I ALIVE
STILL, AM I ON?
STILL, AM I ON KAWARA?
STILL, AM I KAWARA?
ALIVE, I AM ON KAWARA
ALIVE, I AM STILL
ALIVE, I AM ON
ALIVE, AM I ON KAWARA?
ALIVE, AM I STILL?
ALIVE, AM I ON?

274. I AM STILL ALIVE. ON KAWARA. 1970.

As a project for the Summer 1970 issue of Studio International, *Seth Siegelaub asked art critics from various cities to choose artists to fill eight pages each. From New York, Lucy Lippard asked each artist on a list of eight to send "instructions" to the next one on the list. On Kawara sent a telegram saying "I am still alive. On Kawara" to Sol LeWitt, who sent the following to Douglas Heubler: "Begin at the beginning, end at the end, end the beginning, begin at the end." He produced a dot.*

Paragraphs on Conceptual Art

The editor has written me that he is in favor of avoiding "the notion that the artist is a kind of ape that has to be explained by the civilized critic." This should be good news to both artists and apes. With this assurance I hope to justify his confidence. To use a baseball metaphor (one artist wanted to hit the ball out of the park, another to stay loose at the plate and hit the ball where it was pitched), I am grateful for the opportunity to strike out for myself.

I will refer to the kind of art in which I am involved as conceptual art. In conceptual art the idea or concept is the most important aspect of the work. When an artist uses a conceptual form of art, it means that all of the planning and decisions are made beforehand and the execution is a perfunctory affair. The idea becomes a machine that makes the art. This kind of art is not theoretical or illustrative of theories; it is intuitive, it is involved with all types of mental processes and it is purposeless. It is usually free from the dependence on the skill of the artist as a craftsman. It is the objective of the artist who is concerned with conceptual art to make his work mentally interesting to the spectator, and therefore usually he would want it to become emotionally dry. There is no reason to suppose, however, that the conceptual artist is out to bore the viewer. It is only the expectation of an emotional kick, to which one conditioned to expressionist art is accustomed, that would deter the viewer from perceiving this art.

Conceptual art is not necessarily logical. The logic of a piece or series of pieces is a device that is used at times, only to be ruined. Logic may be used to camouflage the real intent of the artist, to lull the viewer into the belief that he understands the work, or to infer a paradoxical situation (such as logic vs. illogic). Some ideas are logical in conception and illogical perceptually. The ideas need not be complex. Most ideas that are successful are ludicrously simple. Successful ideas generally have the appearance of simplicity because they seem inevitable. In terms of ideas the artist is free even to surprise himself. Ideas are discovered by intuition.

What the work of art looks like isn't too important. It has to look like something if it has physical form. No matter what form it may finally have it must begin with an idea. It is the process of conception and realization with which the artist is concerned. Once given physical reality by the artist the work is open to the perception of all, including the artist. (I use the word perception to mean the apprehension of the sense data, the objective understanding of the idea, and simultaneously a subjective interpretation of both.) The work of art can be perceived only after it is completed.

Art that is meant for the sensation of the eye primarily would be called perceptual rather than conceptual. This would include most optical, kinetic, light, and color art.

Since the functions of conception and perception are contradictory (one pre-, the other postfact) the artist would mitigate his idea by applying subjective judgment to it. If the artist wishes to explore his idea thoroughly, then arbitrary or chance decisions would be kept to a minimum, while caprice, taste and other whimsies would be eliminated from the making of the art. The work does not necessarily have to be rejected if it does not look well. Sometimes what is initially thought to be awkward will eventually be visually pleasing.

To work with a plan that is preset is one way of avoiding subjectivity. It also obviates the necessity of designing each work in turn. The plan would design the work. Some plans would require millions of variations, and some a limited number, but both are finite. Other plans imply infinity. In each case, however, the artist would select the basic form and rules that would govern the solution of the problem. After that the fewer decisions made in the course of completing the work, the better. This eliminates the arbitrary, the capricious, and the subjective as much as possible. This is the reason for using this method.

When an artist uses a multiple modular method he usually chooses a simple and readily available form. The form itself is of very limited importance; it becomes the grammar for the total work. In fact, it is best that the basic unit be deliberately uninteresting so that it may more easily become an intrinsic part of the entire work. Using complex basic forms only disrupts the unity of the whole. Using a simple form repeatedly narrows the field of the work and concentrates the intensity to the arrangement of the form. This arrangement becomes the end while the form becomes the means.

Conceptual art doesn't really have much to do with mathematics, philosophy, or any other mental discipline. The mathematics used by most artists is simple arithmetic or simple number systems. The philosophy of the work is implicit in the work and it is not an illustration of any system of philosophy.

It doesn't really matter if the viewer understands the concepts of the artist by seeing the art. Once it is out of his hand the artist has no control over the way a viewer will perceive the work. Different people will understand the same thing in a different way.

Recently there has been much written about minimal art, but I have not discovered anyone who admits to doing this kind of thing. There are other art forms around called primary structures, reductive, rejective, cool, and mini-art. No artist I

know will own up to any of these either. Therefore I conclude that it is part of a secret language that art critics use when communicating with each other through the medium of art magazines. Mini-art is best because it reminds one of mini-skirts and long-legged girls. It must refer to very small works of art. This is a very good idea. Perhaps "mini-art" shows could be sent around the country in matchboxes. Or maybe the mini-artist is a very small person, say under five feet tall. If so, much good work will be found in the primary schools (primary school primary structures).

If the artist carries through his idea and makes it into visible form, then all the steps in the process are of importance. The idea itself, even if not made visual, is as much a work of art as any finished product. All intervening steps—scribbles, sketches, drawings, failed works, models, studies, thoughts, conversations—are of interest. Those that show the thought process of the artist are sometimes more interesting than the final product.

Determining what size a piece should be is difficult. If an idea requires three dimensions then it would seem any size would do. The question would be what size is best. If the thing were made gigantic then the size alone would be impressive and the idea may be lost entirely. Again, if it is too small, it may become inconsequential. The height of the viewer may have some bearing on the work and also the size of the space into which it will be placed. The artist may wish to place objects higher than the eye level of the viewer, or lower. I think the piece must be large enough to give the viewer whatever information he needs to understand the work and placed in such a way that will facilitate this understanding. (Unless the idea is of impediment and requires difficulty of vision or access.)

Space can be thought of as the cubic area occupied by a three-dimensional volume. Any volume would occupy space. It is air and cannot be seen. It is the interval between things that can be measured. The intervals and measurements can be important to a work of art. If certain distances are important they will be made obvious in the piece. If space is relatively unimportant it can be regularized and made equal (things placed equal distances apart) to mitigate any interest in interval. Regular space might also become a metric time element, a kind of regular beat or pulse. When the interval is kept regular whatever is irregular gains more importance.

Architecture and three-dimensional art are of completely opposite natures. The former is concerned with making an area with a specific function. Architecture, whether it is a work of art or not, must be utilitarian or else fail completely. Art is not utilitarian. When three-dimensional art starts to take on some of the characteristics of architecture, such as forming utilitarian areas, it weakens its function as art. When the viewer is dwarfed by the larger size of a piece this domination emphasizes the physical and emotive power of the form at the expense of losing the idea of the piece.

New materials are one of the great afflictions of contemporary art. Some artists confuse new materials with new ideas. There is nothing worse than seeing art that wallows in gaudy baubles. By and large most artists who are attracted to these materials are the ones who lack the stringency of mind that would enable them to use the materials well. It takes a good artist to use new materials and make them into a work of art. The danger is, I think, in making the physicality of the materials so important that it becomes the idea of the work (another kind of expressionism).

Three-dimensional art of any kind is a physical fact. This physicality is its most obvious and expressive content. Conceptual art is made to engage the mind of the viewer rather than his eye or emotions. The physicality of a three-dimensional object then becomes a contradiction to its non-emotive intent. Color, surface, texture, and shape only emphasize the physical aspects of the work. Anything that calls attention to and interests the viewer in this physicality is a deterrent to our understanding of the idea and is used as an expressive device. The conceptual artist would want to ameliorate this emphasis on materiality as much as possible or to use it in a paradoxical way (to convert it into an idea). This kind of art, then, should be stated with the greatest economy of means. Any idea that is better stated in two dimensions should not be in three dimensions. Ideas may also be stated with numbers, photographs, or words or any way the artist chooses, the form being unimportant.

These paragraphs are not intended as categorical imperatives, but the ideas stated are as close as possible to my thinking at this time. These ideas are the result of my work as an artist and are subject to change as my experience changes. I have tried to state them with as much clarity as possible. If the statements I make are unclear it may mean the thinking is unclear. Even while writing these ideas there seemed to be obvious inconsistencies (which I have tried to correct, but others will probably slip by). I do not advocate a conceptual form of art for all artists. I have found that it has worked well for me while other ways have not. It is one way of making art; other ways suit other artists. Nor do I think all conceptual art merits the viewer's attention. Conceptual art is good only when the idea is good.

Reprinted from *Artforum* (New York), June 1967

Sentences on Conceptual Art

1 Conceptual artists are mystics rather than rationalists. They leap to conclusions that logic cannot reach.

2 Rational judgments repeat rational judgments.

3 Irrational judgments lead to new experience.

4 Formal art is essentially rational.

5 Irrational thoughts should be followed absolutely and logically.

6 If the artist changes his mind midway through the execution of the piece he compromises the result and repeats past results.

7 The artist's will is secondary to the process he initiates from idea to completion. His willfulness may only be ego.

8 When words such as painting and sculpture are used, they connote a whole tradition and imply a consequent acceptance of this tradition, thus placing limitations on the artist who would be reluctant to make art that goes beyond the limitations.

9 The concept and idea are different. The former implies a general direction while the latter is the component. Ideas implement the concept.

10 Ideas can be works of art; they are in a chain of development that may eventually find some form. All ideas need not be made physical.

11 Ideas do not necessarily proceed in logical order. They may set one off in unexpected directions, but an idea must necessarily be completed in the mind before the next one is formed.

12 For each work of art that becomes physical there are many variations that do not.

13 A work of art may be understood as a conductor from the artist's mind to the viewer's. But it may never reach the viewer, or it may never leave the artist's mind.

14 The words of one artist to another may induce an idea chain, if they share the same concept.

15 Since no form is intrinsically superior to another, the artist may use any form, from an expression of words (written or spoken) to physical reality, equally.

16 If words are used, and they proceed from ideas about art, then they are art and not literature; numbers are not mathematics.

17 All ideas are art if they are concerned with art and fall within the conventions of art.

18 One usually understands the art of the past by applying the convention of the present, thus misunderstanding the art of the past.

19 The conventions of art are altered by works of art.

20 Successful art changes our understanding of the conventions by altering our perceptions.

21 Perception of ideas leads to new ideas.

22 The artist cannot imagine his art, and cannot perceive it until it is complete.

23 The artist may misperceive (understand it differently from the artist) a work of art but still be set off in his own chain of thought by that misconstrual.

24 Perception is subjective.

25 The artist may not necessarily understand his own art. His perception is neither better nor worse than that of others.

26 An artist may perceive the art of others better than his own.

27 The concept of a work of art may involve the matter of the piece or the process in which it is made.

28 Once the idea of the piece is established in the artist's mind and the final form is decided, the process is carried out blindly. There are many side effects that the artist cannot imagine. These may be used as ideas for new works.

29 The process is mechanical and should not be tampered with. It should run its course.

30 There are many elements involved in a work of art. The most important are the most obvious.

31 If an artist uses the same form in a group of works, and changes the material, one would assume the artist's concept involved the material.

32 Banal ideas cannot be rescued by beautiful execution.

33 It is difficult to bungle a good idea.

34 When an artist learns his craft too well he makes slick art.

35 These sentences comment on art, but are not art.

First published in *0-9* (New York), 1969, and *Art-Language* (England), May 1969

Wall Drawings

I wanted to do a work of art that was as two-dimensional as possible.

It seems more natural to work directly on walls than to make a construction, to work on that, and then put the construction on the wall.

The physical properties of the wall: height, length, color, material, and architectural conditions and intrusions, are a necessary part of the wall drawings.

Different kinds of walls make for different kinds of drawings.

Imperfections on the wall surface are occasionally apparent after the drawing is completed. These should be considered a part of the wall drawing.

The best surface to draw on is plaster, the worst is brick, but both have been used.

Most walls have holes, cracks, bumps, grease marks, are not level or square, and have various architectural eccentricities.

The handicap in using walls is that the artist is at the mercy of the architect.

The drawing is done rather lightly, using hard graphite so that the lines become, as much as possible, a part of the wall surface, visually.

Either the entire wall or a portion is used, but the dimensions of the wall and its surface have a considerable effect on the outcome.

When large walls are used the viewer would see the drawings in sections sequentially, and not the wall as a whole.

Different draftsmen produce lines darker or lighter and closer or farther apart. As long as they are consistent there is no preference.

Various combinations of black lines produce different tonalities; combinations of colored lines produce different colors.

The four basic kinds of straight lines used are vertical, horizontal, 45° diagonal left to right, and 45° diagonal right to left.

When color drawings are done, a flat white wall is preferable. The colors are yellow, red, blue, and black, the colors used in printing.

When a drawing is done using only black lines, the same tonality should be maintained throughout the plane in order to maintain the integrity of the wall surface.

An ink drawing on paper accompanies the wall drawing. It is rendered by the artist while the wall drawing is rendered by assistants.

The ink drawing is a plan for but not a reproduction of the wall drawing; the wall drawing is not a reproduction of the ink drawing. Each is equally important.

It is possible to think of the sides of simple three-dimensional objects as walls and draw on them.

The wall drawing is a permanent installation, until destroyed. Once something is done, it cannot be undone.

Reprinted from *Arts Magazine* (New York), April 1970.

Doing Wall Drawings

The artist conceives and plans the wall drawing. It is realized by draftsmen (the artist can act as his own draftsman); the plan (written, spoken, or drawn) is interpreted by the draftsman.

There are decisions that the draftsman makes, within the plan, as part of the plan. Each individual, being unique, if given the same instructions would understand them differently and would carry them out differently.

The artist must allow various interpretations of his plan. The draftsman perceives the artist's plan, then reorders it to his experience and understanding.

The draftsman's contributions are unforeseen by the artist, even if he, the artist, is the draftsman. Even if the same draftsman followed the same plan twice, there would be two different works of art. No one can do the same thing twice.

The artist and the draftsman become collaborators in making the art.

Each person draws a line differently and each person understands words differently.

Neither lines nor words are ideas, they are the means by which ideas are conveyed.

The wall drawing is the artist's art, as long as the plan is not violated. If it is, then the draftsman becomes the artist and the drawing would be his work of art, but art that is a parody of the original concept.

The draftsman may make errors in following the plan. All wall drawings contain errors, they are part of the work.

The plan exists as an idea but needs to be put into its optimum form. Ideas of wall drawings alone are contradictions of the idea of wall drawings.

The explicit plan should accompany the finished wall drawing. They are of equal importance.

Reprinted from *Art Now* (New York), June 1971

Serial Project No. 1 (ABCD)

Serial compositions are multipart pieces with regulated changes. The differences between the parts are the subject of the composition. If some parts remain constant it is to punctuate the changes. The entire work would contain subdivisions that could be autonomous but that comprise the whole. The autonomous parts are units, rows, sets, or any logical division that would be read as a complete thought. The series would be read by the viewer in a linear or narrative manner even though in its final form many of these sets would be operating simultaneously, making comprehension difficult. The aim of the artist would not be to instruct the viewer but to give him information. Whether the viewer understands this information is incidental to the artist; one cannot foresee the understanding of all one's viewers. One would follow one's predetermined premise to its conclusion, avoiding subjectivity. Chance, taste, or unconsciously remembered forms would play no part in the outcome. The serial artist does not attempt to produce a beautiful or mysterious object but functions merely as a clerk cataloging the results of the premise.

The premise governing this series is to place one form within another and include all major variations in two and three dimensions. This is to be done in the most succinct manner, using the fewest measurements. It would be a finite series using the square and cube as its syntax. A more complex form would be too interesting in itself and obstruct the meaning of the whole. There is no need to invent new forms. The square and cube are efficient and symmetrical. In order to free a square within a larger square, the larger square is divided into nine equal parts. The center square would be equally distant from the outer square and exactly centered. A single measurement is used as the basis for the series.

The set contains nine pieces They are all of the variations within the scope of the first premise. The first variation is a square within a square. The other variations follow: a cube within a square, a square within a cube, an outer form raised to the height of the inner cube, the inner cube raised to the height of the outer, larger cube, a cube within a cube, and all cross matchings of these forms. The first set contains nine

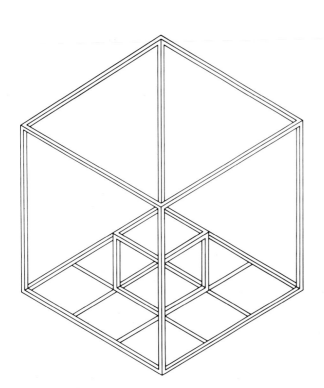

81''

1-1/2''

28''

pieces. These pieces are laid out on a grid. The grid equalizes the spacing and makes all of the pieces and spaces between of equal importance. The individual pieces are arranged in three rows of three forms each. In each row there are three different parts and three parts that are the same. The inner forms of one row of three are read in sequence, as are the outer forms.

The sets of nine are placed in four groups. Each group comprises variations on open or closed forms.

closed inside
closed outside

D	C
A	B

open inside
closed outside

open inside
open outside

closed inside
open outside

In cases in which the same plane is occupied by both the inside and outside forms, the inside plane takes precedence. This is done so that there is more information given the viewer. If it were otherwise more forms would be invisible, impeding the viewer's understanding of the whole set. When the larger form is closed and the top of the smaller form is not on the same plane as the larger—but lower—the smaller form is placed inside. If the viewer cannot see the interior form, one may believe it is there or not but one knows which form one believes is there or not there. The evidence given him or her by the other pieces in the set, and by reference to the other sets will inform the viewer as to what should be there. The sets are grouped in the most symmetrical way possible. Each set mirrors the others, with the higher pieces concentrated in the center.

Reprinted from *Aspen Magazine*, nos. 5 and 6, 1966

The Cube

The most interesting characteristic of the cube is that it is relatively uninteresting. Compared to any other three-dimensional form, the cube lacks any aggressive force, implies no motion, and is least emotive. Therefore it is the best form to use as a basic unit for any more elaborate function, the grammatical device from which the work may proceed. Because it is standard and universally recognized, no intention is required of the viewer. It is immediately understood that the cube represents the cube, a geometric figure that is uncontestably itself. The use of the cube obviates the necessity of inventing another form and reserves its use for invention.

Reprinted from *Art in America* (New York), Summer 1966

Some Points Bearing on the Relationship of Works of Art to Museums and Collectors

1 A work of art by a living artist would still be the property of the artist. A collector would, in a sense, be the custodian of that art.
2 The artist would be consulted when his work is displayed, reproduced, or used in any way.
3 The museum, collector, or publication would compensate the artist for use of his art. This is a rental, beyond the original purchase price. The rental could be nominal; the principle of a royalty would be used.
4 An artist would have the right to retrieve his work from a collection if he compensates the purchaser with the original price or a mutually agreeable substitute.
5 When a work is resold from one collector to another, the artist would be compensated with a percentage of the price.
6 An artist should have the right to change or destroy any work of his as long as he lives.

Some Points Bearing on The Museum of Modern Art and its Relationship to Artists and the General Community

1 The MoMA would be limited to collecting work no more than 25 years old.
2 Older work would be sold and the proceeds used to maintain a truly modern collection.
3 The shows should reflect an interest in and the promotion of modern works of art.
4 A system of branch museums would awaken interest in modern art in the communities of the city. More exhibition space would then be available and curators would be responsive to elements within the community.
5 The museum could not only purchase work but also commission works of painting, sculpture, film, dance, music, and drama and use its facilities to show them.
6 The works of artists not usually shown or works of art not readily available because of size or location should be encouraged and shown.

Public hearing, Art Workers Coalition, School of Visual Arts, New York, April 10, 1969

Ziggurats

The most common type of office building seen in midtown Manhattan is built in the ziggurat style with multiple set-backs. The design conformed with the New York Zoning Code of 1916 to 1963. The original purpose of the set-backs was to allow sunlight into the street and free circulation of air. In 1916 this was feasible, but as the buildings became higher the regulations became obsolete. However, since they were in effect during the postwar building boom, the result is a unique group of buildings that give the area a distinctive look.

The zoning code preconceived the design of the ziggurats, just as an idea might give any work of art its outer boundaries and remove arbitrary and capricious decisions. In many cases this is a liberating rather than a confining form. The ziggurat buildings conform to the code, yet no two are alike; the slab-type buildings that now are being built seem more uniform.

The zoning code established a design that has much intrinsic value. The ziggurat buildings are heavy looking, stable, inert, and earthbound. There is nothing graceful or lightweight here, as in the slab buildings. There is also a logic in the continually smaller set-backs, which allow for intricate geometric patterns. By having to conform to this rather rigid code, aestheticism was avoided, but the code was flexible enough to allow great originality of design. New materials were not necessary. The earlier brick buildings, which were some of the most successful of the genre, are particularly opaque and homely. The slab-type buildings, on the other hand, established by the rules of taste and aestheticism, require new materials for variety. The ziggurat buildings are most satisfying when seen from a little distance (two or three blocks) so that the entire massive design is seen. This is difficult in New York, but the ziggurats, when seen from the

immediate return on the investment and a sufficient supply of floor space.

Now architects do not think very highly of the ziggurat buildings. Since they are no longer forced by the zoning code to provide set-backs, they will probably no longer build them. Ironically, the new Whitney Museum is an upside down ziggurat and is considered high-style, while the office buildings are not thought to be very classy. In view of this obvious suspension of judgment it might be time to take a new look at the ziggurats. Many will be seen to be valuable works of art.

Reprinted from *Arts Magazine* (New York), November 1966. Photos: Gretchen Lambert

upper floors of other buildings, are especially impressive. The new zoning code allows slab-type buildings, and also stipulates that a certain amount of plaza space must also be allotted. This will permit more flexibility in site planning and more space on the ground level.

Besides being impressive in design, the ziggurat allowed flexibility to the renting agent, who could offer higher floors with less floor space to companies that desired the prestige of height and did not want to share the floor with another organization. This design also made available more terraces and more sunlight.

Most of the ziggurats were built in the fifties as part of the business expansion following World War II. They were built quickly, cheaply, and not very well, reflecting a desire for an

Ruth Vollmer: Mathematical Forms

These pieces are not sculpture; they are ideas made into solid forms.
The ideas are illustrations of geometric formulae; they are found ideas, not invented, and not changed.
The pieces are not about mathematics; they are about art. Geometry is used as a beginning just as a nineteenth-century artist might have used the landscape.
The geometry is only a mental fact.
There is a simple and single idea for each form; there is a single and basic material of which the piece is constructed.
The material used has physical properties that are evident, and useful to the form.
The pieces have a size small enough to mitigate any expressiveness. They are not gross and pompous. They are of the necessary size, neither large nor small; the form is in harmony with the idea.
The scale is perfect.
They are works of quality and excellence.

Reprinted from *Studio International* (London) December 1970

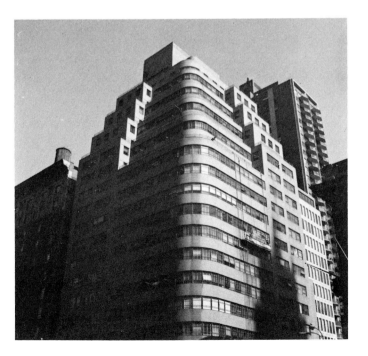

Comments on an Advertisement Published in Flash Art, April 1973.

I would like to comment on an advertisement that appeared in *Flash Art* two issues back. The text read: "Which work of what European artist of the sphere of neue konkrete Kunst will be taken next by Sol LeWitt for a copy of his newest works which will be propagated with as much publicity as his own innovation?" Following this statement were three illustrations with double attributions:

1. Jan J. Schoonhoven, Zeichnung, 1962/Sol LeWitt, Drawing, 1969.
2. François Morellet, Grillages, ca. 1958/Sol LeWitt, Arcs, Grids and Circles, 1972.
3. Oskar Holweck, paper relief, ca. 1958/Sol LeWitt, paper piece, 1972.

The folded paper piece might or might not be my work, but I did not do the other two pieces, nor did I copy them. Here is a comparison of Schoonhoven's drawing and one of mine that is closest in appearance to it and Morellet's drawing and the one of mine described in the ad photos. The reader can make his own judgments. I would like to add that I have been an admirer of Schoonhoven's work for a long time and own a small drawing of his. Before last summer I never saw a work by Morellet; the drawing described, "Arcs, Circles & Grids," is the 195th and last variation of all the combinations of these forms and cannot be fully understood as an isolated work.

In the Morellet illustration there are only grids. In my drawing there are arcs from sides and corners, and circles as well as grids. Before reading the ad, I never saw any work of Holweck, but I do not doubt that he or many other artists have done folded paper pieces. I have been doing mine since 1966.

I would like to discuss the more interesting part of the ad: the accusation that I "copy" other artist's work, and that I claim "innovation." There are many works of artists that superficially resemble the works of other artists. This has been true throughout art history. Single works can always be shown to be similar to other single works. Unless one compares the total work of each artist, one cannot say the work is the same. Comparisons have been made between Manzoni and Ryman because they both made white paintings; between Beuys and Morris because they both used felt; between Ulrich and Bochner because they both used measurements, and many others. Those that make such comparisons do not know the work of these artists and operate on the level of petty gossips. They are not be taken seriously. It is a pathetically outworn romantic notion that "real" artists emerge fully formed, having no traceable antecedents. The absurdity of this idea is apparent, and yet there are artists who claim this for themselves.

I believe that ideas, once expressed, become the common property of all. They are invalid if not used, they only can be given away and cannot be stolen. Ideas of art become the vocabulary of art and are used by other artists to form their own ideas (even if unconsciously).

My art is not of formal invention; the forms I use are only the carrier of the content. I am influenced by all art that I admire (and even art I don't admire).

They are all part of art history, and of my thinking process once they are assimilated. Art that is important is the art that investigates ideas in depth, not who did what first. Artists who do not understand this are tempted to predate their work, an activity that seems to beg for a footnote in art history.

One would have thought that the attendant idea of an "avant-garde," which is a product of that same mentality, would have been discarded by now. I don't believe most artists take it seriously, only critics who shop each year for the latest fashion in art, and who seek to become the discoverers of new movements. They use artists as their medium. One should resist being used in this way. After all, an artist can be in the "advanced guard" only once and cannot be flitting from one idea to another, merely to be first once again. Eventually he must settle down to do his art. My own work of the past ten years is about only one thing: logical statements made using formal elements as grammar. I am neither the first artist nor the last to be involved with this idea. If there are ideas in my work that interest other artists, I hope they make use of them. If someone borrows from me, it makes me richer, not poorer. If I borrow from others, it makes them richer but me no poorer. We artists, I believe, are part of a single community sharing the same language. Because of this there may be arguments, but it is sad to think that artists are set against one another by the owners of galleries who hope to profit by such controversy.

Those who understand art only by what it looks like often do not understand very much at all. The physical appearance of a work is often misleading. Art that emphasizes content (such as mine) cannot be seen or understood in a context of form. This is a large and crucial difference. It cannot be said that what looks alike is alike. If one wishes to understand the art of our time one must go beyond appearance. I hope that will be the last hate ad to be published in *Flash Art,* which has become a real forum for artists. One can always find interesting items in *Flash Art* because the texts are mostly by artists and not by art critics who would place their ideas between those of the artists and the reader. I want to thank Mr. Politi for the opportunity to answer this vicious and stupid attack.

Reprinted from *Flash Art* (Milan), June 1973

SELECTED BIBLIOGRAPHY AND LIST OF EXHIBITIONS

(Arranged chronologically within each section.)

BOOKS BY THE ARTIST

1. LeWitt, Sol. *Serial Project No.1* from *Aspen Magazine,* nos. 5 and 6, Section 17, 1966. 16 pp. (including covers), 8 x 8 in.
2. ———. *Set IIA, 1–24.* Los Angeles: Ace Gallery, 1968. 28 pp. (including covers), 9⅞ x 10 in. (see also Exhibitions, 1968)
3. ———. *49 Three-Part Variations Using Three Different Kinds of Cubes, 1967–68.* Zurich: Bruno Bischofberger, 1969. 28 pp. (including covers), 6⅝ x 13 ¹⁵/₁₆ in. (see also Exhibitions, 1969)
4. ———. *Four Basic Kinds of Straight Lines.* London: Studio International, 1969. 32 pp. 7⅞ x 7⅞ in.
5. ———. *Four Basic Colours and Their Combinations.* London: Lisson Publications, 1971. 37 pp., 7⅞ x 7⅞ in. (see also Exhibitions, 1971)
6. ———. *Arcs, Circles & Grids.* Bern: Kunsthalle Bern & Paul Bianchini, 1972. 208 pp., 8⅛ x 8⅛ in. (see also Exhibitions, 1972)
7. ———. *Cercles & Lignes.* Paris: Galerie Yvon Lambert, 1973. 8 pp. (see also Exhibitions, 1973)
8. ———. *Wall Drawings: Seventeen Squares of Eight Feet with Sixteen Lines and One Arc.* Portland, Oregon: Portland Center for the Visual Arts, 1973. 18 pp., 8½ x 5½ in. (see also Exhibitions, 1973)
9. ———. *Diciassette quadrati con sedici linee ed un arco.* Milan: Galleria Toselli, 1974. 20 pp.
10. ———. *Six Wall Drawings: Arcs with Straight Lines, Not-Straight Lines and Broken Lines.* Houston: Cusack Gallery, 1973. 16 pp., 8⁹/₁₆ x 5½ in. (see also Exhibitions, 1973)
11. ———. *Grids, Using Straight Lines, Not-Straight Lines & Broken Lines in All Their Possible Combinations.* 28 etchings in an edition of 25 copies, with 10 artist's proofs. Printed at Crown Point Press, Oakland, California. New York: Parasol Press, Ltd., 1973. 60 pp., 11 x 11 in.
12. ———. *The Location of Eight Points.* Washington, D.C.: Max Protetch Gallery, 1974. 24 pp. (including covers), 5½ x 5½ in. (see also Exhibitions, 1974)
13. ———. *Squares with Sides and Corners Torn Off.* Brussels: MTL (1974). 32 pp., 5½ x 5½ in. (see also Group Exhibitions, 1974)
14. ———. *La posizione di tre figure geometriche/The Location of Three Geometric Figures.* Turin: Galleria Sperone, 1974. 16 pp. (see also Exhibitions, 1974)
15. ———. *Incomplete Open Cubes.* New York: John Weber Gallery, 1974. 264 pp., 8 x 8 in. (see also Exhibitions, 1974 and bibl. 40)
16. ———. *Drawing Series I, II, III, IIII A & B (1970).* Turin: Galleria Sperone and Düsseldorf: Konrad Fischer, 1974. 224 pp., 8⅞ x 8⅞ in.
17. ———. *The Location of Lines.* London: Lisson Publications, 1974. 48 pp., 8 x 8 in. (see also Exhibitions, 1974)
18. ———. *Arcs and Lines.* Lausanne: Editions des Massons S.A., and Paris: Galerie Yvon Lambert, 1974. 56 pp., 8 x 8 in.
19. ———. *Lines & Color.* Zurich: Annemarie Verna; Bari: Marilena Bonomo; and Basel: Rolf Preisig, 1975. 72 pp., 8 x 8 in. (see also Exhibitions, 1975)
20. ———. *Grids, Using Straight, Not-Straight and Broken Lines in Yellow, Red & Blue and All Their Combinations.* Forty-five etchings in an edition of 10 with 7 artist's proofs, printed by Crown Point Press, Oakland. New York: Parasol Press Ltd., 1975. 10 ¹³/₁₆ x 11 in.
21. ———. *Grids.* Brussels: Pour Ecrire La Liberté, 1975. 8 pp., 10 x 9⅞ in.
22. ———. *Red, Blue and Yellow Lines from Sides, Corners and the Center of the Page to Points on a Grid.* Jerusalem: Israel Museum, 1975. 16 pp., 7⅛ x 7⅛ in. (see also Exhibitions, 1975)
23. ———. *Stone Walls.* Oakland: Crown Point Press, 1975. 32 pp.
24. ———. *The Location of Straight, Not-Straight & Broken Lines and All Their Combinations.* New York: John Weber Gallery, 1976. 16 pp., 8 x 8 in.
25. ———. *Geometric Figures within Geometric Figures.* Boulder: Department of Fine Arts of the University of Colorado at Boulder, 1976. 52 pp., 8 x 8 in. (see also Exhibitions, 1976)
26. ———. *Modular Drawings.* Geneva: Adelina von Furstenberg, 1976. 104 pp., 5⅞ x 5⅞ in.
27. ———. *Wall Drawings in Australia.* Sydney: John Kaldor, 1977. 16 pp., 7 x 7 in. (see also Exhibitions, 1977)
28. ———. *Brick Wall.* New York: Tanglewood Press, Inc., 1977. 32 pp., 10¼ x 8½ in.
29. ———. *Photogrids.* New York: Paul David Press, 1977. 48 pp., 10½ x 10½ in.
30. ———. *Color Grids.* New York: Multiples, 1977. 92 pp., 8 x 8 in.
31. ———. *Five Cubes/Twenty-Five Squares.* Bari: Galleria Marilena Bonomo, 1977. 100 pp., 8 x 8 in.

OTHER PUBLICATIONS BY THE ARTIST

32. LeWitt, Sol. "Lines and Combinations of Lines." *Art & Project* (Amsterdam), bulletin 18 (1969). 4 pp. (see also Exhibitions, 1970)
33. ———. "Ten Thousand Lines/Six Thousand Two Hundred and Fifty-Five Lines." *Art & Project* (Amsterdam), bulletin 32 (1971). 4 pp. (see also Exhibitions, 1971)
34. ———. "Folded Bulletin." *Art & Project* (Amsterdam), bulletin 43 (1971). 4 pp. (see also Exhibitions, 1971)
35. ———. *Lithographs and Wall Drawings.* Halifax: Nova Scotia College of Art and Design, 1972. (see also Exhibitions, 1972)
36. ———. "Lines & Lines, Arcs & Arcs, & Lines & Arcs." *Art & Project* (Amsterdam), bulletin 60 (1972). 4 pp. (see also Exhibitions, 1972)
37. ———. *Sol LeWitt.* Bari: Galleria Marilena Bonomo, 1973. (see also Exhibitions, 1973)
38. ———. "Vier Muurtekeningen/Quatre Dessins Muraux." *Art & Project* (Amsterdam)/MTL (Brussels), 1973. 4 pp. (see also Exhibitions, 1973)
39. ———. *Location of Three Geometric Figures.* Ed. by Hossmann, Hamburg, and Yves Gevaert, Société des Expositions, Brussels. Brussels: Société des Expositions, Palais des Beaux-Arts, 1974. (see also Exhibitions, 1974)

40. ———. *Wall Drawings & Structures: The Location of Six Geometric Figures/Variations of Incomplete Open Cubes.* New York: John Weber Gallery, 1974. 4 pp. (see also bibl. 15 and Exhibitions, 1974)

41. ———. "Sol LeWitt." *Extra* (Cologne), no. 3 (January 1975). 7 pp.

42. ———. "Incomplete Open Cubes." *Art & Project* (Amsterdam), bulletin 88 (1975). 4 pp. (see also Exhibitions, 1975)

43. ———. *Graphik 1970–1975.* Bern: Kunsthalle Basel & Verlag Kornfeld und Cie., 1975. (see also Exhibitions, 1975)

44. ———. "The Location of Six Geometric Figures." *Double Page,* no. 1 (January 1976). Zurich: Annemarie Verna.

45. ———. *Five Structures* (Hammarskjöld Plaza Sculpture Garden). New York: John Weber Gallery, 1976. 8 pp. (see also Exhibitions, 1976)

46. Lippard, Lucy R. *Eva Hesse.* New York: New York University Press, 1976. Designed by Sol LeWitt.

WRITINGS BY THE ARTIST

47. LeWitt, Sol. "Ziggurats." *Arts Magazine* (New York), vol. 41, no. 1 (November 1966), pp. 24–25.

48. ———. "Paragraphs on Conceptual Art." *Artforum* (New York), vol. 5, no. 10 (June 1967), pp. 79–83.

49. ———. "Drawing Series 1968 (Fours)." *Studio International* (London), vol. 177, no. 910 (April 1969), p. 189.

50. Weber, Anna Nosei and Hahn, Otto, eds. "La Sfida del Sistema." *Metro* (Venice), no. 14 (June 1968), pp. 34–71. Essay by Sol LeWitt, pp. 44–45.

51. LeWitt, Sol. "Sentences on Conceptual Art." *Art-Language* (England), vol. 1, no. 1 (May 1969), pp. 11–13.

52. Battcock, Gregory, ed. "Documentation in Conceptual Art." *Arts Magazine* (New York), vol. 44, no. 6 (April 1970), pp. 42–45. Includes Sol LeWitt on wall drawings, p. 45.

53. LeWitt, Sol. "I Am Still Alive, On Kawara." *Studio International* (London), vol. 180, no. 924 (July-August 1970), p. 37.

54. ———. "Ruth Vollmer: Mathematical Forms." *Studio International* (London), vol. 180, no. 928 (December 1970), pp. 256–257.

55. ———. "Doing Wall Drawings." *Art Now: New York* (New York), vol. 3, no. 2 (June 1971).

56. ———. "All Wall Drawings." *Arts Magazine* (New York), vol. 46, no. 4 (February 1972), pp. 39–44 and cover.

57. ———. "Sol LeWitt." *Flash Art* (Milan), no. 41 (June 1973), p. 2. (See also bibl. 94–96)

58. ———. "Books." *Art Rite* (New York), no. 14 (Winter 1976–77), p. 10.

59. ———. "White in Art is White?" *The Print Collector's Newsletter* (New York), vol. 8, no. 1 (March-April 1977), pp. 1–4.

BOOKS: MONOGRAPHS AND GENERAL

60. Gemeentemuseum, The Hague. *Sol LeWitt.* Texts by John N. Chandler, Enno Develing, Dan Graham, and others. Statements and layout by the artist. (see also Exhibitions, 1970)

61. Harvey, Michael. *Notes on the Wall Drawings of Sol LeWitt.* Geneva: Editions Centre d'Art Contemporain, Salle Patiño & Ecart Publications, 1977.

62. Battcock, Gregory, ed. *Minimal Art: A Critical Anthology.* New York: E. P. Dutton & Co., Inc. 1968.

63. Burnham, Jack. *Beyond Modern Sculpture. The Effects of Science and Technology on the Sculpture of this Century.* New York: George Braziller, 1968.

64. Kulturmann, Udo. *The New Sculpture: Environments and Assemblages.* Translated by Stanley Baron. New York: Frederick A. Praeger, 1968.

65. Siegelaub, Seth and Wendler, John W., eds. *Carl Andre, Robert Barry, Douglas Huebler, Joseph Kosuth, Sol LeWitt, Robert Morris, Lawrence Weiner.* New York: Siegelaub/Wendler, 1968. (Includes Sol LeWitt, *Set IA, 1–24*).

66. Müller, Grégoire and Gorgoni, Gianfranco. *The New Avant-Garde: Issues for the Art of the Seventies.* New York: Praeger Publishers, Inc., 1972.

67. Lippard, Lucy R., ed. *Six Years: The Dematerialization of the Art Object.* New York: Praeger Publishers, Inc., 1973.

68. Hunter, Sam. *American Art of the 20th Century.* New York: Harry N. Abrams, Inc., 1974.

69. de Vries, Gerd, ed. *Über Kunst—On Art: Artists' Writings on the Changed Notion of Art after 1965.* Cologne: Verlag M. DuMont Schauberg, 1974.

70. Cork, Richard. "Alternative Developments." *English Art Today 1960–76,* vol. 2, pp. 310–343. Milan: Electa Editrice, 1976.

PERIODICALS

71. Lippard, Lucy R. "The Third Stream: Painted Structures and Structured Paintings." *Art Voices* (New York), vol. 4, no. 4 (Spring 1965), pp. 44–49.

72. ———. "Rejective Art." *Art International* (Lugano), vol. 10, no. 8 (October 1966), pp. 33–37.

73. ———. "Sol LeWitt: Non-Visual Structures." *Artforum* (New York), vol. 5, no. 8 (April 1967), pp. 42–46. Reprinted: Lippard, Lucy R. *Changing, Essays in Art Criticism.* New York: E. P. Dutton & Co., Inc., 1971, pp. 154–166.

74. Bochner, Mel. "Serial Art Systems: Solipsism." *Arts Magazine* (New York), vol. 41, no. 8 (Summer 1967), pp. 39–43.

75. ———. "The Serial Attitude." *Artforum* (New York), vol. 6, no. 4 (December 1967), pp. 28–33.

76. Lippard, Lucy R. and Chandler, John. "The Dematerialization of Art." *Art International* (Lugano), vol. 12, no. 2 (February 1968), pp. 31–36.

77. Smithson, Robert. "A Museum of Language in the Vicinity of Art." *Art International* (Lugano), vol. 12, no. 3 (March 1968), pp. 21–27.

78. Chandler, John N. "Tony Smith and Sol LeWitt: Mutations and Permutations." *Art International* (Lugano), vol. 12, no. 7 (September 20, 1968), pp. 16–19.

79. Reise, Barbara. "'Untitled 1969': A Footnote on Art and Minimal-stylehood." *Studio International* (London), vol. 177, no. 910 (April 1969), pp. 166–172. (See also Group Exhibitions, 1968)

80. Smithson, Robert. "Aerial Art." *Studio International* (London), vol. 177, no. 910 (April 1969), pp. 180–181.

81. Plagens, Peter. "The Possibilities of Drawing." *Artforum* (New York), vol. 8, no. 2 (October 1969), pp. 50–55.

82. Reise, Barbara. "Sol LeWitt Drawings, 1968–1969." *Studio International* (London), vol. 178, no. 917 (December 1969), pp. 222–225.

83. Atkinson, Terry. "From an Art & Language Point of View." *Art-Language* (England), vol. 1, no. 2 (February 1970), pp. 25–60.

84. Alloway, Lawrence. "Artists and Photographs." *Studio International* (London), vol. 179, no. 921 (April 1970), pp. 162–164.

85. Ashton, Dore. "Intercultural Gaps on the Côte d'Azur: Maeght Foundation Shows American Art." *Arts Magazine* (New York), vol. 45, no. 1 (September-October 1970), pp. 38–41. (see also Group Exhibitions, 1970)

86. Chandler, John Noel. "Drawing Reconsidered." *Arts Canada* (Toronto), vol. 27, no. 5, issue no. 148-149 (October-November 1970), pp. 19–56.

87. Smith, Peggy. "Prints and Drawings: Some New Approaches." *Arts Canada* (Toronto), vol. 27, no. 5, issue no. 148-149 (October-November 1970), pp. 72–74.

88. Pacquement, Alfred. "Sol LeWitt et les systèmes de combinaisons." *Opus International* (Paris), no. 22 (January 1971), pp. 30–31. Translated by Sarah La Brasca, "Sol LeWitt and The System of Combinaison," p. 71.

89. Antin, David. "It Reaches a Desert in Which Nothing Can Be Perceived but Feeling." *Art News* (New York), vol. 70, no. 1 (March 1971), pp. 38–41, 66–71.

90. Shulman, David. "First Person Singular - 1: Bay No. 37." *The Art Gallery Magazine* (New York), vol. 14, no. 6 (April 1971), pp. 19–21.

91. Menno, Filiberto. "Sol LeWitt: Un Sistema Della Pittura." *Data* (Milan), no. 4 (May 1972), pp. 14–21. Translated, "Sol LeWitt: A System of Painting," p. 74.

92. Celant, Germano. "LeWitt." *Casabella* (Milan), no. 367 (July 1972), pp. 38–42.

93. Pincus-Witten, Robert. "Sol LeWitt: Word ⟷ Object." *Artforum* (New York), vol. 11, no. 6 (February 1973), pp. 69–72.

94. *Flash Art* (Milan), no. 39 (February 1973), p. 33. (See also bibl. 57, 95, and 96)

95. "Sol LeWitt." *Flash Art* (Milan), no. 42 (October-November 1973), pp. 4–6. (See also bibl. 57, 94, and 96)

96. Barthelme, Donald. "Letters to the Editore." *The New Yorker* (New York), February 25, 1974, pp. 34–35. (See also bibl. 57, 94, and 95)

97. Alloway, Lawrence. "Artists as Writers, Part Two: The Realm of Language." *Artforum* (New York), vol. 12, no. 8 (April 1974), pp. 30–35.

98. ———. "Sol LeWitt: Modules, Walls, Books." *Artforum* (New York), vol. 13, no. 8 (April 1975), pp. 38–45, cover.

99. Kuspit, Donald B. "Sol LeWitt: The Look of Thought." *Art in America* (New York), vol. 63, no. 5 (September-October 1975), pp. 42–49. (See also bibl. 103)

100. Young, Joseph E. "Serial Prints." *The Print Collector's Newsletter* (New York), vol. 6, no. 4 (September-October 1975), pp. 89–93.

101. Geelhaar, Christian. "Sol LeWitt: Das Druckgraphische Werk." *Kunstforum International* (Mainz), Bd. 16, 2, Quartal 1976, pp. 208–216.

102. Adams, Brooks. "Sol LeWitt: Graphik 1970–1975. Katalog der Siebdrucke, Lithographien, Radierungen, Bücher." *The Print Collector's Newsletter* (New York), vol. 7, no. 4 (September-October 1976), pp. 121–124. (See also bibl. 43)

103. Masheck, Joseph. "Kuspit's LeWitt: Has He Got Style?" *Art in America* (New York), vol. 64, no. 6 (November-December 1976), pp. 107–111. Also, Kuspit, Donald B. "Kuspit/Masheck (con't)." *Art in America* (New York), vol. 65, no. 1 (January–February 1977), pp. 5–7. (See also bibl. 99)

ONE-MAN EXHIBITIONS: CATALOGS AND REVIEWS

(Arranged chronologically. Exhibition dates are listed when known. An asterisk indicates the artist was present to install serial works or execute wall drawings.)

1965

DANIELS GALLERY, NEW YORK. May 4–29.
104. Lippard, Lucy R. "New York Letter." *Art International* (Lugano), vol. 9, no. 6 (September 20, 1965), pp. 57–61.
105. Hoene, Anne. "Sol LeWitt." *Arts Magazine* (New York), vol. 39, no. 10 (September–October 1965), pp. 63–64.

1966

DWAN GALLERY, NEW YORK. April 1–29.
106. Bochner, Mel. "Sol LeWitt." *Arts Magazine* (New York), vol. 40, no. 9 (September–October 1966), p. 61.

1967

DWAN GALLERY, LOS ANGELES. May 10–June 4.

1968

*GALERIE KONRAD FISCHER, DÜSSELDORF. January 6–February 3.
DWAN GALLERY, NEW YORK. February 3–28.
107. Siegel, Jeanne. "Sol LeWitt: 46 Variations Using 3 Different Kinds of Cubes." *Arts Magazine* (New York), vol. 42, no. 4 (February 1968), p. 57.
108. Tucker, Marcia. "Sol LeWitt." *Art News* (New York), vol. 66, no. 10 (February 1968), p. 14.
109. Krauss, Rosalind. "Sol LeWitt, Dwan Gallery." *Artforum* (New York), vol. 6, no. 8 (April 1968), pp. 57–58.

GALERIE BISCHOFBERGER, ZURICH. February 8–March 14.
GALERIE HEINER FRIEDRICH, MUNICH. February 13–March 8.
*ACE GALLERY, LOS ANGELES. December 3–January 11, 1969. See bibl. 2.

1969

*GALERIE KONRAD FISCHER, DÜSSELDORF. April 22–May 16.
*GALLERIA L'ATTICO, ROME. May 2–20.
GALERIE ERNST, HANOVER.
*DWAN GALLERY, NEW YORK. "Wall Drawings," October 4–30.
110. Nemser, Cindy. "Sol LeWitt." *Arts Magazine* (New York), vol. 44, no. 2 (November 1969), p. 63.
111. Bourgeois, Jean-Louis. "New York." *Artforum* (New York), vol. 8, no. 4 (December 1969), pp. 66–73.
112. Ratcliff, Carter, "New York Letter." *Art International* (Lugano), vol. 8, no. 10 (Christmas 1969), pp. 71–75.
*MUSEUM HAUS LANGE, KREFELD. "Sol LeWitt: Sculptures and Wall Drawings." October 26–November 30.
113. Catalog with text by Paul Wember.
GALERIE BISCHOFBERGER, ZURICH. See bibl. 3.

1970

ART & PROJECT, AMSTERDAM. Opened January 2. See bibl. 32.
WISCONSIN STATE UNIVERSITY, RIVER FALLS, WISCONSIN. April 14–May 8.
*GALERIE YVON LAMBERT, PARIS. June 4–27.
*GALLERIA SPERONE, TURIN. "Wall Drawings," June 12–28.
DWAN GALLERY, NEW YORK.
*LISSON GALLERY, LONDON. June 15–July 24.
*GEMEENTEMUSEUM, THE HAGUE, THE NETHERLANDS. July 25–August 30. Catalog, see bibl. 60.
GALERIE HEINER FRIEDRICH, MUNICH. September.
*PASADENA ART MUSEUM, CALIFORNIA. "Sol LeWitt," November 17–January 3, 1971.
114. Catalog.
115. Plagens, Peter. "Los Angeles." *Artforum* (New York), vol. 9, no. 6 (February 1971), pp. 88–92.
116. Terbell, Melinda. "Los Angeles." *Arts Magazine* (New York), vol. 45, no. 4 (February 1971), p. 45.

1971

ART & PROJECT, AMSTERDAM. Opened January 4. See bibl. 33.
*PROTETCH-RIVKIN GALLERY. WASHINGTON, D.C. "Wall Drawings," opened April 17.
DWAN GALLERY, NEW YORK. "Prints & Drawings," May 1–26.
*LISSON GALLERY, LONDON. June. See bibl. 5.
GALERIE STAMPA, BASEL.
*GALLERIA TOSELLI, MILAN. July.
INFORMATIONS-RAUM 3, BASEL. August 24–September 18.

*GALERIE KONRAD FISCHER, DÜSSELDORF. September 3–October 1.

ART & PROJECT, AMSTERDAM. September 7–October 2. See bibl. 34.

*JOHN WEBER GALLERY, NEW YORK. "Structures and Wall-Drawings," September 25–October 20.

117. Domingo, Willis. "In The Galleries." *Arts Magazine* (New York), vol. 46, no. 2 (November 1971), pp. 59–61.

DUNKLEMANN GALLERY, TORONTO, CANADA.

GALERIE ERNST, HANOVER. December–January 1972.

1972

MASSACHUSETTS INSTITUTE OF TECHNOLOGY, HAYDEN GALLERY, CAMBRIDGE, MASSACHUSETTS. "Wall Drawings, Sculpture," February 28–March 28.

HARKUS-KRAKOW GALLERY, BOSTON, MASSACHUSETTS.

DAYTON ART INSTITUTE, DAYTON, OHIO.

*KUNSTHALLE BERN. See bibl. 6.

GALLERY A-402, CALIFORNIA INSTITUTE OF THE ARTS, VALENCIA, CALIFORNIA. Opened April.

NOVA SCOTIA COLLEGE OF ART AND DESIGN, HALIFAX, NOVA SCOTIA. Catalog, see bibl. 35.

*GALERIE MTL, BRUSSELS.

*GALERIE KONRAD FISCHER, DÜSSELDORF. September–October.

ART & PROJECT, AMSTERDAM. Opened September 25. See bibl. 36.

1973

*GALERIE YVON LAMBERT, PARIS. Opened January 9. See bibl. 7.

118. Peppiatt, Michael. "Paris: Mid-January." *Art International* (Lugano), vol. 17, no. 3 (March 1973), pp. 51–53.

*JOHN WEBER GALLERY, NEW YORK. January 27–February 14.

119. Frank, Peter. "Judd, LeWitt, Rockburne." *Art News* (New York), vol. 72, no. 3 (March 1973), pp. 71–72.

120. Stitelman, Paul. "New York." *Arts Magazine* (New York), vol. 47, no. 5 (March 1973), pp. 68–70.

121. Borden, Lizzie. "Sol LeWitt." *Artforum* (New York), vol. 11, no. 8 (April 1973), pp. 73–77.

122. Crimp, Douglas. "New York Letter." *Art International* (Lugano), vol. 17, no. 4 (April 1973), pp. 57–59, 102–103.

123. Gula, Kasha Linville. "Sol LeWitt at John Weber." *Art in America* (New York), vol. 61, no. 3 (May–June 1973), pp. 101–102.

ROSA ESMAN GALLERY, NEW YORK. February 3–28. See bibl. 119.

VEHICULE ART, INC., MONTREAL, CANADA.

*LISSON GALLERY, LONDON.

*MUSEUM OF MODERN ART, OXFORD, ENGLAND.

*GALLERIA L'ATTICO, ROME.

*GALLERIA TOSELLI, MILAN.

GALLERIA MARILENA BONOMO, BARI. Catalog, see bibl. 37.

*PORTLAND CENTER FOR VISUAL ARTS, PORTLAND, OREGON. September 16–October 14. See bibl. 8.

*CUSACK GALLERY, HOUSTON, TEXAS. October. See bibl. 10.

ART & PROJECT, AMSTERDAM/GALERIE MTL, BRUSSELS. November 13–December 8. See bibl. 38.

1974

GALERIE YVON LAMBERT, PARIS. "Incomplete Open Cubes."

*LISSON GALLERY, LONDON. April–May. See bibl. 17.

124. Stezaker, John. "Sol LeWitt." *Studio International* (London), vol. 187, no. 967 (June 1974), review 10.

125. Crichton, Fenella. "London Letter." *Art International* (Lugano), vol. 18, no. 6 (Summer 1974), pp. 40–42, 62–64.

*MAX PROTETCH GALLERY, WASHINGTON, D.C. Opened April 6. See bibl. 12.

GALERIE DECEMBER, MUNSTER, GERMANY.

*PALAIS DES BEAUX ARTS, BRUSSELS. May–June 1974. See bibl. 39.

RIJKMUSEUM KRÖLLER-MULLER, OTTERLO, THE NETHERLANDS.

JOHN WEBER GALLERY, NEW YORK. "Incomplete Open Cubes," October 26–November 20. See bibl. 15 and 40.

126. Lubell, Ellen. "Sol LeWitt." *Arts Magazine* (New York), vol. 49, no. 5 (January 1975), p. 9.

127. Smith, Roberta. "Sol LeWitt." *Artforum* (New York), vol. 13, no. 5 (January 1975), pp. 60–62.

*STEDELIJK MUSEUM, AMSTERDAM. November 29–January 1975.

ACE GALLERY, LOS ANGELES.

*DANIEL WEINBERG GALLERY, SAN FRANCISCO.

*GALLERIA SPERONE, TURIN. See bibl. 14.

GALERIE VEGA, LIEGE, BELGIUM.

GIAN ENZO SPERONE, NEW YORK. December–January 1975.

NEW YORK CULTURAL CENTER, NEW YORK. "Fifty Drawings: 1964–1974." Traveled to Vancouver Art Gallery, Vancouver, Canada, 1974; Everson Museum of Art, Syracuse, New York, 1975; High Museum of Art, Atlanta, Georgia, 1975; *San Francisco Museum of Modern Art, San Francisco, July 5–August 17, 1975; Mint Museum of Art, Charlotte, North Carolina, 1975; Tyler Museum of Art, Tyler, Texas, 1975; Arkansas Arts Center, Little Rock, Arkansas, 1976; Illinois State University, Normal, Illinois, 1976; The Winnipeg Art Gallery, Winnipeg, Manitoba, Canada, 1976; Herbert F. Johnson Museum of Art, Cornell University, Ithaca, New York, 1976.

128. Martin Fred. "San Francisco Letter." *Art International* (Lugano), vol. 19, no. 9 (November 20, 1975), pp. 53–55.

1975

*LUCIO AMELIO MODERN ART AGENCY, NAPLES.

*DANIEL WEINBERG GALLERY, SAN FRANCISCO.

ART & PROJECT, AMSTERDAM. "Incomplete Open Cubes," March 4–15. See bibl. 42.

*SCOTTISH NATIONAL GALLERY OF MODERN ART, EDINBURGH. "Incomplete Open Cubes and Wall Drawings."

129. Macmillan, Duncan, "Sol LeWitt," *Studio International* (London), vol. 190, no. 976 (July–August 1975), pp. 78–79.

GALLERY KONRAD FISCHER, DÜSSELDORF.

SAMAN GALLERY, GENOA.

ARONOWITSCH GALLERY, STOCKHOLM.

ANNEMARIE VERNA, ZURICH. See bibl. 19.

ROLF PREISIG GALLERY, BASEL. See bibl. 19.

ISRAEL MUSEUM, JERUSALEM. "Wall Drawings." See bibl. 22.

GALLERIA SPERONE, TURIN. "Incomplete Open Cubes," September–October.

*KUNSTHALLE BASEL. "Graphik 1970–1975," October 18–November 23. Catalog, see bibl. 43.

130. Geelhaar, Christian. "Basel." *Pantheon* (Munich), vol. 34, no. 1 (January–March 1976), pp. 75–76.

KUNSTHALLE BASEL. "Incomplete Open Cubes," October.

CLAIRE COPLEY, GALLERY, INC., LOS ANGELES. October 25–November 20.

PRINTMAKERS' WORKSHOP, EDINBURGH. November 1–22.

1976

VISUAL ARTS MUSEUM, NEW YORK. March 1–19.

*DAG HAMMARSKJÖLD PLAZA SCULPTURE GARDEN, NEW YORK. March–May. Catalog, see bibl. 45.

KÖLNISCHER KUNSTVEREIN, COLOGNE. "Incomplete Open Cubes," May 26–August 1.

*GIAN ENZO SPERONE, ROME. June–July.

KORNBLATT GALLERY, BALTIMORE. "Drawings, Prints and Cubes," September 5–30.
*FINE ARTS GALLERY, UNIVERSITY OF COLORADO, BOULDER. "Wall Drawings, Structures and Prints," October 4–November 12. See bibl. 25.
*CLAIRE COPLEY GALLERY, INC., LOS ANGELES. "Wall Drawings," October 12–November 8.
GALERIE MTL, BRUSSELS.
WADSWORTH ATHENEUM, HARTFORD, CONNECTICUT.
STEDELIJK, VAN ABBEMUSEUM, EINDHOVEN. "Incomplete Open Cubes."
CENTRE D'ART CONTEMPORAIN, GENEVA. "Incomplete Open Cubes," November.

1977

JOHN WEBER GALLERY, NEW YORK. "Structures," March 2–19.
131. Perreault, John. "Patterns of Thought." *Soho Weekly News* (New York), vol. 4, no. 23 (March 10–16, 1977), pp. 17–19.
132. Wooster, Ann-Sargent. "Sol LeWitt." *Art News* (New York). vol. 76, no. 5 (May 1977), p. 140.
LISSON GALLERY, LONDON. March 12–April 9.
GALERIE KONRAD FISCHER, DÜSSELDORF.
*THE ART GALLERY OF NEW SOUTH WALES, SYDNEY, AUSTRALIA. Opened March 19. See bibl. 27.
NATIONAL GALLERY OF VICTORIA, MELBOURNE, AUSTRALIA.
JOSLYN ART MUSEUM, OMAHA, NEBRASKA.
UTAH MUSEUM OF FINE ARTS, SALT LAKE CITY, UTAH.
UNIVERSITY OF NORTH DAKOTA ART GALLERY, GRAND FORKS, NORTH DAKOTA.
MUSEUM OF MODERN ART, OXFORD, ENGLAND. "Incomplete Open Cubes," April 24–May 29.
SAMAN GALLERY, GENOA, ITALY. Opened June 6.
*ART AND ARCHITECTURE GALLERY, YALE SCHOOL OF ART, NEW HAVEN, CONNECTICUT. September 5–30.
*UNIVERSITY GALLERY, UNIVERSITY OF MASSACHUSETTS, AMHERST. "Incomplete Open Cubes, Prints and Wall Drawings," September–October.

GROUP EXHIBITIONS: CATALOGS AND REVIEWS

1963

ST. MARK'S CHURCH, NEW YORK. May 8–31.

1964

KAYMAR GALLERY, NEW YORK.

1965

DANIELS GALLERY, NEW YORK.
BYRON GALLERY, NEW YORK. "Box Show."
GRAHAM GALLERY, NEW YORK. "Young Masters," November 30–December.
WORLD HOUSE GALLERY, NEW YORK. "Sculpture from All Directions."

1966

INSTITUTE OF CONTEMPORARY ART, BOSTON. "Multiplicity," April 16–June 5.
133. Catalog with Introduction by Molly Rannels.
THE JEWISH MUSEUM, NEW YORK. "Primary Structures," April 27–June 12.
134. Catalog with Introduction by Kynaston L. McShine.

135. Robins, Corinne. "Object, Structure, or Sculpture: Where Are We?" *Arts Magazine* (New York), vol. 40, no. 9 (September–October 1966), pp. 33–37.
FINCH COLLEGE MUSEUM, NEW YORK. "Art in Process."
136. Bochner, Mel. "Art in Process—Structures." *Arts Magazine* (New York), vol. 40, no. 9 (September–October 1966), pp. 38–39.
PARK PLACE GALLERY, NEW YORK. "Three-Man Show" (with Leo Valledor and Robert Smithson), October 16–November 9.
DWAN GALLERY, NEW YORK AND LOS ANGELES. "10," ended 1967.

1967

DWAN GALLERY, NEW YORK. "Scale Models and Drawings," January-February.
137. Graham, Dan. "Models and Monuments: The Plague of Architecture." *Arts Magazine* (New York), vol. 41, no. 5 (March 1967), pp. 32–35.
138. Graham, Dan. "New York: Of Monuments and Dreams." *Art and Artists* (London), vol. 1, no. 12 (March 1967), pp. 62–63.
LOS ANGELES COUNTRY MUSEUM OF ART. "American Sculpture of the Sixties," April 28–June 25. Traveled to Philadelphia Museum of Art, September 15–October 29.
139. Catalog edited by Maurice Tuchman. Los Angeles: Los Angeles County Museum of Art, 1967.
*INSTITUTO TORCUATO DI TELLA, MUSEO DE ARTES VISUALES, BUENOS AIRES.
FINCH COLLEGE MUSEUM, NEW YORK. "Art in Series," ended 1968.

1968

GEMEENTEMUSEUM, THE HAGUE, THE NETHERLANDS. "Minimal Art," March 23–May 26. See bibl. 79. Traveled to Kunsthalle, Düsseldorf and Academie der Künste, Berlin.
140. Catalog with Introduction by E. Develing. The Hague.
141. Blok, C. "Minimal Art at The Hague." *Art International* (Lugano), vol. 12, no. 5 (May 15, 1968), pp. 18–24.
KASSEL, GERMANY. "Documenta 4," June 27–October 6, 1968.
142. Catalog.
THE MUSEUM OF MODERN ART, NEW YORK. "The Art of the Real," July 3–September 8. An exhibition organized and circulated under the auspices of the International Council of The Museum of Modern Art, New York. Traveled to Grand Palais, Paris, November 14–December 23, 1968; Kunsthaus, Zurich, January 19–February 23, 1969; The Tate Gallery, London, April 22–June 1, 1969.
143. Catalog with text by E. C. Goosen. New York: The Museum of Modern Art, 1968.
DWAN GALLERY, NEW YORK. "Earthworks," October.
PAULA COOPER GALLERY, NEW YORK. "Benefit for the Student Mobilization Committee to End the War in Vietnam," October–November.
KUNSTHALLE, DÜSSELDORF. "Prospect '68."
KÖLNISCHER KUNSTVEREIN, COLOGNE. "Kunstmarkt."

1969

KUNSTHALLE BERN. "When Attitudes Become Form," March 22–April 27. Traveled to Institute of Contemporary Art, London, and Museum Hans Lange, Krefeld.
WHITNEY MUSEUM OF AMERICAN ART, NEW YORK. "American Contemporary Sculpture," April 15–May 5.
INDIANAPOLIS MUSEUM OF ART, INDIANAPOLIS, INDIANA.
144. Warrum, Richard L. Introduction to *Painting and Sculpture Today—1969* (bulletin). Indianpolis Museum of Art, vol. 55, no. 3 (May 1969).

PAULA COOPER GALLERY, NEW YORK. "Number 7," May–June.
KRANNERT ART MUSEUM, UNIVERSITY OF ILLINOIS, CHAMPAIGN. "Contemporary American Painting and Sculpture."
STÄDTISCH MUSEUM, SCHLOSS MORSBROICH, LEVERKUSEN. "Konzeption/Conception."
145. Catalog edited by Rolf Wedewer and Konrad Fischer. Cologne and Opladen: Westdeutscher Verlag (and) Leverkusen, Städtisch(es) Museum, Schloss Morsbroich, 1969.

1970

METROPOLITAN MUSEUM OF ART, TOKYO. "Tenth Biennale."
MUSEUM OF CONTEMPORARY ART, LA JOLLA, CALIFORNIA. "Projections: Anti-Materialism."
146. Young, Joseph E. "Los Angeles." *Art International* (Lugano), vol. 15, no. 1 (January 20, 1971), pp. 46–52, 84.
GALLERIA CIVICA D'ARTE MODERNA, TURIN. "Conceptual Art, Arte Povera, Land Art," June–July.
147. Catalog.
THE MUSEUM OF MODERN ART, NEW YORK. "Information," July 2–September 20.
148. Catalog edited by Kynaston L. McShine.
MAEGHT FOUNDATION, ST. PAUL-DE-VENCE, FRANCE. See bibl. 85.

1971

MILWAUKEE ART CENTER, MILWAUKEE, WISCONSIN. "New Directions: Eight Artists," June 19–August 8.
149. Catalog with Introduction by John Lloyd Taylor.
ARNHEM, HOLLAND. "Sonsbeek '71," June 19–August 15.

1972

INSTITUTE OF CONTEMPORARY ART, UNIVERSITY OF PENNSYLVANIA, PHILADELPHIA. "Grids," January 27–March 1.
150. Catalog with text by Lucy R. Lippard.
KASSEL, GERMANY. "Documenta 5," June 30–October 8.
151. Catalog.
PAULA COOPER GALLERY, NEW YORK. Summer.
152. Smith, Roberta Pancoast. "New York." *Data* (Milan), nos. 5/6 (Summer 1972), pp. 89–93.
JOHN WEBER GALLERY, NEW YORK. May 27–July 29.

1973

THE NEW YORK CULTURAL CENTER, NEW YORK. "3D Into 2D: Drawing for Sculpture," January 19–March 11. See bibl. 121 and 122.
153. Catalog with text by Susan Ginsburg.
PAULA COOPER GALLERY, NEW YORK. "Works from the Early Sixties," January 20–February 15. See bibl. 122.
PARCHEGGIO DI VILLA BORGHESE, ROME. "Contemporanea," November–February 1974.
154. Catalog edited by Achille Bonito Oliva. Incontri Internazionali d'Arte. Florence: Centro Di, 1973.

1974

THE MUSEUM OF MODERN ART, NEW YORK. Traveling exhibition, "Some Recent American Art." An exhibition organized and circulated under the auspices of the International Council of The Museum of Modern Art, New York. Traveled in Australia and New Zealand to: The National Gallery of Victoria, Melbourne, February 12–March 10; Art Gallery of New South Wales, Sydney, April 5–May 5; Art Gallery of South Australia, Adelaide, May 31–June 30; West Australian Art Gallery, Perth, July 26–August 21;

City of Auckland Art Gallery, Auckland, October 14–November 17.
155. Catalog with Introduction by Jennifer Licht. Melbourne: The National Gallery of Victoria, 1973.
THE ART MUSEUM, PRINCETON UNIVERSITY, PRINCETON, NEW JERSEY. "Line as Language: Six Artists Draw," February 23–March 31.
156. Catalog with text by Rosalind Krauss.
157. Gilbert-Rolfe, Jeremy. "Line as Language: Six Artists Draw." *Artforum* (New York), vol. 12, no. 10 (June 1974), pp. 67–68.
KÖLNISCHER KUNSTVEREIN, COLOGNE. "Kunst-Über Kunst: Werke und Theorien eine Ausstellung in drei Teilen," April 11–May 26.
158. Catalog.
JOHN F. KENNEDY CENTER, WASHINGTON, D.C. "Art Now 74: A Celebration of the American Arts," May 30–June 16.
159. Catalog. Washington, D.C.: John F. Kennedy Center for the Performing Arts, Artrend Foundation, 1974.
MTL GALLERY, BRUSSELS. See bibl. 13.

1975

THE CORCORAN GALLERY OF ART, WASHINGTON, D.C. "34th Biennial of Contemporary American Painting."
THE MUSEUM OF MODERN ART, NEW YORK. Traveling exhibition, "Color as Language." An exhibition organized and circulated under the auspices of the International Council of The Museum of Modern Art, New York. Traveled to Museo de Arte Moderno, Bogota, February 24–March 30; Museu de Arte Moderna de São Paulo, April 18–May 18; Museu de Arte Moderna, Rio de Janeiro, June 12–July 20; Museo de Bellas Artes, Caracas, August 3–September 14; Museo de Arte Moderno, Mexico City, October 2–November 23.
THE MUSEUM OF MODERN ART, NEW YORK. Traveling exhibition, "American Art Since 1945: From the Collection of The Museum of Modern Art." Traveled to Worcester Art Museum, Worcester, Massachusetts, October 20–November 30, 1975; Toledo Museum of Art, Toledo, Ohio, January 10–February 22, 1976; Denver Art Museum, Denver, Colorado, March 22–May 2, 1976; Fine Arts Gallery of San Diego, San Diego, California, May 31–July 11, 1976; Dallas Museum of Fine Arts, Dallas, Texas, August 19–October 3, 1976; Joslyn Art Museum, Omaha, Nebraska, October 25–December 5, 1976; Greenville County Museum, Greenville, South Carolina, January 8–February 20, 1977; Virginia Museum of Fine Arts, Richmond, Virginia, March 14–April 17, 1977; Bronx Museum of the Arts, New York, May 10–June 30, 1977.
160. Catalog with Introduction by Alicia Legg. New York: The Museum of Modern Art, 1975.

1976

THE MUSEUM OF MODERN ART, NEW YORK. "Drawing Now," January 23–March 9. Circulated under the auspices of the International Council of The Museum of Modern Art, New York. Traveled to Kunsthaus, Zurich, October 10–November 14, 1976; Staatliche Kunsthalle, Baden Baden, November 25–January 16, 1977; Albertina Museum, Vienna, January 28–March 6, 1977; Sonja Henie-Niels Onstad Foundations, Oslo, March 20–April 24, 1977; Tel Aviv Museum, Tel Aviv, May 12–July 2, 1977.
161. Catalog with text by Bernice Rose. New York: The Museum of Modern Art, 1976.
SCHOOL OF VISUAL ARTS, NEW YORK. "Lines," January 26–February 18. Traveled to Philadelphia College of Art, March 5–April 9.

THE ART INSTITUTE OF CHICAGO. "Seventy-second American Exhibition," March 13–May 9.
162. Catalog with Introduction by Anne Rorimer.
WHITNEY MUSEUM OF AMERICAN ART, NEW YORK. "200 Years of American Sculpture," March 16–September 26.
163. Catalog with Essay by Barbara Haskell.
ROSA ESMAN GALLERY, NEW YORK. "Photonotations," May 4–28.
VENICE. "Biennale."
164. Catalog.
DETROIT INSTITUTE OF ART. "American Artists: A New Decade," July 30–September 19. Traveled to Fort Worth Art Museum, Texas, ended January 2, 1977.
165. Kutner, Janet. "The Visceral Aesthetic Of A New Decade's Art." *Arts Magazine* (New York), vol. 51, no. 4 (December 1976), pp. 100–103.

1977

ROSA ESMAN GALLERY, NEW YORK. "Photonotations II," May 3–June 4.
HUNDRED ACRES GALLERY, NEW YORK. "10 Alumni, School of Visual Arts," ended June 18.
JOHN WEBER GALLERY, NEW YORK. September 10–27.